Enacting History

Enacting History

Edited by Scott Magelssen and
Rhona Justice-Malloy

THE UNIVERSITY OF ALABAMA PRESS
Tuscaloosa

Copyright © 2011
The University of Alabama Press
Tuscaloosa, Alabama 35487-0380
All rights reserved
Manufactured in the United States of America

Typeface: Garamond

∞
The paper on which this book is printed meets the minimum requirements of American
National Standard for Information Sciences-Permanence of Paper for Printed Library
Materials, ANSI Z39.48-1984.

Library of Congress Cataloging-in-Publication Data
Enacting history / edited by Scott Magelssen and Rhona Justice-Malloy.
 p. cm.
 Includes bibliographical references.
 ISBN 978-0-8173-1728-7 (cloth : alk. paper) — ISBN 978-0-8173-5654-5 (pbk. : alk.
paper) — ISBN 978-0-8173-8535-4 (electronic) 1. Historical reenactments. I. Magelssen,
Scott, 1974– II. Justice-Malloy, Rhona.
 E179.E555 2012
 900—dc22

 2010051387

Contents

Illustrations

Acknowledgments

We would like to gratefully acknowledge the wonderful work of our administrative associate, Catherine Mayhew, who has been instrumental in every step of the process of putting this volume together. Our heartfelt thanks, Catherine.

We also thank our friends and family for all their support and patience. We recognize the Mid-America Theatre Conference for its importance to the volume as well; it was indeed in the hallways between sessions at an annual conference where the idea for *Enacting History* was initially sparked. And, of course, many thanks to Dan Waterman at The University of Alabama Press for his enthusiasm for the project from the beginning.

Introduction

Scott Magelssen

Enacting History is a collection of new essays by scholars in theater and performance studies tracing the ways recent performance practices have been used to select, devise, and perform narratives of the past to their participants and audiences. Such practices include living history museums, battle reenactments, pageantry, rendezvous, Renaissance festivals, and adventure-tourism destinations. The essays that comprise this collection by no means constitute a complete survey of performative representations of the past. Rather, we sought out a relatively short list of scholars, and in some cases practitioners, who are currently conducting crucial work in this area through their focus on specific case studies and methodologies and whose observations and arguments contribute to the larger questions of an ongoing discussion.

For example, each of these popular forms, depending on its context and purpose, claims a greater or lesser degree of historical "accuracy" or "authenticity" to its participants and spectators, and the authors in this volume tease out the representational and historiographic issues related to such claims. But, moreover, they carefully consider other emerging dilemmas concerning spectatorship, politics, and the construction of communal identity. How, for instance, are issues of race, ethnicity, and gender dealt with at museums and events that purport to be accurate windows into the past? How are political and labor issues handled in local- or state-funded institutions that rely heavily on volunteer performers, and how do these issues shade or compromise the performances? How do tourists' expectations shape the choices made by would-be purveyors of the past? Where do matters of taste or censorship enter in when reconciling archival evidence with a family-friendly mission? How is meaning conveyed by these enactments, and how is it received—or produced—by their spectators? On what criteria does "authenticity" hinge, and who, ultimately, is to judge whether a particular spectator's experience of the past is "authentic"?

The past has been a subject of theater and performance since the beginning. On the face of it, a glance at the "canon" of Western non-comedic drama, for instance, suggests that if one were to catalog the material written for the stage into that which fabulates incidents in the present and near future and that which portrays events that have already happened (or *ought* to have happened, per the dicta of Aristotle and later the Neoclassicists), the bulk of the plays would fall into the latter variety. (Let us not forget, either, that any playwright's depiction of her or his contemporary milieu, with few exceptions, defaults into a "historical drama" upon subsequent revival.) And when we expand the umbrella to cover the realm of historical performance that takes place, for the most part, *outside* traditional theater venues, it becomes even clearer that spectators and participants have found the past to be a seemingly inexhaustible repository of material for public consideration and reworking.

It is this larger umbrella with which the authors of this collection are concerned. Whether closely following a script, improvised around a loose scenario, or based completely on free-play, performative representations have shaped audiences' understanding of the past for centuries. These performances have been manifested in civic spaces, as was the case with medieval mystery pageants in England and on the Continent, and spaces with decidedly more limited access: *Le Ballet de la Nuit* at the Louvre's Salle du Petit-Bourbon or *The Birth of a Nation* in the White House's family theater. They have been witnessed by hundreds of thousands, like the commemorative spectacle *The Storming of the Winter Palace* in revolutionary Russia, and by very intimate audiences, as in Eastern European living rooms when martial law or censorship prohibited artists like Vaclav Havel from telling any story outside the officially sanctioned "past." In a similar manner, performances have restaged famous battles with casts of thousands in the stadiums of antiquity, and they have been performed by a sole troubadour, the custodian of his people's exploits and victories. And practitioners' intentions have been as deeply religious as the ritual commemorations performed by a Catholic priest during Mass and a Muslim pilgrim on the hajj or as secular as an antique tractor pull.

It would seem, then, that the public's fascination with enacting and watching history has been a perennial and vital theme in much of our society. Since the late nineteenth century, though, there have been numerous shifts and thresholds that have pushed representations of past events into new territory, and it is possible to suggest that even more recently we have been experiencing a surge of sorts in re-enactments, historical reality shows, specialty cable channels, historical film and costume drama, museum displays, world fairs and cultural festivals, pageants, historical hobbyism, role-playing, and online gaming with historical premises.

The recipe for this particular surge is as complex as it is resistant to parsing, although we have been equipped with helpful tools for grappling with its tortuous genealogy by theater scholars and performance theorists like Joseph Roach, Rosemarie Bank, and Barbara Kirshenblatt-Gimblett; by cultural historians and anthropologists like Tony Bennett, Maxine Feifer, John Urry, Dean MacCannell, David Lowenthall, Robert Hewison, Richard Slotkin, Marie-Louise Pratt, Jay Anderson, Stephen Eddy Snow, Tony Horwitz, Jenny Thompson, Richard Handler, and Eric Gable; by postmodern watchdogs like Jean Baudrillard, Roland Barthes, and Umberto Eco; and by performance-artist revisionists and gadflies like Robbie McCauley, Rebecca Schneider, Guillermo Gomez-Peña, and Coco Fusco. As these scholars and artists well elucidate, the causes of our preoccupation with performing history could be anything from emerging styles of realism and naturalism coupled with the rise of democracy and social reform to a powerful nostalgia symptomatic of waves of immigration and cultural-pride movements. From the intractable baggage of colonialism and imperialism to the need for legitimizing narratives to shore up new nationalisms. From shifts in economics and booms in family mobility, fomenting what Kirshenblatt-Gimblett has called "heritage as a 'value-added' industry,"[1] to the philanthropic efforts of key millionaires like Henry Ford and John D. Rockefeller Jr., who desired to shape the historical landscape into a space that affirmed their notions of the cosmos. Add to these catalysts the periods of flux and national anxieties in the twentieth century accompanying the world wars, McCarthyism, and the upheavals of the 1960s, each of which produced their own cottage industries of tourist attractions, community organizations, and subcultures offering soothing narratives of the "good old days."

The purpose of these essays is not to put a finger on the causes of why historical enactments are, if anything, as strong as ever. Rather, each piece in the volume seeks to tease out the contours of contemporary performance practices that bear witness to a moment or a set of moments of the past, whether actual or largely imagined (and, it should be noted that for some the difference between the two is a matter of splitting hairs).

Readers will find, for instance, the authors using ideas and theory from theater and performance studies to think differently about the construction of ethnic, regional, communal, or national identity at living history events, historic sites, and other kinds of performances. Leigh Clemons does this when she turns her attention to the historical battle reenactments, or "impressions," commemorating the Texas Revolution's Battle of Coleto Creek and "Goliad Massacre," which not only structure public memory of these events through performance but also work to constitute "Mexican" and "Texian" identity for participants and audiences.

Lindsay Adamson Livingston investigates the way certain geographical spaces associated with the Church of Jesus Christ of Latter-day Saints have been charged with meaning in such a way that they perform for church members histories and memories foundational to Mormon identity. Amy M. Tyson approaches her own study, an examination of gender-role construction at Historic Fort Snelling, as a participant-observer. Based on her experience as a costumed interpreter, Tyson offers accounts of how contemporary gendered expectations and management practices inform the historiographic performance, offered to the museum's visitors, in ways we rarely consider.

In these and other essays in the collection, readers will also encounter the challenges practitioners face when seeking to balance a respectful approach to past lives with accessibility and authenticity (not to mention entertainment) for present-day audiences. In fact, many of the contributors turn their scholarly eye upon their own practices as case studies. Richard L. Poole interrogates his own creative process in a pageant he was commissioned to direct as part of the Lewis and Clark Bicentennial and the way his production fit within the larger milieu of Lewis and Clark memorials and other memory productions in the U.S. Midwest and West. In particular, Poole asks whether his decisions challenged or reaffirmed audiences' ideas about the explorers' "Corps of Discovery" and the Native peoples with whom they interacted. Aili McGill similarly reflects on the choices she made in the inaugural year of a new interactive museum theater program at Conner Prairie, a living history museum. McGill's detailed account, not only of the nuts and bolts of building a museum theater program from the ground up, but also of the broader questions of the educational goals and philosophies raised by such a program, makes it a valuable resource for scholars and practitioners alike. Patricia Ybarra describes her production of Marcus Gardley's play "And Jesus Moonwalks the Mississippi" at Brown University in order to discuss how an Ivy League school uses commemorative performance to wrestle with an institutional history wrapped up in the business of slavery. Where many events commemorating legacies of loss or trauma are quick to promise closure and reconciliation, Ybarra meditates on what she learned about the productive possibilities in fomenting and allowing for anger as a means for continued discourse about—and *remembering of*—past injustices.

In addition to offering pieces that focus on the ways enacting history makes meaning and identity or that illustrate the complexities of the historiographic and performative processes that go into these events, the essays in this collection also model ways of theorizing about the affective and cognitive experiences of practitioners and audiences (sometimes one and the same) during the performances in question. Catherine Hughes uses reader reception theory to tackle the question

of what makes historical performances "real" for audiences at museums and other sites. Far from hinging on historical accuracy, Hughes reports from her research of theater programs at these sites, the realness or authenticity of a production depends on each audience member's aesthetic and emotional engagement with the performance and the surrounding venue and the way it matches up with her or his own life experiences. In other words, the constitution of authenticity lies in the audience members' own affective response as much as in the production's choices. Kimberly Tony Korol-Evans unpacks the dynamic quality of the space where the contemporary real world overlaps or "collides" with the historical record of the sixteenth-century at Renaissance festivals—a space that Korol-Evans calls the "intrastice"—and maps out the movements of the various bodies that inhabit that space. But Korol-Evans layers even more complexity into her analysis when she examines an instance when the Food Network's *Dinner: Impossible* program immersed a chef into the Maryland Renaissance Festival and challenged him to prepare a meal fit for a king (from historically accurate scratch) in only seven hours—all for a decidedly contemporary reality-TV audience. Scott Magelssen inventories the emergent phenomenon of interpretive programs that invite spectators to become a part of the action by assigning them roles in the historical narrative. Focusing on a program in Mexico that offers tourists the chance to play illegal migrants attempting to cross the border into the United States, Magelssen discusses how the bodies of these tourist performers, including his own, contribute to or even resist the stories being enacted. Finally, Rhona Justice-Malloy's concluding essay to the volume documents a recently devised production in her own community whereby performance was used to remember the histories of those at whom we "often choose not to look." Based on her personal interviews with the artists and ensemble members involved in "Secret Histories: Oxford," an installment of Ping Chong & Company's "Undesirable Elements" series of performances, Justice-Malloy details the process in which the oral histories of some of the marginalized residents of Oxford, Mississippi, were brought together in a public forum with song and poetry. Justice-Malloy's account reveals the ways in which performance and storytelling can work to bridge divides between "included" and "excluded" members of our communities.

It is evident, given the above, that a cohesive collection of essays interrogating representational and historiographic practices of enacting history is critically important, and it is therefore to this end that we have committed our efforts. We hope that our text will become a useful resource for scholars and practitioners, especially as it draws together the latest in theory and application, and will prompt readers to draw innovative comparisons and find intersections between the essays.

We are concerned with not only the subject matter treated by these performances, but the mode of performance itself. The very notion of performance as a practice of *creating* history is an essential issue today, and it is in this regard that the essays in this volume draw from valuable discussions started by scholars in folklore, cultural anthropology, and museum studies and use these discussions as springboards for some new discursive trajectories. Indeed, scholars in all of our disciplines believe that performance can offer an understanding of the past more accessible, more efficacious, and more *authentic* than a more traditionally accepted medium like a book or an article. As Charlotte Canning writes, "The performance of history is not usually held up as a legitimate mode of historiography. . . . But performance can demonstrate aspects of and ideas about history that are less possible in print. It can encourage considerations of the gestural, the emotional, the aural, the visual, and the physical in ways beyond print's ability to evoke or understand them."[2]

In a similar manner, Freddie Rokem holds that theater and performance more "forcefully" participate in historiographic procedures than other forms of discourse. Not only can enacting history reinforce cultural identities and ideologies, but it can serve as a more appropriate means for challenging dominant ideologies than the written text, "sometimes contesting the hegemonic understanding of the historical heritage on the basis of which [those] identities have been constructed."[3]

Furthermore, as Diana Taylor has reminded us, performance entails a "repertoire" of practices that convey meaning in ways that cut across or exceed the limits imposed by class structures or other systems of oppression. Embodied performance, Taylor writes, is a means of "knowledge transmission" perhaps more egalitarian and unrestricted than print and other media of the privileged. If it were not so, "only the literate and powerful could claim social memory and identity."[4]

Unlike other media devoted to a more traditionally "legitimate" means of disseminating history, many forms of historiographic performance treated in this book are refreshingly absolved of the (impossible) onus to tell the "straight story" of what happened. For practitioners, participating in the performance of history does not have to be about resuscitating the archival documents exactly as written by some sacrosanct forefather long ago, but rather it can be about creating a space of potential and community in the present. In other words, to reenactment groups like the Society for Creative Anachronism (whose unofficial motto reads, "The Middle Ages as they *Should* have Been") and other live and online role-playing communities, or to costumed Renaissance faire characters, the bottom line is not whether the scholarly community recognizes their historiography as "accurate." It is about the praxis of performance itself, which offers an agency

and authenticity outside the discursive boundaries produced and policed by academics.

Wendy Erisman, for example, has criticized historians who would dismiss the Society for Creative Anachronism and reenactment groups like the Buckskinners (American frontier fur-trade hobbyists). These historians, she writes, privilege a definition of authenticity grounded in an objectively measurable correspondence between the actual past and a rigorous representation of it, but such a definition fails to take into account the personal searches for meaning and identity in the participants' lives.[5] This is not to mention the fact that the "meaning" that is perhaps intended for an audience by the producers of a historical performance is not always received in that same manner. Marvin Carlson has argued that the meaning of a performance is a coproduction between the performer and the spectator, and that spectators "read" a performance differently depending on their particular set of expectations or agendas, or world views.[6] And S. Michael Halloran has suggested, further, that in some cases the meaning experienced by the spectators may be completely separate from the meaning scripted by the performance and, rather, is conditioned by the circumstances of the event, the social context, the behavior of the surrounding spectators, and the general energy of the occasion.[7]

Such questions of spectator and practitioner agency and identity, as well as of spectator reception and meaning production, are an imperative to consider in a cultural moment when community-based theater and the political performance of Augusto Boal's Theatre of the Oppressed are re-steering the way we think about theater and performance and when more emphasis is being placed on the participants' *active* co-creation of the performance text (Boal offered the term "spect-actor" for this kind of participant), rather than on the passive experience of the audience members merely absorbing a narrative, however moving, that has been produced for them on the other side of the proscenium.

The flip side of this coin, however, is the looming question of just *who* gets to produce the narrative of the past being performed. While it is important that the means by which the past is represented sometimes be wrested from institutions or individuals whose values, politics, and enfranchisement have become distanced from those of the audience, we must also ask if the enacting of history can be left to just anyone. Who decides what is true? What *really* happened? Are there voices that are being left out? Is every enunciation of the past fraught and contestable, by virtue of the fact that every individual's or community's selective memory, designed as it is to affirm and shore up that individual's or community's identity, defines itself against and/or erases that of another? Consider the grand chronicles of Manifest Destiny orchestrated by Buffalo Bill Cody and lesser ped-

dlers of Wild West spectacles in the late nineteenth and early twentieth century, which pitted the forces of civilization against the frontier-darkening savages in their immense arenas. Consider the absence of slaves in Colonial Williamsburg's simulated eighteenth-century Virginia capital throughout much of the twentieth century. Consider the Smithsonian's *Enola Gay* exhibit in the 1990s, purged as it was of any question as to the necessity of dropping the bomb in the face of protests from conservative groups who demanded that plans for depicting the Japanese civilians as victims be scuttled. These questions regarding apposite stewardship of our histories are not new, but they are no less important because of that. On the contrary, the consequences of selective omission (at best) or exoticization and demonization of the other (at worst) demand that we continually examine the enactment of history.

Far, then, from an unqualified celebration of performance as a better mode of historiography than the "archive," the essays in *Enacting History,* while at times commenting on the power of performance to make meaning for spectators via visual and aural language, or affective and emotional engagement, also treat their subjects with a critical eye: Magelssen is skeptical of the stated claims of tourist attractions that boast second-person performance. Clemons describes the fluid meanings generated when two or more performances commemorate the same event. Poole turns a critical eye on his own work and the assumptions or stereotypes he may have perpetuated. Tyson is critical of the way Fort Snelling's social environment informs the performances visitors will encounter. Korol-Evans discusses the way television's goals compromise or muddy the already muddy goals of Renaissance festival performance. Livingston describes the way a site's perceived sacredness might produce meanings contrary to or otherwise different from actual historical events. Ybarra discusses the way the goals of a production are contingent upon the social and political environment in which they're seen, and not always perceived as the artists intend, depending on the spectator's views and so forth. Taken together, the essays offer a sophisticated conversation about the *kinds* of knowledge these performances do a good job of producing, even if the jury is still out on whether the knowledge they produce is beneficial to all parties.

As the following essays demonstrate, severally and as a whole, the discursive space between contemporary performance/audience practices and the historical events and individuals they commemorate, mourn, or re-envision is haunted by issues of contested public memory, politics, taste, accuracy, and clashes of education and entertainment. At the same time, that very space is one of potential, change, agency, and redress. While performing the past has been guilty of the worst kind of presentist chauvinism and diminution of its subjects, it has also been a venue for setting the record straight—if not by creating an accurate

window into a moment in time gone by, at least by creating a space where the voices, past and present, of those who have been silenced by other histories are finally given audience. We invite readers to navigate into this space between performance and the past, with the essays in this collection offering one set of signposts to assist and inform their itinerary, and we hope the time spent here will encourage scholars and practitioners alike to think in new ways about enacting history.

Notes

1. Barbara Kirshenblatt-Gimblett, *Destination Culture: Tourism, Museums, and Heritage* (Berkeley: University of California Press, 1998), 150.

2. Charlotte Canning, "Feminist Performance as Feminist Historiography," *Theatre Survey* 45, no. 2 (November 2004): 230.

3. Freddie Rokem, *Performing History: Theatrical Representations of the Past in Contemporary Theatre* (Iowa City: University of Iowa Press, 2000), 3.

4. Diana Taylor, *The Archive and the Repertoire: Performing Cultural Memory of the Americas* (Durham: Duke University Press, 2003), xvii.

5. Wendy Erisman, "Forward into the Past: The Poetics and Politics of Community in Two Historical Re-Creation Groups" (PhD diss., University of Texas at Austin, 1998), 60–61, 63.

6. Marvin Carlson, "Theatre Audiences and the Reading of Performance," in *Interpreting the Theatrical Past,* ed. Thomas Postlewait and Bruce A. McConachie (Iowa City: University of Iowa Press, 1989), 82–98.

7. S. Michael Halloran offers the example of the 1927 spectacle commemorating the 150th anniversary of the second Battle of Saratoga, involving six thousand participants and upwards of 160,000 spectators. The event, reported the press, was a success, and a meaningful experience was had by most everyone, despite the unlikelihood, given the numbers and the chaotic milieu, that more than a "tiny fraction" of those gathered would have heard the reenactors' lines (S. Michael Halloran, "Text and Experience in a Historical Pageant: Toward a Rhetoric of Spectacle," *RSQ: Rhetoric Society Quarterly* 31, no. 4 [Fall 2001]: 11).

Present Enacting Past

The Functions of Battle Reenacting in Historical Representation

Leigh Clemons

Battle reenactments function as enactments of history, and their particular modes of representation address questions of authenticity, performance, and meaning. Popular since their initial inception in the 1960s, battle reenactments today boast hundreds of thousands of participants who portray soldiers from wars ranging from the French and Indian War to Vietnam. Their purpose is twofold: to entertain audiences with a showy display of artillery and to educate these same audiences about the history of the war and the living conditions of the soldiers who fought in it.

Reenactors view their representations of history not as performance but as embodiment. Rather than "characters," they refer to their actions and appearance as "impressions." The idea is not to represent specific people, although some reenactors do represent major figures as needed (more on that later), but to portray the common solider. This focus on the "average Joe" allows reenactors to sidestep the major ideological arguments that surrounded the war in question, as, for example, in the Civil War, where Confederate soldier reenactors are not bound, in their minds, to have an opinion on slavery. Yet reenacting does raise ideological issues, especially with regard to the representation and interpretation of history. What is the event? Who has the "right" to represent it? What is the link of the reenactment event to the "original"?

Reenactments occupy a unique space within the field of history and historical enactment. They are events that reference either a specific battle or a specific time, depending upon the war.[1] Because of this, they cannot be considered battle simulations, or aspects of hyper-reality, as there is a historical event to which they each refer. Yet they are not specifically historical, either, because they are reoccurring in present times, causing a rupture between the signifier and signified. As a result, reenactment and the history it purports to enact are trapped together in a symbiotic relationship of progressive clarification and determination, a form of Deluzean *ritornello*. As Michel de Certeau reminds us, "historical science cannot

entirely detach its practice from what it apprehends to be its object. It assumes its endless task to be the refinement of successive styles of this articulation."[2] This oscillating process bounces around in an in-between space whose function is dependent upon how it is observed: as history, as performance, or as education. It occupies a liminal space, functioning as a rite of passage from enacted present into reenacted past.

The question of authenticity lurks around every corner of battle reenacting and, in fact, in all aspects of the larger living history phenomenon. Authenticity is a linchpin for reenactors; they judge the impressions of themselves and others by how closely they adhere to the available information about the war being fought. To the outsider, it can seem like splitting hairs, as a successful impression may hinge on a type of button or color of thread. Jenny Thompson recounts an anecdote from a Battle of the Bulge event where a participant was dressed down by his commander, a confirmed hard-core reenactor, for having 1944 suspenders on his uniform instead of 1943 suspenders.[3] Tony Horwitz's *Confederates in the Attic* contains numerous stories of reenactors striving for authenticity in their impressions, even down to dropping weight to achieve "the gaunt, hollow-eyed look of underfed Confederates."[4]

The desire for authenticity divides the reenactment community into two basic camps: the "farbs" and the "hardcores."[5] The term "farb" has several definitions. To Tony Horwitz, farbs are "reenactors who [approach] the past with a lack of verisimilitude."[6] Jenny Thompson defines a farb as "a reenactor who is judged as having failed to establish a legitimate link to history."[7] Hardcores, on the other hand, are the opposite extreme, those persons who go to tremendous lengths to make their impressions as authentic as possible. This farb/hardcore binary is, in my opinion, the core issue for battle reenacting: It encompasses the representation of history, how real is it; the authenticity of that representation, how true is it; and the meaning that can be made from the representation—can those viewing the representation believe it or not? Such a focus means that authenticity, while ostensibly a surface issue, remains a driving force in reenacting and living history circles, at least for the participants.

This farb/hardcore binary also asks how far is far enough where authenticity is concerned. Hardcore battle reenactors, as well as reenactors at other living history sites,[8] have gone to great lengths to make their impressions as authentic as possible based upon available records, but how far is too far? Many hardcore reenactors no longer participate in commemorative battle events because they cannot experience the ultimate "period rush": live gunfire. These groups prefer to focus on drilling, forced marches, and the details of the soldier's life that occurred outside of fighting. By keeping their impressions outside of the space of the actual

reenactment, hardcores remove their discourse from the overall historical enactment process. While this may appear to simplify the issue (authenticity debates are no longer a real factor), it actually makes the reenactment's ability to link to the historical event more difficult because it severs potential links to the past it is trying to represent.

A final question that must be addressed is the question of who is more "professional"—the hobbyist reenactor or the professional living historian. Living history sites such as Plimoth Plantation and Colonial Williamsburg employ full-time living historians who are trained in the history and practices of the time they represent and how to convey that information to the tourists who come through their exhibits. These people see themselves as separate from—and often superior to—battle reenactors, who, in their minds, are amateurs who lack the necessary training and education to be more effective (and, in fact, are usually seen as a hindrance to the living history profession as a whole because they are believed to convey inaccurate information).[9] The antipathy is so pronounced that many reenactors detest the term and prefer to be called living historians, as they feel the former designation contains only negative connotations. Yet is this aversion to the term necessary? Many reenactors devote the same amount of time to preparing and researching an impression as any professional performer puts into creating a role. Reenactors at Texas Revolution events I have attended are a treasure trove of trivia and minutia likely unknown even to most PhDs in Texas history.

I propose that *amateur*, used to describe those involved in "the hobby," as battle reenacting is called, is not used in the modern sense, with its overtones of ineptitude and lack of commitment, but in the way it was used by interpretation pioneer Freeman Tilden: "For this word once described a person who could not be otherwise than happy, since he was doing something for the love of it; not for material gain, not even for fame or pre-eminence."[10] In this sense, most, if not all, reenactors are amateurs, regardless of the level of authenticity they display (and that level is, of course, dependent upon who is setting the bar). This type of amateur status, however, conveys not a sense of inadequacy but a unique knowledge gained from self-study, accumulation of materials for impression, and participation in events that further the participants' understanding of both the hobby and the events it represents.

I now want to turn to a specific example of how battle reenacting can be fraught with issues of authenticity, performance, and meaning in the enactment of history. It concerns the relationship between the construction of "Mexican" and "Texian" in the battles of the Texas Revolution. Each spring since 1985, the Crossroads of Texas Living History Association and Presidio La Bahia have presented the reenactment of the Battle of Coleto Creek and the "Goliad Massacre." The

two-day event includes three battle sequences and living history displays of period weapons, cooking styles, army encampments, and military drills—all common to exhibitions of war culture.[11] It also includes the screening of films about La Bahia and lectures by noted authors about the history of the area and major historical figures like Col. James Fannin. Unlike most public battle reenactments, however, this particular event contains something a bit different: a reenactment of the massacre, the execution of 342 men under the command of Lt. Col. James Walker Fannin by the Mexican Army forces of General José de Urrea.[12] Video cameras in tow, the audience follows behind as a group of "Texian" soldiers are marched to a site near the Presidio (where part of the actual executions are thought to have occurred);[13] then, with the accompanying audience safely tucked behind a barbed-wire fence, the Texians are gunned down by the Mexican soldiers, who then stab the corpses with bayonets and rifle the pockets of the dead men for valuables. The audience proceeds back to the Presidio for the execution of Fannin and the wounded before a final first-person living history performance by longtime area reenactor Dennis Reidesel, based upon the account of Isaac Hamilton, a Texian army survivor.

The Battle of Coleto Creek/Goliad Massacre living history program is only one example of how the major events of the Texas Revolution have been transformed into powerful sites of performative remembrance. All of the major Revolutionary battle locations—Gonzales, the Alamo, Goliad, and San Jacinto—hold annual reenactments, usually on the actual sites themselves or close to them. (In the case of the Alamo, the reenactment is somewhat allegorical in nature, given the shrine's current location in what is now downtown San Antonio; however, as with all good reenactments, there is still plenty of cannon fire to excite the viewers.) The San Jacinto battle site is a Texas state park that can be visited year-round, as can the Alamo shrine and Presidio La Bahia (the site of the Coleto Creek/Goliad reenactment). Other arenas, such as the city of Austin's Bob Bullock Texas State History Museum, also provide a year-round venue for the remembering and performance of Texas history in general and the events of the Texas Revolution in particular. Each of these sites functions as a locus of cultural memory for Texans and non-Texans wishing to re-view the past as well as a way for individuals to actually take part in the making of history (in the case of the reenactments themselves).[14]

Historian Richard Flores states that "cultural memories, disguised and 'entangled' with the workings of the historical discourse, are spatially and geographically embedded in geographically fixed sites of public history and culture."[15] Goliad is one such site; the massacre of the Texian forces became a battle cry for the Texian army at San Jacinto less than one month later, where, with cries of "Re-

member the Alamo!" and "Remember Goliad," the Texians routed the Mexican Army in a nineteen-minute battle. The ensuing slaughter of Mexicans troops was justified in the minds of the Texians as payback for the killing of their fellow soldiers at the two earlier battles. So, Goliad is a site infused with history and memory on both sides of the Texas Revolution; the yearly reenactment determines how those issues are enacted for the benefit of the attending public and, therefore, how history is remembered.

Certainly, there are questions of authenticity in play at Goliad. Mexican Army soldiers are kitted out in appropriate uniforms, and Texian army members are also appropriately attired. Dennis Reidesel, for example, wears the traditional red coat of the Alabama Red Rovers unit to which Isaac Hamilton belonged. While I have run into a few "stitch nazis" (as hardcores are often called), most of the reenactors are happy with maintaining the essence of an impression without sweating every little detail.[16] For example, one Mexican Army officer I spoke with at Goliad was drinking a Dr. Pepper from the can throughout our conversation. The two Mexican Army cavalry riders were teenage girls who wore their hair up under their caps. Many of the Texian and Mexican army officers, who were supposedly thin to the point of emaciation due to poor rations, were significantly overweight. Do these anachronisms make Goliad a less "authentic" representation of history? Perhaps. Yet there may be more to Goliad than just representing what happened. Certainly, the decision to enact the massacre in a brutally authentic fashion is a decision that, for whatever reason, ensures that the overall impression remains in keeping with the dominant interpretation of Texas revolutionary history.

Many of the participants are self-reflexive about their role in reenacting, seeing the need for communication with the audience as more important than the need to be continuously "in character."[17] This foregrounding of the "educational mission" of the reenactment, the ability of the participants to relate to people both inside and outside of their impressions, makes Goliad a very accessible event. Even Dennis Reidesel was willing to answer questions from the audience following his first-person Isaac Hamilton reminiscence as part of the massacre reenactment, although he did so in "character." (During the "down times" between battles on Saturday, Reidesel not only spoke about his impression, but also was willing to discuss the craft of reenacting with interested parties.) Many times, the quest for authenticity is a barrier to audience interaction, as audiences do not expect authenticity or understand the reenactor's desire for it.[18] Yet without some elements of authenticity, the reenactment could not unfold and tell its story. So, authenticity, while not the watchword of the day at Goliad, is still in play and a necessary part of a successful present-time enactment of the historical event, reinforcing the symbiotic relationship discussed earlier.

Performance is also a central issue at Goliad since, as a small reenactment (by most standards), it does not attract a large number of participants. (My count one year was between seventy-five and one hundred participants. San Jacinto, on the other hand, had well over one hundred soldiers alone one year.) Battle reenactors typically play more than one role, depending upon the venue. This process, called galvanizing, ensures that there are equal numbers on both sides to make the battle more interesting and last longer.[19] Many find themselves on both sides of the field during the same event. At Goliad, Ricardo Villerreal, a longtime reenactor, plays both the Mexican officer who demands that the Texians be executed as Santa Anna ordered and Carlos de la Garza, a Tejano rancher who saves his Texian friend Nicholas Fagin (and several others) from execution.[20] (Villerreal plays Juan Seguin at Alamo reenactments.) Another reenactor, who plays the Mexican battlefield commander at Goliad, joked that he would be sure to "die" during the battle at San Jacinto either because the Texian reenactors treat the POWs badly or because the woolen Mexican uniform was too hot for late April in Baytown. This ability to "choose" their roles in the events allows them to craft an impression that is comfortable to them. Questions of ethnicity are not addressed—most of the Mexican army officers are played by Anglos. This trend makes for a whitewashing of the event that privileges the hegemonic interpretation of Goliad as the site of a massacre of innocent men instead of the execution of rebellious citizens and insurgents. Due to the Texian victory, the former interpretation of the event trumped the latter, with consequences that were far-reaching for portrayals of Mexicans in Texas history to this day.

The image of the "Mexican" reflects a complex web of political, economic, and cultural factors that had emerged by the early twentieth century. It is a facet of what Richard Flores calls "Texas Modern" or "how the forces of modernity wreaked havoc on Mexicans and Mexican Americans as they were displaced through the forces of technology, industrialization, and capitalism, or social production more generally."[21] A performance of positive "Texan" characteristics in counterpoint to negative imagery relating to Mexicans ultimately legitimated the use of violence and other tactics to disenfranchise the Hispanic population. The "police arm" of the state had a long history of dispensing unequal justice by allowing "Anglos who murdered *mexicanos* to go unpunished,"[22] a history predating the Texas Revolution.

The disenfranchisement of the Hispanic population helped to bolster the image of the Texan as decidedly non-Hispanic. Performances of the "Mexican" became the ethnic counterpoint to performances of the "Texan."[23] The creation in the latter part of the nineteenth century of a "dual wage" and colonial labor system (which segregated workers into different classes of work and different pay

scales based upon ethnicity) separated non-white workers economically from their Texan counterparts. So did the segregation of Mexican American schools, which operated (until found unconstitutional in 1948),[24] without even the pretense of the "separate but equal" conditions found in black and white schools.[25] The formation of a "Chicano labor reserve," which ensured labor that was cheap and plentiful, set the boundaries of Texan identity in the first half of the twentieth century firmly outside the Hispanic community.

Goliad is also permeated with conflicting meanings found in the stereotypical characters of the "good Texian" and the "evil Mexican." One redeeming Mexican character, a woman, to break the evil Mexican stereotype was the "Angel of Goliad," Francita Alavez.[26] The "traveling companion" of a Mexican army officer, Alavez is credited with saving several of the men under Col. James Fannin's command from execution following the Battle of Coleto. In addition to her inclusion in the yearly reenactment, her descendants travel to Goliad each year to commemorate her role in the revolution, and there is a statue erected in her honor near Presidio La Bahia.[27]

In addition to including Francita Alavez in the Goliad Massacre reenactment, the Crossroads of Texas Living History Association has also tried to problematize the evil Mexican/good Texian binary that pervades the event. During the candlelight vigil held the Saturday evening before the massacre reenactment (after the Texians have been captured), visitors can pay an extra fee to tour the Presidio and see what life was like before the Texians were executed. As a part of the tour, visitors are treated to two scenes that call into question the traditional history. The first is a conversation with a Mexican officer who reminds the listeners that the captured soldiers were no better off than the Mexican Army in terms of food and health. Many of the Mexican soldiers, like the Texians, lacked adequate clothing for the cold snap that occurred in March 1836. A second scene occurs between the top officers, including General Urrea, in which the audience learns that Urrea did not want to execute the prisoners; rather, he wanted them disarmed and escorted to the Louisiana border but was ordered to carry out Santa Anna's threat that any man taking up arms against Mexico would be shot. Both of these representations help to call into question the overwhelming historical bias against Mexico. All of this work is undone, however, by the enactment of the massacre the following morning. Channeling past actions into present representations helps to resolidify the binaries that fuel animosities in and around the Goliad area to this day. For example, one lifelong resident of Goliad, who lives three miles from the Presidio, sees the reenactments as damaging to what remains of the actual history—he and other Latino residents of Goliad find the term "massacre" offensive. This resident, who does not participate in the reenactments, wants the directors of La

Bahia and the battle reenactors to leave the ghosts of the Presidio in peace and focus more attention on the current socioeconomic problems rampant throughout the area. He says that with each successive reenactment the "real" story of what happened at La Bahia becomes more fragmented and diffused, lost within the cheers of spectators and smoke from blank cannon and rifle shots.

Not all people see the battle and the massacre in a negative light, however. For many contemporary Hispanics, the Battle of Coleto and the Goliad Massacre represent the ultimate act of subversion, a way of achieving dominance over a force that would ultimately disenfranchise them for the next 172 years. One year I was speaking with a Hispanic man at Goliad when his cell phone rang. When the person on the other end asked what he was doing, he replied, "I am watching my people kick the white man's ass." While ultimately cast as an act of evil—a massacre—the Battle of Coleto Creek represents to some audience members a chance to subvert the traditional hegemonic reading of Texas history, if only for a brief time.

So, what, ultimately, do battle reenactments contribute to the enactment of history? Is the question of authenticity so overwhelming that deeper issues cannot be considered? I do not believe so, although I have become resigned to the fact that battle reenacting cannot escape the rhetoric of authenticity. It not only feeds the participants, however; questions of authenticity are also part of the audience's experience, as many of them use the existence of the past event itself to legitimate ideas in present interpretation. Vanessa Agnew asserts that "the substitutive character of reenactment themes suggests that if reenactment performs the work of *Vergangenheitsbewältigung* (coming to terms with the past), then this process is not directly tied to a specific historical process, conflict, or set of agents. In fact, the contrary is true. Reenactment's emancipatory gesture is to allow participants to select their own past in reaction to a conflicted present."[28] This is certainly true in Goliad, where both reenactors and audience are able to focus their attention on the part of the total that best reinforces their own ideas of Texas history.

Battle reenacting is also about appealing to the heart and not just the mind. When speaking of nature interpretation, Freeman Tilden writes that "the interpreter of the story of the artifact is not dealing with beauty as such, but with man's attitude towards beauty; and this can be made warmly appealing, for it is an appeal to the heart even more than to the mind."[29] While war is not beautiful, battle reenacting does attempt to craft narratives for visitors that appeal as much to their emotions as to their intellect, often by downplaying war's brutality. Reenactments may purport to serve an educational purpose, but their primary goal is commemoration, either of a specific battle or of the life of the common soldier. Commemoration, while a vital part of the process, primarily seeks out sentimen-

tality to drive home its point. Goliad does have places where the brutality of war peeks through. In addition to the Sunday massacre staging, the Saturday night vigil contains a scene in the Presidio chapel of wounded Texian soldiers writhing in pain on the floor while a doctor removes a bullet from Fannin. These scenes are brief, however, and not all audience members see them (to see the vigil, one must pay extra, and many people do not return on Sunday after the Saturday battle). Also, the entire event wraps up with a trip to the Fannin monument, a short distance from the Presidio, where speeches are given and a wreath is laid in honor of the Texians who died there. Ultimately, commemoration reigns supreme, and its underlying function is to reify implicit agendas within Texas history, agendas that inform who gets to participate in Texas history and how they are to do so.

In the end, the enactment of history through battle reenacting takes the participant and the audience on a journey through not only the event itself but also the process of representing that event. The Battle of Coleto Creek/Goliad Massacre is a prime example of how journey and process merge. As Richard Flores states, "the events of 1836 . . . serve as an episodic element that advance a plot of social and racial difference with a myth of origin."[30] Regardless of which types of wars are being reenacted, however, it becomes readily apparent that the battles being waged are not just the "fake" ones on the battlefield but real and contemporary struggles for the right to determine identity, history, and meaning in a given society.

Notes

Small portions of this chapter appeared in my book *Branding Texas: Performing Culture in the Lone Star State* (Austin: University of Texas Press, 2008).

1. In Civil War reenacting, for example, the focus is usually on reenacting specific battles, such as Gettysburg, as part of a commemoration usually around the time the battle was fought. In twentieth-century reenacting, often there are events that carry a generic name, such as "Eastern Front 1943," where the participants are not commemorating a specific event. I will spend much of this essay focusing on the former type of event, the yearly commemoration.

2. Michel de Certeau, *The Writing of History*, trans. Tom Conley (New York: Columbia University Press, 1988), 45.

3. Jenny Thompson, *War Games: Inside the World of 20th Century War Reenactors* (Washington, D.C.: Smithsonian, 2004), 20.

4. Tony Horwitz, *Confederates in the Attic: Dispatches from the Unfinished Civil War* (New York: Vintage, 1998), 12.

5. There are other terms that help create a continuum between the two extremes,

but these two are by far the most used and analyzed forms of reenactment behavior. For more on the other terms, see Paul Calloway, "An Attempt at Defining the Terms: Authentic, Hardcore, Progressive, Mainstreamer, Farb and Campaigner," http://www.authentic-campaigner.com/forum/showthread.php?t=1081&highlight=manifesto (accessed January 31, 2008).

6. Horwitz, *Confederates in the Attic*, 10.

7. Thompson, *War Games*, 216.

8. For an example of how far some living history sites have taken their desire to get back to origins, see Scott Magelssen, "Resuscitating the Past: The Backbreeding of Historic Animals at U.S. Living History Museums," *TDR: The Drama Review* 47, no. 4 (Winter 2003): 98–109.

9. My favorite quote that illustrates this prejudice comes from William Sommerfeld, a historical interpreter from the American Historical Theatre who plays George Washington at Mount Vernon, on the July 5, 2004, edition of National Public Radio's *Talk of the Nation*. When I called into the show to ask for his definition of battle reenactors versus living historians, he replied with the following: "There are reenactors, the people who are in costume and have weapons and march about. But most often they are not superlative presenters. And then we have people who are generic living history people who do people that are not actually well-known. But I would say with modesty, at the top of the heap we have what I would call notable historical interpreters and all of them are easily recognized by the public. So those are the categories that I split up the business of interpretation up into" (transcript, 7).

10. Freeman Tilden, *Interpreting Our Heritage*, 4th ed., expanded and updated (Chapel Hill: University of North Carolina Press, 2007), 138.

11. For an overview of various types of public war culture events centered around twentieth-century battle reenacting, see Thompson, *War Games*, chapter 5.

12. Various sources cite between 322 and 342 men were executed. The actual executions were carried out by men under the command of Col. José Nicolás de la Portilla, whom Urrea had left in command at Goliad. *Handbook of Texas Online*, s.v. "GOLIAD MASSACRE," http://www.tsha.utexas.edu/handbook/ online/articles/GG/qeg2.html (accessed May 23, 2005).

13. The Texian soldiers were divided into three groups upon leaving the Presidio and marched off in three different directions. The site of the massacre reenactment is believed to be the place where one of these groups was executed.

14. For more information on the formation and function of these sites, see Leigh Clemons, *Branding Texas: Performing Culture in the Lone Star State* (Austin: University of Texas Press, 2008), chapter 2.

15. Richard Flores, *Remembering the Alamo: Memory, Modernity and the Master Symbol* (Austin: University of Texas Press, 2002), 18.

16. This is not to imply that Texas revolutionary reenactors are not dedicated to the

quest for authenticity. In 2003, Goliad event coordinator David Vickers published a detailed list of acceptable equipment and clothing for both men and women who wished to participate in the reenactment. While not everyone lived up to the standards set, the list does indicate that there are participants at Goliad who value what could be called hardcore authenticity (http://www.cotlha.com/DRESS_AND_CAMP_CODES.htm [accessed October 21, 2008]).

17. Indeed, it would be hard to do research at reenactments if super hardcore members refused to discuss the hobby itself, and often the events are the only places where a researcher can gather data, as reenactors come from many disparate locations. The Internet is helping the situation, however; and groups such as the Texas Army are using the Internet to recruit and inform people of their mission and events (http://www.earlytexashistory.com/TexasArmy/). The Crossroads of Texas Living History Association, which cosponsors the event at Goliad, is also on the Web (http://www.cotlha.com/ [accessed October 21, 2008]).

18. Horwitz has several accounts of how the tourists at Civil War events often misinterpret or are misinformed about the most basic aspects of Civil War history and the patience that reenactors must have in dealing with them (*Confederates in the Attic,* 278–279). Thompson's *War Games,* chapter 5, is devoted completely to a discussion of public events and reveals the frustration that many reenactors have in dealing with tourist ignorance when it arises.

19. Horwitz, *Confederates in the Attic,* 135. Galvanizing is most common at Civil War events, due to the overwhelming number of Confederate reenactors in relation to Union participants. Many participants carry uniforms from both sides in their vehicles and decide which side to fight for upon arrival at the event.

20. Although Carlos de la Garza's rescue of Nicholas Fagin is the only rescue depicted during the reenactment, he is also credited with saving the lives of John Fagin, James W. Byrnes, Edward Perry, Anthony Sideck, and John B. Sideck.

21. Flores, *Remembering the Alamo,* 154.

22. Robert J. Rosenbaum, *Mexican Resistance in the Southwest: "The Sacred Right of Self-Preservation"* (Austin: University of Texas Press, 1981), 39. The Cortina Affair, which began in 1859 after the slaying of an Anglo law officer who "was pistol-whipping a vaquero," was the beginning of the post-annexation Anglo-Mexican border wars, and its end result "saw Anglos, principally the [Texas] Rangers, retaliate indiscriminately against all mexicanos in a fit of bloody terrorism" (Rosenbaum, *Mexican Resistance,* 42–43). The League of United Latin American Citizens (LULAC) Web site reports that "more Mexicans were lynched in the Southwest between 1865 and 1920 than Blacks in other parts of the South and cases of Mexicans being brutally assaulted and murdered were widespread" (http://www.lulac.org/ Historical%20Files/Resources/History.html, paragraph 10 [accessed February 6, 2006]).

23. Americo Parades, *Folklore and Culture on the Texas-Mexican Border* (Austin: Center

for Mexican-American Studies, University of Texas, 1993), 33. These include the "Mexican car wash (leaving your car out in the rain), Mexican credit card (a piece of hose to siphon gasoline out of other people's cars), Mexican overdrive (driving downhill in neutral), Mexican promotion (an increase in rank without a raise in pay), [and] Mexican two-step (dysentery)" (ibid., 33). None of these tags are indigenous to the area, but the proliferation of them reinforces the ethnic binary and further solidifies the surface images of good (Anglo-inferred) and bad Mexican.

24. The League of United Latin American Citizens (LULAC) was formed February 17, 1929, out of three civic organizations whose job it was to advocate for the rights of Mexican Americans and was instrumental in the 1948 school segregation ruling (http://www.lulac.org/Historical%20Files/Resources/History.html, paragraph 15 [accessed February 6, 2006]).

25. John R. Chavez, *The Lost Land: The Chicano Image of the Southwest* (Albuquerque: University of New Mexico Press, 1984), 116.

26. "Alavez, Francita." The Handbook of Texas Online. Internet. http://www.tsha.utexas.edu/handbook/online/articles/view/AA/fa153.html (accessed April 15, 2003). Little is known about her, including her real name (which is listed in various sources as Francita, Panchita, or Pancheta, and her surname as Alavez, Alvarez, or Alevesco). After being deserted by Captain Telesforo Alavez in Mexico City following the revolution, she returned to Texas and lived out her life on the King Ranch.

27. Alavez was the subject of a 1936 Centennial Celebration one-act play, entitled *The Angel of Goliad.* The *Angel of Goliad* indicts Mexican barbarity and the army officers' slavish devotion to duty over honor, but Senora Alavarez (as she is named) is venerated for her attempts to save the soldiers. Such a depiction, however, is rare, and such Mexican characters are never central to historical dramas. Their main representation is as the enemy. These performances help to reinforce the stereotypes that both contemporary Latinos and Anglos have of one another. Mabel Claire Thomas, *The Angel of Goliad* (Dallas: Tardy Publishing, 1936), Daughters of the Republic of Texas Library at the Alamo, Vault 812 T459a: 1.

28. Vanessa Agnew, "Introduction: What Is Reenactment?" *Criticism* 46 (Summer 2004): 328.

29. Tilden, *Interpreting Our Heritage*, 154.

30. Flores, *Remembering the Alamo*, 161.

"This Is the Place"

Performance and the Production of Space in Mormon Cultural Memory

Lindsay Adamson Livingston

> What is an ideology without a space to which it refers, a space which it describes, whose vocabulary and links it makes use of, and whose code it embodies?
> —Henri Lefebvre, *The Production of Space*

Fundamental to both the origin myth and the continuing identity of the Church of Jesus Christ of Latter-day Saints (LDS or Mormon) is the conception of early church members as migratory and largely without national affiliation. From its inception, the church was heavily involved in missionary efforts in Europe and elsewhere, a practice that led thousands to convert to Mormonism and subsequently immigrate to the United States, making the early church a multinational (though still overwhelmingly white and European) entity. Although the initial vision of this pan-national movement continues to loom large over the imaginary consciousness of church members, it is the ensuing westward migration that is most foundational to LDS identity.

In the mid-nineteenth century, after successive expulsions from several towns, an extermination order issued by Missouri's governor, and the death of their prophet and founder, over seventy thousand Mormon believers trekked west.[1] The majority of these pioneers ended up in an area of the Mexican Territory that would later become Utah. The stops made along this trek (both scheduled and impromptu), along with sites central to the nineteenth-century founding of the religion, have become pilgrimage destinations for contemporary church members, locations where space, performance, and memory work together to codify a sanctioned historical narrative of the church's founding and early existence.

That founding is tied to a particularly spectacular narrative, one that colors all understanding of the LDS faith. According to the official LDS version of founder Joseph Smith's "first vision," one morning in early spring the fourteen-year-old "retired to the woods" to pray.[2] Troubled by the religious upheavals in his community, the young man sought spiritual guidance. As the story goes, Smith saw a

vision while praying, wherein God spoke to the boy, encouraging him to abstain from joining any established church and, instead, to found his own. Ten years later, Smith, along with a small congregation of believers, established the LDS church.

Pierre Nora's conceptualization of memorial and historical space is particularly helpful in understanding how a cultural group, in this case the LDS Church, utilizes sites of origin to define and defend specific narrative constructions of its own identity and history. In his 1989 essay, "Between Memory and History: *Les Lieux de Mémoire*," Nora explains that if a society has to set aside "places of memory," it is because memory is no longer clear and present in the community—members must visit these newly consecrated sites in order to simulate memories. As a condition of modern existence, we simply are too far from memory to inhabit it any longer and now must make do with a geographically situated copy. Distinguishing between history and memory, Nora claims that though foundational events can impart meaning to a place, it is the site, rather than the event, that carries memory. He expounds upon this point: "Indeed, it is the exclusion of the event itself that defines the *lieu de mémoire*. Memory attaches itself to sites, whereas history attaches itself to events."[3]

Just as geographical sites carry memory, so too does performance. Authorities overseeing church history sites have seized upon this notion, and many tourist locales associated with the Mormon Church feature formal performances meant to enhance visitors' experiences and increase their memorial identification with the site and the events that purportedly transpired there. Most often, these performances are what Joseph Roach would term a "performance of origin," and they reenact the foundational narratives of the LDS community.[4] Less formally, the performances serve as a way for tourist-spectators to further connect to the site, seemingly erasing the spatio-temporal boundaries keeping them away from a true memory of the founding of the religion.

While this traditional type of performance is certainly more visible, there are other subtler performance elements that heavily influence the meaning and efficacy of church history sites as *lieux de mémoire*. Most intriguing is the function of space at such sites. Suspended as they are between history, memory, and contemporary phenomenological experience, they trip lightly between functioning as absolute, sacred space and present, social space. Compellingly, the space at these sites is expected to "perform"—to live up to the imaginary landscape church members have created in their minds.

In this essay, I will explore two prominent LDS tourist sites, the cities of Palmyra, New York, and Nauvoo, Illinois, and how the various performances featured at these sites help to define a spiritual community of believers joined not

only by their shared religion, but also by the religion's history, which members then adopt as their own. The "spatial maps," or imaginary spatio-performative landscapes, created by LDS historical sites and performances have influenced the cultural experiences of generation after generation of church members by codifying history through performance and the production of spatial meaning. This tightly controlled, regularly reenacted, and spiritually invested history is re-presented to and re-lived by church members who participate in heritage tourism that is meant to give physical legitimacy to history and doctrine and to build a sense of spiritual community rooted in an "American religion" that is rapidly becoming a global one.

Palmyra, New York

In the early nineteenth century, Joseph Smith lived in Palmyra, a small farm town located in an area of upstate New York that was so swept up in the heavy evangelizing of the Second Great Awakening that it came to be known as the "Burned-Over District"—a prime location for the founding of one of the United States' longest-lasting and furthest-reaching restorationist religions. Frustrated with the vituperative sermons given by and the animosity between the leaders of the various sects, Smith withdrew into a grove of trees behind his home to pray and seek guidance as to which congregation to join. It was here, he claimed, that he had a vision wherein God instructed him not to join any existing churches; rather, he was to found a new religion, one that would restore the original doctrinal tenets established by Jesus Christ. By repairing to the woods—a space he chose for its quiet privacy—Smith gave the Church of Jesus Christ of Latter-day Saints the ideal setting for a foundational act.

According to Henri Lefebvre's division of spatial types, before Smith's vision, the woods near his house could possibly have functioned as absolute space, or space that has no social function and is therefore undefined. Lefebvre explains, however, that absolute space cannot actually exist, because as soon as it is utilized in any way, it no longer functions as an absolute: it is at once historicized and endowed with meaning.[5] The newly utilized and therefore endowed space now functions in a completely new way—in this case, as sacred space. As Lefebvre explains, "all holy or cursed places, places characterized by the presence or absence of gods. . . , all such places qualify as special preserves. Hence in absolute space the absolute has no place, for otherwise it would be a 'non-place'; and religio-political space has a rather strange composition, being made up of areas set apart, reserved—and so mysterious."[6] Certainly, wherever Smith had his vision would have then become sacred space, but the woods lend the LDS Church's originary

episode a romantic aspect that has echoes of absolute space and lends even greater weight to the religious space that was produced by the vision and the subsequent founding of the church.

Along with its important role in establishing the spatial legitimacy of the LDS origin narrative, the space of the Burned-Over District functioned in another vital way: as what Joseph Roach terms a "vortex of behavior," a spatial "center of cultural self-invention through the restoration of behavior." Roach explains:

> Although such a zone or district seems to offer a place for transgression, for things that couldn't happen otherwise or elsewhere, in fact what it provides is far more official: a place in which everyday practices and attitudes may be legitimated, "brought out into the open," reinforced, celebrated, or intensified. When this happens . . . condensational events result. The principle characteristic of such events is that they gain a powerful enough hold on collective memory that they will survive the transformation or the relocation of the spaces in which they first flourished.[7]

In *Cities of the Dead,* Roach applies the term "vortices of behavior" primarily to "carnival space"—the spatial intersection of commerce and pleasure. But his concept can also elucidate the spatial meaning of the Burned-Over District as a place and a space that allowed for a different, also seemingly transgressive, performance: the performance of the sacred. Smith found himself in a geographically liminal borderland (northwestern New York was a frontier at that time) and separated from the enlightenment ideals that characterized rhetoric in many urban centers. This borderland and the spatial conception of the Burned-Over District as behavioral vortex enabled the performance of transgressively sacred practices: the young boy saw angels, received revelation, and brought forth new scripture. The everyday practice of communicating with God was brought out into the open and intensified, creating a rupture wherein the condensational event of the church's founding could take place. This foundation took hold of members' collective imagination and memory, allowing it not just to survive but to instigate the westward migration.

Official versions of the church's foundational myth and the history of the Sacred Grove (as the woods have come to be known) have been retold in many different media, but these versions always emphasize certain elements of the story— the spring morning, the young boy, the vision, the woods. Part of the allure of visiting the *lieu de mémoire* of the Sacred Grove is the desire to physically connect (through performances and spatial experience) with these elements.

For many tourist-spectators, there is a hope to connect with the space itself as

an atemporal marker of God's continuing interaction with human beings. Here, space functions as performative: it is supposed to *do* something. It ought to elicit feelings, create connections, inspire revelations, and this desire for space to perform is intimately tied up in the development of the LDS spatio-cultural imaginary. As David Lowenthal explains,

> We need the past, in any case, to cope with present landscapes. We selectively perceive what we are accustomed to seeing; features and patterns in the landscape make sense to us because we share a history with them. Every object, every grouping, every view is intelligible partly because we are already familiar with it, through our own past and through tales heard, books read, pictures viewed. We see things simultaneously as they are and as we viewed them before; previous experience suffuses all present perception.[8]

Shared narratives so completely infuse the imagination of cultural groups that when group members participate in pilgrimages to their sites of origin, those places are always already phenomenologically charged, even for visitors only casually associated with the group. It is, therefore, impossible *not* to imbue the material experience of a space with the previous spectral experience one has constructed around that space: the individual and collective imaginary "overlays physical space, making symbolic use of its objects."[9] As members visit places vital to their spiritual history, those places are made to perform in a specific way based on this spatio-cultural imaginary.

Hearkening back to a well-known LDS hymn, "Joseph Smith's First Prayer," which details the physical aspects of Smith's first vision, when LDS tourists visit the Sacred Grove, they often expect a certain type of performance from nature, as described by the song:

> Oh, how lovely was the morning!
> Radiant beamed the sun above.
> Bees were humming, sweet birds singing,
> Music ringing thru the grove,
> When within the shady woodland
> Joseph sought the God of love.[10]

Of course, such expectations often remain unfulfilled. When I traveled to Palmyra in April 2008, I anticipated seeing the grove as it had been depicted in song and innumerable paintings sanctioned by the church: as a lush, Edenic space suffused with pale light (fig. 1). What I found instead was the early spring gray of north-

1. John Scott, *The First Vision*, 1970. Photo courtesy of the Church of Jesus Christ of Latter-day Saints.

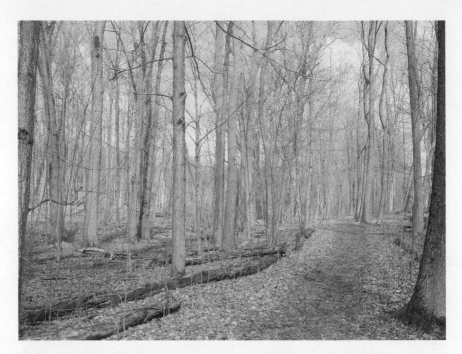

2. The Sacred Grove, Palmyra, New York, April 14, 2009. Photo by Lindsay Adamson Livingston.

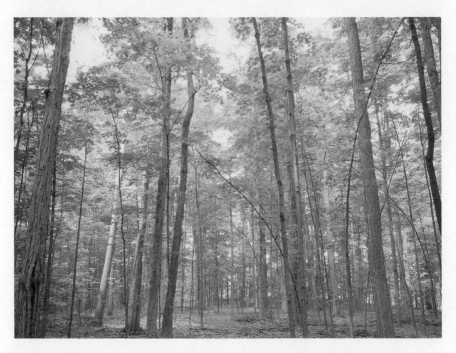

3. The Sacred Grove, Palmyra, New York, May 30, 2009. Photo by Lindsay Adamson Livingston.

western New York; the still-frozen trees were skeletal against an ashen sky, and the grove seemed a stark, unforgiving place (fig. 2). A few months later, in late spring, I returned to visit the Sacred Grove. This time, the space performed beautifully: birds were, indeed, singing, the entire grove had erupted in green, and my imaginary landscape matched rather perfectly with the material reality (fig. 3).

At the Sacred Grove, as at most of the consecrated church sites, special volunteer missionaries perform as combination tour guides/evangelists, welcoming tourists to the site, explaining the site's importance in LDS history and theology, and sharing their testimony while inviting visitors to think of anyone (including themselves) who may want to hear more about the gospel. As part of this historical/evangelical tour, the church-sanctioned historical narrative of the site is told to visitors in several different ways: interactive displays, the missionaries as storytellers, special performances that depict the historical time period and particular stories associated with that place, and even second-person experiences.

At the Joseph Smith home in Palmyra, missionaries are invited to learn about the history of the site on their own time, and then, as they are prompted spiritually, to relate some of what they have learned to the visitors. The several times that I have visited the site, this policy has resulted in a number of amusing and faith-inspiring stories being told to our group; often these stories serve to further endow the space with sacred meaning. On one visit I made to the Smith farm, a missionary explained how the church came to own the land, including the intact grove behind the house. According to this account, in 1907 then-Apostle George Albert Smith purchased the land;[11] when he first saw the grove, he was amazed at its pristine state and said so to the previous owner. The owner replied that his father had been a young man in the area when Joseph Smith had lived on the farm and that, though the father never believed in the LDS religion, he believed that something miraculous did occur in those woods, and he had been compelled by some spiritual force not to cut down any trees. The father admonished his son to treat the woods with the same respect, telling him that dead wood may be cleared from the grove, but beyond that, the space must be left alone. This, the missionary told us, revealed the Lord's hand in protecting this most sacred space for future generations to visit.

I couldn't verify whether this story was true; as Megan Sanborn Jones has quipped, in LDS culture "Church tradition and oral history are considered period documents and valid merely through repetition."[12] Whether accurate or not, this story reveals compelling elements about the Mormon cultural imagination and conception of space, serving to reify the primacy of space on several levels, including the possibility that certain spaces are so important to God that he is willing to intervene in their preservation.

The story also speaks to the vital role that nature plays in this kind of spatial understanding: these are the very trees that existed when a great opening of the heavens occurred. According to the missionary, the trees now stand as witness to the truthfulness of the gospel's claim; they have been marked by the event. Lefebvre argues that "the historical and its consequences, the 'diachronic,' the 'etymology' of locations in the sense of what happened at a particular spot or place and thereby changed it—all of this becomes inscribed in space. The past leaves its traces; time has its own script. Yet this space is always, now and formerly, a *present* space, given as an immediate whole, complete with its associations and connections in their actuality."[13] The story shared by the missionary functioned as a reaffirmation that the event that transpired there over 175 years before was important enough to inscribe itself in that space and that the space would forever bear that inscription.

Along with the performance of space in Palmyra, more traditional historical performances are staged as well. Each summer the church sponsors a historical pageant that features a cast of over 650 performers and is presented on a ten-level stage constructed directly on the hill where Joseph Smith claimed to have received the Book of Mormon from an angel. Functioning as a "performance of origins," the pageant reenacts the double foundation tales at the heart of Mormonism: the migration and settling of an ancient Israelite culture in the Americas (tales that are a part of the LDS scriptural canon) and the coming forth of the Book of Mormon in the nineteenth century.

Roach defines "performance of origin" as "the reenactment of foundation myths along two general axes of possibility: the diasporic, which features migration, and the autochthonous, which claims indigenous roots deeper than memory itself."[14] Intriguingly, the pageant seems to put forth an argument for both kinds of origin, with the early peoples of the Book of Mormon not only laying claim to the ancient lineage of the Jews but also providing the genetic origins of some indigenous groups that would come to power in parts of the Americas. A similar claim is made on behalf of the religion: it is both a restoration of ancient principles, many of which existed before the peopling of the earth, and a new and vital faith that breaks with the apostatized Christianity of the past.[15]

As with many claims of origin, this one is troublesome, but at heritage sites the presentation of that history through performance serves to reassert a kind of embodied authenticity, a goal Scott Magelssen associates with most kinds of living history: "Living history infuses the reconstruction of the past with a surrogate body and proceeds to write its history upon both that surrogate body and the body of its spectator. In this manner, the body itself becomes the implicit

contract of authenticity and authority at living history sites."[16] So, through performance, the body (of both spectator and performer) is made complicit in the authenticity of origin and aids in the perpetuation of those claims.

As in other aspects of heritage tourism, spatial relations are primary here as well. The pageant advocates a kind of total sacred space: not only is this the space where Joseph Smith received the scriptural record that would become the Book of Mormon, but it is also where some events of that book took place and where an angel, the very embodiment of sacred space, appeared repeatedly. This complex history and symbolism overlays the material space of the hill: a natural place where landscaping teams have planted grass on one side and underbrush on the other. Here space and time cease to function normally; there is a semiologically dense tangle of pre- and post-Christian, nineteenth-century, present, and celestial time and space, the boundaries of each bleeding into the others.

Rodger Sorensen, who directed the pageant for several years, expressed the appeal of participating in such a venture, saying it's where "modern-day saints come to a sacred space to learn about and tell their sacred stories."[17] The use of the phrase "their sacred stories" here is ambiguous; the implication is that the stories are personal, individual. On the other hand, the stories being performed are stories shared by the church at large. As in the tales of pioneer tribulation and their application to modern-day trials, the stories of the pageant are, in certain ways, individual in that they work to structure individual members' understanding of the universe and their place in it. The pageant functions as "performance [that] makes visible (for an instant, live, now) that which is always already there: the ghosts, the tropes, the scenarios that structure our individual and collective life. These specters, made manifest through performance, alter future phantoms, future fantasies."[18] Both the spectators and the performers, through their spatial and embodied experiences at the site, are reminded of the church's history and mythology, while at the same time their future understanding of the church is affected by their participation in the spatial production of the site and the performance.

Nauvoo, Illinois

The migratory path of the church thus began in 1820 in upstate New York, though it wasn't long before members ventured far from the area they had known. Ten years after his vision, Smith officially founded the LDS Church in Fayette, New York; and in 1831 he and other members of the newly formed religion started migrating from New York to Kirtland, Ohio. Later that same year, after missionar-

ies settled Independence, Missouri, Smith led a group of members there. In a 1831 edict, Smith explained that God had revealed to him that Independence would be the "New Jerusalem" and wrote that this was "the land which [God had] appointed and consecrated for the gathering of the saints." The scriptural consecration of the land continues: "Wherefore, this is the land of promise, and the place for the city of Zion."[19] The place of Independence is therefore also designated as a sacred space, but one that is perhaps more problematically coded than the woods of Palmyra. On the one hand, the claim that Independence is to be the place for the city of Zion, a place where "saints" would one day live, clearly establishes it as a utopia: what Foucault terms a "site with no real place."[20] On the other hand, Independence was also a physical location that people migrated to and settled in, and the early Mormons referred to themselves as "saints," rooting the revelation in the members' actual experience; thus the space of Independence became at once a material reality for early church members as well as a location defined in the cultural imagination, a land that they had taken possession of, but only by God's permission.

Possession of this land, however, was to be fleeting. In 1838, Governor Lilburn Boggs, provoked by anti-Mormon sentiment, issued an edict ordering all Mormons to either be driven out of Missouri or else exterminated. After a string of violent outbursts incited by Boggs's decree, the Missouri Mormons, led by Brigham Young, left for Illinois. There, on the banks of the Mississippi River, the saints established Nauvoo and experienced relative peace and safety for a few years; but, as they gained more power through a population boom fueled by the influx of European converts, the anti-Mormon sentiment grew there as well. It was in Nauvoo that Smith received some of the best-known and most controversial revelations concerning the doctrinal practices of the early Mormons, including baptism for the dead and polygamy. As rumors of the latter practice spread, non-LDS neighbors who had heretofore grudgingly accepted Mormons in their midst became less and less accommodating. In 1844, the ill will between members of the church and non-Mormons reached a zenith, and Joseph Smith was arrested along with his brother Hyrum and taken to Carthage Jail.[21]

On June 27, 1844, an incensed mob disguised in blackface broke into the jail and murdered both Joseph and Hyrum. Nauvoo and Carthage would certainly have been considered sacred places in the Mormon worldview, even without Joseph's death: Nauvoo was the first theocratic city that members of the young religion successfully created, it was the setting of some of the church's most important modern-day revelations, and the second temple built by the saints was located there. Smith's death, however, undoubtedly served to further consecrate the site and imbue the space with meaning.

In *Cities of the Dead,* Roach examines how communities deal with losses through surrogation, a process that "does not begin or end, but continues as actual or perceived vacancies occur in the network of relations that constitutes the social fabric."[22] The young LDS community was dealt an almost paralyzing blow when Joseph was shot. In contemporary accounts of the ensuing succession crisis, it is often remarked that, had Hyrum lived, he would have been Joseph's automatic successor, but as he had been murdered along with Joseph, the next leader of the church was left entirely up to the congregation of saints. This crisis was complicated by the fact that in the years immediately prior to his death, Joseph had spoken of at least eight different possible methods of succession.[23] Clearly, this is a prime example of Roach's concept of surrogation: the social fabric had a gaping vacancy, a hole that presented Mormons with the opportunity to shape their own leadership by determining who would fill the empty space.

In further explaining his concept of surrogation, Roach stresses a society's need to emphasize the relative stasis of the one over the plurality of the many. Roach's example of this is the tradition of the king's two bodies, typified by the utterance "The king is dead. Long live the king." Just as when the royal mantle was passed on to a successor, a similar emphasis on continuity—one that recognized and mourned the passing of Smith while simultaneously reifying the new claimant's position—was necessary to smooth the transition from one prophet to the next. The practices and performances that help ease such a transition "answer the need to symbolize the inviolate continuity of the body politic," something they do "by dramatizing a duality, a core of preternatural durability invested within a shell of human vulnerability."[24]

In the case of the Mormon prophetic succession, Brigham Young, who subsequently became the next president of the LDS Church, performed this mortal/immortal duality by appearing as Joseph Smith. In what has been passed down through generations of Mormon folklore as a modern-day miracle, persons in attendance at the meeting that decided the fate of the church's leadership claimed to have seen a "transfiguration" of Brigham Young into Joseph Smith, a divine manifestation of God's will that Young succeed Smith as prophet and president. Among the witnesses that day was Benjamin F. Johnson, whose account of the day's events positions him as observant spectator: "But as soon as he spoke I jumped upon my feet, for in every possible degree it was Joseph's voice, and his person, in look, attitude, dress and appearance; [it] was Joseph himself, personified; and I knew in a moment the spirit and mantle of Joseph was upon him."[25] Johnson's use of the word "personified" anchors this experience in embodiment and performance; the same word is often used to praise actors who have exceeded spectator's expectations in the fulfillment of a role, especially when performing a historical

figure who actually existed. Johnson was not the only witness of this miracle; in a 2005 article, Lynne Watkins Jorgensen identifies 121 such documented experiences.[26]

The original veracity of these accounts is, of course, up for debate, and many of them were committed to paper only long after the actual occurrence. Reid L. Harper argues that the idea of the "mantle of Joseph" passing on to Brigham Young began as a metaphor relating to Elijah, and only through the retelling of the tale and the later codification of authority under Young did it start to take on an element of performative divinity.[27] Memory is a tricky thing, after all; just like performance, it is a continued reiteration in which any two retellings or re-rememberings can never be exactly the same. Slippage in the relation of memory can in turn allow for the creation of narratives of origin that are endowed with mystery and divine promise, remembered and relayed by witnesses of the miracle. As the church became more solidly established, there arose a need for individual members to reaffirm their belief in the deific purpose behind the succession of the prophet, and the stories changed from a mere agreement to pass a metaphorical mantle on to a new prophet into a literal transfiguration of the person of Brigham Young into Joseph Smith: a reassurance that this was, indeed, the divinely endorsed choice. Though Nauvoo was already a sacred space, cultivated by the Mormons and the site of a temple, this performance of surrogation, the passing of the mantle of the prophet and the ensuing miracle, assures its place in the Mormon imaginary consciousness as a space uniquely touched by the divine.[28]

The Creation and Perpetuation of Spatio-Cultural Memory

In the introduction to their 2003 collection *The Anthropology of Space and Place: Locating Culture,* Setha M. Low and Denise Lawrence-Zúñiga include an explanation of Stuart Rockefeller's conception of space, a theory that insists that public places are produced by "individual movements, trips, and digressions." They continue: "Starting with [Nancy D.] Munn's idea that the person makes space by moving through it, [Rockefeller] traces how movement patterns collectively make up locality and reproduce locality. Places, he argues, are not in the landscape, but simultaneously in the land, people's minds, customs, and bodily practices."[29] As early church members migrated from upstate New York to the West, they left their physical imprint upon the lands they crossed and, through various cultural performances including burials, religious meetings, and spiritual experiences, created spontaneous localities in the landscape. The relationship between the pioneers and the landscape was multifaceted, and their experiences were understandably deeply shaped by their interaction with this wild land that was as

close to absolute space as they probably would have known. Importantly, the experience of this crossing, now etched into the bones and flesh of those who survived the arduous journey, became a central element of the foundation narrative of the LDS Church and, in turn, influenced members' mental understanding of the land. Therefore, the places marked by the pioneer migration are now simultaneously geographical locations, historical sites, and imaginary spaces in members' minds and embodied practices.

After the move to Salt Lake, the church practices and beliefs became more codified; because they were now in a protected area fully separated from the United States by geographical boundaries, members and the church leadership were able to focus on developing their Zion. For the first decades following the migration, there was little emphasis on the preservation or cultivation of the sites fundamental to the church's founding or to the pioneer trail: it was nearly fifty years after the early settlers had entered the Salt Lake valley that the church leaders began to look at such locations as essential to the work of perpetuating memory among its members. Nora explains that such a shift is endemic in modern society and represents a society's lack of spontaneous memory, suggesting that "if we were able to live within memory, we would no have need to consecrate *lieux de mémoire* in its name."[30] This would certainly seem to be the case with the early pioneers and their immediate descendants: there was no need to consecrate such sites, since those sites and the occurrences associated with them were already inscribed upon their bodies. Nora claims that true memory has "taken refuge in gestures and habits, in skills passed down by unspoken traditions, in the body's inherent self-knowledge, in unstudied reflexes and ingrained memories." This he compares to "memory transformed by its passage through history," which is "nearly the opposite: voluntary and deliberate, experienced as a duty, no longer spontaneous."[31]

As leaders began purchasing the lands and sites where remarkable moments in the church's history had happened, they were in essence acknowledging that the kind of true memory that Nora speaks of was slipping away and needed to be bolstered with sites consecrated not by the collective experiences of the saints who had lived in and traveled through them but rather by the naming of these sites as religio-historical space. In LDS tradition, as each heritage site is set aside as sacred space, it is formally "dedicated" by a church leader; that is, a prayer is said on the site dedicating it to the work of promoting the church's narrative. The performative act of naming such places sacred is what transformed them from practiced or lived space into sacred, symbolic, and representational space.[32]

Even as it reflected the need to create historical memory, the increasing emphasis on "heritage" sites worked to shape the imaginary consciousness of members. Members of the LDS faith are often admonished to remember their pioneer

forebears and the tribulations they endured. This history is so much a part of LDS teachings and the members' cultural imagination that Jones has noted that "for Mormons, identifying with the past is not just an educational enterprise, but a doctrinal imperative."[33]

Talks and lessons given by leaders remind current members of the desperate trials faced by those who came before, and often those trials are compared to the contemporary trials faced by modern-day members, as in this passage by the current president, Thomas S. Monson: "But what of today's challenge? Are there no rocky roads to travel, no rugged mountains to climb, no chasms to cross, no trails to blaze, no rivers to ford? Or is there a very present need for that pioneer spirit to guide us away from the dangers that threaten to engulf us, and lead us to a Zion of safety?"[34] Monson's evocation of the pioneer past here makes ample use of geographical metaphors, metaphors that work for his audience primarily because they have heard of these stories of pioneer triumph over many years, some of them over lifetimes, and these geographies of struggle have become a part of their imaginary landscape: this is not the first chasm, river, or rocky road that members have imagined, nor will it likely be the last. As Diana Taylor puts it, "cultural memory is, among other things, a practice, an act of imagination and interconnection. . . . There is a continuum between inner and outer, much as there is between the live present and the living past, and a notion (or act of imagination, perhaps) that individuals and groups share commonalities in both the here/now and there/then, made evident through embodied experience."[35] The shared commonalities are the experiences of struggle borne by the bodies of members, past and present.

For many members, in numbers that have been exponentially increasing over the last twenty-five years, allowing the spaces of the pioneer past to remain imaginary is no longer enough. As more and more latter-day pilgrims seeking a connection with their past trace the migratory route of the pioneers, they, in turn, influence what other members imagine of those spaces by bringing home new descriptions of these sacred spaces. Paul Connerton's *How Societies Remember* emphasizes the importance of a group's spatial experience (both material and mental) on the cultural imaginary of the individual who belongs to that group: "Groups provide individuals with frameworks within which their memories are localized and memories are localized by a kind of mapping. We situate what we recollect within the mental spaces provided by the group. But these mental spaces . . . always receive support from and refer back to the material spaces that particular social groups occupy."[36] By traveling to sacred sites and enacting spatial performance, individuals influence the group conception of these sites; the group then, in turn, influences individual spatial conception, creating a Möbius strip of spa-

tialized experience of the religion and its foundational sites that is always tied to the material reality of the space.

The desire to experience that material reality, and the influence that such experience may have on one's understanding of the world and the LDS religion, is certainly a primary reason for participating in LDS-themed heritage tourism. Perhaps there is also, however, a desire to communicate with the past: to walk where Smith walked, to touch the woods wherein he had his vision, to see the very spot where Brigham Young "became" Joseph Smith. The sites, and the performances featured there, seek to break down the spatio-temporal boundaries separating LDS tourists from their spiritual ancestors. Though there is no literal calling forth of the ghosts of the past, the echoes of events and personalities associated with the spaces reverberate throughout visits to the sites.

Writing about the modern practice of separating cemeteries from the city proper, Roach asks the haunted question at the root of much historical practice: "If the dead are forever segregated, how are the living supposed to remember who they are?"[37] Roach's tricky usage of "they" (Who is the antecedent? The dead? Or the living?) reveals some of the ambivalence surrounding the practice of history: for whom are we preserving the past? For members of the Mormon Church, it is for both the dead and the living: there is personal growth that comes from understanding the historical underpinnings of the church and the possibility of identifying personal struggles with those of members who came before. Additionally, recovering history is important for the dead because they can benefit from work done vicariously by the living. Indeed, preserving LDS history and remembering ancestors is not an abstract idea for members but an embodied practice. Members participate in rituals on behalf of the dead, with the belief that one day all will be resurrected and re-embodied and will need to have that work done for them. Along with these rituals, participation in heritage tourism and performance serves to further anchor that history in the material realities of historical bodies and spaces, each of which are consecrated by and for God.

Notes

In 1847, when Brigham Young and the first set of Mormon pioneers descended into the Salt Lake Valley, Young stopped his carriage and declared, "It is enough. This is the right place. Drive on" (quoted in B. H. Roberts, *A Comprehensive History of The Church of Jesus Christ of Latter-day Saints, Century One,* six vols. [Salt Lake City: Church of Jesus Christ of Latter-day Saints, 1930], 3:224). A shortened version of the refrain, "This is the place," echoed among the exhausted and relieved pioneers. The phrase has come to have significant cultural purchase in contemporary Mormonism, as it represents to be-

lievers the moment when God revealed that they could stop wandering and establish a rooted community—their exodus was complete upon arrival at this place.

1. See Richard Edmond Bennett, *We'll Find the Place: The Mormon Exodus, 1846–1848* (Norman: University of Oklahoma Press, 2009); Joseph E. Brown, *The Mormon Trek West: The Journey of American Exiles* (New York: Doubleday, 1980); John K. Carmack, "Father Brigham in His Western Canaan," *BYU Studies* 40, no. 2 (2001): 13–22; William Hill, *The Mormon Trail: Yesterday and Today* (Logan: Utah State University Press, 1996); Craig S. Smith, "The 1847 Mormon Pioneer Trek," *Overland Journal* 27, no. 1 (Spring 2009): 3–18; Roberts, *A Comprehensive History;* Leonard J. Arrington, *The Mormon Experience: A History of the Latter-day Saints* (New York: Vintage Books, 1980).

2. Joseph Smith, "Joseph Smith—History," Pearl of Great Price, verse 14 (sacred text) (Salt Lake City: The Church of Jesus Christ of Latter-day Saints, 1981).

3. Pierre Nora, "Between Memory and History: *Les Lieux de Mémoire,*" trans. Marc Roudebush, *Representations* 26 (Spring 1989): 21.

4. Joseph Roach, *Cities of the Dead* (New York: Columbia University Press, 1996), 42.

5. Henri Lefebvre, *The Production of Space,* trans. Donald Nicholson-Smith (London: Blackwell Publishing, 1991), 48. The woods probably would not qualify as absolute space in the strictest sense, as they were most likely known of and used by the Smith family (and perhaps others) to gather firewood, acquire timber for building, etc. But the idea of the woods as a site "chosen for [its] intrinsic qualities" would have functioned as such.

6. Lefebvre, *The Production of Space,* 35.

7. Roach, *Cities of the Dead,* 28.

8. David Lowenthal, "Past Time, Present Place: Landscape and Memory," *Geographical Review* 65, no. 1 (January 1975): 6.

9. Lefebvre, *The Production of Space,* 39.

10. George Manwaring, "Joseph Smith's First Prayer," Hymns—LDS Church Music, Church of Jesus Christ of Latter-day Saints, http://www.lds.org/churchmusic/detailmusicPlayer/index.html?searchlanguage=1&searchcollection=1&searchseqstart=26&searchsubseqstart=%20&searchseqend=26&searchsubseqend=ZZZ (accessed June 29, 2009).

11. In LDS hierarchy, the president of the church is supported spiritually and administratively by twelve men called "apostles."

12. Megan Sanborn Jones, "(Re)living the Pioneer Past: Mormon Youth Handcart Trek Reenactments," *Theatre Topics* 16, no. 2 (September 2006): 120.

13. Lefebvre, *The Production of Space,* 37.

14. Roach, *Cities of the Dead,* 42.

15. For a discussion of ways in which early Mormon settlers interacted with and mythologized American Indians (whom they believed to be the descendants of the Lamanites, a racial and cultural group depicted in the Book of Mormon), see Jared Farmer, *On Zion's*

Mount: Mormons, Indians, and the American Landscape (Cambridge, MA: Harvard University Press, 2008).

16. Scott Magelssen, "'This Is a Drama. You Are Characters': The Tourist as Fugitive Slave in Conner Prairie's 'Follow the North Star,'" *Theatre Topics* 16, no. 1 (March 2006), 20.

17. Rodger Sorensen, interviewed by Lindsay Adamson Livingston, Brigham Young University, August 18, 2008.

18. Diana Taylor, *The Archive and the Repertoire: Performing Cultural Memory in the Americas* (Durham, NC: Duke University Press, 2003), 143.

19. Doctrine and Covenants, 57:1–2 (sacred text) (Salt Lake City: Church of Jesus Christ of Latter-day Saints, 1981).

20. Michel Foucault, "The Other Spaces," trans. Jay Miskowiec, *Diacritics* 16, no. 1 (Spring 1986): 24.

21. There are, of course, many conflicting stories as to why Smith was arrested at this particular time. After consolidating power in Nauvoo, Mormons were becoming more and more politically powerful in the state, and Smith had even announced his intention to run for president of the United States. This increasing power, coupled with the destruction (ordered by Smith) of an opposition newspaper in Nauvoo, led to a public outcry that resulted in criminal charges being brought against Smith. Though he had the opportunity to flee, Smith chose to remain and face the charges.

22. Roach, *Cities of the Dead,* 2.

23. D. Michael Quinn, "The Mormon Succession Crisis of 1844," *BYU Studies* 16, no. 2 (1976): 1. In this article, Quinn outlines the possible methods of succession laid out by Joseph Smith and addresses question of how prophetic authority was legitimized in the fledgling church.

24. Roach, *Cities of the Dead,* 38.

25. Benjamin Johnson, *My Life's Review* (Independence, MO: Zion's Printing and Publishing, 1947), 103–104.

26. Lynne Watkins Jorgensen, "The Mantle of the Prophet Joseph Smith Passes to Brother Brigham: One Hundred Twenty-one Testimonies of a Collective Spiritual Witness," in *Opening the Heavens: Accounts of Divine Manifestations, 1820–1844,* ed. John W. Welch (Provo, UT: Brigham Young University Press, 2005), 374–480.

27. Reid L. Harper, "The Mantle of Joseph: Creation of a Mormon Miracle," *Journal of Mormon History* 22, no. 2 (Fall 1996): 35.

28. In my larger project, I continue exploring the spatial dimensions of the tourist-spectator experience at Nauvoo and Carthage through on-site ethnographic interviews with visitors, performers, and missionaries who serve there.

29. Setha M. Low and Denise Lawrence-Zúñiga, "Locating Culture," in *The Anthropology of Space and Place: Locating Culture,* ed. Setha M. Low and Denise Lawrence-Zúñiga

(Malden, MA: Blackwell Publishers, 2003), 6. See also Della Pollock, ed., *Exceptional Spaces: Essays in Performance and History* (Chapel Hill: University of North Carolina Press, 1998).

30. Nora, "Between Memory and History," 8.

31. Ibid., 13.

32. Lefebvre, in *The Production of Space,* establishes a useful triad to explain the ways in which different spatial realities interact and over-code one another. The three types of space he names are spatial practice, which is the lived space we all inhabit without being necessarily conscious of it; representations of space, which are the ways people conceptualize and otherwise "name" space, verbal explanations of space; and representational space, which includes the complex symbolisms certain groups associate with certain spaces.

33. Jones, "(Re)living the Pioneer Past," 113.

34. Thomas S. Monson, "Come Follow Me," *Liahona* (November 1988), http://lds .org/ldsorg/v/index.jsp?hideNav=1&locale=0&sourceId=1e278b5c1dbdb010VgnVCM100 0004d82620a____&vgnextoid=f318118dd536c010VgnVCM1000004d82620aRCRD (accessed June 29, 2009).

35. Taylor, *The Archive and the Repertoire,* 82.

36. Paul Connerton, *How Societies Remember* (Cambridge: Cambridge University Press, 1989), 37.

37. Roach, *Cities of the Dead,* 55.

Men with Their Muskets and Me in My Bare Feet

Performing History and Policing Gender at Historic Fort Snelling Living History Museum

Amy M. Tyson

Introduction: Truth Is Stranger than Fiction

Beginning in the late 1990s, a mini-genre of satiric commentary on management-labor relationships at living history museums emerged on the literary stage with the publication of Julian Barnes's novel *England, England;* George Saunders's lead story in his acclaimed short story collection, *Pastoralia;* and, most famously, Chuck Palahniuk's *Choke,* which was also released as a film in 2008.[1] Taken together, the three pieces point to the choices made in the backstage world of living history sites in similar ways. For example, in Barnes's novel a tycoon takes over the Isle of Wight, and employees at this heritage theme park are constantly negotiating the whims of their eccentric boss, who is obsessed with the idea of authenticity; in *Choke,* Palahniuk's main character works at a colonial theme park where workers could find themselves in the stocks if they are found breaking the conventions of historical accuracy; and, finally, in Saunders's short story, workers at the Pastoralia living history theme park are required to live at the park and remain in character when on duty, even though the park is suffering from serious visitor decline. While the problematics of "authenticity" in the service economy serve as the fulcrum for all three satirical pieces, Saunders's satire is the only one in which we never leave the living history park. As such, Saunders makes Pastoralia's living history environment totalizing—never allowing us to escape his rendering of the uneasy marriage between historic representation (be "authentic") and service economy directives (be "nice").

In its struggle to stay afloat, Pastoralia has cut back its programming. Popular areas such as Pioneer Encampment remain open, but areas such as Wise Mountain Hermit and Russian Peasant Farm have not survived the economic crisis. Workers from these stations have either been laid off or reassigned; the Russian peasants, for example, "are all elsewhere, some to Administration but most not."[2] For those still employed, threats of layoffs loom large. Saunders writes the story

through the perspective of one of the park's workers whose job it is to authentically portray a prehistoric caveman along with his coworker of six years, Janet. Like other workers at the park, the two live at the park twenty-four hours a day and, in the spirit of strict verisimilitude, are supposed to break character only when their shifts are over. Both Janet and the narrator desperately need these jobs to help support their families, but Janet—who burned out years ago—has ceased playing by the rules; she frequently speaks English in the cave and has even worn an "I'm with Stupid sweatshirt over her cavewoman robe."[3] Looking for excuses to eliminate positions, management encourages the narrator to corroborate what park visitors have been writing about Janet; Pastoralia's management is already aware of Janet's transgressions vis-à-vis Client Vignette Evaluations that park visitors fill out. What course of action the narrator should take provides the central tension for Saunders's short story. Will the narrator be loyal to Janet and continue to positively evaluate her in his Daily Partner Performance Evaluation Forms—or will he turn Janet in, listing her many violations as a way to protect his own precarious position within the service economy?

In the Pastoralia living history park, as in many work sites in the New Economy, management is not the sole proprietor of control. Indeed, inside and outside of the cave, clients, management, and coworkers are involved in what labor scholar Robin Leidner has identified as a "three-way dynamic of control" that involves workers, management, and customers in a triadic relationship that changes with circumstance.[4] Sometimes the manager and worker align to manipulate the behavior of the client, while at other times the client and manager work together to control the performance of the worker. The workplace dynamics satirized in "Pastoralia" work to show how management in a service economy disperses its managerial control among both customers and other employees. Indeed, in the story, management never directly supervises employees; instead, as its means of surveillance, it relies on evaluations that clients and coworkers provide about each worker.

But while Saunders's satire is most certainly an indictment of how worker surveillance and control operates in the New Economy, as with Barnes's *England, England* and Palahniuk's *Choke,* setting "Pastoralia" in a living history theme park also allows Saunders to play with the notion of what it means to *authentically* enact history. At one point in the story, for example, Janet and the narrator find that a major "authentic" prop that they use for their prehistorical enactments— a goat—has been replaced by a plastic goat "with a predrilled hole for the spit to go through." Attached to the plastic goat is a note from management that reads: "*In terms of austerity . . . [n]o goat today. In terms of verisimilitude, mount this fake goat and tend as if real. Mount well above fire to avoid burning.*"[5] Although the

living history theme park purports to aim for strict interpretive accuracy, management throws the very idea of authenticity into question in asking its workers to interpret cave life with a pre-drilled plastic goat. The plastic goat symbolizes management's shifting stance toward authenticity; they reject or embrace it depending on how they wish to discipline or control park workers. On the one hand, management could very well fire Janet for speaking English in the cave; on the other hand, they expect her to treat an ersatz goat as though real.

To those uninitiated into the world of living history, the scenarios crafted in "Pastoralia" might seem impossibly fictionalized. Plastic goats? Surely this is absurd. To those of us who have worked on the front lines of living historical interpretation, however, the workplace issues Saunders spins in "Pastoralia" may only seem a half step away from reality. Sometimes the truth is stranger than fiction.

The following pages examine the way managerial culture at Historic Fort Snelling, a living history site in St. Paul, Minnesota, dispersed its power to discipline and control its workers. At the time of my study (2001–2006), workers at this site were required to dress in costume finery circa 1827 and were expected to demonstrate early nineteenth-century skills while portraying characters from the past. These historical guides neither lived on site (although some visitors assumed they did) nor were expected to roast plastic meat. Nonetheless, as with the caveperson duo in "Pastoralia," they did experience a managerial culture that dispersed its power among customers and employees to discipline and control workers. At the fort, however, it was coworkers rather than management or customers whom employees most often perceived as surveilling their actions and monitoring their behavior. Here, as in "Pastoralia," the battle for control was often fought with the weapon of "authenticity"—and coworkers leveled any number of critiques at colleagues on the grounds that they were enacting history in a way that was not "period" or "authentic."

In this chapter, I move from the world of fictionalized living history to focus on the workplace culture of an actual living history work site—Historic Fort Snelling—focusing on the years 2001–2006. Having borrowed managerial tactics from the private sector, management at the fort, as in "Pastoralia," built an organizational structure that strongly encouraged worker-on-worker surveillance. I argue that this surveillance took on a particularly gendered timbre. Given the sex segregation at the fort, female coworkers tended to supervise each other, and it was the same for males. Likewise, observations—in the form of praise or critiques—were of a particularly gendered nature. While women were subject to scrutiny about, say, sewing, cooking, and cleaning, men were most often scrutinized for their ability to march, fire muskets, be "good soldiers"—and to convincingly portray masculinity, in both its historic and present-day dimensions (fig. 4).

4. Male interpreters marching at Historic Fort Snelling. Photo by Amy Tyson.

As in "Pastoralia," notions of "authenticity" were often used to give weight to an employee's efforts to control the behavior and comportment of a coworker. For example, one male living history interpreter might critique another's less than perfect performance during a military demonstration by claiming that he was not accurately portraying (what he believed were) the disciplined soldiers of the past. By the same token, the less than perfect soldier/coworker could rebuff his critics by using the same weapon of authenticity, claiming that the soldiers they portrayed on the outskirts of the United States frontier would not have been models of disciplined military perfection. The initial critique is distinctively gendered because it comments on the interpreter's ability to portray a "real" man. Likewise, in rejecting their coworkers' claims about the "authenticity" of their portrayals, these men were defending their manhood; if, in the face of these critiques, they could argue their own case for what would be authentic, they were being good workers and good men because they were doing what this job called for—being true to the past. This battle over masculinity continued in and out of costume— as men were pressured to conform to social norms of what it meant to be a "real" man. As such, I argue that enacting *history* made claims to the worker's *contemporary* sense of self.

Fort Snelling was built in the early years of the 1820s to house the soldiers and officers of the Fifth Regiment of the U.S. Infantry, who were sent to the netherlands of the Northwestern Territory to support American economic interests in the fur trade. Throughout its history, the fort was mostly a quiet post; indeed, its primary purpose in 1858 was to pen sheep.[6] Decommissioned in 1946, the fort was declared a National Historic Landmark in 1960, which set the stage for the fort's transition to become a premier tourist destination for Minnesota. Indeed, in 1965, State Representative William J. O'Brien expressed his hope that the yet-to-be-restored fort would one day be "Minnesota's Williamsburg."[7]

Throughout the 1960s and 1970s, the fort underwent a full-scale reconstruction and restoration of its stone walls and of the sixteen buildings that had originally comprised the 1820s frontier fort. On a national scale, this project was not unique. Throughout the 1960s and 1970s, as Mike Wallace has quipped, everyone was "doin' it."[8] In the economic boom of the post–World War II years, the nation saw an exponential growth in the numbers of American families who were setting out in their automobiles for family vacations, with cash in their pockets. As Wallace notes, established living history museums such as Colonial Williamsburg and Old Sturbridge Village saw enormous spikes in attendance; in the period from 1947 to 1967, for example, Williamsburg's attendance "went from 166,000 . . . to nearly 710,000" and Sturbridge's "went from less than 12,000 to over 520,000."[9] Investors and developers met demand by funding and creating more tourist destinations; locations touched by history were prime targets. With a coalition of middle-class advocates and funders ready to back development, city squares, districts, and main streets lined up to receive historic facelifts designed to attract the modern tourist.[10] Fort Snelling should be seen as part of this larger national trend to reconstruct the past. Although the reconstruction and restoration of the post was not completed until 1983, in 1970—the fort's sesquicentennial year—the fort found new life and purpose as a living history museum. Since 1970, tourists have interacted with the fort's cadre of living history interpreters who portray figures from the fort's frontier past. Over the years, interpreters have portrayed soldiers, laundresses, officers, officers' wives, domestics, keelboat captains, immigrant refugees, and American Indians.

Several scholars have analyzed the meanings embedded in the practice of living history at museums and historic sites, most notably Stephen Eddy Snow's *Performing the Pilgrims: A Study of Ethnohistorical Role-Playing at Plimoth Plantation* (1993), Kevin Walsh's *The Representation of the Past: Museums and Heritage in the Post-modern World* (1992), Scott Magelssen's *Living History Museums: Undoing History through Performance* (2007), and Richard Handler and Eric Gable's *The New History in an Old Museum: Creating the Past at Colonial Williamsburg* (1997).

While Snow's primary concern in his study of New England's Plimoth Planta-
tion is to situate living history within the field of performance studies and to de-
fend living history as acting,[11] Walsh's book focuses predominantly on the heri-
tage industry in the United Kingdom. In his study, Walsh theorizes heritage sites
and living history museums as hegemonic projects of the New Right, claiming
that such sites "have promoted an uncritical patriotism which numbs our ability
to understand and communicate with other nations."[12] Walsh's is an important
text for its critical focus on the dominant ideologies that sites such as these often
perpetuate; it is a critique similar to one that historian Thomas Schlereth posed
in 1978 when he chastised the living museum genre for being "lodged in the 'con-
sensus' historiography of the 1950s."[13] But while Walsh and Schlereth assess the
limitations of living history as tourist productions that serve largely as "historical
shrines" to which "visitors are beckoned to make pilgrimages,"[14] theater histo-
rian Scott Magelssen goes beyond "pinpointing inaccuracies in living history mu-
seums" in favor of examining "conceptions of time and space, modes of perfor-
mance, and the fields of relationships in the twentieth century that determined
the conditions that allowed living history to emerge."[15] Magelssen's study pushes
the study of living history museums beyond judging the performances therein as
producing "authentic" or "inauthentic" messages to asking how "living history
museums [have] used performance to make accuracy and authenticity."[16] Simi-
larly, this essay is not concerned with how "accurate" or "authentic" the portray-
als of the past were at Historic Fort Snelling; but I depart from Magelssen's study
and examine how workers at this living history museum embraced the idea of
authenticity as a method of control and, in so doing, policed the contemporary
gender identities of coworkers.

In terms of method, the study most analogous to my own is Richard Handler
and Eric Gable's ethnographic study of Colonial Williamsburg. In their study,
Handler and Gable examine the process by which the Colonial Williamsburg
Foundation adapted to the new social history in the 1980s and 1990s and how
the corporate structure of the foundation affected the programming at large. But
Handler and Gable's rich ethnography does not consider issues of gender in their
analysis and also tends to deny Colonial Williamsburg's interpreters much agency—
something my study helps to amend because of its attention to labor and use of
the extended case method as its major methodology.[17]

The extended case method requires that the ethnographer engage in partici-
pant observation at a site over an extended period of time and that he or she en-
ters the field with existing social theories in mind; the ethnographer's experiences
work toward improving theory.[18] In short, this study builds on and departs from
prior studies of living history museums, not only because I examine the sites

through a labor-studies approach with an attention to gender, but also because I use the extended case method as a central approach to my project in order to get at the hives of subtlety that surround how enacting history affects workers' subjectivities.

My participant observation at Historic Fort Snelling was rather extensive; I worked as a historic interpreter at Historic Fort Snelling for seven tourist seasons, beginning in 1999 and again from 2001 to 2006. Initially, I sought employment at the fort because I needed summer employment between my first and second years of graduate study at the University of Minnesota. In 2001, I returned to work as an interpreter, but I was forthright with management and my coworkers that I was writing on the work of living historians and that I was using the fort as my main site for research. Having worked at the fort for so long strongly colors my research for this essay because my own experiences—not always the most pleasant—are necessarily offered as part of the case study, for my analysis and for your consideration.

In addition to participant observation, while I was employed at the fort, I conducted in-depth interviews (one to three hours long) with twenty-three living history interpreters who worked at Historic Fort Snelling: sixteen males and seven females, which roughly represented the ratio of male to female interpreters at this military history site. Of the twenty-three interviewees (who are given pseudonyms here), all but five had at least a bachelor's degree, at least five had either a master's degree or a doctorate, and all but one racially identified as white—one identified as Asian. The interviews were conducted between 2001 and 2003, and as such, the programming, management, work conditions, and other issues about which the informants spoke referred to their experiences at or before that time.[19]

The greater part of my participant observation notes also draws from those three years. This is important to keep in mind because the fort described in this essay is undergoing constant change, and the content of the interviews, as well as my own experiences at the site, should be contextualized in terms of their location in time and space. For example, during my final season at the fort, in 2006, there was a complete turnover in the incumbent fort management, three new on-site supervisory positions were created, and there were plans in the works to address previously underinterpreted aspects of the fort's history, such as slavery. As part of this transition, the fort also shifted from "modified first-person" interpretation (wherein costumed guides would pretend to be characters from the past until they perceived a need to break character for the public) to "modified third-person" interpretation (wherein they would strive to provide visual and audible impressions of the past—through costumes and speech—but they would not portray people from the past). Had such programmatic and managerial overhauls occurred ear-

lier in my fieldwork, the results and content of this study would, no doubt, be altered. Because I recognize that museums (and all work sites) are always in a state of flux, I refer to the culture that is the focus of this study in the past tense and offer my analyses as case studies that will yield broader implications for those interested in the labor and work of those who enact history.

Me in My Bare Feet: Female "Lead Guides" and Gender Micromanagement

During the years of my study (2001–2006), site management at Historic Fort Snelling consisted of one site manager, one assistant site manager, and two site technicians.[20] Site technician II only had purview over running the various "shops" at the fort (blacksmith's shop, carpenter's shop); the other, site technician I, had managerial responsibility as he not only worked on scheduling and filling out timesheets but, like the two site managers, also had supervisory authority over the military and civilian interpretation at large. All four positions were staffed by males who had had a fairly extensive background with living history; the "shops technician" had roughly ten years of experience and the other three had more than two decades.

The other managerial "arm" at the fort during those years consisted of "lead guides" (a position that was eliminated in 2004) who worked side by side with regular interpretive guides but had more responsibilities—one of which was to evaluate the performance of their coworkers.[21] In a staff of forty, roughly eight individuals—men and women—would be hired as lead guides. To be sure, working as a lead guide at the fort was the only concrete mark of achievement for interpreters at Historic Fort Snelling; outside of taking tests to qualify to portray additional character roles, serving as a lead guide *was* the glass ceiling. The honor of being a lead guide was largely in name only. In 2001, for instance, the difference of pay that distinguished lead guides from regular guides amounted to a minimum of only forty-three cents an hour.[22] The lead guide position carried with it a considerable amount of increased responsibility with little monetary remuneration. Remuneration for lead guides was the honor of being differentiated from "regular guides" and from any satisfaction they could derive from a job well done.[23]

As part of their increased responsibility, lead guides were expected to conduct specialty seminars on interpretation or fort history, run special events, assist with scheduling, survey the work performance of their coworkers, and contribute to coworkers' pre-performance reviews (PPRs), and performance reviews (PRs)—the real-world equivalents to Pastoralia's "Daily Partner Performance Evaluations"

(DPPEs). Although lead guides did have significant responsibilities compared to other staff, most guides I interviewed did not think taking the position as a lead guide would have been worth it, and a few did not see the function of the position at all, as Craig articulated: "There's no distinction between lead guides and anybody else. [Someone] told me once that most people turn down the lead guide [position]; he didn't want to be a lead guide. And [another guide] quit being a lead guide. Nobody wants to do it because all it *is* is a little bit of extra work—locking and opening—and nobody wants to do it for the extra thirty cents an hour. I don't know why anybody would want to do it. It's stupid."[24] Craig also took issue with lead guides having the responsibility of contributing to performance reviews, saying that he just didn't "understand that whole lead guide thing—I mean they do these evaluations and I never see most of these people—I never work with most these people, but they evaluate, so I don't take it very seriously."

Not being taken seriously in managerial authority was endemic to the lead guide position and ultimately caused trouble on multiple fronts, leading to the position's elimination in 2004. Brynn, who served as a lead guide for several years before the position was eliminated and, for her part, did take the position seriously, felt that "one of the anomalies of the lead guide position" was that they had all "the responsibility without having the authority," so while they were expected to evaluate their coworkers, their positions were not technically supervisory. This frequently caused dissension among the staff as boundaries blurred and a small handful of lead guides began to be excessively critical of their coworkers—from the way they polished furniture or baked bread to the way some chose to blow off steam when the public was not around.

One of my interviewees, Kathleen, had served as a lead guide for two of her eight seasons on staff. After her second season as a lead guide, she decided to reapply only as a guide. She felt both that management exploited lead guides and also that lead guides were overstepping their bounds with regard to their surveillance of coworkers. Ideally, Kathleen saw "lead guides as being a resource for the other guides," but unfortunately, she too often saw that "as not happening."[25] In her view, some lead guides used "their position as one of authority to kind of play God and to make people feel bad. I see a lot of times that they're pointing out the bad things and not the good things." In my years working there, complaints about lead guides were almost always directed at those who were female.

An example from my own participant observation might help flesh this dynamic out a bit more. In my field notes from August 3, 2002, I noted my own frustration with one lead guide who, in a locker room exchange, remarked to me about a visitor photograph she had seen of me in the staff meeting room. In the

photograph, I am portraying a domestic who is serving dinner to one of the officers on the veranda; I had no shoes on—a clear violation of dress codes for a domestic serving dinner "at table" to an officer. To provide some context, prior to the taking of the photograph, I had cooked the meal downstairs in the officer's basement kitchen, where I was also supposed to pretend that I was quartered with my family. Upstairs, a coworker was portraying Lieutenant Platte Rogers Green; my charge for the day was to pretend that my character, Mrs. Tyson, worked for his family. Downstairs in the kitchen, my character did not need to follow any particular dress code, but at table, she needed to have a neater appearance, complete with shoes.

After cooking the meal barefooted, I prepared to bring the meal upstairs. A group of visitors, who had watched me cook the meal in front of the hearth, followed me upstairs to see the next step in the process—serving the meal. As I gingerly balanced the china in my hands, about halfway up the staircase to the lieutenant's quarters, I announced to the visitors that I had forgotten to put my shoes on (I left them off deliberately) and explained to them that while I did not need to mind how I dressed downstairs where I did the cooking, I was supposed to be dressed appropriately when in the presence of my employer, which included the wearing of shoes. Rather than going all the way back downstairs to put my shoes on, my character decided to risk it and shared the following exclamation with the visitors: "Hopefully the lieutenant won't notice this once!" In so doing, I felt that I was providing some dramatic tension for the fort's visitors who were looking on; had the man playing the lieutenant noticed that I was violating the dress code, he might have improvised any number of scenarios, from sending me back downstairs to dress appropriately to threatening my job. Lieutenant Green did not notice, so I quickly served him his plate of fish, poured his tea, and took my leave, visibly relieved that I avoided reproach—either to the relief or the disappointment of the onlookers. As it was, one visitor, who was a weekly regular at the fort, happened to snap a picture during that brief moment when I was serving dinner to the lieutenant in my bare feet—proof that I was "speaking English in the cave" as it were.

Eventually, this photograph made its way down to the staff meeting room. At the end of a work day, as female interpreters were changing into "civilian clothes" in the locker room, without asking or knowing the context for this photograph, one of the lead guides remarked, in a condescending tone of reprimand, that she had seen the photograph and that "aside from if you were an upper class domestic you wouldn't have had bare feet—it's such a good picture." There was no compliment here.

In this comment, the lead guide was insinuating that I was shirking my duties

as an interpreter and was giving the wrong impression to the public in this display of my body: bare feet and ankles. When I had made the choice not to wear my shoes, I was operating under the assumption that even while there were— and continue to be—established codes of behavior for women and domestics, those boundaries were so rigidly policed because sometimes they were crossed. Meanwhile, this lead guide, a woman, was using notions about the "authentic" nineteenth-century domestic in order to defend her claims about the inappropriateness of my display. This was uniquely gendered because it was a critique made in the locker room by one female to another and also because of its attention to my body. For even though I felt confident in my interpretive choice, I nonetheless reacted to the comment with a feeling of embarrassment for having exhibited my body—even if it was just my feet—for public consumption.[26]

Taken in isolation, I may not have taken the lead guide's comment much to heart and may have been only too happy to explain the context for the photograph. That season, however, many other female interpreters felt they could not escape the critical gazes of certain female lead guides who made them feel as though they could not be trusted as interpreters; in particular, their hearthcooking skills were frequently called into question and sometimes ridiculed. As a result of these collective comments and critiques, during the 2002 season it seemed that any remark that these lead guides made met the gritted teeth, rolled eyes, and sighs of exasperation from interpreters who collectively felt micromanaged.

A week before the comment was made about my bare feet, for example, the tense work environment had reached a boiling point even before the first visitor had walked through the gates. On that hot day in July, as the females guides were changing into costume, one lead guide remarked that it was "inauthentic" for one of the female interpreters to portray Mrs. Snelling because the interpreter was too old. While the "real" Mrs. Snelling in 1827 was only thirty years old, this interpreter was in her late forties and was changing into costume with the rest of us when the comment was made. Her feelings were clearly hurt and she was visibly holding back tears. After she left for her post, another coworker, Elizabeth, and I went to see if she was all right.[27] At this point, she did cry and said that this comment was "just the tip of the iceberg" and that she was tired of being criticized at every turn—so that now even her age was being criticized.

Shortly after we talked over what had transpired, I took my place downstairs in the kitchen where I was assigned to work that day and began sorting coals from the ash in preparation to cook. Although Elizabeth's schedule dictated that she was supposed to be cleaning the static exhibits in the Long Barracks (a task that rarely required the full thirty minutes that our schedules allotted—often interpreters would simply read the exhibit displays to stretch the time), on this occasion, she

quickly finished cleaning the Plexiglas display cases so that she could talk to me about what had happened in the locker room that morning. Although no one from the public had yet arrived to visit the site that morning, as we crouched by the hearth, sorting coals and talking about the morning's events, another lead guide approached us, shook her finger at us, and warned that the two of us needed to "be very cautious," that "everyone from lead guides on down" had been talking about the two of us, that "it was suspected that we had been arranging our schedules to see each other," that we had been "jeopardizing our stations," and, finally, that we had been seen on several occasions walking arm-in-arm together on the parade—which, incidentally, would not have been historically inappropriate for women of the same social status but in this instance was claimed to be "inauthentic."

These warnings were issued with such gravity that it took Elizabeth and me several moments to realize that they carried no substance or merit; while we were more than certain that some of the lead guides disapproved of those of us who tended to break character and joke when the public was not around, we were both confident that our stations had never been "jeopardized," nor did we ever compromise our living history impressions at the expense of the public. We felt micromanaged, to be sure, but we also felt that although Elizabeth and I were only friends, this lead guide was insinuating that we were carrying out a relationship of other sorts—one that was apparently threatening enough to this lead guide to make her grasp at straws. We were being critiqued for the apparent "inauthenticity" of walking arm-in-arm—even while historians, such as Carroll Smith-Rosenberg, in her article "The Female World of Love and Ritual: Relations between Women in Nineteenth-Century America," have persuasively argued that such a gesture was not likely to have turned heads. Smith-Rosenberg writes, "Nineteenth-century American society did not taboo close female relationships but rather recognized them as a socially viable form of human contact—and, as such, acceptable throughout a woman's life. Indeed it was not these homosocial ties that were inhibited but rather heterosexual feelings."[28] Had either Elizabeth or I been seen walking arm-in-arm with one of the soldiers, this lead guide's critique would have held water.

The criticism of my bare feet, the accusation that a worker appeared "too old" to portray Mrs. Snelling, and the charge about walking with linked arms are all uniquely gendered critiques. First, they would not likely have been made to men, and, second, they would not have had the same effects. It is unlikely, for instance, that a male interpreter would have been brought to tears for being told that he looked too old to play Colonel Snelling; certainly, women in our society have been conditioned to take more personally comments about their appearance, includ-

ing their age. Likewise, being called out for exposing "bare feet" was gendered in that the comment was about an exposed body part whose exposure violated propriety. Finally, when I was accused of carrying out an inappropriate relationship with another female coworker by walking arm-in-arm with her, this policed appropriate "sexual" behavior as well. In each of these examples, not only were the critiques gendered, but each of the critics used notions of historical authenticity to give weight to their claims. Because as lead guides they had no real supervisory power, authenticity became a managerial tool to control coworkers whom they saw as their subordinates. Without real supervisory authority, their ability to lay out these "historical" critiques was their only "legitimate" claim to power.

As part of the triadic labor model, lead guides were intended to serve as "the eyes and the ears of management" as a way to create a culture of surveillance and, thus, accountability.[29] But taken a step too far, as Linda Fuller and Vicki Smith have argued, in interactive service work wherein employees need to feel the freedom to make their "own" choices about what kind of service is appropriate, a culture of surveillance could be experienced as "intrusive or overtly antagonistic," as certainly was the case for many interpreters that season.[30] Although we regular guides experienced it as such, I do not think that the lead guides were intending to be cruel or antagonistic. Rather, the tendency of some of the guides to criticize and micromanage could be read as a sign that these lead guides were operating under "normative control."

In his ethnographic study of an engineering wing of a company he calls "Tech," Gideon Kunda draws on Erving Goffman's notion of the self in order to describe the "organizational self"—the subjective meanings attributed to the self arising out of balancing acceptance and rejection of the organizational ideology and the member role it prescribes."[31] According to Kunda, organizations strive to control their workers' member roles through "normative control," which he describes as the organization's

> attempt to elicit and direct the required efforts of members by controlling the underlying experiences, thoughts, and feelings that guide their actions. Under normative control, members act in the best interest of the company not because they are physically coerced, nor purely from an instrumental concern with economic rewards and sanctions. It is not just their behaviors and activities that are specified, evaluated, and rewarded or punished. Rather, they are driven by internal commitment, strong identification with company goals, intrinsic satisfaction from work. . . . In short, under normative control it is the employee's self—that ineffable source of subjective experience—that is claimed in the name of the corporate interest.[32]

Under normative control, the hope is that workers will cheerfully toe the party line, largely because their sense of self is so wrapped up with the identity of the corporation. In the case of the lead guides at the fort, it is possible that they had so identified with their roles as the eyes and ears of management that they felt hyper-patrolling coworkers was not only warranted but was serving the best interests of the company—in this case, a living history museum, Historic Fort Snelling.[33]

Still, some have suggested that micromanagement can also signal insecurity and desperation on behalf of the micromanager. In Carol Hymowitz's *Wall Street Journal* editorial on micromanagement, top business executive David D'Alessandro, the former president of John Hancock's insurance division, offered his opinion that when bosses micromanage their employees, "it's a sign of insecurity."[34] Other business editorials focusing on micromanagers have drawn similar conclusions, such as Jared Sandberg's piece "Bosses Who Fiddle with Employees' Work Risk Ire, Low Morale." In the piece, one former CEO, Joe Esposito, commented that because "managers frequently have to serve the interests of constituencies that are unknown to their staff members" they might resort to micromanagement as "a response to outside pressures." Citing one specific example of a micromanager, Esposito said, "He was doing what he was doing in order to make it appear he had greater control than he had." Esposito added that what no one suspected was that in reality "he was feeling desperate himself."[35]

It is certainly possible that the lead guides at the fort were "trying to appear that they had greater control than what they had" because the extent to which they really had control was tenuous. As Brynn explained, "going from guide to lead guide, you enter a rather nebulous state. We are expected to plan and organize parts of the program, we are expected to do work assignments for people, we are expected to give input on people's evaluations, and yet we are not given any kind of supervisory title."[36] Lead guides may have micromanaged as a way to try and do something within the structure provided them while also maintaining a self-identity of being "in control" and more able than their fellows.

In the following, for example, note not only that Brynn, a lead guide, felt thwarted by the working conditions set up for the lead guides, but also that she conceived of herself as more knowledgeable than her coworkers:

> One of the anomalies of the lead guide position is about having the responsibility without having the authority because, what I see, you cannot do what is expected of a lead guide, as far as I'm concerned, to the very best that it can be done, within the current structure, unless you are willing to give time off the clock. It physically cannot be done properly be-

cause as lead guides we also have a responsibility to be out there in front of the public as much as the other guides and to spend that time with the public because we are some of the most knowledgeable and informed and broad as far as what we're capable of doing. The vast majority of the lead guides are qualified in anywhere from eight to all eleven areas of the fort; we may not always work in all of them, but we are qualified in them. So we are the ones; if there is nobody else there who can answer the question, one of us ought to be able to, and because of that we have to stay out in front of the public.

Like Brynn, Paul took the role of the lead guide seriously, even while he also felt that his ability to fulfill the requirements of the position was defeated by the structure of the position. Understaffed as the fort often was, lead guides found little opportunity to properly observe their coworkers, whom they were supposed to be evaluating for staff performance reviews. Addressing me in the interview, Paul said: "I literally did not hear you interpret until like the end of July or early August, and how was I supposed to get any sort of feedback for you if I had no idea who you were. [I might know you're] cooking down in the kitchen but [if] we're short on duty squad again, that means [I have] to sit around and mind the barracks while the guys take their breaks. When they had bigger staffs, it was not a problem."[37] Paul would have liked to have been able to observe his coworkers so that he could have given them better feedback, but because of the sex segregation of the work site, which prevented males and females from much contact during the work day, and because the fort was usually understaffed, often with only one person at any given station, lead guides often felt thwarted in their attempts to adequately contribute to their coworkers' evaluations.

Also like Brynn, who felt that lead guides represented "the most knowledgeable and informed" of the staff, it seems Paul took the role seriously because it was a symbol of achievement for him. Indeed, when I asked him if it was an easy transition going from guide to lead guide, he spoke with great pride about his achievements in his first year of working at the fort that led to his being offered a lead guide position for the following year: "I think it was natural, moving up, because I had done so well my first year. As a first-year person I had taken and passed five tests and would have been studying for a sixth which I had never gotten around to doing."[38] His belief that his superior performance as a first-year interpreter naturally led to his lead guide role suggests that Paul desired the position of lead guide to hold some esteem, a marker of achievement. Meanwhile, both on-the-clock and after-hours conversations among staff suggested that many

guides aligned with Craig's perspective of lead guides: for the most part the positions were not regarded "too seriously," so when some acted as though they had managerial authority, it only created dissension and fostered resentment among the interpretive staff.[39]

Management sometimes helped to undermine the significance of tests as markers of achievement. In some instances, for example, management asked individuals to play roles that they had not tested into, as was the case when management asked two new female staffers to play officers' wives for a short play that was to debut on Memorial Day weekend in 1999. As Alyssa recalled, this occurred during their first month of employment at the site. The rub was that one of the managers asked them to portray these roles before they had passed the House Basic Test, a test that was designated as the entrance exam for female staffers to portray officer's wives and to interpret "upper-class" characters in either the officers' quarters or the commanding officers' quarters. When management asked them to portray the parts of Mrs. Amelia Green (wife of a lieutenant) and Mrs. Abigail Snelling (wife of the commanding officer, Colonel Snelling) they ignored their own protocol regarding testing procedures, a breach which clearly upset three of the female lead guides on staff. Alyssa, who was asked to portray Mrs. Green, recalled that the lead guides "were really mad about the fact we were given these parts when we weren't even technically supposed to be given upper-class roles because we hadn't taken the test yet to be upper class and there was some talking behind backs going on. And we were just doing what we were told. Our management told us, 'You're to play these parts.' But then the other workers were like, 'Well, they're not qualified to play those parts. Why are they being given those parts?' There was also some kind of, what would you call it? Not sexism, but looks-ism—when they pick the pretty girls to be in the play."[40] Alyssa also recalled that most people on staff did not seem to care whether the two new interpreters played parts they had not tested into; however, two veteran female staff members in particular were quite vociferous in their objections, one of whom was accustomed to playing the role of Mrs. Snelling, a role that management had asked a newcomer to play. Playing Mrs. Snelling after one month on the job without having tested into the role seemed to be a personal affront to this veteran staffer, who was also a lead guide.

Notably, at this time in 1999, the role of Colonel Snelling was *not* interchangeable between staff members, and throughout the years management approved only the smallest handful of male interpreters to play him.[41] Thus, the lead guide who took an affront to the newcomer portraying Mrs. Snelling prior to properly qualifying to play the role perhaps did so with good reason; this infraction sug-

gested that the upper-class roles for women really demanded no great amount of expertise and were easily interchangeable with any woman on staff, regardless of experience. By contrast, specialized male roles such as Colonel Snelling, Doctor MacMahon, and the fort's sutler, Captain Leonard, were next to sacrosanct as only one or two male members of staff were ever permitted to portray them. This might help explain why some female lead guides reacted so strongly to management's breach of protocol; the transgression undermined the meaning of achievement at the living museum. If tests lost their authoritative power to differentiate the qualified staff from the unqualified staff—the *authentic* workers from the *inauthentic*—perhaps some female lead guides felt that their precarious positions would find a similar fate. This might also help explain why these same lead guides tended to micromanage their coworkers, using the weapon of authenticity to strengthen their own rocky sense of prestige within the fort's organizational hierarchy. While I hate to be a spoiler, at the end of "Pastoralia," the narrator turns Janet in.

Men and Muskets: Performing Masculinity for the Military Police

Although the lead guide dynamics did not function the same for both sexes, that is not to say that male staff members were not subjected to normative control; the male staff just experienced worker-on-worker surveillance a bit differently. As with the female lead guides, it was only a few who excessively scrutinized their coworkers. The "military police"—as I will call them—were those male staff members who very seriously took the charge of portraying the U.S. Army and who also set the tone for behavior in the men's locker room, a place free of management and female staff. Several of my male informants told me about how these members of the military police would sometimes yell at and other times simply make fun of those interpreters who either did not take the military aspects of interpretation as seriously as they did or did not physically do very well at following drill commands.

Jay, a former Fort Snelling employee, felt that whoever was assigned to play the sergeant on the drill squad "immediately became a lot more authoritarian" even after the change in management in 2006. In a particularly thoughtful appraisal of why this might be the case, Jay guessed that it could be attributed to "the way the leadership structure is set up at Fort Snelling." Borrowing "shamelessly from Freire" (his words),[42] Jay noted that at the fort "individuals don't really have a chance to participate authentically and bring themselves into the process

to create, so that when they are put into these positions of *power*—even though it is just an artificial role-playing power—that they abuse it in sort of an authoritarian way." Complementing my analysis of why female lead guides micromanaged their coworkers, Jay believed that those portraying sergeants "immediately became a lot more authoritarian . . . not necessarily because it's their intent to; I mean I think most probably don't realize that they're doing it. But it's just sort of the initial reaction that if you've never held power, if you've never held leadership, you tend to mimic those sort of authoritarian role models because that's all you know."[43] This exercise of power over others did not stop once military drill was over; indeed, when someone's "musket didn't go off" the military police would often mockingly bring this issue up in the men's locker room at the end of the day.

One male guide, Henry, recalled, "There was a lot of strife [in the locker room] between the people who took the military program so serious to the point of thinking that we were in the real army opposed to those who it's just a job and a pretend army."[44] Henry believed that the soldiers at Fort Snelling "would have been . . . the worst trained . . . in the army," so that portraying less than perfect soldiers was the most "authentic" way to portray the past. Those in the military police disagreed and felt it was most authentic to perform military maneuvers as they should have been performed. In either case, attacks on a guide's performance at military drill were often experienced as attacks on his modern-day self as a man and his "pride in [his] work." Thus, the claims about how a guide portrayed a soldier of the past spilled over into a judgment about his manliness in the present.

Locker room displays of manliness did not only manifest between men in arguments about the military drill. While female guides tended to collect hanks of yarns and checkered gingham cotton in their lockers, some male guides kept whiskey bottles and weapons in theirs. While the new management seemed to have nipped this practice in the bud in 2006, drinking in the men's locker room had long been a part of the culture at this living history museum. Henry recalled having seen a "whisky bottle cracked open at 9:20 in the morning and half of it consumed before we leave." He also was "amazed at the quantity of weapons that are actually in the men's locker room." As he described, there were "lots of muskets and various firearms and edged weapons and swords in their lockers. They'll need it for interpretation once, so they'll have it for that, but they never seem to take it home, and there almost seems to be . . . who can collect the most weapons over the year. I feel so unmanly. *I've* got a pocketknife and someone is pulling a ball and cap revolver out of his locker, [saying] 'Yeah, I could put four holes in you in two seconds with this,' and I'm like, 'Don't hurt me!'"

In terms of material culture, it was not just booze and muskets that were grounds for assessing a fellow interpreter's masculinity in the men's locker room. In the men's locker room, there was a bell that a few of them would ring from time to time if a particularly attractive female visitor had been seen touring the fort on any given day. As Jay recalled, "Men at the Fort were expected to ring a bell if they'd seen an attractive female visitor, and then they were expected to describe her and to describe sexual acts they would like to perform. Not necessarily like in a pornographic, *Hustler*-type way, but in a 'Would you do her?,' 'Yeah, I'd tap that!' stereotypical locker room chatter."

Based on my interviews as well as on conversations with male interpreters through-out the years, it is clear that many of the men were not entirely comfortable with locker room conversation or antics—ranging from the blackface minstrel routines that had been performed a few times to the ringing of the bell. However, also based on these conversations, it seems that most men either kept their objections silent or passively went along with it; as one coworker told me in conversation, "Well, I've never actually rung the bell myself."[45] Seeing as how this happened in a decisively masculine space, it is likely that to object too passionately would have been to negate one's claim to masculinity itself. Indeed, Jay felt that male interpreters who "were less socially popular would try and use the bell to relate to other coworkers" as a way to claim their space in the fraternity: "Like we've always had a number of kind of awkward folks and the bell and bell discussions were something of an equalizer of sorts because, theoretically, anyone could par-ticipate in the bell conversation."

It should not be overlooked that male interpreters in the men's locker room were generally portraying soldiers whom the site's training materials described as "'the scum of the population of the older states,' 'the sweepings of the cities,' 'the dissipated, idle or improvident,' 'the dregs of American society.' These expres-sions reflect the general truth that the dull, the lazy and the troublesome found the army an alternative to starvation or jail. Not all regulars deserved the repu-tation, but it had the effect of discouraging willing and able men from enlisting, thus reinforcing the stereotype."[46] It would seem that the "bawdy" humor and masculine bravado that Oliver and others described as the prevailing culture in the men's locker room may have been related to how some workers interpreted and absorbed the roles they had portrayed throughout the day. In a sense, acting in such a fashion may have been considered "authentic"—even though the lines were blurring between the past and the present.

Of note, the fort had two separate locker rooms for each gender—one for those playing working-class roles (the majority of the staff) and one for those playing middle- or upper-class roles (this is where the costumes and accoutre-

ment for those roles were kept). For females, these changing rooms were called "the women's locker room" (working-class roles) and "the ladies locker room" (middle- and upper-class roles); and for males, the rooms were referred to as "the men's locker room" (for those portraying soldier roles) and the "civilian locker room" (for those portraying non-soldier roles, including all civilian men and officer's roles). Of the latter, there were only one to three employees portraying those roles. Those workers who changed in the civilian locker room generally had no shared experiences with their coworkers, so that in that locker room—in the presence of just one or two coworkers—it would be unlikely and awkward to razz each other about their work performance during the day. Likewise, to paraphrase one of my former coworkers, in *that* context, it would seem weird to ring a bell and get all worked up about that "hot Russian woman who had on the short skirt and the tank top."[47] Several men confessed that they preferred to be in the civilian locker room. Oliver, for instance, eventually moved all of his gear over to the civilian locker room because he preferred the atmosphere there: "I find that a lot of the men who portray officers or gentlemen at the fort at least attempt to elevate the level of their conversation above what I would willfully enjoy if I was with the rest of the staff."[48] Jacob also said he preferred to be in the civilian locker room because he felt uncomfortable with some of the "good old boys'" views that a few of his coworkers felt free to express in the men's locker room.[49]

While changing in the civilian locker room provided Jacob with a certain distance from those good old boys, he was still not immune to the pressures of performing masculinity: "There have been a few occasions where I had to do something I didn't want to do. Like the time they wanted me to skin the muskrat [which] was not very fun. They already think I'm a wussy boy, the vegetarian; I'm just a little hippie kid. I didn't want to do it at the time, but looking at it from a historical standpoint, it was good that I had done it. I can say I've done it now and I know what it entails. It's not very much fun; it's smelly and bloody. [When they asked me to skin the muskrat] I was like, 'You guys know I'm a vegetarian, right?' And they're like, 'Yeah that's why we want you to do it, Jacob.'" When the military police made racist comments in the locker room or chastised interpreters for their lack of prowess in firing their muskets, interpreters would usually deflect these comments by enlisting the power of authenticity themselves. For example, they could claim that when interpreting a soldier it was authentic *not* to march well. Likewise, it certainly wasn't common practice in 1827 to ring a bell to declare the "hotness" of a woman on post.

But in the above-relayed muskrat-skinning incident—which was spawned by the military police—Jacob had no claims of authenticity with which he could

defend himself. This incident occurred on a day when Jacob had been assigned to portray a fur trader, and, in his words he, "couldn't exactly say, 'It's not authentic for fur traders to skin muskrats.'" In order to preserve his manhood in the face of the military police, on this occasion Jacob felt that he had to perform this masculinity ritual and reluctantly join the fraternal "muskrat-skinning club." Even so, in the interview Jacob took care to differentiate himself from the men who pressured him to do it, collectively calling them "weird" and comparing one to a "psycho." Of note, in this particular instance, one of the men who pressured Jacob to skin the muskrat was also a member of the management team—so that the performance of masculinity was encouraged from multiple directions in the triadic labor model.

Conclusion

Management at Historic Fort Snelling seldom monitored the performance of workers directly. Instead, management tried to elicit normative control from its workers in hopes that they would be internally motivated to do good work, while they also encouraged a culture of surveillance wherein coworkers monitored one another's behavior. While the surveillance performed by lead guides was institutionalized, the surveillance performed by the military police grew more organically out of the fort's militaristic and homosocial environment.

As in "Pastoralia," this culture of worker-on-worker surveillance made for a divided workforce, where workers often felt as though they had to justify their interpretive actions and personal decisions. Also as in "Pastoralia," at this work site, the notion of authenticity was enlisted as a major tool of control in two main respects; as customer service employees, workers were expected to be *genuinely* upbeat and interested in visitors while they also were expected to authentically portray the past. But because emotions and history itself are subjective, these are untenable and impossible expectations for workers to consistently satisfy. At any moment someone could claim that they did not *believe* an interpreter's performance—in any of the myriad ways that they were performing.

But above and beyond the use of authenticity as a tool of control were the uniquely gendered ways in which those tools were manipulated—as when I was faulted for my bare feet or when a soldier was yelled at for being out of step. But as this essay has shown, it was not just those public performances that were monitored. As a major organizational claim on the employee's self, how convincingly interpreters performed *gender*—historically or otherwise—was constantly under surveillance, both in and out of the locker rooms.

Notes

1. Julian Barnes, *England, England* (New York: Alfred A. Knopf, 1999); George Saunders, "Pastoralia," in his *Pastoralia: Stories* (New York: Riverhead Books, 2000); and Chuck Palahniuk, *Choke* (New York: Anchor Books, 2002).

2. Saunders, "Pastoralia," 2.

3. Ibid., 44.

4. Robin Leidner, *Fast Food, Fast Talk: Service Work and the Routinization of Everyday Life* (Berkeley: University of California Press, 1993).

5. The italics are in the original. Saunders, "Pastoralia," 49.

6. While Fort Snelling never entered into the larger historical consciousness of most of the American public, the fort did play a role in a few key historical events; for example, from 1847 to 1857 the enslaved man Dred Scott repeatedly sued for his freedom on the basis of having lived in free territory while at Fort Snelling, and in 1862 the U.S. Army imprisoned approximately 1,700 Dakota Indians just below the fort's walls as a response to what white settlers referred to as "the Dakota Uprising." By 1866, the fort headquartered the Department of Dakota, which oversaw all military activities in the state of Minnesota and the territories of Dakota and Montana. The Department of Dakota was dissolved in 1911. However, by the 1920s Fort Snelling (particularly its upper post, which began construction in 1879) was more widely recognized as the "Country Club of the Army." Although it was used both by the Military Intelligence Service Language School and as a recruiting, reception, and induction station during World War II, prior to the 1940s the fort earned local notoriety because it was home to a trick horse named Whiskey.

7. William J. O'Brien, "Notes for Presentation to Minnesota Planning Association," dated February 5, 1965, Folder: Fort Snelling Restoration Committee, 1964, 1965, Box 147.D.9.1, in Minnesota Historical Society Archives, St. Paul, Minnesota.

8. Mike Wallace, *Mickey Mouse History* (Philadelphia: Temple University Press, 1996), 199.

9. Ibid., 188.

10. This kind of historic re-branding was aided by the passage of three major preservation laws or federal acts in 1966: the National Historic Preservation Act of 1966, the Department of Transportation Act, and the Demonstrations Cities Act, which collectively buoyed preservation efforts by creating more checks before properties could be demolished (especially via highway construction or urban renewal) and by providing funding to survey areas that potentially had historic significance.

11. Stephen Eddy Snow, *Performing the Pilgrims: A Study of Ethnohistorical Role-Playing at Plimoth Plantation* (Jackson: University Press of Mississippi, 1993).

12. Kevin Walsh, *The Representation of the Past: Museums and Heritage in the Postmodern World* (New York: Routledge, 1992), 1.

13. Thomas J. Schlereth, "It Wasn't That Simple," *Museum News* 56 (January/February 1978): 36–41. For a more optimistic appraisal of living history museums, see Kate F. Stover,

"Is it REAL History Yet? An Update on Living History Museums," *Journal of American Culture* 12, no. 2 (Summer 1989): 13–17.

14. Schlereth, "It Wasn't That Simple," 36–41.

15. Scott Magelssen, *Living History Museums: Undoing History through Performance* (Maryland: Scarecrow Press, 2007), 2–3.

16. Ibid., 2.

17. Richard Handler and Eric Gable, *The New History in an Old Museum: Creating the Past at Colonial Williamsburg* (Durham and London: Duke University Press, 1997). Handler and Gable confess that by not being participant observers, they were barred from certain kinds of knowledge: "At Colonial Williamsburg, and at many other museums, on-stage versus backstage is more than a simple dichotomy due to the pervasive front-staging of backstage scenes during which visitors, assigned temporary VIP status for one reason or another, are taken behind the scenes to see how the museum 'really' works. Needless to say, these backstage scenes are themselves carefully staged, and the preparation and planning that go into them are not available to public scrutiny. As ethnographers, we gained some access to back stages from which most visitors are excluded; but even those back stages were prepared, we presume, in ways beyond our ken" (*The New History*, 11).

18. See Michael Buroway, Joseph A. Blum, Sheba George, Zsuzsa Gille, Teresa Gowan, Lynne Honey, Maren Klawiter, Steven H. Lopez, Sean O'Riain, and Mille Thayer, *Global Ethnography: Forces, Connections, and Imaginations in a Postmodern World* (Berkeley: University of California Press, 2000). Also see Michael Buroway, "Critical Sociology: A Dialogue between Two Sciences," *Symposia* 27, no. 1 (January 1998): 12–20.

19. I conducted five additional interviews in 2008. For this essay, I draw on one of these more recent interviews because the interviewee reflected specifically on the workplace culture that existed during my own tenure at the site (2001–2006).

20. In this essay, I do not refer to specific site managers or site technicians. Furthermore, to assist with anonymity, I conflate those with supervisory authority, referring to them collectively as "management." I do not group "lead guides" with management, although they served as the arm of management. Above the authority of the site management were a bevy of individuals who worked downtown in the Minnesota History Center in St. Paul. Generally, workers at Fort Snelling collectively referred to these individuals (who could range from the director of the Minnesota Historical Society to the director of Historic Sites) as "upper management," but they do not figure into this essay.

21. I use the term "interpreters" to refer both to guides *and* to lead guides.

22. The word "minimum" is significant here. Interpreters did receive merit increases for their hourly wages, and as such, there was a wide range among interpreters in terms of their hourly pay. While a lead guide *would* make more than the lowest paid guide, a lead guide could conceivably have a lower hourly wage than other regular guides.

23. As noted, the lead guide position was eliminated in 2004; it was replaced with two additional site technician positions; one was expressly charged with overseeing the

military aspect of interpretation, the other with overseeing the interpretation of women's roles. In 2006, the highest-ranking site technician resigned, as did the assistant site manager. The site manager was reassigned duties as a researcher for the Minnesota Historical Society. Starting fiscal year 2006–2007 in July, three "site technician" positions were renamed and revamped so that they would have supervisory authority.

24. Craig (pseud.), interview by author, St. Paul, MN, February 21, 2001, transcript. Interviews have been edited slightly for clarity.

25. Kathleen (pseud.), interview by author, St. Paul, MN, September 10, 2002, transcript.

26. Author's field notes, August 3, 2002.

27. Elizabeth is a pseudonym.

28. Carroll Smith-Rosenberg, "The Female World of Love and Ritual: Relations between Women in Nineteenth-Century America." *Signs* 1 (1975): 1–29, 27.

29. Borrowing from Kathleen (pseud.), interview by author, St. Paul, MN, September 10, 2002, transcript.

30. Linda Fuller and Vicki Smith, "Consumers' Reports: Management by Customers in a Changing Economy," in *Working in the Service Society,* ed. Cameron Lynne Macdonald and Carmen Sirianni (Philadelphia: Temple University Press, 1996), 74–91, 76.

31. See Erving Goffman, *The Goffman Reader,* ed. Charles Lemert and Ann Branaman (Oxford: Blackwell Publishing, 1997); Gideon Kunda, *Engineering Culture: Control and Commitment in a High-Tech Corporation* (Philadelphia: Temple University Press, 1992), 162.

32. Kunda, *Engineering Culture,* 11.

33. One might also claim that they were loyal to the Minnesota Historical Society, but given the legacy of antagonism between the fort and what many workers and management derisively referred to as "Downtown" (to suggest the difference between "us" and "them"), there seemed to be little allegiance to the society, per say, even among lead guides.

34. David D'Alessandro, quoted in Carol Hymowitz, "IN THE LEAD: The Confident Boss Doesn't Micromanage or Delegate Too Much," *Wall Street Journal* (Eastern edition), New York, March 11, 2003, B1.

35. Joe Esposito, quoted in Jared Sandberg, "Bosses Who Fiddle with Employees' Work Risk Ire, Low Morale," *Wall Street Journal* (Eastern edition), New York, April 25, 2006, B1.

36. Brynn (pseud.), interview by author, Minneapolis suburb, MN, February 13, 2003. This lack of supervisory authority, according to one longtime staff member, Gavin, occurred in the late 1980s to early 1990s when the lead guide position was formed out of what had previously been called "Level 3s." During this shift, the "Level 3s" became "lead guides," and, in the process, they, as Gavin said, "avoid[ed] any language in the job descriptions of these lead guides that would indicate that they were supervisors." Nonetheless, as Gavin noted, "they were still performing all kinds of work performed in other

situations like supervisors. They were writing out schedules for people. They were scheduling events. They were planning events like they still do. They were going around checking on people, helping them with breaks. They could not hire and fire. Let's face it, you and I know that [lead guides] work closely with [management]. . . . They plan special events and organize things and go shopping and lots of things; they're really on the management team." Gavin (pseud.), interview by author, Minneapolis, MN, September 5, 2002, transcript.

37. Paul (pseud.), interview by author, Minneapolis, MN, April 2001, transcript.

38. Ibid. First-year employees were only required to take one such of these tests, so that Paul's passing into five specialty areas in his first year can be viewed as exceptionally ambitious. That he named the passing of five tests as a marker of his achievement is testament to the seriousness with which he regarded that test taking.

39. Craig (pseud.), interview by author, St. Paul, MN, February 21, 2001, transcript.

40. Alyssa (pseud.), interview by author, Minneapolis, MN, February 19, 2001, transcript.

41. Reserving the colonel's role for one or two interpreters had been the custom at the fort at least since the 1980s, but with the overturn in management in 2006, this ceased to be the case.

42. See Paulo Freire, *Pedagogy of the Oppressed,* trans. Myra Bergman Ramos (New York: Continuum, 2000).

43. Jay (pseud.), interview by author, Chicago, IL, November 20, 2008, transcript.

44. Henry (pseud.), interview by author, Minneapolis, MN, September 25, 2002, transcript.

45. Male interpreter at Historic Fort Snelling, in conversation with the author, June 2006.

46. John Grossman, *Army Life in the Early 19th Century,* 1978, updated and revised by Thomas G. Shaw, 2004, Historic Fort Snelling Training Material, 10.

47. Male interpreter at Historic Fort Snelling, in conversation with the author, July 2, 2006.

48. Oliver (pseud.), interview by author, Minneapolis, MN, September 2002, transcript.

49. Jacob (pseud.), interview by author, Minneapolis, MN, March 2001, transcript.

History, Archive, Memory, and Performance

The Lewis and Clark Bicentennial Play as Cultural Commemoration

Richard L. Poole

The Lewis and Clark Voyage of Discovery was a defining moment for the fledgling United States. Two hundred years later, from 2004 through 2006, the bicentennial was marked by commemorative acts that included speeches, scholarly papers, articles, a multitude of commercial enterprises, and the creation of hundreds of different styles of performances. They comprised one-person shows, musicals, reader's theater, and full-length plays. I was involved in the creation and presentation of the latter two.

Sioux City, Iowa, my home, is also home to the final resting place of Sgt. Charles Floyd, the only fatality among the explorers who traveled with Meriwether Lewis and William Clark. He died near Sioux City, and his grave is marked by a one-hundred-foot-tall obelisk. The local Lewis and Clark bicentennial committee, drawn from interested citizens, chaired by the director of the city's public museum and historical association, commissioned me to write a play to be presented on August 20, 2006. On that day in 1804, Sergeant Floyd died and was buried in what is now Sioux City. I was chosen to create a production because I was a playwright, director, and professor of theater at a local university, Briar Cliff. Also I was, and am, passionately interested in the creation of history on the stage.

My commission confronted me with considerable historiographic and performative challenges, not the least of which being a segment of today's population that didn't consider the occasion especially worthy of "celebrating." I will be treating my approaches to this and other challenges in the following pages, having had four years to reflect on the entire process.

Creating history carries with it substantial burdens, among them the need to provide some truth, some authenticity, and some reality. But whose truth, whose authenticity, and whose reality gets created? As Eric Foner tells us in *Who Owns History: Rethinking the Past in a Changing World*,

> For years, historians have been aware that historical memory is unavoidably selective and that historical traditions [the journey of Lewis and Clark

in all its permutations] are "invented" and manipulated. Forgetting some aspects of the past is as much a part of historical understanding as remembering others. Selective readings of the past, often ritualized like veterans' reunions and publicly constructed monuments [the Sergeant Floyd obelisk and his "reburial" every year by a group of Lewis and Clark reenactors], help to give citizens a shared sense of national identity.[1]

Beyond the historical "realities" inherent in the Lewis and Clark journals (the essential source for all commemorations), I accepted the task of making at least a part of those journals come to life on a stage. I had to make those historical characters, and others who surrounded them, live, breathe, and create their own reality. In short, I had a play to write, a production to create, a performance to direct and design, actors to recruit and train, and an audience to entertain. I also had to raise the money to pay for it all. A challenge indeed!

To begin, the journals of Lewis and Clark were the major source for all the bicentennial activities wherever and whenever they occurred. The most recent edition, with the greatest number of annotations, considered the most authoritative, is the thirteen-volume set edited by Gary Moulton.[2] Earlier journal editions were those by Nicholas Biddle, Elliott Coues, and Rueben Gold Thwaites. Other informative journals included those by Corps of Discovery members Patrick Gass, Joseph Whitehouse, and John Ordway. The most important for my purposes was penned by Sgt. Charles Floyd. There may have been other members of the Corps of Discovery who penned journals, but they have not been found. "Jefferson had insisted on detail—and multiple records, Lewis and Clark, in turn, ordered the sergeants 'to keep a separate journal from day to day of all passing occurrences, and such other observations on the country &c. as shall appear to them worthy of notice.' Privates were apparently encouraged to do the same."[3] Other sources that I utilized were *Lewis and Clark among the Indians,* by James P. Rhonda; *The Letters of the Lewis and Clark Expedition with Related Documents, 1783–1854,* edited by Donald Jackson; *Undaunted Courage: Meriwether Lewis, Thomas Jefferson, and the Opening of the American West,* by Stephen E. Ambrose; and *Lewis and Clark: The Journey of the Corps of Discovery,* by Dayton Duncan and Ken Burns. Those who created performances of many kinds undoubtedly used these sources and probably others. Activities took place throughout the United States, especially along the route of the expedition. The National Park Service sponsored a competition titled Signature Events, where historic sites could vie for considerable monies that supported the development and creation of Lewis and Clark Interpretive Centers as well as performance-based activities. Eventually, fifteen signature events were created, supported by monies from other sources. Numerous other activities were created and sponsored by state and local bicentennial com-

missions, mine being one of them. One need only Google "Lewis and Clark Celebrations" to discover how many thousands of sites and activities occurred during the two-year bicentennial.

In addition to my source materials, several key theorists informed my understanding of history and how to consider its representation on the stage: Edward Said, Robert Berfhofer Jr., Philip J. Deloria, Freddie Rokem, Joseph Roach, Marvin Carlson, and Diana Taylor. From an overall perspective, Taylor's ideas provoked as much and perhaps more than any of the others; especially helpful was chapter 2 of *The Archive and the Repertoire*, "Acts of Transfer." In it she states that "performances function as vital acts of transfer, transmitting social knowledge, memory and a sense of identity." Performance has two levels or layers. One, it can be "the many practices and events . . . theatre [among them] . . . that involve theatrical, rehearsed or conventional/event-appropriate behavior. . . . On another level 'performance' also constitutes the methodological lens that enables scholars to analyze events as performance."[4] Both of these constructions were perfect for my play. I could analyze my play as play and as metaphor for the transference of culture, ascertaining both its entertainment value and cultural impact. As an occasion imbued with multilayered significance, the play could be analyzed on a practical and theoretical level. How could its performance values be realized as performance while at the same time transferring unspoken but clearly evident cultural implications?

Another idea that resonated substantially with me was Taylor's explanation of "Scenarios of Discovery." "Theatricality, for me, sustains a scenario, a paradigmatic set-up that relies on supposedly 'live' participants, structured around a schematic plot, with an intended (although adaptable) 'end.' "[5] And "Scenarios of Discovery . . . have reappeared constantly through the past five hundred years in the Americas."[6] While she is writing specifically about Spanish and Portuguese involvement in Latin America, clearly, scenarios of discovery can be applied to the entire Lewis and Clark journey as well as any performance about it. Colonial encounters as acts of discovery created Latin America as much as Lewis and Clark created the "American" West. In fact, Lewis, Clark, and the more than four dozen men who went with them called themselves "the Corps of Discovery."[7] Discovery in both hemispheres meant outsiders found land that belonged to indigenous people yet claimed it for themselves. The journeys always had similar scenarios and the voyagers were almost always white. Discovery, of course, meant internal as well as external. What did all those "explorers" find out about themselves as well as the people they encountered and the lands they appropriated?

Finally, Taylor spends considerable time dealing with the fascinating idea of the archive and the repertoire. The *archive* is written, stored knowledge, the *rep-*

ertoire is the "performed" knowledge. The "archive and the repertoire work to constitute and transmit social knowledge. The scenario places spectators within its frame, implicating us in its ethics and politics."[8] And she asks, "Whose memories 'disappear' if only archival knowledge is valorized and granted permanence. Should we simply expand our notion of archive to house the mnemonic and gestural practices and specialized knowledge transmitted live? On the contrary: as I have tried to establish here, there is an advantage to thinking about a 'repertoire' performed through dance, theatre . . . and many other forms of repeatable behaviors as something that can not be housed or contained in the archive."[9] I saw the archive as the journals themselves, and the repertoire as embodied performance(s), ephemeral, never repeatable or lasting but having the potential of significant impact, i.e., my play. Three other ideas sprang from this analysis. First, between the archive and the repertoire, between the repository and the performance, there are three liminal spaces. Within those thresholds creativity takes hold. The first is the threshold between the repertoire and the playwright, where fashioning the repertoire into a play takes place. The second liminal space occurs between the play's creation and the creation of performable acts; change being a constant during the entire process. The third threshold occurs between the performance and its reception by the audience. Keeping this in mind, I had to consider the following: How true, how authentic was the repertoire—the journals themselves? Taylor states that "theatricality strives for efficaciousness, not authenticity."[10] But does it really? Would the audience accept the theatrical performance they witnessed as an accurate portrayal of historical characters? Was I, as playwright and director, just bringing them to life? Would they have any "life" beyond what occurred on the stage? How accurate was the archive? Clearly, white colonial explorers created reality through the lens of their memories, as I, and the audience, created reality through ours. Or did any of this matter? Theories are fine, wonderful. They are intensely intellectually stimulating. Scholarship buzzed in my head. Still, I had a play to write and direct and an audience was coming and they were paying money. How would these ideas help me create this play, this performance? Was I under an ethical or moral obligation to present something that I hadn't yet considered or didn't yet know about? Or would this play, by virtue of its being performed, present itself as something else? During the moment of its performance would it become, could it become, more than just an entertainment. Would it become culture itself? I was writing about not only Lewis and Clark, but their contact with native peoples and, perhaps most important to Sioux Cityans, the death of Sgt. Charles Floyd. After all, my play was titled "A Young Man of Much Merit: Sgt. Charles Floyd and the Corps of Discovery." I needed to find other ideas that would connect with the three "themes" of my

play: the death of Floyd, the expedition's connection with native peoples, and the journey itself. The following theorists prompted my own "voyage of discovery." They became my "corps."

Edward Said's *Orientalism* reinforced my ideas about how Europeans created Indians, and how that creation imbued the fertile ground through which Lewis and Clark trod, literally and intellectuality. Philip Deloria, Robert Berkhofer Jr., and others provided insights and critical background on the treatment native peoples received at the hands of white playwrights, authors, and filmmakers. That treatment created, disseminated, and maintained a perverse cultural attitude that whites had, and still have, about Indians. In *Performing History,* Freddie Rokem provided penetrating insights about the nature of history and its performative creation on a stage. He used specific examples that directly connected with Taylor's archive and repertoire, shaping my approaches to the journals and, eventually, the play itself. Joseph Roach's *Cities of the Dead* got me thinking about how the Sergeant Floyd memorial (a one-hundred-foot obelisk overlooking Interstate 29, scale models of which are recreated every year as a city-wide fourth-grade history project) became a major creator and reinforcer of memory and culture. Finally, Marvin Carlson's *The Haunted Stage* conflated theater, memory, culture, and repetition, ideas that clarified my approach to the work, both in creating and directing the play.

As I stated earlier, there were multitudes of Lewis and Clark celebrations throughout the United States from 2004 to 2006. The creation of those celebrations had much to do with the dispositions of those creating them. In *A Guide to Visiting the Lands of Many Nations,* written by the Circle of Tribal Advisors, published by the National Park Service and the Bureau of Indian Affairs, there is a statement under the title "Celebration or Commemoration." It reads:

> While the 28-month long, 7,000 mile journey of the Lewis and Clark Expedition increased America's knowledge of the West and set the stage for expansion and migration that would soon follow, it was the beginning of irrevocable and devastating changes for Native People. Thus the Lewis and Clark bicentennial is not a celebration for American Indians. To us, the bicentennial is a time to commemorate the expedition's achievements, but more importantly, it is a time to honor and remember our ancestors and their contributions to the expedition's successes. It is an opportunity to examine events of the past 200 years and to plan for the well being of future generations.[11]

It is interesting to note that the first part of the title *(A Guide to Visiting the Lands of Many Nations)* is in type that is three times the size of the rest of the title *(and to the Lewis and Clark Bicentennial).* Further, the illustration on the cover

is of a Native American, Cecilia Bearchum, Waluulapam elder and language teacher, rather than the typical publicity images of Lewis and Clark themselves. The pamphlet then talks about native peoples, their current lands, their heritage, reminding non-native readers that "at the time of the Lewis and Clark Expedition, American Indian reservations did not exist," and even though sometimes native peoples have been placed on reservations far from their ancestral lands, "to this day tribes still consider their traditional territories to be their homelands." Non-native peoples are urged "to be aware that every landscape you experience continues to be an ancestral homeland."[12] This one pamphlet alone changed my title from celebration to commemoration. It also got me thinking about how native peoples had been and are characterized. Before getting more deeply into my play and its development, however, one last bit of exposition is necessary: a brief background on the expedition itself. It is essential to understand the impetus for the expedition's creation, its history, and consequences. As a military expedition, why was Lewis and Clark's mounted at all? Who was responsible; what impact did it have; how has it been remembered, commemorated, or commodified?

Without greed, failure, and desire, the expedition would never have taken place. In 1803, Napoleon sold a large chunk of what is now the United States to the nascent democracy for approximately $11.25 million. The territory encompassed St. Louis in the east to almost Santa Fe in the west, from New Orleans in the south to Lemhi Pass in present-day Idaho in the north. America more than doubled in size.[13] Of course, the buying and selling of territory by people who neither owned it nor lived there would have surprised the native people who did live there. Practically, these actions, on the part of both Napoleon and Jefferson, merely maintained a colonial tradition where white men sold aboriginal land they didn't own. Jefferson's purchase was not received in the existing United States with universal acclaim. He, however, saw it as a golden opportunity to increase the territorial integrity of the United States while simultaneously impeding French, Spanish, and especially English North American land claims. Additionally, he could achieve two long-sought goals: a water route to the East and the "civilizing" of the Indians.

Even before Congress approved the request for $2,500 to underwrite the expedition's costs, Jefferson had made plans. He was so confident of Congress' approval that he hired Meriwether Lewis, his personal secretary and sole aide since 1801, and had him trained by four scientists at the American Philosophical Society in "describing and preserving botanical specimens," "determining latitude and longitude," fossil identification, and medicine.[14] The military expedition initially numbered fifty-six, many of them soldiers, Clark's slave, York, and Lewis's dog, Seaman. Lewis was appointed the expedition's leader with the rank of captain.

The expedition was by many accounts an astounding feat of exploration, comparable to men landing on the moon. It was, however, successfully completed

only through the assistance of native people, especially Sacagawea, the Shoshone woman. The only white person to die on the expedition was Sgt. Charles Floyd, who may have had a ruptured appendix or a severe bacterial infection. He was buried on a hill in present-day Sioux City overlooking the Missouri River, with "the honors of war, much lamented."[15] On their return from the West Coast, Lewis and Clark visited the grave in 1806 and found the cedar-post grave marker still intact. By 1832, however, there was a noticeable lean to it, evidenced in the painting by the noted American artist George Catlin.[16] Erosion continued to be a constant problem. In 1857 a Missouri River spring flood "undermined Floyd's Bluff, sending part of the bluff tumbling into the water," possibly along with the grave marker and a number of Floyd's bones.[17] By 1895, several Sioux Cityans decided to rebury Floyd, but "there was one problem: the grave could not be found!"[18] Finally, some bones and a skull were discovered by digging a few inches below the surface. The remains were reburied in 1895 in two urns. By 1900, funds had been raised to erect a one-hundred-foot Egyptian-style obelisk. This obelisk, high on a hill overlooking what is now Interstate 29, is a constant reminder to the locals as well as those passing by that an important person is buried there. His deeds, in fact those of the entire expedition, are recounted in the plaque at the base of the obelisk, which reads, "This shape marks the burial place of Sgt. Charles Floyd. Graves of such men are pilgrim shrines, shrines to no class or creed confined. Erected A.D. 1900 by the Floyd Memorial Association, aided by the United States and the State of Iowa." The memory of Floyd's death, indeed, the memory of the entire expedition, is reinforced not only by the physical object itself (the obelisk) and the fourth-grade history project, but by a yearly reenactment of Floyd's burial by "authentically" costumed reenactors. Every year there is an encampment where men come together dressed in period costumes, impersonating those involved in the expedition. The burial ceremony takes place at the obelisk, further reinforcing local and personal value. Two ironies are glaringly apparent. Most of the reenactors are neither in the physical condition nor close to the age of the original members; and the obelisk, one hundred feet high, is a physically larger memorial than any other national monument for Lewis, Clark, or the expedition. Obelisks occur throughout the world. The most famous ones are Cleopatra's Needles, Egyptian steles appropriated for European use. Obelisks are primarily used to mark significant occasions or people, not just to commemorate the death of a rather obscure sergeant who died three months into a two-year tour of duty.

The Voyage of Discovery really began on May 14, 1804. Sergeant Floyd was only with the expedition for a few months. Why did his brief sojourn merit such memorialization, both in the nineteenth century and now? While the need for

Sioux Cityans to create a memory of importance, both locally and nationally, perhaps prompted the building of the obelisk and subsequent activities dealing with the expedition, the monument's erection had as much to do with boosting Sioux City's flagging economic fortunes as it had to do with reinforcing exciting memories or honoring a fallen soldier. And yet, its reality affected much more than its original creators could have imagined. It memorializes not only Floyd but the entire expedition. The obelisk garnered national importance in 1960 when it became the first National Historic Landmark designated by the National Park Service and the U.S. Department of the Interior. Continued reinforcement of the expedition and Sergeant Floyd's death occurs yearly during the teaching of fourth-grade history in the Sioux City public schools. Each year, students study Sioux City history and make models of famous Sioux City landmarks celebrating the past: the corn palaces, the elevated railroad, and the Floyd Monument among them. Models are then displayed and judged in a competition held every year at the Sioux City Public Museum and Historical Association. These officially sanctioned physical shrines, both large and small, memorialize Floyd and, by extension, the expedition itself. With the monument continually in the minds of local citizens, the groundwork had been laid for a grander celebration. The bicentennial fulfilled the need perfectly.

Early in the twenty-first century, meetings were held throughout the country to begin the celebratory process, which would officially begin in 2004, the bicentennial of Lewis and Clark's expedition. There had been other commemorative events noting the expedition as far east as Jefferson's home in Monticello; the national capital, Washington, D.C.; and the American Philosophical Society in Philadelphia. But the commencement from St. Louis in the spring of 1804 really marked the event's beginning.

While multiple locations participated in the bicentennial, all approached it from their own perspective. Many saw it as the perfect way to "cash in." Along with the nationally funded signature events and local activities, scores of so-called collectables were produced, including coins, busts, bookmarks, paintings, prints, and other art objects, even miniature Newfoundland dogs made in China. Seaman, Lewis's Newfoundland dog, was an essential member of the expedition, so, of course, he too was included as a saleable item. Joining the production frenzy were a host of other gimcracks, knickknacks, and doodads as well as a plethora of comestibles, including such fare as buffalo jerky and specially created chocolate candies. Clearly, the commemoration, celebration, or event recognition was a marketing executive's dream.

Some of the local events were plays and musicals. A number of them were performed along the trail, from Iowa to Idaho. Even Pulitzer prize–winning play-

wright Robert Schenkkan used the expedition to create a piece entitled *Lewis and Clark Reach the Euphrates:*

> Mr. Schenkkan eventually created a river play, billed as "Huck Finn" meets "The Heart of Darkness," only this river crosses the boundaries of space and time to suggest that Lewis and Clark's Journey was America's first step toward imperialism. By having the explorers bring commercial colonialism to Native Americans and stumble into Cuba in 1898, the Philippines in 1901, Vietnam in 1968 and on to Iraq, he locates the roots of contemporary foreign policy in the doctrine of Manifest Destiny and the "Empire of Liberty" envisioned by Jefferson. In the process, Mr. Schenkkan suggests that America is doomed to repeat its history.[19]

The play I created was much more straightforward and not as intentionally politically framed. After doing the basic research and reflecting on history-as-performance, I decided for eminently practical reasons that the show had to have a recognizable, snappy title taken from the journals. After all, the play dealt primarily with Floyd, and the audience would be primarily Sioux Cityans who knew about the Floyd monument, the history project, Floyd Boulevard, and other Sioux City locations and businesses bearing the Floyd name. Plus, the show was advertised as being taken directly from the journals. It came down to marketing. That is why I titled the show *A Young Man of Much Merit: Sgt. Charles Floyd and the Corps of Discovery.* "A man of much merit" was how Floyd was referred to by Lewis.

Originally, as the lights dimmed and prior to any action taking place on a unit set, there were to be a series of rear projections, from stage right to stage left, featuring eighteenth-century maps showing sections of the United States. The first set of images was to illustrate the route of the expedition, starting at the Falls of the Ohio, from Pittsburgh to St. Louis, up the Missouri to the Mandan Village in North Dakota, where the expedition wintered in 1804–1805, through the Rocky Mountains to the Pacific Coast. Next there was to be an enlarged view of a map of the Sioux City area through which the expedition passed, followed by a third image portraying area flora and fauna that was seen by the explorers. Finally, the actors portraying the characters of Floyd, Lewis, Clark, some of the Corps of Discovery, and several Native Americans, including Sacagawea, were to appear on the unit set in a series of *tableaux vivants.* Simultaneously, a present-day image of the Sergeant Floyd obelisk would appear behind them. The actors would then leave the stage to the strains of period music, the obelisk slide would remain, and elementary school student voices would be heard from offstage.

For a variety of reasons, the only image visible at the show's opening was a current view of the Floyd Monument. Then rushing in from offstage right was a Sioux City fourth-grade class with their teacher. They were taking a field trip to the monument and responded to teacher queries about the monument and what it meant to them, to the city, and to the entire country. During the questioning period, Jefferson, Floyd, Lewis, Clark, York, Native Americans, and French and British trappers appeared on stage and the students were able to interact with them. The characters answered typical fourth-grade student questions in the manner of the historical character they represented. The questions and answers, expanded in the play's two acts and eleven scenes, reflected the production concept and were responsible for the play's development. Much of the dialogue was adapted from actual correspondence written by Jefferson, Lewis and Clark, and Sergeants Ordway and Floyd, as well as other historical figures of the period.

Many of the scenes were pure invention on my part. A few will stand as examples. Two focused on Sergeant Floyd, his family, and personal life. The other focused on powerful native chiefs as they discussed the impact of the coming of the white men. The first example has Floyd and his mother in Kentucky and makes it clear that he wanted a life of adventure. Such a life could only be provided by the army.

(Location: Clarksville, Indiana Territory)
MOTHER. Charlie, what ya doing out there?
FLOYD. Just lookin', Ma.
MOTHER. Lookin' at what son? Come on in. Time for supper.
FLOYD. Ma?
MOTHER. Yes, son?
FLOYD. Ever get an urge?
MOTHER. An urge? Whatever you talking about? Come in and sit yourself
 down. It's gonna get cold.
FLOYD. Yeah, just an urge to, oh, I don't know. To get up and go.
MOTHER. Go? Go where?
FLOYD. Oh, I don't know. There.
MOTHER. There?
FLOYD. Yeah, there. *(He points.)* There. Out there.
MOTHER. There ain't nothin' out there. I swear boy, ain't you got enough to do
 without thinking about THERE!
FLOYD. I know, Ma.
MOTHER. Goodness sakes. You're a nice boy, Charlie, you truly are. But you

just got yourself appointed constable of the new township here. Ain't that enough? And what about your "friend" Maggie?

FLOYD. That's all we are, Ma—friends. And don't go makin' more of it than it is.

MOTHER. I swear boy, I don't know what you want.

FLOYD. I don't know, Ma. Maybe I'll go in the army.

OTHER. The army. The army? What in heaven's sake for?

FLOYD. I don't know, Ma. I don't know. I just want to do something with my life. Dad had the station, built the fort, had excitement. . . .

MOTHER. I think being a constable will bring you plenty of excitement. Lots more people comin' in every day now, lots more trouble. Did you get enough to eat? Seems like you never eat enough anymore, son. You always usta eat real good.

FLOYD. Ma, I'm fine.

MOTHER. Was the food OK?

FLOYD. The food was great, Ma, jus' great. I think I'm just going to sit out for a while.

MOTHER. You go ahead and sit and think son. You go ahead and sit and think. I surely hope you know how much you really do have. *(Exits.)*

FLOYD, *to himself.* I know it's out there. Somethin's out there. And I want to be there. *(Louder, so his mom can hear.)* I want to see it.

MOTHER, *from off stage.* See what Charlie?

FLOYD. The west, the west, Ma.

MOTHER, *still from off-stage.* What say Charlie? It's getting dark. You otta come in soon. Gettin' chilly.

FLOYD. Yeah, Ma. I'll be in soon. *(To himself)* I wonder what its like? The west, the west.

Clearly, the scene reflects Taylor's scenarios of discovery, revealing an internal desire realized as an external journey, a journey filled with struggle, power, and conquest. A journey that gave greater meaning to life, but one that was more than mere travel or self-fulfillment: it was a quest, one that some of us may have been able to construct at some point in our lives. If the actual journey didn't occur, at the least the idea remained in our minds.

The next scene was between Floyd's mother and his girlfriend, Maggie. They had a feeling of foreboding about Floyd, but they couldn't identify why they felt as they did. The scene comes shortly before Floyd's illness finally kills him. This scene begins directly after Floyd, desperately sick and dying, murmurs Clark's final words of comfort to him about his burial.

CLARK. We'll bury you on a hill across the river, with all the honors of war.

FLOYD, *faintly.* With all the honors of war. *(Sounds of men assembling for the burial ceremony.)*

(Mother and Maggie, seated at table drinking tea.)

MOTHER. I haven't heard from him in quite a while.

MAGGIE. Oh, I'm sure he's fine, galavanting around out there, doing just what he always wanted to do, adventure and all.

MOTHER, *standing up.* Something's happened.

MAGGIE. How do you know? You don't know. You just haven't heard from him in a long time and you're worried.

MOTHER, *looking off.* Something's happened.

There is no evidence that Floyd had any girlfriend, let alone anybody named Maggie, but it made sense to me that he could have had two women in his life who meant a great deal to him. The scene with the women gives his death an increased poignancy by highlighting the fact that he died so far from two who loved him and whom he also loved. Of course, history is filled with reports of people having premonitions about the impending death of those they love. The dramatization of that idea added tension and interest to the women's scenes. Further, the visual, unstated actions, gestures, and facial expressions, combined with the musicality of the voices, produced a multitude of meanings. Those meanings were impossible to capture, either in the archive or the repertoire. They could only be felt ephemerally during the performance and audience members experienced meaning through their own lenses and felt emotion through their own hearts.

Floyd's death scene, however, has been described in the journals. We know that he asked to have a letter written. But we don't know to whom. We know that York, Clark's slave, assisted in trying to comfort Floyd in the last moments, but we don't know exactly what was said, what York did, or how. I reasoned that a young man, dying far from home, and knowing he was dying, would write a letter to his mom, so that's what I had him do. I also reasoned that York would try to cool his probably fevered brow with a water-soaked cloth, so that's what I had him do. The setting for Floyd's death was historically accurate, but the dialogue and character responses for both Floyd's death and the women's scene were imaginatively created.

Dialogue that was more problematic occurred in the scene between two native chiefs who did meet and talk with Lewis and Clark—Little Thief (the Oto chief) and Big Horse (the Missouri chief). There is no record of their conversation. I created all of it. They might have met and talked during an encampment

by the Missouri River, but there's no absolute confirmation of this. Originally, the scene was to have been translated into the Oto tongue, with simultaneous English translation running across the top of the proscenium arch.

LITTLE THIEF. Where the sun rises, more are coming.

BIG HORSE. Yes.

LITTLE THIEF. Many more.

BIG HORSE. What will they want?

LITTLE THIEF. What will they want? I saw it all in a vision.

BIG HORSE. I know. I, too, had a vision.

LITTLE THIEF. What did you see my brother?

BIG HORSE. I saw them, many of them. They took the animals, and the fish and the birds. They followed the sun. They came out of the sun and they passed through us and they took from us and they left us. And the animals and fish and birds they didn't take went with them.

LITTLE THIEF. Went with them?

BIG HORSE. Yes, went with them.

LITTLE THIEF. Do you trust the white men?

BIG HORSE. They want to be friends.

LITTLE THIEF. Do you trust them?

BIG HORSE. I do not trust the Omahas.

LITTLE THIEF. Do you trust the white men?

BIG HORSE. I think we can trade with them. I think we will have to trade with them. I think if we do not trade with them, they will find other ways of getting the animals, the fish, and the birds.

LITTLE THIEF. When will they be here?

BIG HORSE. Soon. Not tomorrow, but soon.

LITTLE THIEF. Meanwhile, what of the Omahas?

BIG HORSE. We will deal with the Omahas. I worry my brother. What was your vision?

LITTLE THIEF. I saw many buffalo. And then I was standing where they were and they were gone and the sky was bright and I was all alone in the big land. I was alone.

BIG HORSE. We should talk to the others. Maybe they have had a vision too.

LITTLE THIEF. Yes. We will talk with the others. Meanwhile, we must be careful and watch for the Omahas.

BIG HORSE. And for our other enemies.

LITTLE THIEF. Yes.

BIG HORSE. And we must watch the river.

LITTLE THIEF. Yes. We must watch the river and watch for the men, the white men who come with the sun.

All the dialogue was invented. I did not consult with any members of any tribe about whether or not this type of conversation could have occurred. Besides, how would they know? Native people had no written history. They had pictographs, such as winter counts, pictures marking significant events painted on tents or robes. According to Candace S. Green, "Some Lakota people refer to the many types of old drawings as forms of winter counts that recorded individual events rather than a sequence of years. Authors have similarly extended the term, using it as a metaphor for historical narratives regarding American Indians." The book she and Russell Thornton edited, *The Year the Stars Fell: Lakota Winter Counts at the Smithsonian,* contains hundreds of illustrations, but only one—"The Cloud Shield"—has markings (inverted American Flags) that meant "many people camped together and had many flags flying." The editors commented, "This may mark the time when the Lewis and Clark expedition came through Lakota Territory."[20] As for oral history, its veracity is always questionable, as it inevitably alters when it passes from one generation to the next. So, once again, I was on my own. Originally, I was going to have simultaneous translation in English as the dialogue would have been in the Oto language. The Missouri tribe is extinct, but I hoped I could find some Otoes to lend authenticity to the scene. This idea, among others, was changed due to circumstances concerning time, money, and effort. Still, as I read the script over, almost four years later, I am both chagrined and excited. Excited because I think the scene works—I know many native peoples were guarded in their enthusiasm for the coming of the white man. And I think the scene reflects that as well as foreshadows the eventual destruction of native peoples and their habitat by selfish, racist, single-minded pioneers. Chagrined because I can see this dialogue being spoken in a 1930s western by John Ford, starring John Wayne: especially when the native people call each other "my brother," talk to each other about "having visions" that foretell the future, and use the image of the sun as a way of describing the advent of the white people—"they followed the sun. They came out of the sun." Also problematic was verb construction—using no contractions but the entire verb form—"I do not trust the Omahas," as opposed to "I don't trust the Omahas." Did the dialogue create an aura of mystery, otherness, romance, or had I fallen prey to a typical white person's view of the noble romantic red man, so prevalent in the early part of the nineteenth century? At the time I felt sure that Indians would have talked that way. Upon reflection, I'm not so sure. I unconsciously created a typical white person's stereotype of the "old chief," a fa-

vorite common image, according to Vine Deloria, in movies and literature. Certainly, theater could also be added to that list. "The old chief . . . contains the classic posture of mysterious earth wisdom. He speaks primarily in aphorisms and rarely utters a word that is not wise and sentimental. He also is in favor of love and understanding . . . recognizes the futility of opposition to progress and sadly relates his wisdom in every movie scene where the younger men council for war."[21] While my chiefs never talked about war, they still had visions, and the implication is clear that conflict with the whites was inevitable and coming soon. Realistically, why should the chiefs have been concerned? Native peoples could easily have wiped out the expedition, if they had wanted to. There were more of them than expedition members. If they really were afraid, why not just kill all the white men and free the slave? My dialogue makes it appear that they were concerned about being destroyed and their lands being taken from them. Clearly, they had other choices and reasons for accepting the strangers. Did I create a dialogue that reflected stereotypical attitudes? Yes, clearly I did. Obviously, my creative imagination drew from my own mental archive. That was all I had to go on. There is no record of any meeting or conversation, so I had to create a history.

I did have to make considerable adjustments in the script for a variety of reasons, and the eventual performance reflected those changes. While I kept most of the script, the dramatis personae went from forty-nine to thirty-three, with many actors playing multiple parts and one cross-gender casting—that of Fairfong, the French trader and the man I had act as interpreter for Lewis and Clark. The real Fairfong was a man. In our performance, which was altered from a full-stage production to a reader's theater format, Fairfong was still a man but was obviously being played by a woman. It had nothing to do with any philosophy or theory of theater or casting. The reasons for the change, like the change from full-stage production to reader's theater, were purely practical. We didn't have enough men or rehearsal time. So we made do.

Exploring the impact of the play's construction four years after it was developed allowed me to reflect on those other theorists who, through their ideas about the conflation of history, theater, and performance, significantly affected my thinking.

Historical critic Hayden White opines that "historiographical consensus about any event of interest to a given society is very difficult to achieve, is always open to revision from another perspective, and never lasts forever. The relation between facts and events is always open to negotiation and reconceptualization, not because events change with time, but because we change our ways of conceptualizing them."[22] In that way he agrees with Foner and Rokem. Their ideas about

history apply to the veracity of the journals themselves. Lewis was Jefferson's aide. Clearly, he wanted, and was in a position, to please the president. When the expedition left the Mandan village, after the winter of 1804–1805, most of the *engagés* (French-speaking boatmen) and some members of the expedition returned to St. Louis on the keelboat. The rest of the expedition continued up the Missouri River. Along with the people who returned to St. Louis were a number of artifacts, samples of flora and fauna, and a letter penned by Lewis to his patron, Jefferson. Neither Lewis nor anyone else knew if they would ever return to the East. There was high probability that they would be killed or die of disease or hunger. Lewis may well have thought that this one letter might be the final record of their journey. Jefferson would read it. Probably it would have been published. What would people think? Was it true that from the Mandan village onward the entire remaining expedition "worked smoothly as one," or is that something Lewis felt both Jefferson and posterity would want to hear? We will never know. What we do know is that there is no such thing as objective history and that perspective is everything when attempting to explain or analyze. Dramatizing any history offers considerable challenges, among them many possible interpretations of history. Certainly, that was true for the creation of the Floyd Memorial.

Joseph Roach's *Cities of the Dead* contains insightful ideas that may explain Sioux City's considerable memorialization of Sergeant Floyd. Roach contends that "Cities of the dead [cemeteries] are primarily for the living. They exist not only as artifacts, but also as behaviors. They endure, in other words, as occasions for memory and invention."[23] The Sergeant Floyd Memorial obelisk standing high atop a hill in Sioux City, visible for miles along Interstate 29, is clearly a significant artifact for Floyd's city of the dead—a city of one. This "cemetery" remains fixed, even if for only a moment, in the memory of those who travel the interstate—a major north/south arterial. Not only are the monument and the plaque attached to it artifacts, but those artifacts encourage and reinforce behaviors within the Sioux City culture: the teaching of Sioux City history in the fourth grade, the building of mini-monuments by the youngsters on history day at the public museum, and the reenactment of Floyd's burial, a ritual where, as Roach suggests, "performers become caretakers of memory through many kinds of public action."[24] This monument to both the dead individual and the expedition in which he participated not only reinforces memories but instigates new ones yearly. Such physical artifacts reify culture, which Roach defines as the "social process of memory and forgetting."[25] This culture "may be carried out by a variety of performances, from stage plays to sacred events"—the production of a play and the reenactment of a burial.[26] Finally, the monument, that magnificent obelisk of public memory, more than any other artifact, including the

journals themselves, allowed Sioux Cityans to point with pride to the accomplishments of a long-dead but continually present adopted native son. Such an artifact also allowed me to create a Floyd and an expedition anew, where the inhabitants spoke words that may have been true. No one knows, however, what Floyd thought of York or any of the native peoples. Regardless of the truth (whatever that elusive thing may be), Roach contends that "performers become caretakers of memory through many kinds of public action."[27] Those public actions included the yearly reenactment of Floyd's burial, the fourth-grade project, and the play I wrote. Therefore, performers become not just caretakers of memory, but creators of memory and, hence, creators of culture. The sticking point becomes one of authenticity and truth. What does one actually remember and is it the truth or just a fiction? Diana Taylor's comments provoke consideration. Does any performance of Sergeant Floyd "enact a theory" of created culture, and does "performing in the public sphere" reinforce that culture, enabling it to be created anew, year after year, even if only in one's mind?[28] And what kind of history are those performances?

Freddie Rokem, in his thought-provoking book *Performing History,* offers penetrating insights into performing history. He contends that "collective identities, whether they are cultural/ethnic, national or transnational, grow from a sense of the past; the theatre very forcefully participates in the ongoing representations and debates about these pasts, sometimes contesting the hegemonic understanding of historical heritage on the basis of which these identities have been constructed, sometimes reinforcing them."[29]

The theater has a "restorative potential in trying to counteract the destructive forces of history. . . . What they have in common is that . . . historical figures and events from the past have been given a new 'life' through historical performances."[30] Rokem's contentions instigate numerous questions about truth, authenticity, and the reality of history itself. Certainly, we have collective identities, and, yes, the theater can promote debates about the past; but, really, how forcibly and with what impact does a history play affect the minds, emotions, and behavior of the audience—*once they leave the theater?* Who determines what truth we are actually dealing with—the playwright, the actors, the audience, historians? Absolutely, we deal with theatrical truth, as the truth of the theater is *its* truth; that is to say, whatever occurred was a theatrical performance no matter what other claims might be made for it. Still, no matter what types of claims are made for its impact, the performance is still a constructed occasion and no amount of theorizing is going to change that. Perspective is all.

Frederick Jackson Turner's *Frontier Thesis,* developed at the beginning of the twentieth century, claimed that American culture developed as the culture mi-

grated from East to West, conveniently ignoring all the native and Spanish cul-
tures that the Euro-Anglo culture rolled over. Did my play reinforce the white
American perspective about Floyd and the expedition, while ignoring the native
people's response? If so, was that wrong, racist, hegemonic? What really was the
native people's response, and could I possibly have discovered it? Outside of what
I had read, no native people had any input at all in the play; neither did they par-
ticipate as actors, nor did they view the play as audience. With the exception of
the statements about commemoration rather than celebration, which I adopted
from *A Guide to Visiting the Lands of Many Nations,* there were no other com-
mentaries initiated by native people. Should I have called the play a white per-
son's perspective on the Corps of Discovery and the death of Sergeant Floyd, or
was that assumed? Rokem is obvious when he says, "Not even the facts about the
past are completely 'pure' unambiguous; they can be contested on various levels,
in particular when seen from the gradually growing time-perspective from which
the notion of performing history operates."[31] Absolutely. Here his thoughts par-
allel White's and Foner's. So what is the purpose in performing history? Rokem
claims that "one of the aims of performances about history is to make it possible
for the spectators to see the past in a new or different way."[32] Of course, they
would. How could it be other? Every time something is performed, it is differ-
ent, the time is different, and the audience is different. And if spectators had no
knowledge of a specific history, what they saw would be the *only* perspective they
would receive. Or maybe performing history allows spectators to have their ideas
about the past remain unchallenged, unchanged, and reinforced, especially ideas
about native peoples.

In *Orientalism,* Edward Said maintains that "the Orient was almost a Euro-
pean invention, and had been since antiquity a place of romance, exotic beings,
haunting memories and landscapes, remarkable experiences." It was, for Euro-
peans, "one of [their] deepest and most recurring images of the Other."[33] With
a few word substitutions, the same could be said for white America's relation-
ship with the created image of those aboriginals mistakenly designated as Indi-
ans. Indeed, Robert Berkhofer Jr., in *The White Man's Indian,* states, "Since the
original inhabitants of the Western Hemisphere neither called themselves by a
single term, the idea and the image of the Indian must be a White conception."[34]
Said and Berkhofer understood that both the Orient and the Indians were crea-
tions of a conquering race, in both cases white Europeans. Further, Berkhofer
maintains that "Native Americans were and are real, but the *Indian* was a White
invention and still remains largely a White image if not stereotype."[35] I was the
white inheritor of a theatrical tradition (which subsequently found expression in
motion pictures and television) that treated Indians successively as noble, savage,

vanishing, or good. Undoubtedly, I inherited those prejudices and stereotypes. More important, did such attitudes find their way into my conception of Native Americans? I was, as I indicated earlier, very careful about the dialogue. While there were no grunts, "ughs," or other stereotypical white conceptions of Indian musicality as they spoke American English, was I truly attempting to dramatize what I thought they might sound like, or was my creative imagination (unconsciously) totally affected by stereotypes of memory? Being aware of the danger and offensiveness of the stereotype supported my careful attention to words and sounds, but was it enough? Costumes for all the characters consisted of pants, shirts, and skirts, basic shells with neutral colors. None of the actors who portrayed native people *redded-up*—the ultimate insult. Was my awareness sufficient to affect the care with which I created nonwhite parts—the two native people and York, Clark's slave, who was played by an African American? Memory affects behavior, but that behavior sometimes is controlled by intention.

Memory and its effects are thematically central in Marvin Carlson's *The Haunted Stage*. He believes that "the relationships between theatre and memory are deep and complex. . . . [O]ne might argue that every play is a memory play," and says, "All theatre, I will argue, is as a cultural activity deeply involved with memory and haunted by repetition."[36] Actors have played similar parts; plays have had similar themes. This ghostly background affects not only the creation and performance of the play but its reception by the audience. But is the performance a truthful reiteration, an authentic memory, or one simply created by the imagination of the artists and the perceptions of the audience? Who creates whose ghosts?

What I'm really struggling with (something I think happens to all theater people at one time or another) are fundamental questions: What effect does performance have, and how is that effect created? The key question, especially for purposes of this essay, is what makes history plays different? It is, I believe, a natural human inclination for an audience watching an avowed history play to ask itself, "Is this the way it *really happened?* Is this the way people *really behaved* back then?" And if the audience believes it is, how does that change the way the performance is absorbed? Is the audience's pleasure increased because people believe they are watching historical truth dramatized? Even if they don't believe they are watching historically accurate representations, doesn't the mere fact of having our minds, hearts, and imaginations engaged allow us to understand more about what it is to be human or what it was to be human under those particular circumstances? Equally important is the question of what responsibility we have to the past. In history productions, does the past come alive, or do we breathe a created life into the past? Anything can be created. Nothing can be re-created. The act of creation occurs at the moment of creation. There never is another moment *exactly* like it.

Finally, here is a last word about my play, theories of performance, and history. Did the play I wrote have any impact on that audience, beyond the fact that it was a play, informative, and (hopefully) entertaining? Audiences may have known just enough about Lewis and Clark to believe what they were seeing might be true, or true enough for what they were seeing. After all, it's only a play and not really history, right? I didn't believe then, and I don't now, that the audience thought about such questions at all. And why should they? This was simply an entertainment about something that happened a long time ago. Audiences were not in a position, nor did they have the desire, to analyze any of it. It didn't matter to them that the adjustments I had to make in the script (cutting down the number of characters) or the style (full stage to reader's theater) had nothing to do with a philosophy of history or a theory of performance but everything to do with how many people I had and how much time I had to mount the production. What may have mattered to them was that they were seeing past behaviors that may have occurred two miles from where they were sitting. If they were Sioux Cityans, it was a play about their past. Maybe they felt some ownership. I don't know. But because of this experience (including putting these thoughts on paper), I'll never be able to watch a play or movie or write a play where history, memory, and culture collide without wondering if it really happened that way, or if it really matters how it happened.

As far as theories go, they can be important, provocative, and mind altering. It goes without saying that considered reflection about what others have done is important. Theories can change how people think and what they subsequently do. For those of us who have been "in the trenches" for many years—acting, directing, designing, writing, producing—theories provide an essential perspective on what we did and what we might do next. And, for those of us who are intimately connected with the construction of performances, there always is a next. And about the nature of history? Well, in the end maybe Ralph Waldo Emerson is correct when he asserts that there is no history, only biography.[37] And that is also open to interpretation.

Notes

1. Eric Foner, *Who Owns History: Rethinking the Past in a Changing World* (New York: Hill and Wang, 2002), 201.

2. Gary E. Moulton, ed., *The Journals of Lewis and Clark Expedition,* 13 vols., (Lincoln: University of Nebraska Press and the American Philosophical Society, 1986).

3. Dayton Duncan and Ken Burns, *The Journey of the Corps of Discovery* (New York: Alfred A. Knopf, 1997), 10, 11.

4. Diana Taylor, *The Archive and the Repertoire: Performing Cultural Memory in the Americas* (Durham and London: Duke University Press, 2003), 2, 3.

5. Ibid., 13.

6. Ibid., 28.

7. Duncan and Burns, *The Journey of the Corps,* x.

8. Taylor, *The Archive and the Repertoire,* 33.

9. Ibid., 36.

10. Ibid., 13.

11. *A Guide to Visiting the Lands of Many Nations and to the Lewis and Clark Bicentennial* (National Council of the Lewis and Clark Bicentennial, Circle of Tribal Advisors, 2004), 2.

12. Ibid., 4.

13. George Brown Tindall, *America: A Narrative History* (New York: W. W. Norton and Company, 1984), 328–329.

14. Duncan and Burns, *The Journey of the Corps,* 10, 11.

15. Ibid., 31.

16. Ibid., 30.

17. Charles Floyd, *Exploring with Lewis and Clark: The 1804 Journal of Charles Floyd,* ed. James J. Holmberg (Norman: University of Oklahoma Press, 2004), 17.

18. Ibid., 19.

19. *New York Times,* Sunday ed., Arts and Leisure Section 2, January 8, 2006, 8.

20. Candace S. Green and Russell Thornton, eds., *The Year the Stars Fell: Lakota Winter Counts at the Smithsonian Institution* (Washington, DC: University of Nebraska Press, 2007), x, 142.

21. Gretchen M. Bataille and Charles P. Silet, *The Pretend Indians: Images of Native Americans in the Movies* (Ames: Iowa State University Press, 1980), xi.

22. Hayden White, "Response to Arthur Marwick," in *Journal of Contemporary History* 30 (1995): 239–240.

23. Joseph Roach, *Cities of the Dead* (New York: Columbia University Press, 1996), xi.

24. Ibid., 77.

25. Ibid., xi.

26. Ibid., xi.

27. Ibid., 77.

28. Taylor, *The Archive and the Repertoire,* 27.

29. Freddie Rokem, *Performing History: Theatrical Representations of the Past in Contemporary History* (Iowa City: University of Iowa Press, 2000), 3.

30. Ibid., 3.

31. Ibid., 9.

32. Ibid.

33. Edward W. Said, *Orientalism* (New York: Vintage Books, 1979), 1.

34. Robert F. Berkhofer Jr., *The White Man's Indian* (New York: Vintage Books, 1979), 3.

35. Ibid.

36. Marvin Carlson, *The Haunted Stage: The Theatre as Memory Machine* (Ann Arbor: University of Michigan Press, 2003), 2, 11.

37. Ralph Waldo Emerson, in Harold Bloom, *Jesus and Yahweh: The Names Divine* (New York: Riverhead Books, 2005), 42.

Defining Museum Theater at Conner Prairie

Aili McGill

In November of 2006 I was offered a unique opportunity. Dan Freas, the director of the Museum Experience Division at Conner Prairie, called me into his office and asked if I was interested in taking the position of museum theater specialist.[1] In the past, the term *museum theater* at Conner Prairie had meant the use of period theater—any scripts written before the year 1836—in our living history setting; however, Dan and others at Conner Prairie were interested in developing a new program that would formalize museum theater as an interpretive discipline separate from our other interpretive experiences. This initiative was part of the museum's latest endeavors to expand and improve guest experiences. The role of museum theater specialist charged me with creating and coordinating daily theatrical performances in the Quaker Meeting House in the 1886 Liberty Corner area.

Of course, I jumped at the opportunity. How could I not? I knew this position would give me the opportunity to put my understanding of guests' needs and interests to good use in creating this wonderful new facet of guest experience at Conner Prairie. More importantly, this project would also be an effort to systematically examine museum theater as an interpretive method distinct from first-person interpretation. The efforts undertaken in this first year of museum theater at Conner Prairie had the potential to set a standard that other history museums could follow, or at least reflect on, and I was deeply honored to be at the helm. I made it my goal to record each step of the process in order to share my experiences with practitioners considering ways to enact history. While I looked forward to the success that this project was likely to garner, I knew that embarking into the relatively uncharted territory of museum theater would be fraught with frustration, confusion, and challenges.

As I jumped into this exhilarating project, I worked out a pattern that shaped my approach for the entire year. I began by identifying my biggest challenges and roadblocks, developed a plan to address those problems, and readjusted after the next set of problems cropped up. This problem-solving cycle repeated itself four

times that year, and I designated each part of the cycle by the type of problems I had to address: identity, production, objectivity, and direction. I will examine each of these problems and its solutions after setting the scene at Conner Prairie. I will end with a look ahead, in the hopes that our trials, tribulations, and lessons learned will offer insight to others looking to create similar programs in museums all over the world.

Setting the Scene: Conner Prairie

Conner Prairie is an outdoor history museum (it recently began billing itself as an "interactive history park") north of Indianapolis in Fishers, Indiana. In the early 1800s, a white man named William Conner arrived in this area, which was peopled with Lenape Indians. He married into the tribe, took ownership of the land, and soon became an influential politician in Central Indiana.[2] Over the years, the property became a productive farm but eventually fell into disrepair. It was purchased and rehabilitated in the 1930s by Eli Lilly, the wealthy pharmaceutical entrepreneur, who used it as an experimental farm and opened it to the public as a historic site.[3] When Lilly ended farm operations, he entrusted Earlham College to operate the property as a museum.[4] Over the years, Conner Prairie grew into a significant attraction and began to employ approaches to first-person historical interpretation in the 1970s. Earlham's management of the property ended in 2006, when the museum became an independent organization. Currently, the entire museum is open to the public from the beginning of April through the end of October, with a few exhibits and programs available to guests from November through March. About 300,000 guests visit Conner Prairie every year: 50,000 schoolchildren, 100,000 visitors to the Symphony on the Prairie concert series, and 150,000 general admission guests. Our operating budget was just under $10 million in 2008.

These factors have led Conner Prairie to think of itself as a mid-sized museum. While we have far more resources than many historic sites in the country, we are still small compared to other living history museums, such as Williamsburg or Old Sturbridge Village, or other local museums, such as the Children's Museum of Indianapolis or the Indianapolis Museum of Art, all of which have larger operating budgets and higher visitation rates. While there are many other organizations in Indiana that interpret Indiana's past in various ways, Conner Prairie is the only one that uses a combination of first- and third-person interpretation to engage guests in a fully immersive, outdoor setting.[5]

Since the 1970s, the museum has featured guided tours of the Conner Homestead and self-guided tours through its outdoor fictional village, Prairietown. Prairietown offers a view of community life in 1836 through the application of first-

person interpretation, in which costumed interpreters portray characters with composite biographies based on detailed research into primary documents from the types of people living in Indiana in the 1830s. At the end of the twentieth century, museum leaders decided to expand on the relative success of the Prairietown model and, in 2001, began building new historic areas to employ a combination of both first- and third-person interpretation, including an 1816 Lenape Indian camp and trading post and a single-family farm set in 1886. In each first-person post, visitors were invited as voyeurs into village life—welcome to watch, but not necessarily invited to interact with the staff. The museum's leaders felt that this approach was following best practices observed by other living history organizations at the time, which put the highest emphasis on strict historical accuracy.

However, beginning in 2002, the museum began to branch out from its original interpretive model in an effort to attract a wider and more diverse audience. At a time when other history organizations were suffering from sharp declines in visitation and significant budget deficits, Conner Prairie decided to change the way it does business in order to find new and better ways to engage its guests. This shift in focus resulted in the Opening Doors Initiative, which has made the museum a global leader and allowed it to explore new modes of interpretation and innovative ways of engaging guests.[6] The Opening Doors Initiative began with two studies to explore the ways in which learning happened in the historic areas. These studies revealed compelling data that indicated that our old style of interpretation, in which guests were not encouraged to participate in discussions or activities with interpreters, did not promote as much learning as hoped.[7] Visitors were expected to soak up fact after fact as interpreters tossed them out in long, informal monologues, loosely constructed to emphasize historical themes, without the regular application of good theatrical technique. Interpreters had no means to coordinate to create flow or consistency among their monologues, so guests were forced to draw connections from interpretive posts without the help of staff.

After reflecting on this evidence, the leadership of the museum encouraged us to break out of this voyeuristic, information-heavy model and explore more guest-centered experiences. This approach put a much higher emphasis on participation and interaction as well as other elements necessary for family learning.[8] After employing these new strategies, we undertook another learning study that revealed that guests were both learning and enjoying more from their visits. They were staying longer at each post and, more importantly, were more comfortable discussing and analyzing their experiences with interpreters.[9] These results have led to a fervent dedication on the part of the museum's leadership to continue to offer a wide variety of family-friendly experiences to welcome a much broader range of guests than ever before. The Opening Doors Initiative helped to shape

Conner Prairie's mission: to "inspire curiosity and foster learning about Indiana's past by providing unique, individualized, and engaging experiences."

After working within the guidelines of the Opening Doors Initiative for a couple of years, more subtle nuances of the guest experience began to emerge, which directly led to the inception of the museum theater project. Experience Division director Dan Freas and others at Conner Prairie began to notice a trend in anecdotal accounts of the guest experience on our grounds: guests felt that the activities in each of the historic areas were a little too similar. Guests were asked to engage in conversation with interpreters and to regularly participate in hands-on activities. After participating at a number of posts, guests grew tired and needed a respite from physical interaction. While we knew from our Opening Doors research that guests appreciated active participation in their visit, we also suspected that we could and should offer alternative types of experiences to help overcome this form of museum fatigue.[10] Freas and others also worried that guests were not regularly engaging on emotional levels within the historic areas—their hands and brains may have been active, but we did not believe that their hearts were regularly connecting with the people of the past. Our goal was to see if museum theater could provide guests with a brief rest from the active participation that was required in so many areas of the grounds while giving them deeper emotional connections to the past. This meant that I had to work to create pieces that would internally engage a wide variety of guests and inspire creativity and foster learning while allowing them to sit back, relax, and just watch something entertaining.

At the start of the project, I faced many challenges and limitations as the museum theater specialist. I had only enough money to pay one actor to perform each day and no money for new props or sets. I had to figure out how to incorporate rehearsal time into a regular workday without disrupting or limiting the average guest's visit by denying them access to the Meeting House for any period of time. I would also have to find ways to justify any subject we presented in context with the Quaker Meeting House and the rest of the experiences in 1886 Liberty Corner to help unify each guest's overall experiences, a task that proved challenging in more ways than I ever expected; however, the greatest challenge facing me as I started developing the Museum Theater Initiative was how to create a distinct identity for museum theater at Conner Prairie.

Problem 1, Identity: What Is "Museum Theater" at Conner Prairie?

From the very beginning of the project in November, I was not sure of how to carve a legitimate and separate space for museum theater at Conner Prairie. I

knew from museum studies classes I took at Indiana University–Purdue University, Indianapolis (IUPUI), as well as the Museum Theater Workshop I had taken with Tessa Bridal at the Children's Museum of Indianapolis, that museum theater could be very widely or narrowly defined, depending on who was undertaking a project and where it was being produced. For example, Catherine Hughes points to ways in which theatrical techniques incorporated into live interpretation can elicit deeper emotional connection with the exhibition content and includes this broad application of techniques into her definition of museum theater.[11] Tessa Bridal, on the other hand, cites that the term *museum theater* has been applied to everything from mascots to Shakespeare staged inside an exhibit.[12] But she insists that we must use the term *museum theater* to specifically refer to those types of interpretation that include the portrayal of a character by professional actors in the form of a story.[13] From studying these and other sources, I also knew that the type of first-person interpretation we undertook on a daily basis at Conner Prairie would easily be considered museum theater in another museum setting— guests at Conner Prairie encounter staff who portray well-developed characters who wear elaborate costumes and who coordinate activities in carefully designed historical settings. Interpreters often create basic plotlines and rely on (although not always intentionally) improvisational techniques to drive their interactions with each other and guests. If this same approach were employed in a more traditional museum setting, where interpreters would be working in a less immersive environment, many of the interactions that occur daily at Conner Prairie could easily fit under the museum theater umbrella.

However, at Conner Prairie many members of the management and interpretive staff have been careful to point out that first-person interpretation is not theater. When I was hired, I was cautioned by managers not to think of myself as an actor, and veteran interpreters sometimes actively encouraged me to ignore my acting experience when trying to develop my interpretive approach. Occasionally, we would experiment with forms of period theater by presenting pieces of Shakespeare or other historical plays, but these instances were few and far between and were not always successful. The philosophy at the time seemed to be that these experiences should be, first and foremost, accurate reenactments of historical theater rather than examples of "good" theater. Scholars including Stacy Roth and Scott Magelssen have noted this propensity on the part of historical interpreters to shun the application of theatrical techniques in their studies of first-person interpretation.[14]

Many of the staff members feel that looking at historical interpretation from a theatrical perspective "cheapens" the experience. At a staff meeting I ran, one interpreter explained that some theatrical approaches applied at Conner Prairie

had boiled lofty historical concepts down to pat, trite sound bites.[15] According to this same staff member, some theatrically minded coworkers turned a historical lesson into a frivolous joke, meant only to get a laugh from guests, rather than cultivating a genuine, authentic immersion experience. This takes Roth's observation that some interpreters "blanch at any insinuation that they are acting" to a new level.[16] Instead of "acting" as if they are living in 1836, a few interpreters see themselves as literally living the past, keeping alive practices and perspectives that they fear would otherwise die out. The concepts of portrayal, characterization, or even interpretation have very little to do with their approach to their job. In realizing this, it became clear to me that I was facing two major challenges in carving out a space for museum theater: creating a distinct identity for museum theater as part of the guest experience and building ownership among the staff.

When it came to creating a distinct definition for museum theater as part of the guest experience, I knew that I would have to go beyond the regular definition of first-person interpretation or academic museum theater practices and find distinct characteristics to define theater experiences at Conner Prairie. It would not be enough to define museum theater as an experience where a staff member portrays a character for a set length of time, since that would not significantly distance theater programming from the first-person experiences. I would have to be creative about playing with audiences' abilities to suspend their disbelief and transcend the confines of time and space, even more than we already did on the grounds, where we signaled a change in setting only with wooden signs, changes in architecture, and the behavior of the staff. I knew it would be difficult to create a substantially different type of experience for guests with a single staff member in a historic building, but I also knew that my second challenge would give me a more immediate hurdle to clear.

My second challenge in creating a distinct identity for museum theater at Conner Prairie was the staff. Since Conner Prairie had a tradition of not actively seeking people with theatrical potential or experience, I knew that my staffing resources would be minimal. I also knew that my efforts would be met with skepticism from certain members of our interpretive staff. In most cases this skepticism would not pose a threat to my approach, but the program would be more successful with interest and support from my coworkers. Because the notion of "triteness" is subjective, I suspected that many of the legitimate approaches other sites have used in exploring museum theater would be met with a modicum of grim disapproval here. Puppetry, for example, was likely to leave a few key members of the frontline staff cold, even though it has both historic roots and whimsical opportunities for exploring folk tales or other magical aspects of the study of history. I could not imagine how many of our staff, who believe in the concrete

nature of facts and are deeply dedicated to disseminating those facts and see the accurate dissemination of those facts as their personal mission, would react to a "playback theater" approach, in which guests might change or add to historical events. Staff were becoming more comfortable involving guests as average, anonymous citizens who could not fundamentally change the course of the event in daily activities and events;[17] but few members of our staff had the improvisational skills necessary to guide groups of guests through Boal-type participatory theater experiences that would harness the lessons of history while meaningfully empowering guests to help determine the performance's outcome.[18] This much was clear: I would have to find evocative ways to introduce, advertise, and promote my museum theater approaches among the existing staff as I worked to find and employ talent from outside the existing organization.

There were other administrative odds and ends that would delineate my approach. I only had enough money to pay for one interpreter a day for the April through October operating season, and I was expected to fill that role myself at least two days a week. This meant that if I presented a piece with multiple characters, I would have to bank hours, either by giving up my own office hours to work on the grounds more often or by cleverly using volunteers. Because we already had too many programs that could only be done by a specific staff member, leading to crises when the trained interpreter was unavailable for an advertised program, I was asked to create programs that could be interchangeable and, as much as possible, not require a specific staff member to implement them.

The lack of money for props did not worry me too much, since I could request just about anything I needed from our collections department, with its large teaching collection of reproductions and originals, but I was worried about how to approach our setting. Throughout Conner Prairie there are beautiful, historically authentic and effective performance spaces, but for this first year of the program I was tied to the Quaker Meeting House, a large, simple building constructed in 2001 as an exact copy of an original Quaker structure in Indiana. I regularly witnessed guests misinterpret this building's purpose, mistaking it for everything from a school, to a town hall, to a place that made oatmeal.[19] It certainly did not appear to be a theater at first glance. To think that I would have to deal with this level of confusion among our guests even before I broached the subject of a museum theater performance was perplexing at best. Even those guests who were familiar with Quakers would most likely be confused by our choice to perform theater in a space normally reserved for quiet reflection and serious community action.

By December, I had a host of challenges to tackle: concretely define the goals of the museum theater program, elicit interest and enthusiasm from the existing staff, hire some adventurous actors, and find a way to make it all fit within an

unusual and challenging space by mid-April of the coming year. Still with all of these problems, I felt that there was a vast array of possibilities to pursue. With some clever machinations on my part, we could create new, emotional monologues and explore a few multiple-person performances over the course of the season. I was also confident that I could sneak in some fun experimentation with puppets and period theater performances, all in an effort to explore the many ways that theater might inspire guests.

Key leaders at Conner Prairie had a wide range of expectations for the program. Our CEO expected museum theater to bring some whimsy to the daily experience. The division director looked for all-around family fun, excitement, and emotional engagement. The division's deputy director said, "Do what you want, as long as it's factual and doesn't distort history,"[20] and if it happened to be good theater, that would be a plus. Luckily, I had a wide range of opportunities for tackling the challenges that lay before me.

Solutions: Create a Conceptual Framework for Museum Theater at Conner Prairie

Within the first month of my role as museum theater specialist, I drew advice and insight from academia and peers into my own vision statement for museum theater at Conner Prairie, which I gave to my peers at work as well as to interpretive staff and anyone else who voiced interest in the project.

Museum theater experiences at Conner Prairie will

- be *experimental, flexible, and creative;*
- offer guests an experience that is *unique* from any other type of experience they will encounter on the grounds;
- offer each guest a *passive respite* from the first- and third-person interpretation on the grounds (although characters in theater pieces may interact with and acknowledge the audience, guests will not be required to respond to or interact with actors in order for the show's content to progress; audience members will also have the opportunity to ask non-period questions to performers after performances);
- use a wide variety of *deep, strong emotions* derived from the play's content to entertain guests;
- explore *mission-related content* through *rehearsed, artful staging;*
- constantly seek new and creative ways to *use theatrical techniques, practices, and technology* to most effectively engage and entertain guests;
- be a *staging area for new experiences* at Conner Prairie through careful testing and evaluation of audience reactions to various types of content.

To achieve this vision, I planned to offer ten- to fifteen-minute single-character shows twice daily in the Quaker Meeting House and occasionally test other types of performances throughout the season. These single-character presentations, which were carefully written, interactive monologues, would focus on the characters' inner struggles as they reflected on their life experiences and would be organized around larger social themes, such as temperance, labor rights, and so on. I would try to write these monologues so that they could appeal to a wide range of guests and hopefully overcome some of the shortcomings of the monologue style, documented by the Opening Doors Initiative. I hoped that the actors would be able to engage the guests in reflective conversations before and after the pieces and promote greater learning and satisfaction. We performed at 1:30 and 3:30 p.m. on weekdays and 1:00 and 3:30 p.m. on weekends, to accommodate other daily and weekly programming and make the most of the typical patterns in guest traffic. I hoped that the actors who took on each monologue could shape and adapt them to their unique performance styles, although I also hoped that the pieces could be interchangeable to accommodate flexibility in staffing.

I was able to easily persuade managers in my division to help me hire people specifically for acting talent. This, of course, was a big departure from our former approaches to hiring, but incorporating a cold reading into our regular interview routine proved to be an effective and fun way to learn more about our job applicants. Once I found four actors that I thought would complement the existing staff, I began to develop projects that would best fit the skills and personalities of my newly organized seven-person staff. My staff included three interpreters with years of experience at Conner Prairie, a first-year volunteer who had recently retired from being a classroom teacher, and three newly hired interpreters in their twenties with acting experience.[21]

In most cases, the actors had a day of the week on which they usually performed, with occasional exceptions to this pattern to incorporate special events, holidays, vacations, and experimentation with other types of performances. Each day I put the title and description of that day's performance on the daily guest map. In theory, these pieces were interchangeable and would achieve the goal of flexible scheduling; however, as the shows became more distinct from one another, they were much more complicated to schedule and advertise.

My biggest regret from this stage of the project is that I did not have the luxury of front-end research. While I might have been able to find the resources to create focus groups or formative surveys, I did not have the time to implement them or enough experience to know what to ask. I had gained some familiarity with guest experience assessment as part of the Opening Doors team, but I was not able to develop a quick and effective way of testing ideas with guests. I did not have

any practical access to our normal demographic of guests in the winter, since we were closed for everything but a few special programs. Also, I felt a tremendous pressure to produce as much as I could in the off-season so that I could concentrate on implementation once the season got underway. Instead of gathering data from our guests as our Opening Doors philosophy would dictate, I decided that it was best to jump in, see what happened, and then adjust my plans throughout the season. While this approach created many challenges on its own, it drove me and my staff to consistently seek improvement.

With that, my plan was in order. Now all I had to do was implement it.

Problem 2: Production

By January, I was responsible for producing an entire season's worth of engaging daily performances from scratch. Even more daunting was the fact that I had about three months to create those performances. As soon as the regular season started, I would not have enough office time each week to effectively research content and create carefully polished scripts among my other duties overseeing staff and performing for guests. I knew that I had to clarify the most important outcomes and boundaries for these projects so that I could usher the scripts through as efficiently as possible.

I concentrated on six projects for the beginning of the season. Each monologue project was assigned to a specific actor, and several of the projects were identified for a specific reason related to mission or available resources. I will detail the writing process for these pieces in the next section, but for now, I think it is important to give an overview of each project:

"Labor of Love": This was a piece about the life of a young factory worker who had escaped the Haymarket Riot of 1886. This piece had already been entitled and described by one of my peers in a winter publication and was slated to coincide with the May anniversary of the riot.

"A Call to Action: The Suffragette": This piece was based on a preexisting program that was featured annually in our 1886 area but had never achieved the guest engagement that management had hoped for. It focused on a young woman fighting for the right to vote. Our thought was that a scripted piece would help interpreters achieve consistency with each performance.

"Assistant to Miracles: The Midwife": This piece was, again, based on preexisting programming, and I was set to be the principal actor. A mid-

wife character had been developed for programming at the Conner Home previously, and all of the research materials were archived in a thick binder. Included in this binder was a script for a performance made up of excerpts from nineteenth-century letters and accounts of the work of midwives that was originally written for four to six actors. I thought it made sense to restructure this existing program into our new museum theater format and believed this topic would attract a regular audience. While I was correct that many of our guests were interested in the topic, I would later have to face the fact that midwifery is not a subject that is comfortable to most family groups.

"Reformed": This piece was based on the account of Mason Long, a reformed alcoholic and famous member of the temperance movement in 1880s Indiana. I developed this piece upon the suggestion of our deputy director. Long's account is memorable and fraught with exciting action, and I hoped that it would be a perfect match for one of our existing interpreters.

"Deliver Us from Evil": This piece was also on the subject of temperance. I hoped that it would be the account of an aging member of the Women's Christian Temperance Union and be instilled with the same humor and fervor that I hoped would characterize some of the other pieces. Hoping to set a good precedent for future collaboration, I asked one of our volunteers (a professional writer) to write the piece.

"Teaching among the Delaware": This piece was based on the diaries of Elizabeth Morse, a missionary teacher working with Delaware Indian children (including some of William Conner's) in Kansas in the 1850s and 1860s. Morse's story is a fascinating study of the relationships between whites and Native Americans in the mid-nineteenth century, but I worried that with only one character to tell the story it would be too one-sided to effectively communicate the central conflict.

In addition to a short timeline for developing projects, I was also dealing with my relative inexperience. Although I had worked on script development during the Museum Theater Workshop at the Children's Museum of Indianapolis and had faith in my writing ability, I worried that working in isolation would cause all of my scripts to be too similar in tone and style. Also, I continued to fret over the lack of front-end evaluation information to rely on as I shaped our approach. I suspected that the safest approach would be to encourage other interested writers to help me produce the scripts in order to get a variety of voices and perspectives incorporated into the writing process.

Of course, writing was not my only production challenge. Once I had the scripts I needed, I had to strive to find consistency among the performances to

unify guest experiences and ease implementation. Each actor would memorize a monologue that was three to four pages long, and each actor approached this task with varying levels of dedication. My hope was that we would appeal to all audiences, but we started to notice, even in our rehearsals, that these pieces would not necessarily be child-friendly. Not only were the pieces long for kids,[22] but they were very conceptual and had almost no action. To illuminate the significance of each story, I felt a little discussion of the political and philosophical underpinnings of the time period was necessary, and we knew that these themes were likely to soar over the heads of elementary-aged children. Basically, these monologues were all "tell" and no "show." I was not able, in our first year, to work each of our original pieces around central action that was effective in capturing the attention of a diverse audience.

As we began rehearsing and performing these first pieces, I found that it was very difficult for us to strive for real theatrical artistry. Between the difficulty of memorizing long passages and my cramped schedule, we did not have a lot of room for rehearsals that focused on craftsmanship and dramatic skill. I coordinated rehearsal time in the mornings, before guests arrived at the site, which usually gave my actor and me about thirty minutes to work together. I started with my initial goals for the piece, watched the actor run through it, and then discussed my opinion after the performance. Rarely was I able to watch two consecutive run-throughs of a piece to be able to see the actor incorporate my direction or evolve their characterization.

I was still searching for the appropriate balance between interpreter autonomy and guidance from an artistic director or coordinator. Autonomy is the standard at Conner Prairie—most interpreters rarely have any supervision as they interact with guests, meaning that they are not accustomed to regular constructive feedback. Often, the presence of a supervisor made them feel threatened or scrutinized, rather than helping them feel someone was taking on the role of director and coordinating "the big picture." Even my team of actors had widely varying views on the importance of a director: In a conversation at the end of the season, one of my actors revealed that he had no respect for directors of plays because he didn't think that they had a significant impact on the outcome of a production.[23] I wanted museum theater actors to feel that they had freedom to explore their characters on their own, but I also did not want them to feel that they had to make all artistic decisions by themselves. I also wanted to be sure that we were achieving consistency in theatrical quality and the role of the audience among the disparate performances. It was a tough balance for me, and in the end, my personal comfort level with individual staff members was often the determining factor in the success of each piece.

I also often had a hard time getting out to watch the performances to see if

they were running the way I expected. My actors often appreciated my feedback and my help orienting guests to what was happening once the show had started. Of course, interaction with guests often caused me to be distracted from the whole performance. What's more, I found that I had an even harder time evaluating my own performances. I began the season performing as the midwife character in "Assistant to Miracles," and I, myself, needed an objective observer to determine the performance's efficacy with guests. Later in the season, I began a storytelling program, and although the audience seemed to consistently enjoy my style, I could have benefited from having another administrator comment on whether or not my approach was truly achieving the goals for museum theater at Conner Prairie.

Finally, one of our biggest production challenges turned out to be the building itself. Echoey, static, and blandly lit, the Meeting House had all the seating we could need, with almost none of the comfort. The building's tall, unadorned plaster walls allowed sound to carry well, but they also encouraged reverberations that would quickly muffle words and numb our audiences' ears. This echo phenomenon only got worse when air-conditioning was installed, although guests greatly appreciated the opportunity to sit and relax in the cool air. The layout of the building certainly helped to reinforce the concept that guests could take a passive audience role. The standard design of an 1880s Quaker meeting house includes a few rows of elder benches facing the rest of the congregation, behind what became the natural stage area. We often found that guests (schoolchildren, in particular) would rush to the seats at the very back of the building, behind the actor, which automatically set their visit up for failure: the actor would have to ask them to move before the piece began or suffer through a very uncomfortable session of theater-in-the-round. Finally, the interpreters in the rest of the 1886 area were constantly trying to make sense of how our presentations would fit into their first-person interpretations, since the Meeting House was an active part of their storyline. This relationship proved problematic whenever we wanted to explore anachronistic pieces set during the early 1800s or the Civil War.

By the beginning of May, one month into the season, we seemed to have a good start; however, with a collection of scripts, actors, and a working plan, I was staring down the barrel of a long and stress-filled season balancing production with employee supervision and implementation of daily guest experience. I was able to bank a few hours every month to allow staff to work on bits and pieces of projects outside of the normal workday, but I was very concerned that the lack of time would diminish the quality of our product.

What is more, our lack of clarity about what museum theater would be at Conner Prairie continued to impact our production capabilities. I began to no-

tice that my staff had a hard time dedicating themselves to certain projects. Not all of my team accepted my definitions of museum theater, and we were suffering from a tension between Conner Prairie's dedication to historical accuracy and the artistic license we needed to make good theater. I also felt caught in a tension between dramatic pieces, which could help us achieve our goal of deep emotional connection, and comedic pieces, which could help our guests to relax and rest while being entertained. This led to a long philosophical debate with a staff member about the purpose of theater and whether museum theater at Conner Prairie should simply entertain or if it was worthwhile to explore a character's emotional struggles. We were never able to reconcile our opinions, and that conflict was emblematic of the program's struggle for identity.

I had similar discussions with other staff about the difficulty of pleasing a broad spectrum of guests at any one time. Very early on we discovered that pieces we had developed with general audiences in mind were not a particularly good fit for school groups because they were often so rushed to make it through all of the historic areas that they were reluctant to stay for a fifteen- or twenty-minute performance. Although the actors quickly learned to tailor their performances to better fit each audience, we also found that some groups simply had mutually exclusive needs and interests. Families with young children seemed to need very different things from performances, such as quicker plot development and simpler themes, than adults visiting on their own. Students seemed to enjoy performances that we designed later in the season for families with young children, but their teachers did not find those shows as relevant as the more content-rich performances.

Because this was still a new process and approach for Conner Prairie, I had no experience to rely on to help staff navigate these dichotomies. Ultimately, I had to keep reassuring myself and my staff that we had to wait and see and that nothing would fail so miserably as to ruin the museum's reputation.

Solutions: Collaboration

Almost as soon as my promotion to museum theater specialist had become official, I began working with students and faculty at Indiana University–Purdue University, Indianapolis (IUPUI). The museum studies program at IUPUI offered a spring-semester course on museum theater, and I developed projects for groups of students to work on at the request of the professor, Dr. Elizabeth Wood. The class coincided perfectly with our season—the students spent January and February learning about and trying to define museum theater, and then they spent time in March and April working on their final class projects. These projects

would include producing scripts for four performances to be presented at Conner Prairie, some of which I described in the preceding section. The projects were "Labor of Love"; "The Suffragette"; "Lucky's Big Break," a puppet show about the types of animals that live at Conner Prairie; and "Civil Sisters," a one-act play about a family living in southern Indiana during Morgan's Raid in the Civil War.

This turned out to be a very useful learning process for me and the other students, and the end result was that Conner Prairie owned four nearly performable pieces. Dr. Wood was careful to negotiate a copyright statement that gave Conner Prairie full ownership of the final products but required that the museum acknowledge the students' work every time their projects were performed.[24] Conner Prairie also received two interns from the class who wished to assist with the further implementation of their projects. These projects, as well as efforts to get other staff to help me write scripts, were successful in getting a variety of voices and perspectives incorporated into museum theater projects, and the collaborations I undertook greatly improved the quality of our first productions.

The script-writing process was somewhat unique for each project, but I tended to rely on a mix of primary and secondary sources to create dialogue that would be comfortable for modern audiences yet still contain the essential cadence and content of the period. Once a draft of the script was completed, I would read it out loud or have other staff members read it to help me shape the order of content and action. For projects like "Labor of Love" and "Assistant to Miracles," I wanted to develop composite characters rather than trying to find primary documentation to create a script based on an actual person from Indiana. For these projects, I relied on many secondary historical sources that provided various perspectives on the topic. For example, for "Labor of Love" I recommended that the students skim books that included first-person accounts of the Haymarket riot along with academic analysis of the event. For "Assistant to Miracles," I sorted through the binder of research materials to get a sense of the mindset of midwives in the nineteenth century and highlighted the most evocative quotations from the four- to six-person script. Whenever possible, I incorporated direct quotes from primary sources in the characters' dialogue to help give the language a period feel and capture as much historical accuracy as possible; however, to help make these pieces comprehensible and compelling for modern audiences, we had to soften historic language with modern structures and phrasing and summarize events and perspectives in ways that were appropriate for the character. These three scripts evolved over the course of the season as we learned more about what was most effective for audiences.

This process of constantly testing and adapting the script has become our standard practice. The actors have learned to approach these single-character scripts

strategically and to group the ideas and imagery into parts that can be rearranged to best meet the needs of the specific audience members in front of them. For example, if Adam Bouse were performing "Labor of Love" for fourth-grade students, he might adapt his performance to focus more on how his experience affected his family, especially his children, rather than on the evolution of labor parties; however, if the audience contained more adults, he might talk less about his family and more about the evolution of his personal political philosophy.

In order to smoothly incorporate the IUPUI students' work, we started implementing museum theater projects in May instead of April. This also allowed our new actors to get a sense of how Conner Prairie worked before throwing them into a new approach to programming. The biggest benefit of this delayed release was that I had an extra month to polish the productions and test a few ideas and approaches with the school groups and families that attended in April. This delay helped to minimize the pressure I was feeling to perform immediately. It also taught me to take advantage of any downtime to take a second look at the new projects we planned to phase in over the rest of the season, including the puppet show and Civil War piece that the IUPUI students developed.

I quickly sought any opportunity to foster collaboration with members of my museum theater team. I relied on my staff to help me make decisions about how to successfully present performances from day to day and the semantics of daily implementation. My staff requested that we offer handbills for each piece. These handbills provided the name of the author(s) and a limited amount of background information and links or sources for further learning. Our hope was also that these bills would help add a sense of theatricality to the productions. Staff input also shaped the decision that each actor would spend most of the day in "blue shirt," our standard third-person uniform, and help orient guests to the site. The museum theater interpreter changed into costume in the basement of the Meeting House before every performance. Actors began their shows in third-person interpretation to help orient guests to the piece and then exited the Meeting House for a moment, returning in character for the start of the performance. After the piece, actors stepped out of character again to answer questions and help facilitate discussions. This format posed an interesting new paradigm at Conner Prairie that caused some staff to rejoice in the opportunity to have a reflective discussion with guests and caused other staff to worry that we were undermining our long-held rules for first-person interpretation. While my personal experience with this approach leads me to believe that guests appreciate the opportunity to engage with interpreters from a modern perspective, we will have to conduct more pointed evaluation to determine the effect this approach has on guests' experiences and learning.

As the season went on, I led forty-five-minute team meetings every two weeks before work to update my staff on the progress of each project. This also gave me time to collect feedback, collaboratively solve problems, and brainstorm. Of course, not all of my staff members came to each meeting, meaning that I never had the level of ownership from the entire staff that I really wanted; however, it was in these meetings that we developed ideas for some of the most successful projects of the 2007 season. For example, Adam Bouse proposed the idea of creating a circus performance in which guests had the opportunity to audition after witnessing a quick juggling exhibition performed by the ringmaster. This idea proved to be extremely popular with families, since it allowed some audience members to participate in various simple circus acts while others watched their antics. Once we began to flesh out this idea, we developed similar performances on different themes—1886 theater auditions, play party games (songs with simple dance moves),[25] and singing. I was even inspired to create a standard format for "Interactive Jack Tales," a storytelling program in which I relied on the audience for help with sound effects and even in choosing the plot.

I encouraged the staff to jump into each of our performances, knowing that their excitement and enthusiasm would carry the performances far. For example, none of my staff had formal experience with puppetry, but those who I asked to work on "Lucky's Big Break" seemed to greatly enjoy the process. In the end, this piece proved to be too technically complicated to be sustainable, but it led to other puppetry experiences, driven by the individual staff member's enthusiasm. Throughout the season, I found myself constantly trying to harness enthusiasm and optimism wherever I encountered it to help deliver short-term wins and drive long-term success.[26] By the end of the first season of museum theater, we had debuted twenty new museum theater experiences. In addition, my team had thought through ways to apply successful museum theater strategies to the first-person historic areas because we had a sense that something we were doing was working really well and would translate to the first-person immersive format. If only we could identify just what that "something" was.

Problem 3: Objectivity

Despite cementing a system for producing pieces quickly and collaboratively, it became evident that we did not have the proper perspective to judge our success. Although the Opening Doors Initiative was founded upon the importance of collecting and acting upon guest feedback, we were unable to collect much systematic data about museum theater and I had not been able to create a strategy to do so. Contributing to this situation was the loss of Conner Prairie's experienced

evaluator, whose expertise we had relied on during the Opening Doors project; we had no one who could regularly investigate guest experience. We were also unable to find an effective evaluative tool for other staff to implement—surveys, interviews, and other classic tools seemed inadequate to track museum theater's ability to meet Conner Prairie's mission.

The variety and frequency of the pieces we chose to perform also challenged our ability to systematically collect feedback. Each piece seemed to inspire unique reactions from our audiences, but with so many variables, including actors' differing personalities, the wide variety of themes, and the ever-changing makeup of our audiences, it was very difficult to draw direct connections between our programmatic choices and audience outcomes. I had given my staff a logbook in which they could record thoughts about performances and audience reactions after each performance. After a few weeks, I began to notice possible trends emerging. For example, two of my staff commented on the fact that while adults seemed mostly content with our approach to theater experiences, their children quickly grew impatient with the long, wordy passages. Similarly, we noticed that when we tried to please students, by presenting our talent-audition-type pieces, their teachers were not always satisfied with the content. We tried to make discussion or debate a regular feature of the single-character pieces, but this often seemed to erupt into noisy chaos rather than meaningful discussion, and some staff became reluctant to try it. Without the systematic collection of data, there was no way for us to make informed decisions that could shape future programs.

Perhaps the most frustrating part of my museum theater duties was that I did not know how best to evaluate my own performance as actress, writer, producer, boss, and manager. I had almost no direct oversight and, therefore, was not receiving regular constructive feedback. I suspected that my acting skill was still adequate to the task, but I had almost no ability to be objective. I knew that the rest of my staff were either too uncomfortable or too unpredictable to direct me in any of the programs we implemented, and even when I tried to capture my own performances on video, I felt that I was not quite seeing the whole picture.

Once we reached the middle of the season and several pieces were up and running, my challenge became identifying ways to measure our successes.

Solution: Defining Acceptable Outcomes and Promoting Personal Accountability

By July, my small group of actors was well engaged in the process of producing and performing museum theater pieces, and I began to see that the key to achieving objective consistency among the pieces was to help my actors clearly identify

our desired outcomes. I would remind them of our key goals: to give guests the opportunity to physically relax while offering them opportunities for entertaining emotional engagement. At team meetings, we often discussed the types of behaviors we were hoping to see from guests that might indicate both relaxation and emotional engagement. We openly discussed the strategies each interpreter relied on to tweak their performances to better meet the needs of each audience. I encouraged staff members to differentiate between their discomfort with a script or an approach and solid evidence they were receiving from guests. For example, one of my staff members was uncomfortable with the character development of Mason Long in our "Reformed" script; however, after his first performance, we discussed the audience's reaction, and that gave him greater confidence in the script's potential. As much as possible, I tried to empower the actors to objectively assess their performances to help them succeed and effectively report on the strengths and weaknesses of their museum theater pieces.

Staff empowerment was critical to the evaluative process because, try as I might, I was not able to be present for a majority of the museum theater performances. I saw each of the pieces at the beginning of the run and toward the middle and videotaped one performance of a majority of the museum theater pieces that we debuted. In these recordings, I made sure to include a few audience members in the frame to have some evidence of guest reactions. These efforts helped to fill the void of our evaluator in collecting some guest feedback, and although my achievements were far from systematic, they gave the whole staff concrete evidence to compare and discuss.

As a manager, I saw it as my duty to be constantly looking for any evidence of our successes or failures in living up to our definition of museum theater. I began to notice growing tensions among the goals of our Museum Theater Initiative. For example, the theater pieces that included the most direct and authentic historical content, such as period speeches, often received the least amount of interest or discussion from guests; modern audiences were not inclined to step into the shoes of historic audiences to listen to long, flowery prose. Also, our original single-character pieces, although moderately successful in evoking emotion from guests, were not always good theater. The very presentational style of each monologue meant that there was no fourth wall and the actor sometimes had to rely on an awkward relationship between audience and space. Each monologue had the potential to become very one-sided and blunt, since we had only one voice to express the issues at hand. And yet, each piece had to tell the audience the entire story even if the character would not necessarily know or agree with the larger picture, which often left the scripts feeling clunky and weighted down with awkward exposition.

The participatory pieces that we developed during the summer, including circus and theater auditions, relied a little too heavily upon active engagement from our guests. "Circus Auditions" and "Calling All Actors" (an interactive piece about 1880s theater auditions) were based rather solidly on historical research, but "Musical Ballyhoo" (an interactive performance in which the audience performed a song together) was not so authentic. These pieces didn't quite fit into the setting of the Meeting House—the boisterous, loud activities seemed to greatly contrast with the Quaker lifestyle represented by the building. "Play Party Games," briefly described above, was completely third person and thus did not quite fulfill my definition of theater. Similarly, our experimentation with storytelling in the Meeting House proved successful with guests but did not fulfill the traditional definition of theater.

Our larger productions proved to be compelling and full of potential, if challenging to produce efficiently. The "Civil Sisters" piece, written by IUPUI students, was very successful in evoking true emotion from the audience and illustrating life on the Civil War home front. However, the number of staff of various ages required by the script meant that we could not present it regularly. Of course, it was difficult to turn the interior of the Meeting House into a home setting, and even more difficult to create a backstage area for actors to utilize effectively. Finally, we created an 1880s medicine show piece for our large fall festival by translating 1880s newspaper advertisements into a silly demonstration of the restorative properties of a fictional type of tonic, which proved to be both entertaining and authentic; however, the script proved to be hard to memorize and rehearse. Our attempt to develop a puppet show was met with interest from guests, but it would need a great deal of editing and rehearsal to seem like a professional presentation. It was clear that if this was the direction we wanted to take museum theater pieces, we would have to reallocate funds and shift our approach.

Ultimately, the staff and I agreed that anything that struck a reasonable balance between entertainment and historical authenticity was a success. I recognized the actors' individual successes whenever possible, and I looked for ways to reinforce their attempts to objectively reflect on and evaluate our programming. I knew that their responsible ownership of the evaluation process would be crucial to ensuring the longevity of Conner Prairie's Museum Theater Initiative.

Problem 4: Direction

Once we had a working system for producing and evaluating museum theater pieces, my challenge became one of direction—how would we make decisions about the most effective approaches for engaging guests in years to come?

By November, after the end of Conner Prairie's regular operating season, I had a large body of experiences and anecdotal evidence to review. Although I informally reported on the progress of museum theater programming throughout the season, I felt it was important to have a year-end review with the division director and deputy director. Although there was no quantifiable evidence of guest responses to our programming, my supervisors thought that there was enough anecdotal evidence to suggest that museum theater had proven to be an effective way to engage guests and added much-needed variety to our menu of experiences.

At this year-end review, I talked about the tensions that emerged among our goals for theater programming. I discussed the frustration my staff and I felt in trying to make a single script serve multiple audiences and the difficulty of pleasing adults, young children, and school students all at the same time. I pointed out that sometimes good theater and good history conflict with one another—the dry facts of a story rarely make for an emotionally engaging performance, and a good performance does not always take accuracy into consideration. I also discussed the constraints of using the Meeting House as a theater and of having no budget for development of new productions. Over all, I pointed to the need to revisit our definition of museum theater—what it was meant to achieve for guests and how it was intended to augment the rest of their experience at Conner Prairie.

I proposed an expansion of our current boundaries for museum theater and presented many of the additional programming ideas that sprang out of team meetings and informal discussions over the course of the season. For example, we never had an opportunity to explore Playback Theater's method of engagement, and Adam Bouse had some creative strategies for applying the approach in a lighthearted and interactive way. We had a few ideas for revamping the single-person format and using it to explore stories of racial diversity and some creative ideas for applying a few key interpretive techniques to the first-person interpretive areas to improve the quality of some programs and coordinated experiences. After all, our flexible approach to museum theater had grown directly out of our experience with first-person interpretation, and it seemed logical that the relationship could and should flow in the opposite direction—we could stage well-coordinated, yet flexible vignettes in Prairietown or Liberty Corner to inspire curiosity among guests of all ages.

With this wide array of challenges and opportunities laid out before them, the director and deputy director had a hard time agreeing on how to proceed. Since the Opening Doors revolution, Conner Prairie has been dedicated to reaching as many people as possible in as many ways as possible. I was not particularly sur-

prised, then, when my supervisors had no definitive answers for me—only more questions. In the end, I had to do my best to wade through all the possibilities to set a course for year two.

Solutions: Simplify, Build, and Play

At the end of the season, I decided that the most important goal was to capitalize on the first year's successes and continue to remove as many barriers to success as we could. Our second-year plan included a conservative expansion of our definition of museum theater to include theatrically structured vignettes presented by theatrically gifted staff in our first-person areas and concentrated on taking the single-person performances to a higher level. Based on the institutional goals for the next year, Adam Bouse and I set the following course:

- Performance Times: We planned to standardize the times of performances for easy and consistent implementation (1:00 p.m. and 4:00 p.m. every day).
- "Town Hall Meetings": We would standardize the single-person topics for students in the spring and fall to fit one town hall meeting format to generate discussion or debate at the end of each speech. This approach could help overcome the one-sidedness of a monologue and engage students as well as be worthwhile for teachers. These performances could fit under a generic title that could be filled by any of the actors—each topic would be interchangeable in the format.
- "Talent Auditions": Similar to "Town Hall Meetings," we planned to advertise the talent audition performances, "Circus Audition" and "Calling All Actors," under one generic title during the peak family audience visitation times, including weekends and throughout the summer. We believed that these experiences were great for families, especially those with young children. We would also do more research to connect the audition activities with historical events and places in Indiana in 1886 and to help us create more performable content.
- "Indentured": We planned to create a new piece for one adult and two of our youth volunteer interpreters. "Indentured" would be a companion to the new programming goal for Liberty Corner, which would focus more on the experiences of hired hands on the 1886 farm, be more emotional and physically passive for guests than our audition pieces, and be highly relevant to the 1886 experience.
- "Orphan Train": Similar to "Indentured," this piece would feature our youth interpreters (ages ten to eighteen) in a more purely theatrical presentation. It would also build on content research conducted by youth interpreters.

- "Teaching among the Delaware": We planned to rewrite this program to include two characters—Elizabeth Morse and the parent of one of her students. We hoped that this would help the piece feel more theatrical and present a more balanced story that dug deeper into the historical significance of the topic.
- "Emancipation Proclamation": We would develop three new scripts that explored various opinions of the Emancipation Proclamation in Indiana in 1863. These pieces would build on the success of our Civil War program, help promote diversity within our experiences, and target adult audiences.
- Puppets: We decided to move the puppet stage into our new children's craft area so we could present very simplified puppet shows, or children could make up their own performances.

In addition to these ambitious projects, we planned to apply certain museum theater approaches to the Prairietown experience. We planned to develop a new tool for interpreters to rely on to guide them through loosely structured vignettes, such as a local election or a shopping experience in the Prairietown store. We called these tools "playbooks," like the tools used by sports teams to keep track of their strategies, upon the suggestion of one member of the interpretive staff. These playbooks would include program goals, a basic plotline, suggested dialogue and activities, and any research on the subject. We hoped that interpreters would improvise their way through the loose structure offered by the playbook to create fun, dynamic, and meaningful experiences for guests.

This process allowed us to examine the close relationship between museum theater and first-person interpretation. I knew that I was facing the possibility of blurring the lines between the two disciplines by trying to insert museum theater practices into Prairietown, but I also felt that emotional engagement, artful story development, and skilled character development and interaction were vital to a truly successful visit to Prairietown. Museum theater remains the technique that we rely on when trying to communicate a specific story on an emotional level, and this technique can be applied in any setting. First-person interpretation remains the technique that we rely on to physically immerse guests in the reality of a certain place and time to help them intellectually explore their understanding of history.

Summary

Only time will tell how successful Conner Prairie's approach to museum theater has been in creating successful guest experiences. I hope that this essay will add

to the acceptance of museum theater as a method of museum education and that my descriptions of the core conflicts I encountered during the first season of museum theater at Conner Prairie—seeking identity, producing consistently high-quality performances, gathering effective evaluation evidence, and setting a direction for the future—will be helpful to other practitioners in similar situations. I look forward to the opportunity Conner Prairie has to continue to examine and compare live interpretive techniques and to investigate the effects of those techniques on guest engagement and learning. Case studies like this one can hopefully help us coordinate our efforts and establish best practices that will set a responsible and useful tradition for future generations of museum educators.

Notes

1. Conner Prairie's Experience Division includes the education, interpretation, collections, and exhibit-design departments.

2. For more information about William Conner, see www.connerprairie.org/historyonline/cphistory.aspx (accessed October 15, 2008).

3. Ibid.

4. Ibid.

5. For more information about how Conner Prairie compares with other museums and history organizations, please browse the Reach Advisors Web site, http://reachadvisors.com/. The researchers at Reach Advisors have conducted many comparative studies of various museum settings, which can be found at their site.

6. Conner Prairie's "Opening Doors to Great Guest Experiences" DVD and CD-ROM resources, which detail the guest-centric approach that the museum adopted in 2002, have sold more than 1,200 copies. They have been sent to all fifty states and at least twelve countries and have become the backbone of training programs at historic sites, both large and small.

7. The first of three studies on the learning process at Conner Prairie can be found in *Listening in on Museum Conversations,* by Gaea Leinhardt and Karen Knutson (Walnut Creek, CA: AltaMira Press, 2004).

8. We based our concept of guest learning and guest-centered approaches on the work of John H. Falk and Lynn D. Dierking as described in their books *Lessons without Limits* (Walnut Creek, CA: AltaMira Press, 2002) and *Learning from Museums* (Walnut Creek, CA: AltaMira Press, 2000).

9. Results from our 2004 study on the effects of our guest-centered approach are still being analyzed by researchers at Ball State University under the direction of Dr. Mary Theresa Seig. Her results were published after the publication of this essay.

10. Benjamin Ives Gilman, "Museum Fatigue," *Scientific Monthly* 2, no. 1 (1916): 62–74; Gareth Davey "What Is Museum Fatigue?" *Visitor Studies Today* 8, no. 3 (2005): 17–21.

11. Catherine Hughes, *Museum Theater* (Portsmouth, NH: Heinemann, 1998).

12. Tessa Bridal, *Exploring Museum Theater* (New York: AltaMira, 2004), 6.

13. Ibid., 12.

14. Stacy Roth comments on this perspective in chapter 5 of her book *Past into Present* (Chapel Hill: University of North Carolina Press, 1998). I first encountered Scott Magelssen's observations at the Indiana Association of Historians conference in Bloomington, Indiana, in 2007, where he presented a paper on this subject (see Scott Magelssen, "'We're Not Actors': Historical Interpreters as Reluctant Edutainers," delivered paper, Indiana Association of Historians [IAH] Annual Conference, February 2007, Bloomington, Indiana; subsequently published in *Midwest Open Air Museums Magazine* 28, no. 2 [2007]: 22–26).

15. This comment was voiced at the Prairietown Team Meeting on July 24, 2008.

16. Roth, *Past into Present,* 50.

17. Scott Magelssen, "Making History in the Second Person: Post-touristic Considerations for Living Historical Interpretation," *Theatre Journal* 58 (2006): 304.

18. Augusto Boal, *Theater of the Oppressed* (New York: Theater Communications Group, 1979).

19. The Religious Society of Friends, or Quakers, is unfamiliar to many Americans, despite its significance to American history. The Meeting House is the equivalent of a church to other religious denominations and would be the spot in which the community of Quakers would gather to explore all community-related issues, from religion to politics and finance.

20. Tim Crumrin, personal communication with author, January 13, 2009.

21. I feel it is important to acknowledge Adam Bouse and Jill Whelan, specifically. Adam Bouse succeeded me as museum theater specialist and continued to refine our definition of museum theater. Jill Whelan later helped us successfully apply museum theater techniques to first-person interpretation in Prairietown.

22. Although the pieces were intended to be ten to fifteen minutes, when embellished with each actor's personal additions, some performances stretched to twenty and even thirty minutes.

23. Anonymous, personal communication with author, November 20, 2007.

24. The students who created projects for Conner Prairie were Amanda Alber, Merv Barenie, Stefanie Gerber Darr, Bethany Fales, Emily Diekemper Hansen, Kara Lewis, Jenny Mack, Rachel Matthews, Erin Monahan, Melissa Pederson, Gwendolen Raley, Beverly Roche, Ben Simmons, and Abby Urban.

25. This program was developed by Jill Whelan and later transformed into an effective activity for the first-person historic areas.

26. I adopted an appreciation for developing and celebrating short-term wins by reading John Kotter's book, *Leading Change* (Boston, MA: Harvard Business School Press, 1996).

Performing History as Memorialization

Thinking with . . . *And Jesus Moonwalks the Mississippi* and Brown University's Slavery and Justice Committee

Patricia Ybarra

This is an angry song, I never realized that before.
—Federico Rodríguez on Kanye West's "Jesus Walks," April 13, 2008

The rage that lingered just below the surface of the madness in the play was palpable. And it was that sense of rage that informed my choice to frame the event in an Afro-Punk aesthetic.
—Director Kym Moore on her staging of *Funnyhouse of a Negro*

Even for those blacks who did make it, questions of race, and racism, continue to define their worldview in fundamental ways. For the men and women of Reverend Wright's generation, the memories of humiliation and doubt and fear have not gone away; nor has the anger and the bitterness of those years. That anger may not get expressed in public, in front of white co-workers or white friends. But it does find voice in the barbershop or around the kitchen table. At times, that anger is exploited by politicians, to gin up votes along racial lines, or to make up for a politician's own failings.

And occasionally it finds voice in the church on Sunday morning, in the pulpit and in the pews. The fact that so many people are surprised to hear that anger in some of Reverend Wright's sermons simply reminds us of the old truism that the most segregated hour in American life occurs on Sunday morning. That anger is not always productive; indeed, all too often it distracts attention from solving real problems; it keeps us from squarely facing our own complicity in our condition, and prevents the African-American community from forging the alliances it needs to bring about real change. But the anger is real; it is powerful; and to simply wish it away, to condemn it without understanding its roots, only serves to widen the chasm of misunderstanding that exists between the races.
—Barack Obama, "Race in America," March 18, 2008

In this essay, I discuss the relationship between historiography, performance, and rage. Perhaps more controversially, I offer the possibility that newly acquired knowledge of racialized violence produces anger as often as closure and that such anger might be productive in its aversion to false reconciliation. And, that acknowledging and finding a place for this anger within histories of atrocity may be the most important thing that commemorations that use performance can do for historiography. In particular, I discuss how the anger and lack of closure created during the process of creating . . . *And Jesus Moonwalks the Mississippi*—a play about a Southern family struggling with the impact of slavery on their definition of family—work within the context of Brown University's larger initiative to come to terms with the university's involvement in the slave trade. While this production was not affiliated with the program, the play did enter conversations about slavery and justice that have remained a part of campus life since the 2004–2005 academic year when the official series of events took place. And, the process of creating the work exposed some of the ideological underpinnings of commemoration within the academic community. These explorations are enriched by thinking about *Jesus Moonwalks* alongside a series of seemingly unrelated but auspiciously timed events: Barack Obama's March 18, 2008, speech on race, the production of Adrienne Kennedy's *Funnyhouse of a Negro* (September 25–October 5, 2008), and the two-hundred-year anniversary of the end of the transatlantic slave trade commemorated at the October 4, 2008, Providence WaterFire celebration.

Brown University and the Slave Trade

The Slavery and Justice Committee had its own auspicious beginnings. In 2003, two years after Ruth Simmons became the first female president of Brown, and the first African American president of an Ivy League university, she created the Committee on Slavery and Justice to investigate Brown University's relationship to the slave trade. The first charge of the committee was to "examine the University's entanglement with slavery and the slave trade and to report [our] findings truthfully and openly."[1] Secondly, the committee was charged with "reflecting on the meaning of this history in the present, in terms of the moral, philosophical and ethical questions posed by any present day confrontation with past injustice."[2] Simmons requested educational programming about the question of reparations as a mode of retrospective justice, while making it clear that the committee would not be making the actual decision to institute reparations.

The narrative of Brown University's culpability emerged within the historical research completed by the committee.[3] When still Rhode Island College, the university was supported by the Brown brothers—Nicolas Jr., John, Joseph, and Moses.

Brown, in fact, took its name from the family, after Nicolas Brown Jr., who gave an important donation to the college in 1804. The Brown brothers—as Nicholas Brown and Company—owned a ship called the *Sally*, which in 1764 sailed to West Africa to purchase slaves to raise revenues for their business. The voyage was a disaster, and all the Brown brothers but John gave up the trade—probably for economic reasons. Later, Moses became a devout Quaker and actively campaigned against the trade—debating his brother, who still was in the slaving business, in a series of letters. Difference of opinion about the peculiar institution was also endemic to the Brown University community as a whole. Its students debated the relative injustice of chattel slavery for much of the first half of the nineteenth century.[4]

This well-documented foundational story aside, tracking material profit from slavery was also strangely diffuse in the sense that slavery arguably permeated every aspect of daily life in colonial and antebellum Rhode Island. As the report from the committee details, Rhode Island was a leader in the slave trade; many of the ships that came and went from Africa and the Caribbean departed from or were routed through Rhode Island ports until the practice was outlawed in 1807; and, as one might suspect, ships sailed illegally long after that.[5] In fact, some 75 percent of slave ships sent to Africa from the United States departed from Rhode Island. More crucial here, many of Rhode Island's industries were dependent on money from the slave trade, and some industries, such as the manufacture of "negro cloth"—material used to make slave clothing in the South—were based in the state.[6] Given the importance of slavery to the area's economic well-being, deciding what amount of the money funneled to Brown University by Rhode Island's prominent citizens was made in the slave trade is an almost impossible task: a task only met by the more difficult one of determining the individual psychic and systemic damage done by the slave trade to its victims and descendents of its victims.

The second part of the committee's work, its public programming and educational mission, led to a stunning array of events, which included film screenings, round tables, and talks by academic and non-academic speakers from a variety of perspectives.[7] Some of the talks were specific to Brown's legacy, but most of them were not. They included debates on reparations, roundtables on how the arts and politics registered the cultural memory of slavery in the United States, and talks on contemporary slavery in a variety of geopolitical sites. Exhibitions of Brown's archive of materials about the slave trade were also a part of this programming. Ultimately, after two years of research and programming, the committee recommended the following actions: acknowledgment; telling the truth in all of its complexity; memorialization; creating a center for continuing research on slavery

and justice; maintaining a high ethical stance with regard to investments and gifts; expanding opportunities at Brown for students disadvantaged by legacies of slavery and the slave trade; using the resources of the university to help ensure a quality education for the children of Rhode Island; and appointing a committee to monitor implementation of these recommendations.[8] In April 2008, the Advisory Committee for a Slavery and Justice Initiative outlined the proposal for the Institute on Slavery and Justice, which would provide funding and other support for scholarship on the history and legacy of slavery, theories of social justice and freedom, race and inequality, slavery and its legacy and Rhode Island, and crimes against humanity.[9] Public programming has also emerged, most recently in the form of the Rhode Island Council for the Humanities' Freedom Festival. In the month of October 2008, the organization sponsored public talks, performances, and film screenings throughout the state to bring "to the forefront the forgotten and neglected stories of individuals and organizations of African-American descent in Rhode Island and encourage thoughtful and productive public conversation about the legacy of slavery and African-American history and culture on the state and country."[10] All of the events associated with the initiatives above, whether explicitly or implicitly, seem committed to the Rhode Island Humanities Council's desire for "thoughtful and productive conversation" about the legacy of slavery.

. . . And Jesus Moonwalks the Mississippi as Memorial

When I began the process of thinking about Marcus Gardley's . . . And Jesus Moonwalks the Mississippi, I conceptualized the piece as a part of the memorialization process mentioned above, largely because of the play's content. Jesus Moonwalks takes place in Proctorville, Louisiana, and Vicksburg, Mississippi, on the eve of the end of the Civil War. It is the story of a family whose allegiances are tested by the possibility of the end of slavery. This poetic work follows Damascus, an escaped slave, as he tries to find his daughter, Po'em, and chronicles the daily lives of the Cajun family he falls upon in Proctorville, comprised of Cadence Verse; her daughter, Blanche Verse; and Blanche's half sister, Free Girl, the daughter of Po'em and her master, Cadence's husband, Jean Verse. It also chronicles the route of Confederate deserter Jean Verse and his companion, Union soldier Yankee Pot Roast. These journeys ultimately take them to the mouth of the Mississippi River, where Damascus (who has transformed from a male to a female incarnation, after being castrated) and Jean Verse both try to find freedom through death—joining the memory of countless men and women lost in their attempts to escape bondage.[11] The cast also includes a character named Miss Ssippi, a mater-

nal iteration of the Mississippi River; the Great Tree; and a young and precocious personification of Jesus. The play's music and poetic storytelling commemorate the legacy of slavery in the United States and ask important questions about simplifying that legacy.

While *Jesus Moonwalks* does not underscore Northern-U.S. profit from slavery, it does show the diffusion of responsibility for the horrors of slavery on a microcosmic level by examining the ambivalent and complicated relationships within a Southern family. And, it asks how one remembers (and re-members) one's family in the midst of slavery. In this sense, *Jesus Moonwalks'* performance of difficult history parallels the work done on the Brown University's Committee on Slavery and Justice because it avoids easy reconciliation between the past and present as it explores the legacy of slavery and its memory within the musical and spiritual legacy of the African American church. Its set of well-placed anachronisms makes sure we are aware of our present presence in this history. This was clear from the first time I read the play. What I did not understand until I was well into the process of directing *Jesus Moonwalks* is that this work would challenge the dialogical structures implicit to educational exercises in retrospective justice, including Brown University's own. The report itself defined memorialization under fairly traditional terms—primarily the possibility of a physical memorial on campus. I saw this play as a memorialization in a different way: as a re-membering of the legacy of slavery as an embodied and emotive performance. Nonetheless, I confined my imagining of the efficacy of the play to its role as a spur toward discussion among the university community between the issuing of the report of the Slavery and Justice Committee and the full implementation of many of its directives. In short, I misapprehended the outcomes the embodiment of this violent legacy would have on cast, crew, and audience alike.

What is striking from my current vantage point about the programming that addressed Brown University's complicity with the slave trade is that while these events were often emotional and affective for presenters and audience alike, the process of bringing this history to light was framed as a rational exercise, dialogical in form, serving the enlightenment telos that undergirds the work of the contemporary university as a site of knowledge production. Meaning that although the research was open-ended and the outcome of these events and the work of the committee were not predetermined by any narrow range of actions, the form in which the discussions about slavery and justice occurred was, in some sense, circumscribed, as the report's conclusion suggests. It claims: "Our task rather was to 'provide factual information and critical perspectives' to enable our students and the nation to discuss the historical, legal, political and moral dimensions of the controversy in reasoned and intellectually rigorous ways. Brown's own

history, the president observed, gave the university a special opportunity and obligation to provide intellectual leadership and foster civil discourse on this important national issue."[12] The emphasis on rationality may exist because the original charge at least in part was based in a discussion about reparations—an issue about which, President Simmons claimed, "men and women of good will may ultimately disagree."[13] The programming went far beyond debating reparations, however. It asked larger questions about retrospective justice and memory that escaped the confines of any clearly defined debates. Yet this dialogical impetus remained, even though many of the speakers ultimately came to the crossroads at the moment in which they tried to assess the consequences of their research. For example, when speaking about the dialectical relationship between narratives and apologies, scholar Ashraf Rushdy argued that the narratives of slavery point to the insufficiency of apologies because the discourse of apologizing is inimical to the work the narratives advise, which is the work of remembering. He enjoined his claim to the theological understanding of forgiveness as an undoing or a forgetting of the deeds of the past.[14] He ended the talk by mentioning a law quoting a 1705 statute from the commonwealth of Virginia that decided who could be held as real estate, which contained a statement that "any master who accidentally killed a slave, in the course of correction shall be free of all punishment as if such accident never happened." He went on to point out that the consequences of the law were this: A slave is someone to whom something did not happen. He concluded his talk by asking, "What kind of apology that could undo the deeds of the past could undo that?" While Rushdy remained calm and collected, the talk ended at a theoretical aporia, which marked the limits of dialectical and dialogical forms of dealing with the legacy of slavery.

Nonetheless, a dialogical impetus inaugurated my process of directing *Jesus Moonwalks*.[15] In the first week of rehearsal, around a seminar table supplied with ample doses of caffeine and sugar, the cast, dramaturge, and crew shared research on the history of slavery in the United States, read through the text of the play together, asking each other questions, and shared music and other relevant cultural media. Lucian Cohen (Yankee Pot Roast), who was in a history seminar with Professor James Campbell, who headed the Slavery and Justice Committee, contributed greatly to this process, as did our dramaturge, Brendan Pelsue.

This research work was paired with more embodied forms of knowledge production such as singing of gospel hymns, dance exercises, and the like, which were often led by the cast. This was the process that led the cast and crew of *Jesus Moonwalks,* which included members of Anglo, Jewish, mixed-race, Latino, Asian, and African American descent, to openly confront the legacy of slavery together. My experience in the rehearsal room was that while we may have been

those "men and women of good will" who may ultimately have disagreed, it never felt that we were really debating anything that would result in a clear directive. The so-called disagreements we had were messier, less restrained, and less demurely Protestant than president Simmons's well-turned phrase suggests—even when we were doing table work, the most dialogic phase of creating performance. Differences of opinion did not always fall on racial lines. The actors' geographical locations and religious backgrounds mattered at least as much as their ethnic identities in determining how they approached the play. Not surprisingly, the most heated conversation we had was about a slave owner's expression of his love for his ex-slave, Po'em, largely because it underscores the historiographical difficulty of re-membering slavery for contemporary Usonians; and it opens a window for the expression of rage and incomprehension that the confrontation with slavery necessitates.

The monologue occurs almost halfway through the play, at a pivotal point in its development. The monologue is in the form of a letter sent from Jean Verse to his estranged wife, Cadence, back in Proctorville. In it Jean reveals his love for Po'em to his wife and tells her that he and Po'em had a child, which he introduced into the house as a foundling. In this letter he repudiates his relationship with Cadence, which he calls his "marriage of wealth and whiteness."[16] The letter is arguably a farewell to his wife and to his two children, Blanche and Free Girl. The poeticism of Jean Verse's text is at odds with the ugliness of the situation and his previous actions as he reports them; he admits that he sold Po'em to be free of her; he has abandoned his family; we also know that he has killed many men in his escape from the army. Yet, one might argue that given the passage's placement within the text, this letter is a kind of emancipation proclamation for Jean Verse. In it, he takes time to rhapsodize about his love for Po'em. The moment is emotionally seductive. So much so that it greatly upset a member of the cast, Mark Brown II, who argued that nothing in the monologue was believable and that Po'em must have been raped.[17] As Po'em is a character referenced and addressed but never seen in the play, there is no way to corroborate or deny Jean Verse's or Mark Brown's version of the events. The tension in the room during this discussion was palpable, even though the students involved in the production had no personal animus with each other. It was here that students' cultural background and personal relationship to the legacy of slavery came into play. Mark, who played Damascus/Demeter, is a biracial African American from the South who was raised by his African American family and, although also of Puerto Rican descent, is usually hailed as black.[18] Federico Rodríguez, who played Jean Verse, is of Spanish and Peruvian descent and, despite his non-Anglo cultural background, is usually simply hailed as white. More importantly, having been raised in

upstate New York by non-U.S.-born parents, he had a different intersection with the play's material than other "white" men may have. As an actor, Fed had the obligation to advocate for his character as did Mark, whose character, Demeter, would certainly be suspicious of Jean Verse in the fictional world of the play. The tension between these two actors/characters was not easily diffused during this evening of table work and it was uncomfortable, although not personal, until we opened the show. The rest of the cast had a range of opinions about Jean Verse, their own experiences and cultural backgrounds coming into play. Erin Adams, who played Miss Ssippi, argued that although it was certainly possible that Jean Verse raped Po'em, we do not actually know that and it was, in fact, possible that the two characters had a consensual—albeit unequal—relationship. Mark pointed out that because slaves could not consent, the relationship, legally at least, could not be predicated on consent.[19] One could also add that Po'em could not have legally been raped because she was technically property under the law, a fact that resuscitates Rushdy's piercing comment.

Discussing these issues was fruitful dramaturgically and historiographically because these conversations exposed two difficult aspects of doing research on slavery in the present. One, it requires us to encounter the very fact of humans not being recognized as such by the laws of our own country. This disgusting absurdity, when added to the acute history of physical violence toward African Americans, is astonishing and horrifying and recalls an affective, rather than a reasoned, logical response. There is simply no logic that can rectify this injustice for most contemporary audiences. Confronting the disjuncture between legality and justice as absurdity is one of the more difficult aspects of dealing with the legacy of slavery in the United States, whose legal code and constitution are held up as a sign of enlightened thought and human progress. At the same time, historical investigations expose the lacunae in what we can know about the subjectivity of slaves in the records and stories to which we have access. While there are numerous slave narratives available to us, the vast majority of slaves' lives, and thus their subjectivities, went undocumented; and as historians, we are faced with making something of or pointing to that absence as a crucial part of U.S. history in the era. Fictional representations, such as *Jesus Moonwalks,* which acknowledge these absences, but nonetheless try to write subjectivity within and through them, complicate the issue.

The cast's conundrum about Po'em's agency in her relationship to Jean Verse re-imagined historically driven debates over how and when one can access, or even allow for the possibility of, slave subjectivity or agency within the practices of chattel slavery. Arlene R. Keizer, a member of the 2004 Slavery and Justice Committee, delineates this theoretical terrain in her work *Black Subjects,* which

examines contemporary novels that depict slavery.[20] Here she places theori-historical positions like Saidya Hartman's, whose *Scenes of Subjection* argues that agency is not imaginable, at odds with the views of many of the fiction writers who see the articulation of the subjectivity of slaves as crucial to contemporary subject formation in African American literature.[21] Our production implicitly staged the dilemma of Po'em's agency without taking sides against or for Hartman's claim.

Obviously, the actors in the play had to take this absence into account when creating their characters, as did I as the director. While directors and actors always have limited knowledge of their characters' subjectivities and have to flesh them out using an imagined emotional landscape, this cast had more to do in that regard because of their historiographical sensitivity. As a director, I did not want to simply decide that Jean Verse and Po'em's relationship was either a consensual relationship or assuredly a rape. I also did not want to limit their relationship to its legal definition, while being adamant that the legal definition of their relationship was an inherent part of the story. I wanted the audience to be wary of Jean Verse, but I chose not to dismiss completely his imagination of the relationship or the fact that the monologue was a revelation for him, which followed his realization that if he deserted the Confederate army and the North won, he might, in fact, be able to join Po'em. I took the counsel of two other members of the cast who pointed out relevant observations that I took into account when deciding to allow the moment to be Jean Verse's revelation. Erin Adams mentioned that all of the words Verse used to describe God were female, suggesting that he had a relationship to women as an exalted force in his own cosmology. Selena Brown, the choreographer, added that it was also during this monologue that Jean Verse recognized his own whiteness as an identity that was not neutral, suggesting that he learns his own privilege at this moment, undoing one of the very conditions that undergirds the violent racial othering endemic to slavery.

Yet, having taken all of this into account, I did not want to over-privilege Jean Verse's as the primary subjectivity through which my audience would view the violence of slavery; nor did I want to suggest a romantic relationship between him and Po'em. The play helps in this regard because a couple of scenes later, Yankee Pot Roast rereads the letter with a critical and sarcastic tone, which takes the wind out of its more poetic moments. I also included another moment that suggests that Jean Verse sees things differently than Po'em might have. During Jean Verse's speech I asked Erin, as Miss Ssippi, to surrogate as Po'em by sitting onstage and listening to him. Jean often sees Po'em as Miss Ssippi in the play; Po'em has presumably drowned in the river and is thus perceivable only through the river's presence, and the river was present at this moment in the script, so my choice made dramaturgical sense. As Miss Ssippi listens, she bathes in the river,

and when Jean Verse recognizes her as Po'em, she covers up and leaves, rejecting his desire for her. This moment undoes the possibility that Jean Verse can reconcile his memory of the affair with anyone else's. It also precludes reconciliation, as does Jean Verse's death. It is also the point at which the actor felt most spectated as a black woman—both by the audience and by the erotic undertow of Jean Verse's exaltation of black femininity—and it made Erin uncomfortable, which fed her onstage rejection of Jean Verse. More to the point here, it staged an embodiment of Hartman's conundrum about subjectivity and spectatorship of slave culture.[22]

What's Rage Got to Do with It?

The rage that bubbles beneath this always poetic and often funny script grew as we worked on the play and made its way into the relationship between Jean Verse and Miss Ssippi, manifesting during Jean Verse's death scene, among other moments. The script only tells us that Jean Verse is drowned by Miss Ssippi. Erin and I agreed that Miss Ssippi's murder of him was a mercy killing, and well into the rehearsal period, his drowning was somewhat gentle. The script itself suggests that his drowning is "an embrace."[23] As the cast, choreographer, and I processed Jean Verse's monologue about Poem and explored the inherent lack of reconciliation between slave and enslaved, however, the moment seemed to ask for more anger on the part of Miss Ssippi and the drowning became more violent. Once we opened, Miss Ssippi snapped Jean Verse's neck before she drowned him, leaving the contradictory emotional legacy of slavery unresolved—which is consistent with many of the other characters' actions. Miss Ssippi often moves between rage, mourning, and compassion. There is blood in her skirts that she cannot remove—the remnants of escaped slaves and dead Union and Confederate soldiers. Damascus/Demeter also shares this mix of contradictory emotions—he/she aids the Creole family responsible for his/her daughter's disappearance but attempts to take Po'em's daughter, Free Girl, as a ransom to cross the river to the peace of death. Jesus has contradictory emotions, too. While he begins the play as a gentle child who guides Free Girl to discover herself, he also turns his back on the characters at the play's culmination, stranding Miss Ssippi with her bloody skirt after decrying the violence onstage with the comment: "They hung me on a tree, pierced and bled me and I came here to save them. What'd you think they'd do themselves?"[24]

The actor playing Jesus, Clarence Demesier, was initially confused both by Jesus's character in the play—which moved from playful to disenchanted rather than remaining serene and wise—and by his dual role as the Great Tree, a fa-

5. Demeter (Mark Brown), *far left,* has a standoff with Cadence (Alicia Coneys), *far right,* as Jesus (Clarence Demesier), Free Girl (Lauren Neal), and Blanche (Samantha Ressler) anxiously look on. Courtesy of Brown University's Department of Theatre Arts and Performance Studies. Photo by Paul E. Rochford Jr., Brown University Media Services photographer.

ther figure and prophet who is filled with rage at the ignorance and cruelty of Damascus's lynching, whom I directed to function as Jesus's Old Testament counterpart. Clarence, raised in the church, had to rid himself of the image of Jesus the Messiah to create his character and, at Mark Brown II's prompting, think about Jesus in the temple with the moneylenders, because this was the one place in the Bible where Jesus is portrayed as an angry young man seeking justice. Mark, although he had no trouble finding Jesus's anger, had a hard time justifying his own at the moment in which his character, Demeter, grabs Free Girl to take her to the river. This was largely because he/she spends much of the play nurturing his/her granddaughter (fig. 5). Yet this abduction happens soon after he/she learns that Cadence, despite her initial denials, did know Po'em. This scene destroys Cadence and Demeter's emotional communion and ends with Demeter angrily marching offstage. While this makes dramaturgical sense, it took awhile into the rehearsal process before Mark and I fully understood his seizing of Free Girl as an act of retributive justice based in buried rage.

I take full responsibility for my choices, of course, and realize that the violence of these scenes is an imposition on the script. Yet I do not think I am wrong in finding buried rage within the silences or interstices of a script. In an essay about the relationship between the golden age of Roman comedy and the aftermath of the destruction of Carthage and the Roman enslavement of its people, Odai Johnson argues that the buried rage of the slave past works its way even into Roman comedies that do not question the status quo of the slave society from which they come.[25] In Plautus's *Carthegenian,* the slave Synecrastus bites his tongue and gnashes his teeth when cursing his master, paralleling the discovered buried tablets that contain slaves' curses against their masters in a silent but present form.[26] These tablets, in Johnson's mind, are "a thin, but enduring subterranean strata of anger running below the triumphal arches and coliseums of Rome, an articulate subsoil littered with the silent and irrepressible rage of its victims."[27]

To my mind, a bit of this subsoil was unleashed over the course of the play, which ultimately led us to avoid reading a false reconciliation into the text. This subsoil helped me to realize how Free Girl's trajectory exposes the play's lack of reconciliation. It would have been easy to miss this dramaturgical reminder. After all, she is the other legacy of Jean Verse and Po'em's relation, the product of a larger set of relations between enslavers and the enslaved. Certainly, Free Girl is written as a beautiful and intuitive young girl, but her presence does not necessarily signify reconciliation between Po'em and Jean Verse, between slaves and masters, or the descendents of slaves and the enslaved. She does represent a certain futurity. After all, she survives the flood and will become legally free as a subject in the historical era that follows the era of the play. Yet, her future is unsure. A mixed-race character who, over the course of the play, discovers her identity as black and as the child of a slave, her gnosis is intuitive and gradual. Yet this revelation does not lead her to any conclusions as to how to live her life in the aftermath of the destructive flood. The playwright could have wrapped it up nicely and allowed a complicit and easy closure to end the play. Gardley chose not to do this.

Free Girl's curious role in the play was underscored by comments made by James Campbell, the head of the Committee on Slavery and Justice and the leader of the first post-show talkback. He suggested that while the play exposed the violence of slavery, as represented by Jean Verse's and Po'em's fates, it also leaves us with Free Girl. Although I took his point, and shared his desire to deal with the complexity of the relationships that occurred under slavery, I saw less reconciliation at the end of *Jesus Moonwalks* than he might have expected. His reading of the play, I believe, caused him to react with surprise at the violence of Jean Verse's drowning and question some of our music choices. Campbell suggested forms

of music, such as Creole jazz, that pointed to the cultural miscegenation might have been more appropriate to the play than some of the music we chose.[28] Such a music selection, however, was not true to our journey as creators of the production (though they are, in fact, representative of the cultural mix of Creole Louisiana). Our soundtrack concentrated less on pulling white and black Creole cultures together than swimming through the righteous anger, desire for release, and hope against hope for change from oppressive political conditions past and present. We chose Nina Simone, Mahalia Jackson, and Kanye West as our guiding lights. Kanye West's "Jesus Walks" formed the backbone of the actor's warm up for the play every night. The song, which is an angry spiritual and a hip-hop anthem, merged with the play in surprising ways. The surface synchronicity of the song's and the play's titles aside, the song has the same lack of reconciliation that the play does; its gesture to the war against "terrorism," "racism," and "ourselves" is not only synchronous with contemporary U.S. geopolitics but hearkens back to the Civil War. It tries to look to the future but is still struggling with the past and present.[29] It is, after all, an angry song, as angry as "Mississippi Goddamn" and "Strange Fruit," which both played a prominent part in the production as we listened to them night after night. Clarence, as Jesus, even had a moment where he "became" Kanye West as he made his way through the space. The productive anger unleashed over the process of the play through listening to each other and to this music may have moved us away from more liberatory possibilities of interpretation, despite the play's articulation of the complex subjectivities of slave owners and slaves, but I think this was a crucial and honest outcome of the process. It prevented us from stopping short of having the difficult realizations that come with staging and living with racialized violence. Trying to make sure everyone was reconciled by the end of an eight-week process was a false reaction to the enormity of the understanding of the slave trade and its legacy.

This curious emotional mix of mourning and rage in Gardley's play, which is so clearly inspired by African American gospel music, makes palpable the very affective consequences of dealing with slavery and its legacy that I find to be missing in more dialogical discussions of U.S. racial relations. It was during rehearsal of *Jesus Moonwalks* that discussions about race began to occur at the national level in response to Barack Obama's relationship to the Reverend Jeremiah Wright. Many people were appalled by the Reverend Wright's so-called anti-patriotic sermons, in which he called out the nation's injustice, particularly racialized injustice. But I think that many people might have been more shocked by the place of anger in the black church than the actual substance of what was said. Obama attempted to deal with the controversy in his March 18, 2008, speech on race by openly admitting the mutual suspicion among and between blacks and whites in

the United States—and the rage that exists on both sides of the color line when dealing with real and perceived injustices.[30] And he did so by recalling the affective gestures of the black church—where voices reaching to the rafters eschew reasoned dialogue as the only mode with which to deal with retrospective justice. His staid delivery notwithstanding, Obama's speech referenced the Sunday-morning passion that he has enacted in other venues. And despite Obama's own reliance on a notion of a unified America, which requires a type of reconciliation and reasoned dialogue in which "men and women of good will may disagree," he made it clear that acknowledging anger was part of the nation's work.

Our own discovery of rage and lack of resolution in the play, in ourselves, and among ourselves was also an inherent part of the rehearsal process as an emotional journey for the cast and crew, irrespective of the production choices made. It was an embodied experience as much as anything else because although there were discursive disagreements among the cast about a variety of political issues, including Barack Obama's speech, we all had to come together every night and be both emotionally and intellectually present while confronting and creating scenes of racialized violence. This process of creating difficult history is historiographically constructive for understanding the possibilities of representing, not only restaging, history, particularly history that attempts to deal with issues of retrospective justice.

A lynching occurs within the first five minutes of the play. In this scene, Damascus is lynched and castrated by two confederate soldiers played by Alicia Coneys, the actress playing Cadence, and Samantha Ressler, the actress playing Blanche, her daughter. After Damascus is lynched, he is transformed into Demeter by the Great Tree, his mutilation having become mythical. It is clearly a resurrection, a moment of triumph, but one gained at an inordinate price—as he moves between life and death for the rest of the play. The lynching is witnessed onstage by the Great Tree and Miss Ssippi, and offstage by the entire audience. To ask an audience to witness this act of violence is daring. The fact that *Jesus Moonwalks* continues on after the lynching and does not end with the lynching, however, asks an audience to confront the violence without disengaging from other forms of racialized violence for the rest of the evening, including a scene where Blanche ropes up Free Girl in a trap, innocently mimicking the act of lynching. This scene does not allow viewers to see the lynching as temporally or spatially other. The memory of violence under slavery is embodied by the theatrical space and the characters for the duration of *Jesus Moonwalks,* which I believe is the affective consequence of the history that the play stages. It also deeply impacted the actors who suffered and enacted violence, in particular Samantha, Alicia, and Mark. So, while much of the material discussed in the dialogues of the Slavery

and Justice Committee made this reality present, the emotional simultaneity that the landscape of *Jesus Moonwalks* afforded did something that many dialogues about difficult historical material cannot necessarily do in terms of connecting the past and present legacy of slavery in a tangible and affective way.

To my mind, this type of simultaneity was effective and affective in a way that may have inhibited the productivity of the play's talkback as such talkbacks are traditionally envisioned. The talkbacks after theatrical productions often carve out an unusual space in that they are staged as dialogic spaces without a clearly affective or analytical imperative. There is an inherent contradiction involved for most of us who participate in them, especially for those of us who do creative work in educational institutions. On one hand, these talkbacks are one of the only moments we have to engage audiences directly about our work, and it is often the only public moment audiences have to process what they have seen. Often, audience comments are impressionistic and "from the gut" since the talkbacks usually take place very quickly upon the end of a show. At the same time, in universities at least, these post-show discussions are the time in which the work is placed in an analytic frame in relation to the play's themes, concerns, and historical and cultural contexts. It is here that the educational worth—the "what did we take away from this experience"—is articulated. Thus it is a moment in which the aesthetic is reframed as pedagogical. The format of the talkback is more akin to the lectures and roundtables sponsored by the Slavery and Justice Committee than the play. What was interesting about the talkbacks for this play was how little the audience spoke—a sign, I think, that the emotional processing that a play about this subject matter asks was not easily turned around as an analytic in the space of fifteen minutes after the play. The actors, the discussion leader, and I, all of whom had extensive experience with the play and its subject matter, dominated the time, despite our many attempts to engage the audience. Although the *Jesus Moonwalks* talkback was not alone in this dynamic, my experience with talkbacks suggested to me that this was an extreme. There was in some sense nothing to debate, no real issue to disagree with—responses were simply not well-reasoned or discursive.

Certainly, I am not the only one who has enlisted performance as a mode of research and historical memory at Brown. Rites and Reason Theatre, headed by Elmo Terry-Morgan, used this research-to-performance method for many years, following in the footsteps of the founders of this unique Africana studies theater program dedicated to staging works based on historical research. These plays are often by and about members of communities of color in the United States or members of third-world communities the world over. Many of these plays deal with political crises or resistance and recognition of racial and political op-

pression. While it is not expressly dedicated to dealing with the legacy of chattel slavery of African Americans, acknowledging these oppressions is an implicit part of the theater's mission. I see the production of *Jesus Moonwalks* as indebted to this tradition, even though the play did not come from one of the research-to-performance-method playwriting classes Terry-Morgan teaches. What *Jesus Moonwalks* shares with these works is its dedication to understanding the performative, affective, emotional, and embodied legacies of those difficult histories. The production also shared the concerns of my colleague Rebecca Schneider, who, in the midst of programming by the Slavery and Justice Committee in 2004, directed Suzan-Lori Parks's *Fuckin' A,* which explores the legacy of lynching and the continued criminalization of black men in the contemporary United States. The issues raised by the play and the talkback about the U.S. prison system were part of the larger concerns of the committee, although they did not officially sponsor the show. And, like my production, Schneider's engendered rage as well as well-reasoned conversation, suggesting the efficacy of anger as a mode of dealing with the subject of slavery at Brown.

So although I agree with Ruth Simmons that education is what universities do best, and that the talks, round tables, and dialogues that the Slavery and Justice Committee organized were productive, I think that affective and emotional labor that acknowledges the inherent illogic of the erasure of humanity necessary to the slave trade is an important part of the work that the campus community has to complete—meaning that the discursive modes the committee privileged do not do all of the work necessary in this regard. The affective work that the production of *Jesus Moonwalks* produced is a necessary supplement not only to dialogue but also to monuments as memorialization of slavery on the Brown campus. The writers of the report seem to realize the limitations of building monuments, and their prose registers some of the irony of universities' investment in them. Yet, finding a more dynamic way to memorialize this history has not yet materialized.

The Long Coda: *A Thousand Ships* and *Funnyhouse of a Negro*

I had planned to end the essay here, but I can't. After all, if there is anything that *Jesus Moonwalks* taught me, it is that when you think you are done, you are not. As I was reworking this essay in late September 2008 after having drafted much of the text above, I was forced to think more about rage in the context of two performances: a production of Adrienne Kennedy's *Funnyhouse of a Negro* and the October 4, 2008, commemoration titled *A Thousand Ships,* designed by

Barnaby Evans, an artist best known in Providence for WaterFire, an installation of fires on the Providence River.

A Thousand Ships, cosponsored by WaterFire, Rites and Reason Theatre, the Providence Black Repertory Theatre, and the Rhode Island Historical Society, was designed to mark the two hundredth anniversary of the end of the transatlantic slave trade. The performance had many parts, including the pouring of one thousand bottles of water into the river as a libation that symbolized the one thousand slave ships that entered Rhode Island ports; a tour of downtown Providence sites implicated in the slave trade, led by torch-bearing guides; an enactment of documents of the slave trade by local professional actors; a performance by New Works, a Brown University dance company whose work is based in Malian dance; songs by Africana Studies' Research to Performance Method singers; the lighting of one thousand candles; the burning of a paper chain linked around a triangle of trees in a waterside park; and a dedication to Rhett Jones, a recently deceased professor of Africana studies. Some of the events included public involvement—such as the libation ceremony, in which attendees of the event poured water into the river, and the placement of the candles, which numbered fewer than one thousand, because of the fire marshal's demands—while the burning of the chains was performed by those who were directly involved in the performances.

The events that involved the public seemed to inspire a sense of *communitas,* as did the burning of the chains and the dance performances. Interestingly, the performances of the historical documents seemed less successful in creating a feeling of common cause or remembrance. One might point out the discursive nature of these works (in a night filled with highly visual and aural symbolic actions) or some of the minor technical difficulties the actors struggled with as potential causes. I am not sure that was the issue. While I saw portions of all of these ceremonies, I spent substantial time listening to the actors that evening. I was struck by how affective and disturbing it was to hear portions of letters between the Brown brothers discussing slaves, testimonies of slaves, and speeches against slavery given by Brown students in the course of the event. Performed by a predominantly (but not exclusively) African American cast, these readings engendered the anguish of slavery, the callousness with which masters treated their slaves, and the passion of those who fought against it. Most difficult to hear, however, were the texts written by slave owners but performed by contemporary African Americans. It was the performance of these texts that ignited the collision of performance, rage, and commemoration.

One might ask: How does one enact the tone of those letters while being dis-

mayed or disgusted by their content? If one is not willing to enact a disingenu-
ously ironic tone, what is one left with? My observation was that these perfor-
mances seethed with anger and disappointment and sadness, and a sometimes
confusing juxtaposition of tones that was difficult for the audience to read—or
reckon with. While watching one of the performances myself, I was shocked when
the man next to me claimed, "I can't hear anything she is saying" and stomped
off. The actress was easily heard in my opinion, even without the microphone.
To be more generous to him than I was at the time, perhaps one might say that
he did not know how to make sense of the combination of what he was hearing
and seeing—a black woman in a Providence public park, reading from a docu-
ment about slaves, mimicking the public affect of an auctioneer. I believe that the
difficulty in reading and enacting these texts is caused by the contradictory feel-
ings that come into play when embodying the history of slavery in contemporary
space. A symposium, held at Brown University's Center for Public Humanities
the next day, seemed to substantiate my gut reactions. Those who attended the
forum were largely those who inaugurated the event or were "invested" audience
members such as myself. Nonetheless, the lively discussion about the event rarely
engaged the enactment of these texts. Ultimately, I felt that those performances,
which recalled the legacy of the transatlantic slave trade as well as the recognition
of its end, were more ambivalent than the rest of the ceremony, in part because of
the affective confusion they may have caused. That confusion was a productive
phenomenon to think about, especially in relation to *Funnyhouse of a Negro*—a
play that embodies confusion and rage and submits an audience to those emo-
tions.[31]

Kennedy's play, first written in 1962 and performed two years later, is a non-
realistic text for the theater that takes one inside the head of Sarah, a young Af-
rican American woman who is struggling with her identity inside her mental
"funnyhouse" in her cramped Morningside Heights apartment. Ultimately, Sarah
suicides, thus ending the play. Produced by the Department of Theatre Speech
and Dance at Brown, the production followed six months after *Jesus Moonwalks*
and featured four of its actors. *Funnyhouse* was written in New York during the
civil rights movement some forty years before Gardley's play. Although Gardley's
play plays with history, it does take place in a particular time and place, whereas
Kennedy's play abstracts time and place because the play takes place in Sarah's
mind. And, whereas Gardley writes from some geographical and temporal dis-
tance, Kennedy writes from within the strife of her lonely and difficult experience
of the landscape her protagonist, Sarah, is submitted to as she ingests the racism
that surrounds her. Despite these differences, what the plays share is their striv-

ing toward, but ultimate lack of, reconciliation—the flood, the hanging—which forces a painful rebirth but does not give the audience the possibility of seeing the rebirth staged. And they share a certain rage and wit. *Funnyhouse*'s rage is not buried, however. The play wears its anger and confusion on its sleeve, as Bill Rodriguez's aptly titled review "Race and Rage" attests.[32] Sarah is, after all, what might become of Free Girl. And Sarah's hanging of herself strangely doubles the lynching of Damascus in *Jesus Moonwalks,* at least to those of us who have seen or were involved with both shows. The noose used in *Funnyhouse* was the same one used in *Jesus Moonwalks,* practical necessity underscoring the legacy of racialized violence, transported from being an instrument of terror to one of self-hatred. This historical and theatrical act of transfer argues for the persistence of unproductive rage rather than productive rage but also looks sideways to a curiously erased story from our recent history: Barack Obama's lost years of late adolescence and early adulthood, a tale that suggests that one can lead to the other.[33]

Barack Obama goes to great lengths in his memoir *Dreams from My Father: A Story of Race and Inheritance* to talk about the rage he felt in those years as he began to see himself as a black man and the years he spent figuring out how to escape his own funnyhouse. It was often newfound knowledge of slavery and other forms of inequality that made his rage percolate; in his case knowledge led to rage before it led somewhere else.[34] Ironically, it was in a cramped apartment in Morningside Heights filled with stacks of dog-eared books, the site that encloses Sarah's rage, that Obama learned to work through his and figure out what he was actually seeing on his long walks through Manhattan.[35] It was in those years that Obama learned how to channel his anger at inequality in the United States into deciding to become a community organizer. Yet, while that all makes for a great redemption narrative, it also seems imperative to acknowledge those years of rage rather than to suppress them—as Obama himself suggested in his March 18, 2008, speech on race. Today, Obama, who, according to his former law students, much to their amazement, could speak calmly and introspectively about personal experiences of racism or those he witnessed, seems to hold forth the possibility of linking the dialogic to the messily affective more successfully than others have done.[36] To say this, however, is not to suggest that rage will disappear into dialogue, or that coming to terms with the history of mutual suspicion between black Americans and white Americans will not ask for us to find a place for rage within histories and historiographies of the slavery past of our nation. Or that it will not ask us to think about its contemporary legacy. Quite the contrary: rage might be produced as much by acquiring knowledge and talking about it as it is fostered by remaining ignorant of that knowledge or keeping our

mouths shut. Yet I firmly believe that the ambivalences of performing difficult history—in spirituals, historical reenactments, or history plays—might lead the way for this task of moving toward productive rage.

Notes

I wish to thank the following people for their generosity and insights: James Campbell, head of the Slavery and Justice Committee at Brown University; Barnaby Evans, the designer of *A Thousand Ships;* the cast of *A Thousand Ships;* Kym Moore, director of *Funnyhouse of a Negro;* the cast and crew of . . . *And Jesus Moonwalks the Mississippi;* and Marcus Gardley. All of the opinions in this essay are my own, of course, and I alone bear responsibility for them.

1. Slavery and Justice: Report of the Brown University Steering Committee on Slavery and Justice (Brown University, 2006), 4.
2. Ibid.
3. Ibid., 12–20.
4. Ibid., 23–26, 30–31.
5. Ibid., 10.
6. Ibid., 26–28.
7. A schedule of these events can be accessed at http://www.brown.edu/ Research/ Slavery_Justice (accessed August 10, 2008), as can the report of the committee and a repository of documents about Brown's involvement in the slave trade and a link to a low-cost curriculum about New England's role in the slave trade.
8. Ibid., 80–87.
9. Report of the Advisory Committee on a Slavery and Justice Initiative, April 2008, available at http://www.brown.edu/Administration/ Provost/committees/sj/SCR.pdf (accessed August 10, 2008).
10. From the Rhode Island Council for the Humanities Web site, http://www.rihumanities.org (accessed September 30, 2008).
11. Marcus Gardley, . . . *And Jesus Moonwalks the Mississippi,* unpublished play, 2005.
12. Slavery and Justice: Report, 80.
13. Ibid.
14. Ashraf Rushdy's talk, "Slavery's New Narratives, Slavery's New Apologies," was given on September 30, 2005, as part of the program Legacies of Slavery in American Life: Politics, Education and The Arts. Video of the talk online at http://www.brown .edu/Research/ Slavery_Justice/events/ (accessed October 1, 2008).
15. Marcus Gardley's . . . *And Jesus Moonwalks the Mississippi,* April 10–20, 2008, Leeds Theatre, Brown University, directed by Patricia Ybarra. Cast included Erin Adams (Miss Ssippi), Mark Brown II (Demeter/Damascus), Lucian Cohen (Yankee Pot Roast), Alicia Coneys (Cadence Verse), Clarence Demesier (Jesus/Great Tree), Lauren Neal (Free Girl),

Samantha Ressler (Blanche Verse), Federico Rodríguez (Jean Verse); designed by Louisa Bukiet (sets), Rebecca Mintz (lights), and Emma Lipkin (costumes).

16. Gardley, *Jesus Moonwalks,* 41.

17. Author's rehearsal notes, February 29, 2008.

18. I use "hail" both in the sense of referring/identifying and as a way of constituting a subject position (versus an immutable state).See J. L. Austin, *How to Do Things with Words* (Cambridge: Harvard University Press, 1962); and Louis Althusser, "*Ideology and Ideological State Apparatuses": Lenin and Philosophy and Other Essays* (New York: Monthly Review Press, 2001), 121–187.

19. Author's rehearsal notes, February 29, 2008.

20. Arlene R. Keizer, *Black Subjects* (Ithaca, NY: Cornell University Press, 2004).

21. Ibid., 16.

22. Saidya Hartman, *Scenes of Subjection: Terror, Slavery, and Self-Making in 19th Century America* (New York: Oxford University Press, 1997).

23. Gardley, *Jesus Moonwalks,* 70.

24. Ibid., 74.

25. Odai Johnson, "Unspeakable Histories: Terror, Spectacle, and Genocidal Memory," in *Theatre Historiography, Critical Interventions,* ed. Henry Bial and Scott Magelssen (Ann Arbor: University of Michigan Press, 2010).

26. Ibid., 14.

27. Ibid., 15.

28. Talkback, . . . *And Jesus Moonwalks the Mississippi,* April 10, 2008.

29. Kanye West, "Jesus Walks," *College Dropout,* Roc a Fella Records, 2004.

30. Barack Obama, "Barack Obama's Speech on Race," transcript: the *New York Times,* March 18, 2008, online at http://www.nytimes.com/2008/03/18/us/politics/18text-obama .html (accessed August 15, 2008).

31. Adrienne Kennedy, *Funnyhouse of a Negro,* directed by Kym Moore, Leeds Theatre, Brown University, September 25–October 5, 2008.

32. Bill Rodriguez, "Race and Rage," *Providence Phoenix,* October 2, 2008. http:// thephoenix.com/Providence/Arts/69351-FUNNYHOUSE-OF-A-NEGRO (accessed October 11, 2008).

33. I borrow the term "acts of transfer" from Diana Taylor's *Archive and the Repertoire* (Durham, NC: Duke University Press, 2003). See Taylor, 1–52, for a more thorough examination of this term.

34. Barack Obama, *Dreams from My Father: A Story of Race and Inheritance* (New York: Crown Publishers, 2007), 92–129.

35. Ibid., 122.

36. Alexandra Starr, "Case Study," *Times Magazine,* September 19, 2008. http://www .nytimes.com/2008/09/21/ magazine/21obama-t.html (accessed October 11, 2008).

Is That Real?

An Exploration of What Is Real in a Performance Based on History

Catherine Hughes

When spectators who have just seen a historical performance say, "It was so real!" what do they mean? Do they mean that the performance appeared to be a restoration, an honest down-to-each-detail recreation of history? Is their interpretation of what is real grounded literally? I propose that what the spectator means is something very different. In a reception study that I conducted of spectators' responses to performances that took place in a museum, I found that spectators' sense of realness was generally based on a complex awareness of the performance medium and emerged from individual interpretations grounded in spectators' prior understanding and experience.

For most museums and historic sites, the engagement of visitor/spectators' imagination is the general goal, and theater has shown itself to be an appropriate and innovative method for doing so.[1] Reading the labels of an exhibition is one way to experience what it has to offer, but a performance invites the spectator inside the experience. Many spectators in my study accepted the invitation, as described by this participant: "Not like reading a book. He didn't just stand there and talk. It really put us in the scene. He really wanted to tell us and completely involved us. We were delighted to see it."[2]

In this essay, using reader-response theories as a basis for conceptualizing the nature of spectator response to performance, I delineate the process by which the spectators come to their interpretations. Reader-response theorists Wolfgang Iser and Louise Rosenblatt have put forward the reading process as one of intangible realization, in which readers realize meaning and a sense of reality from a text via their imagination. It is similar in spectator response. What I am suggesting is that any sense of realness or authenticity is determined by the spectator's interaction with, and subsequent investment in, the performance.

The impact of play and the framing of theater in a museum will be brought into focus through spectators' responses, exploring how play and framing lessen

or strengthen the feeling that something is real. Here the theories of anthropologist Gregory Bateson, regarding play, and sociologist Erving Goffman, on frame, are brought to bear on such performances. Whereas many historical sites, living history performances, and heritage programs submerge the theatrical frame and distance themselves from theatrical performance by insisting on seamless realistic simulations by non-actors, my research in the museum theater field shows that heightening visibility of the theatrical frame and even breaking this convention cannot only be tolerated by spectators' suspension of disbelief but can lead to rewarding results.

We are constantly bombarded with questions of whether something is real in our world today. Has the memoir been fictionalized? Is the person I'm instant messaging real? Is reality television portraying people as they really are? Like the memoir, for historic sites and museums the question of whether something will be believed as real has high stakes and can determine a site's reputation and integrity. This has caused many sites to restrict their live interpretive programming to a naturalized, simulated style, in which visitors interact with "real" historic characters carrying out "real" activities, such as those at Plimoth Plantation.[3] One can question whether this realness is attainable or desirable,[4] but it is, nonetheless, what many historic sites and museums have sought to achieve through careful attention to detail and rigorous research. The re-creation of an event from the historical record, however, is only half the story. I am in agreement with arguments, made most recently by Scott Magelssen, concerning the limitations of strictly defined living history performances when I suggest the other half of the story is what did not get written into the historical record.[5] That is not to say that what living history museums have presented in first-person interpretive programs is not real—it's just not all that was real. It is a fragmented, and therefore incomplete, reality, which should be acknowledged as such. Some sites have taken action regarding this issue. The addition of the African American voice in programming at Colonial Williamsburg is a good example of layering another reality to what was real in Williamsburg's past.

Another sticking point is to tease out what anyone means by the word *real*. My sense of people's use of the term focuses on truthfulness and honesty, rather than academic accuracy. When spectators in my study expressed a feeling that something felt real to them, my interpretation of that term related to their belief in the truth of that moment and in the honesty of the creators of that moment— such as the actor or writer. There was a similar interpretation from the results of a large-scale study at four sites in the United Kingdom, in which respondents saw the performances they experienced as emotionally real.[6] How a spectator comes

to that feeling is what interests me. How does a historical performance feel real to a spectator? How do the creators of historical theater lay the groundwork for the spectator?

There are many ways in which history is played out in theater. Having an actor take on the role of a historical character, whether actual or fictitious, and interact with an audience is one way. Within this sort of historical role-playing, there are a number of choices to be made about how it might be framed. An article in the *Boston Globe* highlighted one choice.

> Cutlass and flintlock pistol dangling at his side, Captain Daniel Malcolm—revolutionary, patriot, privateer—raised his voice over the din enveloping the Old Granary Burying Ground. Bellowing over the roar of jackhammers and the wail of ambulance sirens, he held forth on the presidential politics of his century, specifically the jealousy that John Hancock held for George Washington, the man the nation's founding fathers chose as president of their young republic.
>
> A group of fifth-graders from Blueberry Hill Elementary school in Longmeadow listened transfixed earlier this month, until a boy in a Red Sox T-shirt looked up at the rakish seafarer and inquired in a tiny voice:
>
> "Are you for Obama or McCain?"
>
> "I can't vote," was Malcolm's gruff dismissal of the inquisitive lad. "I'm dead."
>
> Such are the trials of a 283-year-old Son of Liberty in present-day Boston.[7]

The actor in this historical portrayal broke the theatrical frame that was initially established when he dressed in historical costume and talked about the Revolutionary War in present terms.[8] This conscious framing by the creators of this event was adopted, probably unconsciously, by the spectators, whose perception, in a Goffmanian sense, was then guided to accept this communicative event as a performance. In his study of Plimoth Plantation's interpretation program, Stephen Snow used Goffman's ideas on the nature of social interaction to analyze communication between spectators and Pilgrim characters.[9] Snow used, as I have, Goffman's play frame to characterize behavior between spectator and performer. In this frame, "both parties have explicit expectations of the behavior and characteristics of the other . . . and the most fundamental rule is that *the role-players will not be unmasked and thereby forced to lose face*."[10] In the case above, the actor is not losing face, as he might if a spectator purposefully shouted, "I don't believe you!" What he is doing is asking the spectator to be aware of the frame while also maintaining it.

How do audience members make sense when a historical character does something like this? A number of questions might come to a spectator's mind. "What do I believe?" Is the performance, or historical portrayal, perceived by spectators as any less authentic for this admission of death?

Surprisingly, human beings can make sense out of this because they have the wonderful capacity to see double. This means that when an actor informs an audience that he or she is dead, it merely conforms to the understanding already realized by the audience: they are watching an actor playing a long-dead character from another time period in history. It calls attention to that fact rather than letting it proceed unspoken.

According to the theory of conceptual blending, developed by Gilles Fauconnier and Mark Turner,[11] many people constantly blend cognitive categories or concepts and then un-blend them to get a sense of what they are doing. Cognitive concepts are like schemata, broad representations of concepts like blue or fast or furniture. The authors of the theory cite evidence that these mental concepts gain neuronal structure in the mind, which is how spectators can see double without thinking about it.[12] To illustrate their point, they use the example of how people can blend various concepts like "actor," "identity," and "character" to create a new concept: the actor/character.[13] In doing so, people temporarily put aside the knowledge that actors live outside their role-playing and that the character does not live outside the performance. This can be seen in young children when they express the dawning awareness that the person before them may not really be the character but an actor playing a character.[14] Comments from spectators in my reception study of performance in a museum articulated a sense of seeing double in performances.[15] In several extended comments, participants moved back and forth dynamically, and for the most part unconsciously, between describing the actor's actions and those of the character.

I began my study focused on how people made meaning from performances in museums and whether or how emotions affected the meaning they made. I chose two museum sites: the Kentucky History Center in Frankfort, Kentucky, and the Museum of Science, Boston, which both had thriving theater programs and a varied repertory of shows. Among many considerations, these two museums were chosen because they offered similarly styled, scripted performances free of charge. Although the Museum of Science had plays about science, their two plays used in this study were also historical.

The Museum of Science in Boston, Massachusetts, is a large nonprofit institution located in an urban area. At the time of this publication, it had 1.6 million annual visitors and more than four hundred interactive exhibits and programs focusing on natural history, current science and technology, and the history of sci-

ence. The state-run Kentucky Historical Society operates the Kentucky History Center, located in the moderately sized state capital, with approximately 63,000 annual visitors at the time of this publication. It provides quality exhibits and programs and state-of-the-art technology to inform visitors about the history of Kentucky and its people.

These two sites are representative of one type of theater program that has been implemented in museums and share its characteristics: an artistic staff member coordinating a full-time program with professional actors, plays for children and adults, plays that are built around pedagogic objectives while maintaining their artistic quality, and plays that further the educational mission of their host museum. Participants in this study responded to a performance of one of the five scripted plays. I will begin by explaining performances at the Kentucky History Center. Performances there took place in the permanent exhibitions and in a temporary exhibition on flags.

The theater program manager and the main actor in the performances, Greg Hardison, served as my contact at the Kentucky History Center. The first performance I viewed and collected data before and after was *Into the Veins: Conversations from a Coal Town.* This was a three-character, three-scene, scripted play written by Hardison and performed by one actor in approximately twenty minutes. The genesis of the play was the creation of a performance that would work in the coal-mining exhibit. Later, educational goals about immigration and social change in Kentucky were retrofitted.[16]

The performance began in an open area on the edge of the coal-mining exhibit. There were two benches moved to face, at angles, a Model T Ford to the left and a large mural, a grainy black-and-white photograph of a coal-mining town from the 1930s, on the wall to the right. The benches focused spectators' attention on an open area. Before each show, staff of the center announced to all visitors in the entire exhibition that a museum theater piece was about to begin and showed them where to sit. There was no sign, no other indication that a performance would take place. Some visitors would sit on the floor and wait. The staff person would then stand before the audience and make an introduction about what they were about to see.

Because there was no stage for this performance, the lines were blurred between performer and spectator. At some points during this show, the actor was within touching distance of the audience. It was very intimate. Eye contact was made with most members of the audience. Some visitors did watch from the back of the audience area, but most were close and maintained visual contact with the actor throughout the performance. This was true of all of the plays at the Kentucky History Center.

Below, I provide a detailed description of this play as an example of museum theater. I will not describe the other plays included in my research in this much detail. Not all museum theater will feature a promenade performance such as this, but it has been done in other sites with success.

After the first scene of *Into the Veins,* in which the audience was introduced to a young boy living in a coal town in the 1930s, a staff person stepped in and led audience members forward and around a corner of the exhibit into an area simulating a mining company store. The intermingling of an actor performing, intervention by a staff person, and the movement of the audience caused the theatrical frame to materialize and dissolve throughout this performance. Visitors filed into the store and stood facing an open area in front of a counter with a cash register on it. There was a ladder standing in the middle of the store. From behind the open area the actor who played the boy entered, walking with a limp while he tied the strings of a white apron, now in character as an Italian immigrant who ran the store. He saw the visitors assembled and began talking in Italian, gesticulating and asking questions. After a minute, he switched to an accented English and said, "Ok, you no speak English, we'll talk in Italian," thus framing the visitors as new Italian immigrants. He introduced himself and had advice for how to assimilate into the Kentucky mining culture. He brought up how he had been injured, which led him to work in the store. In this scene, the actor interacted even more directly with the audience. At one point, he reached out and patted a person on the shoulder. When I attended, this person was usually an older child or young teenager. Toward the end of his monologue, the actor dismissed the "immigrants" with a warning not to listen to the union organizer who was around.

The staff person then led visitors back outside the store, which had a simulated mine opening across from it. There was a wooden box to the left side of the opening. Without much of a pause, the actor then entered from the left. The white apron was gone, and the actor had a jacket and hat signifying the 1930s. Now in character as a union organizer, he stepped onto the wooden box and began a rousing speech that assumed those before him to be miners and miners' families. He ended an emotional plea with a union song, "Which Side Are You On?" which he sang a capella, beating out the rhythm with his boot on the box.

The three distinct scenes together take about twenty minutes to perform. The actor changed his voice, manner, physicality, and bits of clothing to signify who he was at each point. These changes were distinct to avoid confusion for the spectator. At no point did any participant express confusion over who the actor was portraying during the show, although several described the dawning of their understanding that he was going to play different roles. The staff person was also

available to answer any questions visitors had. The spectators' continual awareness of the process of this performance, discerning the rules of play, allowed them to invest in the actor's portrayals, thus framing each performance.

The other two plays at the Kentucky History Center were *Look for My Picture: Raising the Flag with Franklin Sousley,* a one-person, twenty-minute play about raising the flag on Iwo Jima during World War II, and *Diary of a Depression: A Day with Mary Ruth Dawson,* a one-person, twenty-minute play about life at a family farm during the Great Depression. These plays were all written using archival material.

The plays at the Museum of Science, Boston, were performed on a slightly raised thrust stage. The stage itself was located within an exhibition hall, with amphitheater-style benched seating that visitors could move to and from freely. Dan Dowling, artistic director of the Science Theatre Program, was my contact. As a former employee of the Museum of Science, I was provided considerable support and access to carry out data collection.

The first performance I used was *Frankly Franklin,* written by Margaret Ann Brady. This was a twenty-five-minute performance with two characters who are siblings. They could be brother and sister, or sister and sister, depending on the cast. The premise of the show was that these two siblings ran an eating establishment that had been around since Ben Franklin's time, so they had been running it for 275 years. The educational objective, according to Brady, was to "feature a wide range of Franklin's accomplishments and his significance as a scientist, and to explain the kite experiment."[17] This show had elements of physical humor, multimedia, and farce.

The second show used for data collection at the Museum of Science was called *Unsinkable? Unthinkable!* by Jon Lipsky. This twenty-minute solo performance was about the sinking of the Titanic and the technological theory that posits that as humans move forward technologically, more rather than fewer disasters should be expected. The central character was an albino crab that lived on the wreck and knew everything about it. This nonhuman character, performed by an actor in a simple white suit suggesting a waiter's uniform, served as a sort of absurd narrator of what created the Titanic disaster; and, in telling the tale, the character became many of the people who were on the ship, such as Fred Fleet, the lookout who spotted the iceberg. This show alternated between comedic and tragic, highlighting how human hubris influences advances in technology.

I spoke with museum visitors who chose to watch performances. Through data derived from pre- and post-show surveys, observations, focus-group interviews, and follow-up interviews three to five months later, I analyzed spectator

responses using transactional theory as a lens to reveal what participants selected for attention and how they constructed meaning from their museum theater experience.

The sample of visitors who participated in this study represented a wide range of ages. This was evident in the variety of experiences they brought to their meaning-making of the performances, which inspired a plethora of different interpretations. Conversely, there was consistency across spectators' ages in recall of details of the performances three to five months later.

A primary concept that emerged in the data that showed aesthetic response to museum theater was the centrality of empathy. The human dimension, the interaction between spectator and actor, was of central importance in engaging spectators.

One of the strengths of this study was the variety of instruments used, which allowed participants to construct and clarify their responses in varying ways and at different intervals. The data painted a detailed picture of the museum theater event as a site of activation for participants' affective and cognitive processing, which led to strong recall, comprehension, and learning.

The performances I utilized in this study typify one style of presenting historical events. They are each scripted, clearly framed as theater, performed within galleries of a museum, well-choreographed and directed, and performed by talented actors, and they have minimalist sets. There is a clear beginning, middle, and end to the performance. The actors talk out of character after the shows, and sometimes before. These conventions differ from the historic role-playing carried out in many historic sites.

Commonly, the temporal quality of a character is not acknowledged in historic role-playing. Snow points out the imperative to mask what Goffman called the "back region" of the interpreters playing Pilgrims for the sake of verisimilitude.[18] The reality that the Pilgrim or Revolutionary character is a role to be performed, rather than an actual living human being, is submerged. The fact that the character is dead is not acknowledged.

The intent here is to meld the actor into the character, to increase believability in the portrayal. The focus is on living history. More questions are left unspoken in such presentations. The death of the historic character can only be implied or assumed. For example, at Colonial Williamsburg an actor playing Patrick Henry cannot inform the audience of Henry's death or his eventual legacy in American politics. It is assumed the audience has this information or will get it some other way. The historical portrayal from the *Boston Globe* could be said to be an example of "dead" history. The actor on Boston's Freedom Trail framed his own aware-

ness of this and a communal awareness with the audience and, consequently, an awareness of the game of theater. By saying that he is dead, he gives a wink to the audience, joining them together in play.

In play, humans and other animals have the ability to communicate that actions are not real, though they may look real, and the anthropologist Gregory Bateson theorized that we do this through meta-communication.[19] Bateson's research uncovered meta-communication between monkeys. This meta-communication consisted of signals the monkeys exchanged that told each other they were playing. These signals allowed them to engage in actions that looked like combat, like biting, but were play. Because they were playing, the bite was not fully carried out and did not hurt. Bateson phrased this notion of play this way: "These actions in which we now engage do not denote what those actions for which they stand would denote."[20] The normal rules of behavior are suspended in the play frame. Likewise, in the theater it is agreed that such a thing as a murder that spectators witness is not really a murder, and, therefore, it is allowed to happen. In the play *Into the Veins,* the spectators agreed to let the actor dissolve into the character of each scene and to change their own persona to fit—by becoming Italian immigrants or mining families.

In recognizing play, human beings acknowledge two realities—or show the ability to shift between two different realities. The first reality is watching a performance. The second is realized in a transaction between the actor and spectator. In order to conceptualize what is happening in this transaction, I turn to transactional theory, conceptualized by Louise Rosenblatt, to understand the reading process.[21] In an essay written more than a decade ago, Marvin Carlson urged theater and performance theorists to apply reader-response and reception theories to theatrical performance;[22] and I have utilized one of them, transactional theory, to understand spectator reception of the performance event.

While lines have been drawn between reading and drama in the work of various drama-in-education researchers,[23] no study has explored the fruitful parallels between reading a text and watching a performance. There have been connections made in reception theory to reader response, where, heeding Carlson's advice, there has been a recent shift in recognition of the role of the spectator.[24] In her book *Theatre Audiences,* Susan Bennett suggested that theoretical developments in reader response have pushed this shift, arguing that "without the existing corpus of reader-response theory, it is unlikely that there would be that current concern of drama theorists for the role of the audience."[25] And while Bennett has delineated the influence of reader-response theory on theater reception, the application of transactional theory to analyze a performance event is new, especially a historical performance.

Although separate and distinct activities, reading a literary text and seeing a performance constitute complementary meaning-making processes. According to reader-response and transactional theory, meaning cannot be found solely within a text but must be realized in the construction of interpretation by a reader. Meaning in a literary text is found in a virtual space between reader and sentences, which is similar to the virtual space created between what happens on a stage (or other space) and the spectator's imagination. The meaning made in any of these acts between human and text or performance is shaped by what the human brings to the interaction (culture, experience, psychology) and what is present in the text (sentence structure, horizon of expectations of the author) or performance (the performance text, actor, lighting/sound/visual effects, context). Transactional theory elevated the reader in the meaning-making process. This went against the conventional wisdom of the early part of the twentieth century.

Rosenblatt developed her ideas in response to the New Critics and other literary theorists who focused on the author's intent and the text itself.[26] Writers of New Criticism believed in the autonomy of the literary text and viewed text as verbal structures.[27] The reader was not considered significant to the meaning-making process. Carlson described a similar situation in the theater, where the spectator has been considered passive, without the agency to contribute to the performance, and simply receives the producers' intended message.[28] Transactional theory, as well as reader-response theories, grew out of recognition that New Criticism could not completely explain how texts are understood—while, obviously, the text is significant, it became obvious that readers' responses also carry significance. Two highly educated (in the canon of a particular text) readers can construct different meanings in a given text—and those different meanings can be supported by text structure and/or informational features. And it is a given that two theatergoers or two theater critics may have very different takes on a performance's meaning.

Rosenblatt characterized what happens between a reader and text as a transaction.[29] It is in this transaction that both reader and text not only are realized but are shaped and changed by each other. The actual text remains still and dormant, but the text as meaning is what is shaped and changed by the reader, and the reader is in turn shaped and changed by this process of constructing meaning. This is an extension of the notion of an interaction, when two entities meet but do not necessarily change each other. In reader-response theory, the text is realized in the act of reading. Where before there were marks on a page, when a reader reads the text, the meaning of the text is transformed. A poem or other literary work "is what happens when the text is brought into the reader's mind and the words begin to function symbolically, evoking, in the transaction, im-

ages, emotions, and concepts."[30] Iser also theorized that text is realized as a literary work in the act of reading.[31] But in most reader-response theory, emphasis is on the text, while in transactional theory the reader takes an equal focus. Rosenblatt insisted on the equal importance of text and reader. The reader becomes a reader "by virtue of his activity in relation to a text."[32] The notion of reciprocity is, therefore, at the center of transactional theory. Both the reader and the text are realized in the reading event and in the transaction of making meaning; what is constructed is both unique and transformative to each reader.

In order to understand the performance event, I have equated the reader with the spectator and the text with the performance. In a performance, a transaction occurs between spectator and performers, and it is in this transaction that the performance is realized by the spectator. Without the spectator, the performance cannot be realized, just like marks on a page that must be transformed into meaning by a reader. Without the audience, the performance is meaningless. The act of realization by the spectator is essential. *Into the Veins* provides a clear example of spectators realizing a performance. Each of the actor's three portrayals were only realized as the spectators understood the rules of play and agreed to let the actor recede and the character to move forward. Thus, the spectators' imagination created a new reality. The following comment is from a spectator who saw *Look for my Picture: Raising the Flag with Franklin Sousley:* "When he stood up against the mural, and actually, it was like he became real, you know, you look at pictures in books and incredible photographs, but it was like that person became real, and that was just really striking."[33]

But are all transactions/realizations of a particular performance the same? Returning to Rosenblatt's conception of the reading process, no two transactions are the same. The text presents itself for consideration to the reader, and the reader brings his or her past experiences and present attention to the text, which creates a unique literary experience for each particular reader with each particular text.[34] The contexts of time and place contribute to the uniqueness of each reading, even with the same reader and text. The same can be said of the performance experience. Some spectators who saw the Kentucky History Center's *Look for My Picture* noted resonances between World War II and issues concerning the ongoing war in Iraq. Some older spectators compared public opinion of World War II with response to the war in Iraq. The context of time, coupled with spectators' identity and experience, helped shape the meaning made by these spectators.

Furthermore, Rosenblatt detailed how what is selected for attention in reading is informed by the stance adopted by the reader. Stances fall on a continuum between what Rosenblatt termed the efferent and the aesthetic.[35] While the stance adopted by the reader is most often a mix of both poles, a purely efferent stance

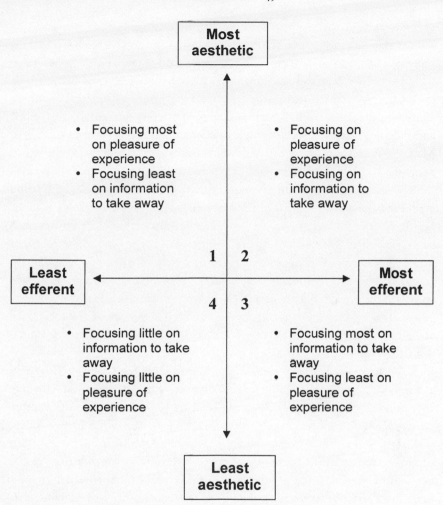

Most
aesthetic

• Focusing most
on pleasure of
experience
• Focusing least
on information
to take away

• Focusing on
pleasure of
experience
• Focusing on
information to
take away

1 | 2

Least
efferent

Most
efferent

4 | 3

• Focusing little on
information to take
away
• Focusing little on
pleasure of
experience

• Focusing most on
information to take
away
• Focusing least on
pleasure of
experience

Least
aesthetic

6. Diagram of Efferent-Aesthetic Axes.

selects for attention only information that will be useful in some way, as someone
might when reading a manual; and a purely aesthetic stance selects for attention
the quality of the experience, pushing aside practicality, as someone might when
reading a poem. The quality of an aesthetic reading is often described in emo-
tional terms, although an efferent reading could contain elements of emotion.

In my study, what was selected for attention and interpreted in spectators' re-
sponses was initially placed on the efferent-aesthetic continuum; but eventually I
generated a different model, synthesized from the findings, which extended from
Rosenblatt's continuum (see fig. 6). I placed the two ends of the continuum on

two axes, which cross to create four quadrants. Each quadrant represents a mix of both efferent and aesthetic response, allowing for all responses to be some measure of both. At no point is any response considered purely one or the other.

What became clear from the data was that all responses were some measure of both efferent and aesthetic stances. Spectators took away information about the content of the performances, such as Kentucky mining, the battle of Iwo Jima, and the Depression era, as well as living in or through the performance events. Many participants' experiences were simultaneously highly efferent and highly aesthetic.

A highly aesthetic experience was one in which the spectator described feeling connected to or engaged by, or even absorbed into, the performance in some way. Penny Bundy explored aesthetic engagement in drama practice and formulated a set of key characteristics for aesthetic engagement: connection, animation, and heightened awareness.[36] Bundy's proposition is that true aesthetic engagement cannot occur unless all three characteristics are achieved, each working in tandem with the others, enabling the others. "When we experience a sense of invigoration (animation) as we connect to an idea at a metaphoric level (connection) we are encouraged to be more alert to new ideas and thoughts (heightened awareness)."[37]

A portion of aesthetic experiences were described by participants in this study as a feeling that the performance was real in some way: "*It was so real,*" "*like you were there,*" "*It helped to make the picture come to life,*" "*taking you along this very emotional enactment.*"[38] Each of these expresses the feeling of participants being transported to a liminal or "in between" reality through their transaction with the performance.[39] I use the word *liminal* to describe the reality that is created between the performance and the spectator. The actor cannot really recreate a moment in history, nor can the spectator travel in time, but provoked by the performance, the spectators' imaginations can transport them to another reality, a liminal one that feels real. Most participants showed little self-awareness concerning their own part in creating this sense of realness: "I thought the quality overall was totally excellent, how a person could perform and put themselves in a situation like that, to where you could actually feel them, just as it was going on at that particular moment, like you were there, at that place."[40]

This spectator attributed the realization of the performance to the actor, rather than to anything he did as the spectator. The actor was identified by many participants as the contributing factor to the sense of realness they felt. It was evident that through the actors' commitment and talent the spectator could accept and believe in the reality presented in the performance; however, this transaction

between actor and spectator is clearly invisible to many spectators. This is an area where spectator response verges away from transactional theory, as no such mediator like an actor exists in the reader-text relationship. In a qualitative study on a museum play about the social and ethical effects of the Human Genome Project, believability was a factor in student responses when they agreed that a sense of realism was evoked through conflict between the characters.[41]

The word *authentic* was used by a number of participants to describe the performance. Magelssen argues that living-history museum visitors' sense of authenticity can be based more on a site's reputation than any other ontological criteria, which may be the case for some people.[42] One participant in this study articulated her belief in the material's authenticity presented to her in the performance because "it was in a museum";[43] however, more data pointed to participants measuring the authenticity of a performance against their own life experiences. In these cases, the performance was described as authentic by spectators because it had elements of history that resonated with their own. This was true for spectators who saw the plays at the Kentucky History Center. Many of these participants felt the performance supported their memories or experiences, or those of relatives, and they brought themselves to the transaction and responded to create a unique performance experience. Again, the actor's portrayal contributed to the sense of authenticity, illustrated in the following comments concerning how actors spoke:

I was so convinced the actor was from Kentucky that I asked him what part of Kentucky he was from, and he said North Carolina. I was convinced he was; he was really good.[44]

I just thought it was a good presentation and stir[red] memories of the past; and her speech was quite good for the period, and farm language.[45]

One quality of the performance that I recall was the way in which the actor spoke, using a very southern accent, which seemed very real. He also used gestures and sounds to convey what had happened to [him] and his friends. His use of the space and the minimal props also lent an authenticity to his performance.[46]

The notion that a performance in a museum can be interpreted as making an idea or exhibition real is echoed in the report "Seeing It for Real."[47] This study compared the experiences of children from four schools at performances at two

museums, the Pump House People's History Museum in Manchester and the Imperial War Museum in London. The authors noted the theme of realness, the feeling that a performance created a sense of reality, was common in the children's responses.

The performances are made real, or realized, by the spectator. They may be judged to be "real" by the spectator, but that is only possible through the work and imagination of the spectator. It is not real in any other sense. I do not mean that the performance contributes little: It is clear from spectator response in my study that the performance, the writing, acting, directing, and any additional sound or lighting is also essential. It must be an equitable transaction between spectator and performance since any lack on the performance's part would lead to lack of investment by the spectator; and, by extension, nothing could feel real.

Both producers (or actors or writers) and spectators of theater in a history site desire the realization of the performance. Some participants of this study talked about and recognized what and how actors spoke and moved to make the experience more real; how light and sound effects were used to make it more real; and all of the details of the narrative, like details about the characters, helped them believe in, relate to, and realize the story. If realized, some participants described moments of transcendence and recognition of the dual realities: within the performance and outside watching the performance. One participant went so far as to describe the moment of watching the actor move from one reality to another. "I remember that when I looked at this young man [actor], he wasn't there; he transposed himself immediately into the character."[48]

Like that participant, others expressed an awareness and appreciation of the theatrical frame, which Baz Kershaw advanced as good practice for theater in heritage sites.[49] They engaged with the ideas within the performances as well as the idea of performance itself.[50] These comments reveal a sophisticated audience, some of whom go so far as to compare theater to other media, as in the following response: "He did a lot with a little, relatively simple, but put the message across very well, appealed to the imagination, what film and television don't do. Radio used to do this, just bare necessities. It's very effective; we don't have to have everything realistic."[51]

This awareness presents a critical aspect to understand about performance in history museums. Spectators have the ability to conceptualize the play form and have a meta-awareness of its effect on them, just as Bateson discovered in his study using monkeys. This is also the ability to see double and blend concepts that Bruce McConachie has proposed are unconscious, neuronal-based capacities in spectators.[52]

When historical-site staff feel that they must submerge the theatrical frame of living history by maintaining only an awareness of the present moment and ignoring contemporary elements like soft-drink machines in order to appear real or authentic, they underestimate their visitor's abilities. Exposing the theatrical frame in the act of breaking it has the potential to lead to a more challenging examination by the visitor of history and time, of their conceptions of past and present. By having an actor declare himself dead, it puts the process of the interpretation of history front and center and allows questions of authenticity and realness to be explored. Breaking the frame allows for dissonance and, like resonance, provokes response.

The benefits of creating a sense of realness in a performance have to do with creating opportunities for aesthetic experiences that will encourage people to be invigorated by connecting with ideas and have a heightened awareness of these ideas going into the future.[53] I hope what I have demonstrated in this essay is that a feeling of realness can emerge from the transaction between performance and spectator even when the spectator is aware of the theatrical frame surrounding the performance event. If the spectator is invited into the play frame through the talents of the actor, the script writing, or the sounds of the scene, they can invest themselves in the performance and, by doing so, contribute to the transaction. Harkening back to Rosenblatt, this reciprocity produces change or growth in both parties. Both the spectator and the performance are realized in the performance event; and in the transaction of making meaning, what is constructed is both unique and transformative to each.

Notes

1. See, for example, Sandra Bicknell and Xerxes Mazda, "Enlightening or Embarrassing: An Evaluation of Drama in the Science Museum," unpublished report (London: National Museum of Science and Industry, 1993); Harry Needham, "Evaluation of Theatre," in *Case Studies in Museum, Zoo, and Aquarium Theater*, ed. Laura Maloney and Catherine Hughes (Washington, DC: American Association of Museums, 1999), 87–99; Lynn Baum and Catherine Hughes, "Ten Years of Evaluating Science Theater at the Museum of Science, Boston," *Curator* 44, no. 4 (2001): 355–369; J. M. Litwak and Andrea Cutting, "Evaluation of Interpretive Programming," report (St. Paul: Minnesota History Center, 1996).

2. Spectator 41, interview by author, telephone, December 11, 2006.

3. Stephen E. Snow, *Performing the Pilgrims: A Study of Ethnohistorical Role-Playing at Plimoth Plantation* (Jackson: University Press of Mississippi, 1993).

4. Scott Magelssen, *Living History Museums: Undoing History through Performance* (Lanham, MD: Scarecrow Press, 2007).

5. Ibid.

6. Anthony Jackson and Jenny Kidd, "Performance, Learning, and Heritage," report (University of Manchester, England: Centre for Applied Theatre Research, 2008).

7. David Filipov, "A history primer come to life," *Boston Globe,* October 21, 2008. http://www.boston.com/news/local/massachusetts/articles/2008/10/21/a_history_primer _come_to_life/?p1=Well_MostPop_ Emailed7 (accessed October 21, 2008).

8. Erving Goffman, *Frame Analysis* (Boston: Northeastern University Press, 1974).

9. Snow, *Performing the Pilgrims.*

10. Ibid., 170.

11. Gilles Fauconnier and Mark Turner, *The Way We Think: Conceptual Blending and the Mind's Hidden Complexities* (New York: Basic Books, 2002).

12. Ibid.

13. Bruce McConachie, "Falsifiable Theories for Theatre and Performance Studies," *Theatre Journal* 59, no. 4 (2007): 559.

14. Anthony Jackson, Paul Johnson, Helen Rees Leahy, and Verity Walker, "Seeing It for Real: An investigation into the effectiveness of theatre and theatre techniques in museums," report (Manchester, England: Centre for Applied Theatre Research, University of Manchester, 2002).

15. Catherine Hughes, "Performance for Learning: How Emotions Play a Part" (PhD diss., Ohio State University, 2008).

16. Greg Hardinson, interview by author, transcribed audio tape, Frankfurt, KY, August 11, 2006.

17. Margaret Ann Brady, interview by author, transcribed audiotape, Boston, MA, September 30, 2006.

18. Snow, *Performing the Pilgrims,* citing Erving Goffman, *The Presentation of Self in Everyday Life* (Garden City: Doubleday. 1959).

19. Gregory Bateson, "A Theory of Play and Fantasy," 1955, reprinted in *The Performance Studies Reader,* ed. Henry Bial (New York: Routledge, 2004), 121–131.

20. Ibid., 122.

21. Louise Rosenblatt, *The Reader, the Text, the Poem* (Carbondale: Southern Illinois University Press, 1978).

22. Marvin Carlson, "Theatre Audiences and the Reading of Performance," in *Interpreting the Theatrical Past,* ed. Thomas Postlewait and Bruce McConachie (Iowa City: University of Iowa Press, 1989), 82–98.

23. Such as David Booth, "Imaginary Gardens with Real Toads: Reading and Drama in Education," *Theory into Practice* 24, no. 3 (1985): 193–198; David Booth, *Guiding the Reading Process: Techniques and Strategies for Successful Instruction in K-8 Classrooms* (On-

tario, Canada: Pembroke Publishers, 1998); and Thomas Crumpler, "Educational Drama as Response to Literature: Possibilities for Young Learners," in *Process Drama and Multiple Literacies: Addressing Social, Cultural, and Ethical Issues,* ed. J. Schneider, Thomas Crumpler, and Theresa Rogers (Portsmouth, NH: Heinemann, 2006), 1–14.

24. Carlson, "Theatre Audiences and the Reading of Performance."

25. Susan Bennett, *Theatre Audiences: A Theory of Production and Reception* (London: Routledge, 1990), 65.

26. Rosenblatt, *The Reader, the Text, the Poem.*

27. Phillip Harth, "The New Criticism and Eighteenth-Century Poetry," *Critical Inquiry* 7, no. 3 (Spring 1981), online at http://www.jstor.org/pss/1343116: internet: (accessed October 11, 2008).

28. Carlson, "Theatre Audiences and the Reading of Performance."

29. Rosenblatt, *The Reader, the Text, the Poem.*

30. R. E. Probst, "Transactional Theory in the Teaching of Literature," ERIC Document Reproduction Service No. ED 284274 (Urbana, IL: ERIC Clearinghouse on Reading and Communication Skills, 1987), 2.

31. Wolfgang Iser, *The Act of Reading: A Theory of Aesthetic Response* (Baltimore and London: Johns Hopkins Press, 1978).

32. Rosenblatt, *The Reader, the Text, the Poem,* 18.

33. Spectator 4, interview by author, transcribed videotape, Kentucky History Center, Frankfort, KY, August 5, 2006.

34. Rosenblatt, *The Reader, the Text, the Poem.*

35. Ibid.

36. Penny Bundy, "Aesthetic Engagement in the Drama Process," *Research in Drama Education* 8, no. 2 (2003): 171–181.

37. Ibid., 180.

38. Hughes, "Performance for Learning."

39. Victor Turner, *From Ritual to Theatre: The Human Seriousness of Play* (New York: PAJ Publications, 1982).

40. Spectator 42, interview by author, telephone, January 15, 2007.

41. Dana Black and Alexander Goldowsky, "Science Theater as an Interpretive Technique in a Science Museum," paper presented at the meeting of the National Association of Research in Science Teaching, Boston, MA, 1999.

42. Magelssen, *Living History.*

43. Quoted in Hughes, "Performance for Learning."

44. Spectator 36, interview by author, telephone, January 6, 2007.

45. Spectator 27, interview by author, telephone, January 6, 2007.

46. Spectator 10, interview by author, e-mail, January 11, 2007.

47. Jackson et al., "Seeing It for Real."

48. Spectator 15, interview by author, telephone, December 11, 2006.

49. Baz Kershaw, *The Radical in Performance: from Brecht to Baudrillard* (London: Routledge, 1999).

50. Bundy, "Aesthetic Engagement in the Drama Process."

51. Spectator 55, interview by author, telephone, December 13, 2006.

52. McConachie, "Falsifiable Theories for Theatre."

53. Bundy, "Aesthetic Engagement in the Drama Process."

Dinner: Impossible

"Medieval Mayhem" at the Maryland Renaissance Festival

Kimberly Tony Korol-Evans

Good afternoon, Reader. Your mission, should you choose to accept it, is to visualize a world lit only by fire, a time and place in which there are no televisions, no computers, no cell phones. In fact, imagine there is no electricity at all. Envision spending days, weeks, and even years attempting to recreate a time and place removed by nearly five hundred years and thousands of miles. See yourself traveling back in time to the year 1540 and dressing, talking, working, and eating just as the people of Tudor England did. Now, picture your perfect, pastoral setting being invaded by people from the present day, complete with lights, cameras, and the attending people to run them. This is the crux of the intrastice, a place that is both here and there, now and then, and it is exactly where the members of the household of Hengrave Hall, a living history performance company at the Maryland Renaissance Festival (MDRF), found themselves in the fall of 2007 as Chef Robert Irvine and his *Dinner: Impossible* legion invaded the village.

On most Saturdays and Sundays in September and October, the living history pavilion at the MDRF in Crownsville, Maryland, is alive with activity as numerous members of the Company of St. George bustle and buzz around the bower. Clad in their taxicab yellow and black garments, their movements remind onlookers of bees swarming around a hive, engaged in an intricate dance only they understand. Throughout the day, the members of the Company of St. George present living history shows on topics ranging from arms and armaments of the sixteenth century to Tudor herbal remedies. The performers serve the lady of the manor and other members of the court as they stop in to visit in the idyllic setting. Visitors to the village of Revel Grove, the sixteenth-century English city portrayed at the MDRF, converse with the members of the household of Hengrave Hall, the name of the manor home to which the livery-clad servants are attached. Often these patrons will watch one of the scripted performances; frequently, they will merely stop by to chat, ask questions, and gain information about the Tudor era. Sometimes these visitors will even try their own hands at one

of the sixteenth-century tasks the household members are accomplishing. The purpose of this living history component of the MDRF is to answer any questions about the time while the members of the company maintain their assigned characters through first-person interpretation. Most weekends in the fall they do exactly that; however, one weekend in the autumn of 2007, the activity at the living history pavilion took on a whole new dimension as twenty-first-century television production descended on the sixteenth-century pavilion.

Reality television has become a mainstay of contemporary programming. Television cameras invade even the most private of spaces. Cable networks focus on individual topics ranging from history to sports to food. Out of the last category sprang a television phenomenon called *Dinner: Impossible.* In September 2007, Food Network's *Dinner: Impossible* chef Robert Irvine, one of his assistants, and an entire filming crew appeared at the MDRF and took over the living history pavilion. That day visitors were unable to ask questions inside the living history area, and members of the household of Hengrave Hall had to focus as never before on their tasks as they were working to continue an illusion of sixteenth-century England while simultaneously providing background entertainment for the twenty-first-century television crew. This essay explores that intersection as I engage issues of enacting history through historical meal-making. When issues of historical accuracy and authenticity collide with the desire to make an event "theatrical," a time and space overlap must be negotiated. In this episode of *Dinner: Impossible,* King Henry VIII (Fred Nelson) challenges Chef Robert Irvine to create a sumptuous Tudor feast fit for a king, his bride-to-be, Princess Anna of Cleves (Paula Peterka), and the entire royal court. Irvine is given seven hours to prepare a multi-course meal using only period ingredients, recipes, and cooking utensils. Irvine's primary aid for the show is Lady Washington (Laura Kilbane), who assures things are being done as much by sixteenth-century standards as possible while Irvine seeks to create his magnificent meal. By analyzing the televised performance in conjunction with conversations with people involved, I seek to explore what happens when the enacting of history is brought to a television audience. This contrast often exists between living history and historical elaboration even within the MDRF venue itself. When the needs of television, which fall heavily on the side of historical elaboration, are added to the mix, the tension is magnified.

In order to understand the collision between the demands of historical enactment and the requirements of television production, I first explicate the theory of the intrastice, which is a state within the overlap of the historical record of the sixteenth century and the reality of the twenty-first century. This overlap occurs as various players in the day's events frame what is occurring in a multitude of

ways. I then relate the history and function of the Company of St. George (also known as the Household of Hengrave Hall) at the MDRF, chronicle the story of *Dinner: Impossible,* and explore how these two groups came together. Finally, I analyze how the collision between these two developed and transpired within the intrastice in order to illustrate how enacting history can come alive on the television screen.

The filming of *Dinner: Impossible* at the 2007 MDRF occurred within the intrastice formed by the overlap of the reality of twenty-first-century America and the historical record of sixteenth-century England. The pretext created is the village of Revel Grove, where the MDRF occurs each fall. In the intrastice, actors at and visitors to the village experience an overlap between the then and there of sixteenth-century England and the now and here of twenty-first-century United States. This both/and experience allows performers and patrons alike to enact history in an embodied manner. Living history is just one aspect of the performances that take place at the Maryland festival. Members of the Company of St. George are different from the other cast members who form the Company of the Rose because the members of Hengrave Hall focus, in particular, on living history, while the Rose actors, the members of the cast who act as village and court characters on stage and in the streets of Revel Grove, participate in historical elaboration. Much of the difference between the two approaches is illuminated through Erving Goffman's frame analysis. Goffman writes that a frame is a "definition of a situation . . . built up in accordance with principles of organization which govern events—at least social ones—and our subjective involvement in them."[1] The members of the Company of the Rose view themselves as actors performing in a theatrical venue, and thereby they participate in historical elaboration. The performers in the Company of St. George see themselves as reenactors, performing in an educational capacity, and, therefore, consider what they do as living history.

Living history and historical elaboration at the MDRF are different both in form and function. I examined several different definitions of living history, but found that many of them were tautological in nature. Exploring the work of living history scholar Jay Anderson and folklore scholar Rory Turner, I combine and refine their discussions of living history and create a definition of my own: a performative attempt, for pedagogical purposes, to reproduce the essential features of past events in the contemporary world. St. George's motto, "God is in the details," reflects the definition I have synthesized for living history, equating the details of the St. George motto to the "essential features." The members of the Household of Hengrave Hall use the details as the building blocks of their performances. On the other hand, historical elaboration is a term I have coined to explain the type of performances that occur at contemporary American Renais-

sance festivals that are not centered on pedagogy. I define historical elaboration as the process by which a theatrical practitioner takes previously accepted notions of truth and individually extrapolates from them an extended reality through the playwright's, director's, designer's, and/or actor's depiction and/or portrayal of a non-fictional character and/or character type in an interactive performance venue. Looking closely at these two definitions, it is clear that historical elaboration features a greater sense of theatricality, while living history, although still performative in nature, is primarily pedagogical in nature. At the MDRF another difference emerges with regard to locale. The actors of the Company of the Rose, who perform historical elaboration, continuously walk the lanes of Revel Grove, performing in multiple locations throughout the day. Conversely, the Company of St. George members perform in a single location called both the living history pavilion and the Household of Hengrave Hall.

The History of the Company of St. George

With these definitions in mind, I turn to examine the history of the Company of St. George, a group that has experienced a significant metamorphosis since its inception in 1998, when it operated not as the Household of Hengrave Hall but as the separate guilds of St. George (court characters) and St. Genesius (village characters). The primary focus of these guilds was to act as a sort of supernumer-ary, increasing the numbers of villagers and courtiers available for street perfor-mances while the more experienced actors were on the stage. The guilds began to take on a living history focus because the Maryland festival entertainment di-rector, Carolyn Spedden, chose Larry and Paula Peterka as directors. Combined, the Peterkas have a total of more than fifty years experience working at Renais-sance faires in Maryland, Virginia, and California, at which they have focused on living history as opposed to historical elaboration. By conducting research with primary documents in several languages and artwork from multiple countries, reading critical sources and evaluating them against their primary evidence, and then embodying that knowledge by performing it, the Peterkas and the Company of St. George test and retest whether it is feasible and viable knowledge, thereby creating a form of ethnohistorical research.

In 1999, the Guilds of St. George and St. Genesius became the Household of Hengrave Hall.[2] The Peterkas chose to portray Sir Thomas Kytson and Margaret Donnington (Lady Kytson), the owners of Hengrave Hall, a grand manor home in Suffolk, which is extant and recently sold its archive of documents, dating back to the sixteenth century, to Cambridge University. In 2000, the Guild of St. Genesius became an actor-training program separate from St. George. MDRF

entertainment director Carolyn Spedden's letter to returning actors explained St. George's concentration: "The Guild of St. George will focus on living history, daily life activities at the festival. . . . Members of the Guild will still be a part of the Household of Hengrave Hall. But the focus of the guild is history."[3] With smaller numbers and a physical location designated for their use, the Peterkas and the members of St. George (then called a guild and not a company) began to focus even more heavily on daily life activities in which they could perform certain essential features of sixteenth-century England.

Paula Peterka illuminated the purpose of St. George in a 2002 e-mail sent to the group's Listserv:

> One thing I can definitely say that we are not is a LARP (Live-Action Role-Playing Game), in its most common context, even though we are live action, and we are certainly playing roles, because not everyone we come in contact with is playing roles, and we are not doing this solely for our own enjoyment (although it is enjoyable). We do this to educate and entertain the public, who pay us to do so. I firmly believe in both aspects, education and entertainment, and to put a finer point on it, education through entertainment. History is not dull boring dry stuff, the way it's taught in most schools. It's colorful, vibrant, interesting, gritty; the stuff soap opera writers only dream of putting in their scripts but can't because no one would believe it. It is the story of all of us.

Peterka emphasized the importance of the pedagogy that St. George provides for the visitors to the MDRF. She was also careful to explain that it is possible to provide that information because they are doing so in an entertainment venue. This concept of "education through entertainment" is critical to understanding the difference between living history and historical elaboration.

The MDRF's equivalent of a playbill lists the Household of Hengrave Hall as a living history entertainment; and the workers at customer service as well as actors in the Company of the Rose direct patrons to the members of St. George if the visitors express an interest in learning more about the time period, the history, or particular areas in which the Hengravians have expertise. Patrons search out the members of St. George to ask them pertinent questions precisely because the festival—and now the spectators—have framed Hengrave Hall as a repository of historical knowledge. Goffman defines a primary framework as something that renders "what would otherwise be a meaningless aspect of the scene into something that is meaningful."[4] Without the framing, the visitors to the village would be unable to differentiate between the living historians and the actors who par-

ticipate in historical elaboration. The differences are obvious because the festival and the patrons both frame the work the Company of St. George performs as living history. Several reasons exist for this rendering: the members use fewer anachronisms, pay greater attention to historical detail, and undertake research using primary documents from libraries, including Johns Hopkins University, the University of California at Los Angeles, and the Folger Shakespeare.

The standards of dialect, costuming, and properties are different for the Hengravians than for the Company of the Rose. For example, the actors in Rose speak in either "received pronunciation" (RP) or Cockney, neither of which is period appropriate. Popular culture assigns RP to higher classes and Cockney to lower classes. On the other hand, Peterka attempts to guide the members of St. George in a slightly different pattern of accent than either RP or Cockney, one based on linguistic research on the Great Vowel Shift (GVS) performed by Dr. Melinda J. Menzer at Furman University. Thus, the St. George members are attempting performance based upon Menzer's theoretical writings, in essence using living history performance to test her theories on the GVS. Peterka admits that the performers succeed to varying degrees. Nonetheless, the undertaking is another component of the embodiment of historical research that marks the living history performance. The visual aspect of the Hengravians is different as well. All costume pieces must be approved by either Paula Peterka or Laura Kilbane, the assistant director of St. George, who has a master's degree in secondary education and is working toward a Master of Arts in British history from the University of Maryland. According to Paula Peterka, there are specific requirements for the costumes that members of Hengrave Hall wear, including appropriate sewing patterns and types of fabric as well as the manner in which these may be worn. In addition to the costuming requirements, the group is very props intensive. Because the Hengravians have a specific space in which to work, there is a place for all of the properties, which include drop spindles and wool, butter churns, wood carving supplies, cooking utensils, and arms and armor, as well as food, herbs, and soap-making ingredients. Why are properties and costumes so important to the creation of the living history mission? According to Turner, "The items are tangible objects that embody the world of the past. They are the props that recreate the past as a lived context, a creation central to the reenactment experience. Tactile, sensual, aesthetic, the material culture of reenacting persuades the experiencing body of the reenactor that he can participate in the Civil War world."[5] These same physical elements, clothing against the skin and properties with which the living history performers at the MDRF work, operate in a similar manner, invoking an embodied experience of a past none of the participants ever actually lived.

Through the tactile experiences, the members of St. George gain an insight into the world of sixteenth-century England that does not exist if one merely pretends to use an item rather than actually employing it. According to Peterka, "I read; I study; I question; I go to historical sources and try to read and understand those. I read descriptions and interpretations of historical sources. And then after I read and I study and I learn and I get a handle on the how and the why and the where, I go out into the field and try to make this stuff work. Sew the clothes and wear them. Build the fire and cook food."[6] Unlike reenactors who are performing for themselves, the members of St. George are also charged with educating the patrons. The spectators are there to learn, to gain knowledge that the living history performers exhibit through their use of the items representing the material culture of the sixteenth century. As Stephen Eddy Snow writes of Plimoth Plantation, "for the truly interested, workshops are sometimes given in the village on how to cook over an open hearth or how to rive a piece of oak. A few individuals are enthusiastic enough to study the historical texts and re-create tools, weapons, or clothing on their own."[7] At the living history pavilion, the workshops also disseminate knowledge, with specific shows on period cooking, defense, and daily diversions, in addition to the activities that are constantly taking place.

The period cooking show for the Company of St. George began in 2001 at the first permanent site for the Household of Hengrave Hall. Larry Peterka had encouraged his wife, Paula, to perform a sixteenth-century cooking show for some time, and that season she finally acquiesced as her character and another, the Duchess of Norfolk, hosted *Cooking with the Kytsons*.

Here, I must comment that I co-hosted the original season of *Cooking with the Kytsons*, portraying Elizabeth Stafford Howard, the Duchess of Norfolk, in 2001 at the MDRF. Much of my research on the festival culture both in Maryland and in other parts of the country has come from ethnographic research in which I participated in what performance studies scholar Dwight Conquergood has labeled "co-performer witnessing."[8] By using this form of research, I am avoiding the trap of privilege, in which academia focuses on study from a distance, looking down upon its subjects from the outside. Instead, I performed with the people with whom I worked, creating an intimate, personal level of knowledge otherwise unattainable.

Peterka and I spent significant time poring over period cookbooks and choosing appropriate recipes for the show. Peterka even translated recipes from German. Furthermore, Kilbane, who was in her first year at the festival in 2001, became an integral part of the show's performance as the weeks went on. She eventually became responsible for the food plan for the Company of St. George, employing her own historical research on period foods.

Cooking with the Kytsons was a nine-week, period-cooking show that provided information on everything from the most basic elements to extravagant subtlety foods. Each week, Peterka and I covered a different topic on sixteenth-century cookery in the half-hour show, and we provided *receipts* (the Tudor term for recipes) for each topic. The first week focused on cooking fundamentals and included receipts for almond milk, verjuice, and pastry dough. In the second week, we discussed pies and pasties, and the third week featured vegetables and other supporting dishes. In weeks four and five, we demonstrated beverage and dessert preparation. Dairy, fish, and meat were the topics we covered in weeks six, seven, and eight. Finally, in week nine, we explained and prepared subtlety foods, the extravagant and lavish dishes for which the court feasts of the period were famous. The show was set up in these segments so that if someone came to see it once, he or she could come away from *Cooking with the Kytsons* with a single idea of something to make from the sixteenth century; however, if patrons chose to attend for all nine weeks, they received a complete course in Tudor cookery, and we had many visitors to the village who did, indeed, attend each and every week.

The show continued on for several years with different members of the household, including Kilbane, at the helm. Much like the explosion in popularity of the Food Network, the show was patronized by visitors to Revel Grove in strong numbers. With Peterka's guidance and Kilbane's consistent participation, the show was always a success. When I came back to perform for a weekend at the festival in 2005, I stepped back into the show for a day. The show continued to exemplify the definition of living history: a performative attempt, for pedagogical purposes, to reproduce the essential features of past events in the contemporary world. The show was not merely educational. They did not deliver the cooking class as a lecture but rather as a performance. Nonetheless, the Company of St. George cooks were reproducing the "essential features of past events" as they created dishes the same way they would have been made nearly five hundred years earlier, using only period ingredients and tools. Thus, when *Dinner: Impossible* came to film in 2007, St. George was prepared with the historical background of sixteenth-century cooking techniques; however, the intrusion of the twenty-first-century needs of television production still needed to be managed.

The Story of *Dinner: Impossible*

In the past decade, the Food Network has exploded in popularity. Once, the only show many people knew was *Iron Chef.* From that popular show, many more have sprung, ranging from *Good Eats*—the basic ins, outs, hows, and whys of cooking—to *Food Detectives,* which merges science and food, to *Ace of Cakes,* which

features cakes created in the most unusual shapes. One of the programs that has captured the audience's imagination is *Dinner: Impossible.* The name of the television show is a play on the 1960s' *Mission: Impossible* program, famous for its soundtrack and signature match lighting. At the beginning of each episode, a disembodied and recorded voice, played on a phonograph or a cassette recorder, presented the star of the show with a difficult mission—often involving exotic locales and such dangers as nuclear warheads—and always included the words "your mission, should you decide to accept it." *Dinner: Impossible* begins much the same way, with the star of the show, the head chef, being greeted by a disembodied voice coming from a sports car; however, even this is a theatrical nod toward historical elaboration since the chef does not actually receive the challenge from the disembodied voice in the car. The voice-over mission is solely for theatrical purposes. Someone at the mission site delivers the challenge to Irvine.

Also unlike the original *Mission: Impossible,* in the new program the chef does not have to save the world but instead must create a difficult meal in a specified amount of time. According to Food Network's Web site, the chef is "challenged to overcome culinary obstacles and deliver a delicious meal before his time runs out."[9] The chef, of course, accepts each meal challenge and attempts to make dinners at a variety of events and sites across the United States. From the time *Dinner: Impossible* premiered on January 24, 2007, until the end of season four in the summer of 2008, the chef creating the impossible dinners was Robert Irvine.[10] Prior to the challenge at the Maryland Renaissance Festival, Irvine had prepared meals in settings as varied as a Philadelphia Eagles football game—where he had to beg, borrow, or buy with only three hundred dollars all the food and the means to cook the meal from the tailgaters in the parking lot—to a frat house that was so disgustingly dirty that the majority of the first two hours were spent on cleaning.

In the fourth episode of the first season, which aired almost exactly one year before the MDRF show, Irvine was confronted with the problems of historical meal-making when he visited Colonial Williamsburg in the episode "Back in Time: Ye Ol' Dinner Impossible." The Food Network Web site reports that the chef had to create an eighteenth-century meal using only "methods, tools, and ingredients from the 1700s."[11] During this particular episode, Irvine lost nearly an hour of cooking time when he was unable to light the fire using the prescribed method. Finally, one of the Colonial Williamsburg historians succeeded in producing flame, and Irvine and his two sous chefs, George Galati and George Kralle, set to work preparing a multi-course feast for six people, including the Colonial Williamsburg food historians. According to TV.com, Irvine faced more hurdles than just the lighting of the fire. The Web site lists milking a cow, using a clock-jack to turn the spit, making cheese out of milk and rennet, and employing a

birch-wood whisk to mix ingredients as eighteenth-century practices the chef had to conquer.[12] For the MDRF show, Irvine would have to "travel back two more centuries" in order to accomplish his task. TV.com quotes Irvine as stating, "If you are a chef, your life is devoted to giving pleasure to other people. We are creative and what we create is gone almost instantly, but there's always the thought that maybe tomorrow we will create something even more spectacular."[13] He probably had no idea that the chance would come to create something more spectacular with even older period methods and tools.

Of Food and Festivals

The creation of the half-hour television program filmed at the MDRF was months in the planning. Paula Peterka, who was the chief liaison between the festival and the television program, said, "I was contacted by Carolyn Spedden, the entertainment director at the festival, who said they had been contacted by the producers of Shooters Incorporated, which produces *Dinner: Impossible* for the Food Network." Once the *Dinner: Impossible* producers had pitched the idea to Spedden, it was logical that Peterka become involved because, as she states, "I was probably the most knowledgeable person on the festival site about historical foodways in this time period." In addition to an extensive library of Tudor-era cookbooks, Peterka had the experience of being the co-creator of *Cooking with the Kytsons,* which she performed in for several years, and extensive experience cooking over an open flame at living history competitions.

Peterka was involved in every stage of the planning process. One of the first issues the MDRF had to address was the absence of a period kitchen on site. For the *Cooking with the Kytsons* show, the living historians prepared the food in front of the audience and then showed the finished product, but did very little open-flame cooking at the faire. So, the owners of the festival and Peterka set out to re-create a period kitchen. Peterka recounts, "I was involved in the design and planning stage with Adam Smith and Jules Smith, with what the historical kitchen would look like. The Smiths were very knowledgeable about outdoor cooking. They got their start with a bakery at the Minnesota Renaissance Festival." Before opening the Maryland faire, the Smiths had participated at one of the earliest contemporary American Renaissance festivals, running an on-site bakery at the Minnesota faire, so they, too, had prior experience with period foodways. Jules Smith Jr. was the general manager of the MDRF and responsible for day-to-day operations of the entire festival, and Adam Smith and his brother, Marc Smith, served as site managers for the MDRF. Adam Smith did a vast majority of the

building on the site, so it was natural that he be tasked with the creation of the hearth necessary to accommodate both the historical and television needs. According to Peterka, "I brought with me research I had done on period ovens and kitchens. I showed them images and pictures and books about cooking both inside and camp kitchens . . . [and] raised hearths and ovens and cook-top-type surfaces. My favorite [cookbook] is *All the King's Cooks.* I also have a lot of other period cookbooks and most of them are illustrated with woodcuts and paintings of the time. *All the King's Cooks* is a book about the two kitchens at Hampton Court. It's dead on to our period." Using their own knowledge and the information Peterka provided, the Smiths began the process of building the period outdoor cooking area.

Once she had given her input on the design of the oven, Peterka's focus shifted to the creation of the challenge for Irvine. Although she had only seen an episode or two of *Dinner: Impossible* before she became involved in the project, Peterka says she began to watch it religiously afterward. She admits she gave careful thought to what the challenge would be because she was certain the MDRF episode would be compared to the Colonial Williamsburg challenge, and Peterka wanted to make them different. She recounts that eventually she decided on the following challenge for Irvine, and she adds explanations on the various parts of the meal:

> He was going to have to come up with a typical Tudor banquet, with a first course, a second course, and a desert or voiding course. You're voiding (leaving) the table. You're deserting the table, that's where desert comes from. A course is all the dishes that are brought out in each. You had a selection of a wide variety of things in that first course. You would have chicken and pheasant and small birds and mutton and venison and a savory pie and a pork pie and sops of diverse things and you would have bread. You would have a splendid display of different types of food all mixed together in one course. Everything that you would see on an average American table at Thanksgiving and Christmas, that's your first course. Imagine everything you would see at Easter and a New Year's buffet; that's your second course.

For the challenge, Irvine had to choose to make dishes from five of seven categories for each of the first two courses, followed by four dishes for the desert or voiding course. The seven categories from which Irvine could choose for the first two courses included meat, poultry, fish, soup, a side dish such as rice, a vegetable, and a savory pie. Irvine was required to prepare two courses of five dishes each,

similar to the mission he faced at Colonial Williamsburg. However, at the MDRF, Irvine was cooking outside and also had to add a desert course. Furthermore, for the Colonial Williamsburg episode, Irvine was only cooking for six people. For the episode at the MDRF, he had to prepare enough food to feed thirty.

Peterka recounts that she and Kilbane, who became involved during the meal-planning stage, spent hours scouring period cookbooks to create the challenge idea. "Quite a few of the books have not only the recipes, but they also have menus for the coronation of this king or menu for the elevation of this archbishop. That's where we got a lot of our ideas. We wanted it to be representative." However, while they focused on the historical accuracy of the number of dishes and types of food, Peterka admits they bowed to the needs of the twenty-first century by not incorporating some important historical information into the challenge. According to Peterka, "We didn't pay too much attention to this, but you have to have a balance of foods for health reasons because if you have dishes that are wet and warm you want to balance them with dishes that are dry and cold. I'm not talking about temperature; I'm talking about the four humors. Eating too much food in one type of humor will overbalance and make you sick. That's the Renaissance mindset. I really didn't think Irvine wanted to get into the diet and nutrition beliefs of the sixteenth century." So while in some ways she was determined to make the challenge as historically accurate as possible, she still knew that Irvine would have to function in the intrastice, in the space within the overlap of that sixteenth-century historical knowledge and the requirements of twenty-first-century television production.

The last part of the preparation in which Peterka took part was purchasing ingredients for the show. Peterka; her husband, Larry; assistant producers from *Dinner: Impossible;* Kilbane; and Cindy Anderson, who also participated in the show, went shopping for food. Peterka recounts, "Based on the dishes and the recipes [that Laura and I had researched], we picked ingredients that could be used for whatever options he chose. We went to the Amish market, and we went to Whole Foods, and we bought all of the raw ingredients that he uses on the show," with a few exceptions that I will explain in greater detail further below. She continues, "The village of Revel Grove doesn't actually have anywhere to buy ingredients unless you go to all of the food booths and try to buy stuff. Instead, we went and bought food that was typical of the fall in that time period in that region of the world." With that preparation finished, Peterka turned the running of the actual cooking show over to Kilbane because in 2007 she was no longer playing Margaret Donnington, Lady Kytson, but rather was portraying Anna, the Princess of Cleves, who was engaged to King Henry VIII.

"Medieval Mayhem"

The tension between the needs of twenty-first-century television production and sixteenth-century historical meal making are evident from the beginning of the episode of *Dinner: Impossible*. The title of the show is "Medieval Mayhem." I can only assume that this appellation was chosen because of the alliteration since it makes no sense whatsoever in the historical context. The performances at the Maryland Renaissance Festival portray the sixteenth century in England during the reign of Henry VIII, and the particular year portrayed during the 2007 season was 1540, placing the faire squarely within the middle of the English Renaissance. While the producers of *Dinner: Impossible* are not the first to conflate the two periods, as a Tudor historian, I shuddered when I saw the title.

When Irvine arrived at the festival site on September 29, 2007, it was King Henry (Fred Nelson) who issued the following challenge: "Welcome to Revel Grove, dear friend. Hast thou any idea why you are here today? Know ye thy task this day dear friend? You are to create a royal feast for thirty people. One designed to please a queen and a king."[14] Irvine's response is initially simple, stating he has cooked for a king and queen before.[15] He then adds, "Where do I cook and where is the food?" A voiceover then illustrates Irvine's thoughts about the challenge and illuminates the collision of sixteenth and twenty-first centuries in the intrastice: "This king tells me I have seven hours to prepare a feast for thirty, which sounds simple, but I have to cook in a medieval kitchen with no modern tools or equipment. . . . So I have to cook a feast with no electricity." Although he is still unaware of the specifics of the task ahead, Irvine now knows what the mission is for the day, and his voiceover to the television audience indicates an awareness of at least some of the difficulties he is going to face.

Following the issuance of the challenge, Irvine is escorted to the kitchen by Zack Rackham (played by Tom Plott), and there he meets the women who will be helping him in his challenge, Lady Washington (played by Kilbane) and Mistress Cindy (portrayed by festival costume designer Cindy Anderson). Also waiting for him at the living history pavilion is his sous chef, Dave Britton II, who has already been costumed. After Irvine laughs at Britton's clothes, the introductions begin. Kilbane greets him, "Well met, Master Irving. Welcome. You are well met to Revel Grove. Well, good sir, please come. This is the household of me and my brother, Sir Thomas Kytson." Before she can say another word, Irvine stops her, saying, "I'm sorry. Stop here. Get that lit quickly," as he points to the hearth. The television program then flashes back to Irvine's time in Colonial Williamsburg, and his voiceover plays: "In historic Williamsburg, I learned that heating

up ye old hearth was the first thing that needed to be done. In Williamsburg, I was cooking eighteenth-century style. Here I'm going back two centuries earlier, where the cooking techniques were even more primitive." Having lost so much time in Williamsburg, it was obvious that Irvine did not want a repeat performance. His basic knowledge of the requirements of living history served him well in this instance. Fortunately for the chef, it was not as difficult a task as his previous experience with living history. According to Peterka, "What we did was we didn't light the hearth or the stove top or cooktop but because bread ovens take so long to heat up . . . we used pre-lighting of the oven the night before. We lit a fire in the oven, so there were coals he could use to light the hearth. He didn't have to use flint and steel, which is more accurate to our period because you wouldn't let the coals go out." Although on original examination the concept that the fire would not have to be lit appears to be a nod to twenty-first-century production needs, Peterka's explanation clearly illustrates that the fire would have been kept burning constantly during the Tudor era, precisely to avoid the need to keep relighting and reheating the cooking spaces.

After making certain that the fire is being lit, Irvine receives his first real lesson in Tudor living history when he begins to examine the rest of the kitchen. When something goes wrong during the show, Irvine often is heard to scream, "Whoa. Whoa. Whoa." This usually occurs at least once during each of the twenty-eight episodes prior to the filming of "Medieval Mayhem." It is a tension-creating moment and frequently happens immediately before a television commercial break, thus creating a desire for the audience to watch through the commercials to see what has upset the super chef. The following exchange between Kilbane and Irvine clearly illuminates the tension between needs of living history and television production:

KILBANE: We have the table laid out, ready for you to cut on.
IRVINE: Whoa. Whoa. Whoa. Whoa. Cut? I can't cut. Where's the cutting boards?
KILBANE: The table *is* the cutting board, good sir. *(She demonstrates.)* You remove the cloth, cut upon it, put the cloth back.
IRVINE: What about cross-contamination and stuff?
KILBANE: Well, we'll clean it off.
IRVINE: With what?
KILBANE: Water, soap.

An Irvine voiceover explains that while those in the sixteenth century were apparently not concerned with food safety, he will not compromise on it, but ap-

parently Kilbane's assertion that the cutting surface will be cleaned with soap and water staves off any further issues with the visiting chef. Then Irvine sees the cutting implements with which he has to work. Normally, he travels with his own set of titanium knives, but part of the challenge is to use only period-appropriate implements. Kilbane explains, "And there are your knives. They were just sharpened this very morning." As Irvine picks up the knives, the disdain on his face is evident, and, completely ignoring that Kilbane is remaining totally in character as Lady Washington, he asks, "Are these original knives?" Since Kilbane will not break character, she replies as Lady Washington would—"Aye"—even though the knives, while looking authentic to Irvine, are not actually period pieces from the Tudor era. Living history won that particular bout between historical authenticity and television production. Even though Irvine eventually needs to resharpen the knife, he does so on the stone of the hearth, and he uses only the period cutting implements throughout the show.

Anderson then announces that it is time for the chef himself to dress for the occasion. Another tension between historical elaboration and living history becomes apparent in the clothing choices for both Britton and Irvine as well as Kilbane and Anderson. Peterka explains, and it is worth quoting at length as the differences in costuming are indicative of the gap between living history and historical elaboration:

> We dressed his sous chef, Dave Britton, in a very historically accurate parti-colored, linen-skirted jerkin. For theatrical reasons, they put Irvine in a kilt. We have one person with a living history background (Laura Kilbane, who plays Lady Washington) who is in a historically accurate working costume made of wool. Cindy Anderson, who is the costume designer for the festival, is wearing a Renaissance faire costume as opposed to a reproduction.
>
> Cindy Anderson is wearing what I believe is a white cotton drawstring neck chemise with blue embroidery-like print on the sleeves, underneath a dark blue front-lacing bodice that laces through metal grommets, a white, blue-flowered-pattern underskirt, a blue cotton overskirt, a white apron with blue patterns on it, and her hair is held back by a clip or two, but it is loose and free-flowing. When [Kilbane] greets him at the beginning, she's wearing her normal dress for the day, [a white linen] shirt, a white silk kirtle embellished with pearls and garnets over a farthingale or hoop skirt, and a red silk over gown that has heavily embroidered silk sleeve turn-backs that is much too nice to cook in. She also has a French hood on.
>
> [During the cooking part of the show,] Laura Kilbane is wearing a white

linen shirt with a square neckline and tapered sleeves under a brown wool kirtle with hooks and eyes in the front, with dark brown velvet banding at the neckline. She is wearing a white linen apron and a black velvet and silver net caul over her hair that befits her station as a knight's widow.

Anderson's dress and that of Irvine are accommodating the needs of historical elaboration in which a theatrical practitioner takes previously accepted notions of truth and individually extrapolates from them an extended reality. In addition to the kilt, Irvine remains in his signature black T-shirt for the cooking portion of the show. Only when he is going to meet the king does Irvine don a period-style shirt. On the other hand, through costuming choices alone, Kilbane and Britton are exhibiting more of a focus on living history through the attempt to reproduce the essential features of past events in the contemporary world. This difference represents the multiple layers of immersion into the intrastice that performers and patrons alike find at venues such as the MDRF. The visual effect of the two side by side on the television show is more than a bit jarring. Sometimes living history and historical elaboration co-exist with little difficulty; at other times, especially when the differences are obvious, performers and patrons viewing the two practices simultaneously might have a difficult time understanding exactly what is being portrayed. In addition, if a patron, for example, moves from one type of performance to the other, it is possible that it will re-key the frame for what is happening. According to Goffman, in keying, "a systematic transformation is involved across materials already meaningful in accordance with a scheme of interpretation, and without which the keying would be meaningless. Participants in the activity are meant to know and to openly acknowledge that a systematic alteration is involved, one that will radically reconstitute what it is for them that is going on."[16] Sometimes that radical reconstitution happens without the patrons' knowledge, and it creates a harsh effect as the visitors to the village do not know what has changed.

Once Irvine is dressed, but before he can begin cooking, he needs to get the ingredients for his meal. Although Peterka and the producers bought the foods beforehand, in the program Irvine goes from booth to booth at the festival looking for ingredients. "The part where he's running around the village trying to get ingredients and provisions from different people is purely theatrical performance," Peterka says, "because at that point in the faire during a faire day it would have been virtually impossible to get to a store, get his ingredients, and get back to the faire site." The traffic delays between the interstate exchange and the MDRF can reach up to two hours or more during the height of the faire season. Furthermore, leaving the village would have broken the illusion that even historical

elaboration creates. Nonetheless, the theatricality created by Irvine's dash around the village is less than historically accurate. Peterka explains, "For dramatic tension, we had him travel to various locations around the faire and ask for [ingredients], with actors playing different notables. Had it really been England in 1540 and he had needed to cook for the king, the household would have had everything right on hand." Once Irvine did have everything on hand, the process of planning and creating the meal began back at the living history pavilion.

The Hengrave Hall household functioned on that day very much like a sixteenth-century manor home would have in the case of hosting a dignitary such as King Henry VIII. According to Peterka, the members of the Company of St. George

> functioned as kitchen assistants. They functioned as crowd control to keep the interested patrons away from filming. They were general assistants, and at one point comic relief. They served the meal. They functioned as general clean-up. They really served as the support staff. They all really did an excellent job. They put together every bit of living history training and interactive training for years to good use. Even though they were doing this for a television production, the household came together and worked as they would if they were an actual sixteenth-century household undertaking this type of endeavor because that's what they'd been trained to do.

Despite the television cameras buzzing around them and crowds gathering to watch the filming from an appropriate distance, the Company of St. George still performed their tasks as living historians by serving the needs of the lady of the manor [Kilbane], who was in many ways supervising the chef "visiting" to prepare a meal for the monarchs and thirty of their closest friends.

For the meal, Irvine chose to prepare the following dishes for the first two courses (some of them very creatively named afterwards): wild rice with almonds, much ado about mushrooms, beefsteaks poached in ale, country castle salad, queen's choice quail with fig and date sauce, pheasant with cranberry honey, spinach and cheese pillows, taming of the squash stew, twelfth-night turkey with wild rice stuffing and ale reduction, swordfish with citrus salad "Veronique," the merchant of venison chops with red wine mushroom sauce, and bulgur porridge. In addition, the following were served: sugared Wensleydale cheese with biscuits and fresh-baked boules. For the voiding course, Irvine prepared apple fritter tarts, almond brittle, and midsummer's night marzipan with rose petals.[17] Note that many of the dishes are named for Shakespearean plays, once again focusing on historical elaboration, since in 1540 Shakespeare's birth was still more than two

decades away. It is interesting to note that the Food Network Web site lists the ravioli as spinach and cheese pillows. Throughout the show, Irvine referred to the creation as ravioli, while Kilbane referred to them as "pillows." In the creation of the name, the writers must have decided that the period-sounding "pillows" was more appealing.

Certain dishes posed greater challenges than others. For example, even though Peterka and the producers had not bought any steak, Irvine insisted on some sort of beef to balance out the colors of the dishes as well as the types of food. In the program, Irvine instructs Zach Rackham (Tom Plott) to find him red meat to cook. Plott eventually returns with about twenty pounds of steak, which Irvine sets about "tenderizing." Since he does not have his usual cooking equipment, he covers the steaks with the table cloth and pounds them using a unique implement. Irvine explains to the viewing audience, "There's always a good use for firewood. You can either make fires with it, or you can beat the heck out of steaks." He then orders ale to make a sauce that will further tenderize the steaks. The rabbits, which were cooked on a spit and had to be turned by hand, were another challenge. Irvine explains some of the difficulties in preparing a large quantity of dishes that all need to be completed nearly simultaneously: "One of the things here that is very difficult for me to get my head around right now is the cooking technique and timing. I can't put everything on too early because I don't know how to keep it warm. It's just very tough to figure out. I've got turkeys in the oven, rabbits and quails on spits, plus soup and beef in pots. To keep it cooking, we are constantly fueling the ovens, rotating the spits, and firing the coals." Irvine's quote illustrates his growing understanding of the needs of living history performance in which the Renaissance meal-making techniques and tools are employed. Other challenges included straining spinach in cloths instead of in a colander and being unable to blend the leek soup since there was no electricity and no blender. He also had to find a way to prepare the pheasant. "Pheasant is a gamey bird," Irving states. "There's not a lot of meat on it, and it doesn't take a lot of time to cook, so I have to be very careful not to overcook it because it becomes very stringy." He decides to prepare the pheasant with cranberry honey, which was one of the few items that was not purchased at the store but came from one of the shops on the festival site. It is interesting to note that even though Irvine is a renowned chef, Kilbane has to explain to him which bird is a pheasant and which is a quail, both staples of the sixteenth-century noble diet.

Irvine's second "Whoa, whoa, whoa" moment comes when Kilbane is mixing the salad. He rushes down to her end of the table to correct the way she is tearing the pieces of lettuce; however, this time Lady Washington stops him dead in his tracks:

IRVINE: Whoa, whoa . . . it's got to be thinner and . . .
KILBANE: The salad must be eaten with our hands, so big pieces to pick up.
IRVINE: Really?
KILBANE: Aye.

In this particular instance, Irvine allows Kilbane's knowledge regarding the six-teenth-century historical record to override his twenty-first-century sensibilities. Nonetheless, he explains the decision to the viewing audience at home. As he looks directly into the television camera, Irvine continues, "So what Lady Wash-ington is saying is today we would never serve a salad like this, but because in olden days they would actually pick this with their hands, she's making it bigger." Kilbane's expertise had obviously overridden Irvine's usual response to something not going exactly as he had planned, but he breaks all illusion of living history immersion when he speaks directly to the audience.

The television cameras were obviously one of the necessities of the filming, but the difference between television and theater also created its own kind of tension. Peterka explains, "They would ask you a question and film it, and then they would ask you to repeat it four or five times so they could get it. We work in a one-shot, improvisational kind of world. Doing it for television, they keep doing it over and over again until they get what they want." This difference ex-ists naturally between stage and film, but in situations where the performers are immersed within the intrastice, the concept of a "do-over" is inconceivable. Fur-thermore, the wants and desires of television often supersede those of living his-tory, and the filming at the MDRF was only one of many examples. According to Peterka, "In television production, like any theatrical endeavor, there was a tension between wanting to tell a plain, unvarnished historical truth as much as we know it (because we really know we don't know everything), but there's al-ways that wanting to tell the story the way it is and television wanting to make it a better story." In this quote, the tension between living history and historical elaboration becomes clear. While living history will assert that life in a specific era was exciting and fulfilling enough to merit contemporary performances, the proponents of historical elaboration in television, film, and theater itself appear to disagree.

At the end of the episode, the members of the Company of St. George assist Irvine in serving his creations to the king, queen, and court. Irvine himself ap-pears, now dressed in a white chemise instead of his signature black T-shirt, to serve the king the quail off of the spit, using his sword to push it onto the king's plate, a very nice theatrical touch. Irvine has completed his mission for the day, or so it seems, when the king announces: "This food, know ye, is delightful. It

is suitable for the royal palate." However, his majesty has one more challenge for Irvine. The king tells him there is a surprise waiting for him at the jousting arena, where the initial challenge was proffered. When Irvine arrives there, the squires help him into a suit of armor and up onto a horse, but he declares: "I was going to test my strength in a joust. I mounted up, watched my would-be opponent in action, and determined my best course of action: to run away as fast as possible." In the program, Irvine is seen running down the side of the jousting field in his armor. Obviously, with no prior experience, the jousting team at the MDRF would never have let Irvine participate. Again, like the food search through the village, the final segment was filmed merely for its theatricality.

Throughout the television program, the differences between living history and historical elaboration are clear. From choices regarding costumes to the naming of the dishes, a desire to reproduce essential details from the Tudor period confronts the wishes to make contemporary television productions interesting for a wide audience. While for many of those watching the program the differences between historical elaboration and living history may seem minor, to those participating in the two practices, the disparity between the two may constitute a tremendous gap; furthermore, when considered within the context of "enacting history," the needs and desires of these two forms of performance produce differing results with regard to the history portrayed. If performance can be used to test the veracity of historical knowledge, then the living historians have developed a viable alternative method of embodied research that offers an entirely different approach to performance from that of actors focusing on historical elaboration and entertainment extrapolated from history. Examining the meal-making practices of the *Dinner: Impossible* "Medieval Mayhem" episode provides an opportunity to explore living history and historical elaboration side by side and to see that although they have different missions, both have a place on the stage.

Notes

1. Erving Goffman, *Frame Analysis: An Essay on the Organization of Experience* (1974; reprint, Boston: Northeastern University Press, 1986), 10–11.

2. The history of the Company of St. George is taken from personal interviews, letters, and ethnographic research I conducted over a period of seven years. Some of this information, in a different format, is included in my book *Renaissance Festival: The "Merrying" of Past and Present* (Jefferson, NC: McFarland Press, 2009).

3. Carolyn Spedden, Crownsville, MD, to actors in the companies of St. Genesius and St. George, April 2000, International Renaissance Festivals, Inc.

4. Goffman, *Frame Analysis*, 21.

5. See Rory Turner, "Bloodless Battles: The Civil War Reenacted," *TDR: The Drama Review* 34, no. 4 (1998): 125.

6. Paula Peterka, interviews with author, August to October 2008, from Tucson, AZ, to Crownsville, MD, via phone and e-mail. All subsequent quotes from Peterka are from these interviews.

7. Stephen Eddy Snow, *Performing the Pilgrims: A Study of Ethno-Historical Role-Playing at Plimoth Plantation* (Jackson: University Press of Mississippi, 1993), 168.

8. Dwight Conquergood, "Critical/Performance Ethnography" (course, Northwestern University, IL, winter 2003) and "Field Methods in Performance Studies" (course, Northwestern University, IL, spring 2003); see also Dwight Conquergood, "Performance Studies: Interventions and Radical Research," *TDR: The Drama Review* 46, no. 2 (2002): 145–156.

9. FoodNetwork.com, *Dinner: Impossible,* http://www.foodnetwork.com/dinner-impossible/index.html (accessed September 15, 2008).

10. Food Network fired Irvine after he had filmed the forty-first episode, when the producers discovered that Irvine had falsified parts of his resume. The Food Network has since re-hired Irvine, and he appeared in several episodes in the spring and summer of 2009.

11. FoodNetwork.com.

12. TV.com, *Dinner: Impossible,* http://www.tv.com/dinner-impossible/back-in-time-ye-ol'-dinner-impossible/episode/966181/summary.html?tag=ep_list;title;4 (accessed September 15, 2008).

13. TV.com, "Robert Irvine," www.tv.com/robert-irvine/person/546960/ biography.html?tag=biography; more&om_act=convert&om_clk=biopph (accessed September 15, 2008).

14. "Medieval Mayhem," *Dinner: Impossible,* Mark Summers Productions, January 30, 2008. All quotes regarding the program are taken from the original episode aired on this date.

15. The part of the exchange in which Irvine states that he has cooked for a king and queen before is only in the original airing of the show. It was removed from the reruns following the discovery that the chef had lied on his resume, specifically with regard to his work with England's royal family.

16. Goffman, *Frame Analysis,* 45.

17. FoodNetwork.com, *Dinner: Impossible,* http://www.foodnetwork.com/dinner-impossible/medieval-mayhem/index.html (accessed September 15, 2008).

Tourist Performance in the Twenty-first Century

Scott Magelssen

> Like Alice, who alternately shrinks and expands after falling down the rabbit hole, the body of the tourist is steeped in violence; its entry into a foreign place a secondary result of imperialism. . . . The body is plastic, adapting to new situations, even as it stubbornly retains its origins and can never quite fit in.
>
> —Paula Rabinowitz, "National Bodies: Gender, Sexuality, and Terror in Feminist Counter-Documentaries"

I slowly picked my way across the narrow stone walkway, perhaps twelve inches across at its widest, and tried to gauge the uneven footing ahead by the light of the moon. To my left was a steep plunge, the stone wall dropping far down to the bushes and mud of the river valley below. To my right, at arm's length, was a rock wall I could use for balance, if I didn't fall into the murky water in between. This would have been difficult enough under normal circumstances, but it was made all the more so by the fact that the U.S. Border Patrol was on my tail.

This was in May of 2008. I was participating in Parque EcoAlberto of Mexico's *Caminata Nocturna,* a simulation of an illegal crossing of the U.S.-Mexico border, with about forty other tourists. The stone ledge was only one of the several rigorous challenges we needed to undertake to make it to the end. Like the tourist Paula Rabinowitz describes above, here I was, a foreign visitor completely out of my element in an outgrowth of the global tourist industry, the bizarreness of which was worthy of a Lewis Carroll story. By no means did I "fit in," but nevertheless I was, through performance, testifying to—resonating with—the experience of the illegal migrant. And, in so doing, I was entering a complex set of historical, national, and often contradictory narratives (which I will treat in this essay). While the *Caminata Nocturna* appears to be the only illegal border-crossing simulation for tourists currently offered anywhere, it is part of a larger emergent phenomenon. The tourism industry has recently begun implementing attractions that privilege explicitly performative participation by immersing tourists as characters in living, fictive scenarios. Visitors to Parque EcoAlberto are offered the chance to experience the six-hour *Caminata Nocturna* every Saturday

evening throughout the year. Guests at the Hotel Cavalieri Hilton in Rome are treated to a gladiator-training program where they can dress in costume and try their skills in combat.[1] And so-called second-person interpretation programs at American living history museums invite visitors to step into the roles of historic personages in a simulated past environment (a fugitive slave, a juror in a historic court case, etc.) and participate in the staging of history. A seeming hybrid of adventure tourism and outdoor museum role-playing, each of these programs negotiates between tensions of tourist comfort and historic realism, between tourist agency in the production of narratives and the agenda of the site or institution staging the event, and between the vacationing body and that of the often abject character it is portraying.

I will examine this phenomenon within the context of recent shifts in the tourism industry as well as a theoretical framework informed by performance studies scholars Diana Taylor, Barbara Kirshenblatt-Gimblett, and others. I argue that, while on the face of it, these programs can be dismissed as kitschy, sensational, niche-tourism for thrill-seekers, there is more than a small element of witness going on: by participating bodily in tourist performances that invite visitors to take on the personae of those who have been made abject by violent or oppressive forces, or those who have been subjected to peril in the pursuit of more authentic agency or self-authorship, the performers, in Taylor's terms, engage in embodied ways of knowing and making meaning, of "vital acts of transfer," which transcend that which is available through print sources.[2] At the same time, however, because the visitor-performers are granted much more agency in the making of meaning in these performances—in their ability to make choices in the development of the narrative, in their agendas or the "horizons of expectations" with which they approach the experiences, and the autonomous "readings" they might assign the narrative—there is considerable slippage to be found between the meanings intended by the producing bodies (the ecopark, the museum, etc.) and the bodies that perform them. For the purposes of this essay, I'll touch on a range of tourist-performance phenomena, but, as a way of situating these theoretical discussions within a concrete set of references, I will place some amount of emphasis on the *Caminata Nocturna* by way of a close reading of my own experience in it.

Simulations that assign an active, participatory role to the tourist are not necessarily all that new, but a brief overview of recent tourism literature suggests that these performative events are presently experiencing a kind of boom, fostered by the particular set of discourses and economic shifts that shape the touristic landscape at the moment. Brian S. Osborne and Jason F. Kovacs report that cultural tourism in general is growing exponentially, fomenting new economies on the

global scene as purveyors of destinations labor to package a "different sense of place, a different *genre de vie*" for retiring baby boomers and the "emerging middle classes of the modernizing non-Western Worlds" in the postindustrial society.[3] And heritage is the key part of the package. Citing David Brett, Ernie Heath, and Geoffrey Wall, as well as Robert Hewison and Howard Hughes, they write, "[A] combination of nostalgia for an imagined past, economic and cultural insecurity, and a growing demand for the consumption of entertainment has made cultural heritage tourism integral to both economic and cultural policy."[4] Local economies are looking to tourism as a way of producing meaningful experiences for paying visitors, to replace industries that have been "disrupted by global economic restructuring."[5] On many occasions, communities develop tourist offerings that restage the glory days of their now defunct industries—a kind of second-go at a community's source of income, based on the first. Barbara Kirshenblatt-Gimblett terms these kinds of tourist-economic moves "afterlives."[6] Elsewhere, Kirshenblatt-Gimblett signals a shift from tourism centering on spaces and objects to the *experience* of the tourist itself, often divorced from the actualities that experience references (Luxor in Las Vegas, for example). She writes:

> Increasingly we travel to actual destinations to experience virtual places. This is one of the several principles that free tourism to invent an infinitude of new products. As the recent textbook *The Business of Tourism* states, "The beauty of tourism is that the number of products that can be devised to interest the tourist is virtually unlimited." The market is king. In New Zealand, you can scale the wall of your hotel or "spend the night in jail for a farm stay with a difference," at Old Te Whaiti Jail, as it advertises itself. Refashioned as a living accommodation, this historic jail wears with pride and humor the irony of its second life as heritage. The Cowshed Cafe markets itself as "New Zealand's only restaurant in a once operating dairy shed (no shit)." The Elephant Hotel in Atlantic City is "the only elephant in the world you can go through and come out alive."[7]

Along these same lines, Dean MacCannell, in his foundational text, *The Tourist: A New Theory of the Leisure Class,* posits a particularly modern touristic desire for an experience of the "authentic" that has been separated from the modern subject by the alienating, fragmenting forces of industrialization and is now to be found "elsewhere" in staged authenticities that often simulate traditional acts of labor in rural settings to stand in for what we've lost. The tourist's consciousness—indeed, the *modern* consciousness in MacCannell's argument—is motivated by a need for communion with a substitute for those lost, authentic, traditional roots

(the family, the neighborhood, the workbench); and the tourism industry has been quick to meet this need with soothing cultural productions, even if there is nothing authentic about them.[8]

But within the tourist sites that boast a sense of heritage, those programs that give the visitors personae and immerse them in an environment where they make performative choices in response to narrative developments are a particularly compelling subset. In the living history museum world, this kind of programming is called "second-person interpretation"—where *you* do the interpreting of the past (versus the first-person character interpreters or the third-person costumed docents) by trying your hand at what a historic individual would do.[9] These programs are becoming more and more popular at living museums as tourists seek more immersive and active experiences. And other cultural productions are tapping into the potential energies offered by inviting the audience to step through the fourth wall. The spectator's desire to get more involved in the action has been detected, for instance, by the theater community for a while now (and more so than just helping decide the ending of a whodunit dinner-theater show or throwing ideas at their local stand-up improviser). Charles Isherwood's 2008 *New York Times* piece, "When Audiences Get In on the Act," details *Etiquette,* an Under the Radar festival production in New York in which audience members are invited, two at a time, to perform the play themselves, with their lines fed through headphones, and Punchdrunk's *The Mask of the Red Death,* a site-specific immersive performance in London where audience members wander through the Battersea Arts Center to happen upon and interact with Poe-inspired vignettes.[10]

And museums and other cultural institutions are experimenting more and more with second-person to a greater or lesser degree. Most of us have heard about the United States Holocaust Memorial Museum, where visitors are assigned an identity of a real Holocaust survivor or victim whose life they follow as they make their way through the permanent narrative exhibit, a way for visitors to become more personally and emotionally engaged. The U.S. Constitution Center in Philadelphia invites visitors to pose as Supreme Court justices, hear cases, and issue verdicts (then compare their decisions with those of actual justices). A quick glance through the travel section of the *New York Times* or an in-flight magazine yields any number of other such programs and attractions. Here is just a small sampling: The Museum of Funeral Customs in Springfield, Illinois, performs Civil War–era simulations of embalming fallen soldiers on the battlefield for shipping home to family and will take volunteers from the audience in some instances to "play" the corpse.[11] Anyone could pay five dollars to help reenact the Boston Tea Party for the 234th anniversary in December 2007, but those who wore "traditional colonial attire" could do it for free.[12] In the same city this past March, at

"Kids Reenact the Massacre," Adams National Park rangers led young visitors
in a reenactment of the Boston Massacre as part of the 238th anniversary cele-
bration sponsored by the Bostonian Society.[13] In terms of more recent history,
weekend tourists play at being astronauts in Las Vegas and Kennedy Space Cen-
ter's Shuttle Landing Facility near Orlando in "Zero G: The Weightless Expe-
rience."[14] And then there are those touristic experiences that aren't listed in the
travel sections, at least in the *New York Times*. Thomas G. Bauer and Bob McKer-
cher's collection, *Sex and Tourism: Journeys of Romance, Love, and Lust,* for in-
stance, catalogues the experiential fantasy offerings of the "hot-pillow" trade in
Cambodia, Thailand, and elsewhere.[15]

The reasons tourists are attracted to these immersive events and programs vary,
and probably more than we can imagine.[16] To step into a character for a weekend
or on a day trip is much easier and more affordable than to commit to a reenac-
tor's pastime, where hobbyists dedicate hundreds of hours to research, costume
fashioning, and accoutrement acquisition for a few events a year, and there's no
such requisite long-term commitment. To some, these autonomous tourist simu-
lations offer a nostalgic "period rush," to others, the next adrenaline rush. But
for many, they can be a poignant act of remembrance, redress, or healing. This
is not a totally new idea, either: in Laurence Stern's eighteenth-century *The Life
and Opinions of Tristram Shandy, Gentleman,* Tristram's uncle Toby regularly re-
enacted the battles of the Nine Year's War (1688–97) in miniature on his bowling
green to work through his traumatic experience in the actual conflict.[17]

This redressive, remediative experience is closer to the kind of deep learning
Indiana's Conner Prairie living history museum hopes to give visitors who par-
ticipate in its "Follow the North Star" Underground Railroad reenactment, in
which visitors pretend to be fugitive slaves on the run from bounty hunters and
slave drivers on their way to freedom in the North. The main thrust of the pro-
gram, offered several evenings in the spring and fall each season, is that visitors
embody the experience of runaway slaves in the nineteenth century—their dis-
comfort, their lack of resources, and their bravery—as they negotiate the inhos-
pitable terrain of the Indiana countryside, looking for a lantern in a window that
signals a safe house, watching out for "wolves" who will catch them and sell them
back into slavery.

I participated in this event in 2004 and found it to be very intense. We were
repeatedly forced to our knees, called monkeys, engaged in Sisyphean tasks of
stacking and restacking wood to break our spirit, subjected to startlingly loud
gunshot noise, and, at the climax of the evening, apprehended and locked up in a
storefront by a tobacco-chewing bounty hunter who got right up in our faces, de-
graded us, and, after being paid off by a helpful Quaker, took one of us, a young

girl, in return for his trouble. After the first moments of the enactment, in which we were trained to never look a white person in the eye (or at their property), most of us saw nothing but the ground in front of our feet. I suggested, when I wrote about the experience, drawing on the work of Phillip Auslander, Susan Leigh Foster, Bertold Brecht, and Rebecca Schneider, that, even though my body and those of my fellow group members did not match those of nineteenth-century black slaves, by being made abject and discomfited (though in a necessarily less traumatic manner than in the original), our bodies more adequately bore witness to the lives and trauma of those who had gone before than had we pursued history from a more comfortable subject position.[18]

I returned to the program in April of 2008, this time with a group of my graduate students, and found that several changes had been made that compromised the intensity I found the first time. We kept to even walking paths. We were told not to run, for liability reasons. Slurs, even the most oblique or de-racialized ones, had been cleared from the dialogue.[19] We were forced to our knees only on a couple of occasions. The gunshots of 2004 (fired by the real gun of the local sheriff and Conner Prairie volunteer) were replaced by a more gentle repro musket noise (more like a loud crack-whoosh than a bang), and the climactic scene, the one in which the bounty hunter took one of our members, had been cut. This was understandable, we found out afterwards: the interpreter who played the wolf had actually been attacked the last few seasons by visitors who slipped too deeply into the immersion. But no new scene was substituted, making for a decidedly wishy-washy dramatic arc: we walked through the eighteenth-century countryside and town, were taken in by various families who gave us expository information, and, in the end, were told our fates. Throughout the evening, while we all carried a piece of white cloth that we could tie around our head if the action got too intense and we wanted to become "invisible," no one in our group ever opted for this escape as they had in 2004. Nor were we given any choice in the trajectory of the narrative. When the out-of-work white laborer we met on the road threatened to detain and sell us, then turned his back, the part where we could put our heads together, weigh our options, and "decide" to make a run for it was precluded by our overly hasty planted volunteer who decided for us.

It is a strange, awkward—perhaps even tasteless—position to be in: wishing for a more intense experience, more discomfort, more fear, as I (a white tourist in the early twenty-first century) played at being a black slave in the nineteenth century. How is this different, after all, from the entitled Western demand, as Osborne and Kovacs put it, for a "glocal" sensory experience that offers escape from "the mediocrity and kitsch of mass tourism?"[20] At the same time, I felt justified on historiographic and political terms. How can we even approach the kind

of deep learning about slave history Conner Prairie hopes to offer if we are subjected to what amounted to little more than a step up from a nighttime walking tour? Doesn't this threaten to do more violence, to perpetuate the erasure of human suffering from the historical narrative, than had we not done the program at all?

The disappointment I felt with the missed potential in the Conner Prairie program is perhaps what set me up to be as impressed as I was by the *Caminata Nocturna*. The program is fairly new. The collectively owned municipal park Eco-Alberto was established in 2004, with the help of government funding, by the indigenous Hñahñu people of the El Alberto community living in and around the town of Ixmiquilpan in the state of Hidalgo, a three-hour bus ride north of Mexico City; and the *Caminata* program opened in July of that year. Strikingly, the reasons for opening the park and the border-crossing experience had everything to do with the fact that the community was threatened by the sheer number of its members migrating north, and these developments were envisioned as a way to keep the population and bring revenue into the area. "The town counts 2,200 residents," reports the *Christian Science Monitor*, "but more than half of those have left for the United States. Those who stay make sponges and purses out of maguey fibers. They also run rappelling trips and offer camping in Parque EcoAlberto. But most people head to Las Vegas, at least temporarily, to find better jobs in construction."[21] The *New York Times* puts the number of currently expatriated Hñahñu people at 1,500, "mostly in Las Vegas and other parts of Nevada, where they install drywall, drive trucks or work on farms, residents say. Many of the tour guides here have crossed the real border several times."[22]

Visitors to the main Parque EcoAlberto resort area find a paradise of sorts: a lush canyon in the Mezquital Valley, crisscrossed by recreational zip-lines, with the Tula River flowing through the bottom. Luxury agave-roofed cabañas can be rented by those who prefer not to camp in tents. For the first-time international tourist, this is a big switch from the shanty towns, glimpsed out the bus window on the way there, that stretch far to the north of Mexico City, but also from the nearby tourist town of Ixmiquilpan, a contrapuntal collection of slick plastic water-parks featuring turquoise pools and Crayola-colored waterslides and empty storefronts and half-finished buildings (evidence of economic hardship and the allure of a better life to the north). Visitors to the ecopark can spend time rafting and canoeing on the river or zip-lining and rappelling on the canyon walls, but the border-crossing simulation is the main draw.[23] Tickets for the regular *Caminata Nocturna* cost visitors two hundred pesos (around twenty U.S. dollars per the exchange rate at the time of writing), and special tours with actual river cross-

ing cost a bit more. Dozens of people from the local community help produce the event each week, playing border patrol guards (*la migra*), fellow migrants, and "coyotes" (slang for the illegal traffickers, also called *polleros* [chicken farmers]). Many of the staff currently live in the United States but are in Mexico for their one year of mandatory service to the El Alberto Hñahñu community. The proceeds from the *Caminata* are shared equally among community members.[24] As of February of 2007, more than three thousand tourists had participated in the event.[25]

The program has generated a substantial footprint on the Web, with many in the press and the blogs pausing to make fun before dismissing EcoAlberto and the *Caminata* as an "immigration theme park."[26] One reporter mused that 'tourists' aping illegal immigrants can seem crass, like Marie Antoinette playing peasant on the grounds of Versailles."[27] More severe reactions are found in readers' posts to contemporaneous *New York Times* and *Los Angeles Times* articles and in conservative discussion boards, where there are rumblings that this is an illegal immigration "training camp."[28] But the organizers maintain that it is completely the opposite. As I said, the program and park were started as a way of keeping members of the Hñahñu community at home, generating jobs and tourist revenue by cleverly tapping into the community's chief resource—its émigrés.

"As in many parts of Mexico," writes Reed Johnson of the *Los Angeles Times,* "mass migration from this area began in earnest in the 1980s, when Mexico's farming sector went into decline. Since the late 1990s, the North American Free Trade Agreement (NAFTA) has further aggravated Mexico's job losses as small farmers have been driven under by competition from industrial farming."[29] Keeping would-be migrants at home has become a crucial effort, as not only El Alberto's population but its traditions are threatened. Ian Gordon of *Slate* magazine writes:

Fewer children speak Hñahñu than in the past, and the town looks like many other places in Mexico and Central America supported by remittances; everywhere you go, you see stickers for the popular Los Angeles morning radio show *Piolín por la Mañana* (hosted by migrant Eduardo Sotelo), new pickup trucks with Nevada and Arizona license plates, and newly constructed and still unoccupied cinder-block homes, some three stories high. "The idea of the park is that people see that . . . they can make money without going to the States," said Pury Álvarez, who works at the park. "El Alberto hopes to be a model Hñahñu community and to convince people to not migrate."[30]

And the Mexican tourists who participate in the *Caminata* are generally not fixing to emigrate, Gordon adds, speaking to the "training camp" anxiety. Rather they are "capitalinos" looking for a weekend away. "Some parents even bring their teenage children to deter them from thinking of heading to El Norte."[31] Others come from as far away as Europe and Asia for the experience. Of my fellow traveling companions the night I participated, many voiced that they were here "hoping to gain some insight into what migrants endure during their trans-border odysseys."[32]

That brings me to my own experience with the *Caminata Nocturna*.[33] To put things into perspective, I attended on the evening of Saturday, May 17, 2008, just five days after U.S. Immigration and Customs Enforcement conducted the largest workplace raid and roundup of illegal workers to that date. Police arrested 389 undocumented meat-plant workers in Postville, Iowa, mostly from Guatemala. Of those detained, 270 were sent to prison a week later.[34]

Around 8 p.m. on this evening, six of us were picked up at the resort's agave-roofed, open-air cabaña restaurant and bar, and we rode to a nearby campground together in a truck: Reed Johnson and Deborah Bonello (two correspondents from the *Los Angeles Times* whom I met earlier that day), a middle-class couple of secondary-school teachers from the state of Mexico, a biology grad student from Mexico City, and I. At the campground, we met up with a larger group, mostly teenagers. There, we were loaded, about forty of us in all, into the backs of several pickup trucks by ski-masked coyotes and brought to the site of an abandoned rural church, where we waited until dark to begin the main part of the experience. The reporters asked the staff who rode with us in the truck if they'd crossed the border before. "Yes, four times," said one. Fifteen times for another.

When the sky above the church grounds had darkened to pitch-black, a ski-masked leader summoned us into a circle and directed us to hold hands (fig. 7). He then delivered a forty-minute speech comprising the context for the adventure in which were about to participate. He said we were here to honor and pay tribute to those who are motivated by a dream, *el sueño,* that propels them to cross the border. He talked about the danger these individuals face: the extreme conditions of the desert, the poisonous spiders, and wild animals. He talked about the tragedy that occurs when individuals don't make it. He peppered in poetic allusions about blindness and vision and how we'd have our eyes opened to new sights on this night. At the conclusion of his talk, he recruited volunteers from our group to hold up the Mexican flag, and we all belted out the Mexican national anthem—over and over again. "Más duro!" he shouted, even when we thought we were singing pretty loudly.

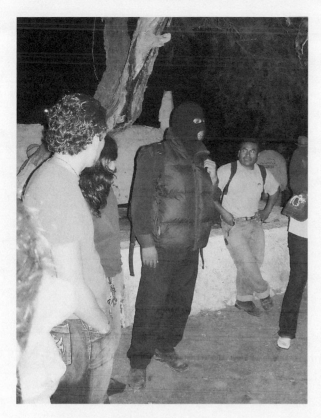

7. A ski-masked "coyote" opens the evening's adventure, establishing the *Caminata Nocturna*'s ground rules and operating metaphors, May 2008. Photo by Scott Magelssen.

The preface taken care of, it was time to begin. The men and women were separated, and the women were sent out first (solidarity was the rule: the slowest and weakest in front, the strongest and fastest in the back, so that we stayed together as a group). The women bolted into the darkness, funneled in the right direction by the coyotes. The men followed (and the *Los Angeles Times* reporters chased along with us). After the first few minutes of darting through the brush, we made it to a deserted road with a bridge a few hundred feet up ahead. Just as we got to the road, a border patrol vehicle turned a corner and came toward us on the opposite side of the bridge. It flashed its lights and turned on the siren. There was nowhere to run if we turned back. Our only option was to sprint toward the truck and descend to the river valley on the other side. The patrol vehicle picked up speed. "*Venga!*" shouted the coyotes, as we ran across the bridge, giddily counterintuitive as we made straight for our pursuers. A hairpin turn to the left as we reached the end of the bridge—and then down the slippery embankment to the Tula riverbed, narrowly escaping *la migra*.

We tripped and careened down the slope, not able to see a thing after looking into the blinding headlights of the border patrol, and, hitting the bottom, our feet sunk into foul-smelling muck and water. We struggled to keep our shoes, but had to keep running, through the dark, along the river, and into the bushes. More muck lay in wide swaths across our path, darker shadows on dark ground. Added to these were other, smaller shadows—cow pats from the grazing herds along the riverbed. But there was no time to dodge them. We were running pell-mell under the low-hanging branches, around shrubs and clinging undergrowth.

And we kept running, along the winding river, always conscious that the border guards were right behind us. From time to time, we were herded into the bushes by our coyotes and told to lie flat. On these occasions, the patrols slowly moved past us, their flashlights sweeping the ground. "We know you're in there, guys. What you're doing is illegal! Go back, or you'll be arrested." A small group of teenage boys took it upon themselves to check in with me every so often on these stops to see how I was doing. They put their hands on my back affectionately to whisper whether I was okay, how my shoes were doing, and how much "poo" they had on them.

By turns, we made it to the stone ledge I described at the top. It was hard to make out the beginning of the narrow walking path, but a small hand—that of a five-year-old boy who appeared out of the darkness—grabbed my own and gently guided me onto the ledge. As we picked our way across, the long line of us thinned out, so that I eventually lost sight of the faster people ahead of me and the slower ones behind. By the time I stepped off the ledge onto solid ground again, I was alone. I made my way forward through the still darkness, hoping I was headed in the right direction and—out of character—hoping I wouldn't be stranded for real in the middle of the Mexican desert. At the moment my situation seemed dire, and I had become convinced I'd taken a wrong turn and had become irrecoverably lost, I was startled by wild-pig snorts: EcoAlberto staff hiding in the bushes. This was a low-tech haunted-house thrill, to be sure, but it generated a visceral bodily reaction all the same, and I was off again on the right path.

We eventually all rendezvoused at a clearing next to the river, where our masked leader again directed us to hold hands in a circle. As the fireflies winked around us, and with the gentle rush of the rapids in the background, he waxed about the dangerous river crossing, about how if we were really migrating across the Río Bravo, all we'd have would be the clothes on our back, which we'd have to remove and carry on our heads as we braved the currents. At his orders, we each picked up a stone to throw into the river, remembering those who had made (or failed) such a crossing. My Spanish was rusty, but I gathered that the stones also represented bad thoughts and associations, which we were symbolically casting

away. The subsequent *Los Angeles Times* story that ran the next Saturday, written by my colleagues who spoke the language regularly, confirmed the vagueness of our leader's metaphors.[35]

I should pause here. I may come across as a bit ambivalent or cynical regarding my relationship with our masked leader. Don't get me wrong. This guy was as charismatic as they come. He was confident, quick with a joke, and had unquestionably established an immediate rapport with our large group, a challenge for anyone, but especially when wearing a sinister-looking black ski mask. He had no trouble in getting us to obey. In part, I imagine, this was because our very safety, if not lives, depended on following his every direction. But he was also arrogant and demanding, and it seemed as though he elicited pleasure from our discomfort and vulnerability. My Spanish did not allow me to experience the full range of his personality either: afterward, in talking with others about our leader, I found out he had also been lacing in crude sexual allusions and digs about women. Even so, we weren't in the best position to criticize. He had us wrapped around his finger the entire time. Vulnerable and in the dark, we wanted him to like us. We wanted to please him. We were completely at his mercy. These stakes go quite a long way when judging someone's performance.

We lingered for a few minutes in the moonlight by the river and then continued. More muck and cow pats. More crouching in the bushes, trying to make ourselves invisible to the border patrol. "There are other ways, guys!" they called out to us. "You can get your visa! You can get your green card! There are other ways! The desert is very dangerous!" The border-patrol characters staged a bust for our benefit: camouflaged guards rounded up three would-be border-crossers, forcing them to the ground and cuffing them as the rest of us watched helplessly from our hiding places.

From there, we crawled under a fence in single file, a pair of coyotes lifting the wire just high enough for us to wriggle beneath it and keep going. Shortly thereafter, we found ourselves crowded into a culvert, trapped, with border patrol on both sides, their searchlights scanning the hills in front of us, their flashlights raking the ground behind us (fig. 8). Loud gunshots and flashing police lights filled the stretch of scrubby clearing in front of the culvert opening. This was the expanse we needed to dash across, in small groups of two and three, so that we could reach the hills beyond to make our escape. After making it across, dodging the searchlights, shoulders hunched against the loud gunshots ringing on the surrounding rock walls, we began ascending into the next leg of the journey.

This mountain hiking, while physically arduous, was a bit of a respite, mostly because we could walk upright much of the time. We removed layers as we hiked up and down the rocky slopes in the warmer air. Herds of goats softly bleated on

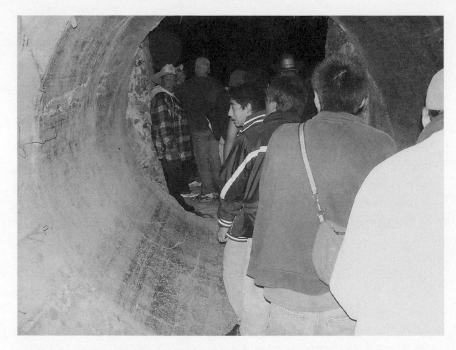

8. *Caminata Nocturna* participants crowd into a culvert where they are temporarily "trapped" by border police, May 2008. Photo by Scott Magelssen.

adjacent hills. Even though we lacked the cover of the bushes on which we relied down in the riverbed, the border patrol seemed less threatening as they prowled the roads far below; but we occasionally had to duck down to avoid their search lights—and then watch out for the sharp spines of the cacti and prickly brambles, only slightly easier to see with the benefit of the nearly full moon.

At the crest of one peak, we stopped to rest, and our attention was directed by our coyotes to the dark valley below. At once, headlights of two border patrol trucks lit up the area to reveal a pickup in the valley, catching a half dozen migrants in various states of inattention. The trucks revved their engines and closed in on their quarry while the migrants piled into their pickup and their driver desperately tried to start the engine. After a couple of tries, as the last guys leapt in back, the engine started, and the wheels spun dust as they peeled out of the bushes. A several-minute, beautifully choreographed chase ensued, tracing wide figure eights as the two border patrol vehicles were foiled time and time again trying to head off the pickup, which narrowly missed their maneuvers. Wheels screeched and kicked up dust, lights flashed, gunshots cracked the air, and the

border patrol barked out orders to desist. "Stop! You are under arrest! Come back here! Those god-dammed Mexicans!" If the romance of the chase hadn't thrilled us up to this point, it certainly had many of our group rooting for the underdogs now. The teenagers literally cheered and laughed at the border patrol, until the pickup was finally fenced in by the patrol vehicles and the passengers apprehended. We looked on as the tiny figures below were detained and put into the patrol trucks, and the pickup was escorted out of the valley.

We scuttled over more hills, negotiating the switchbacks and avoiding getting our sleeves caught on cactus spines, and eventually made it back down to the riverbed, but not before having to skitter down a steep, thirty-foot gravel slope and dash across the road with border patrol approaching. By this time we'd lost a lot of our concern for sticking together. Back into the cover of the bushes, again, we were separated and alone, but I heard distant shrieks behind me as figures reached out from the bushes to touch the arms of unsuspecting teenage girls—more haunted-house thrills. As we snaked along the Tula River, the persistent border patrol called to us from the tops of the embankments far above. "Come out. We have food. There is plenty of food and water for everyone. We know you're hungry."

We arrived by dribs and drabs at a large tree and, from there, made our way up a slope to where pickups awaited. But before we loaded into the trucks, our guide gave another spiel. He checked in with us about how we're doing. "Están seguros?" He weightily reminded us of the lessons we'd learned so far, cracking jokes in between and then chiding us for laughing. He revealed that we'd covered twelve kilometers up to this point, about seven and a half miles.

One more mad dash to the waiting trucks, and then came the part where we were made the most abject we had been in the six-hour event. We were blindfolded and packed, huddled, into the backs of the trucks. In this state, we rode silently, heads down. Our sensory input was now reduced to the crunch of tires on the gravel roads, the metal sides of the truck bed grinding against our backs as we bumped up and down, and the red glow of the nearby trucks' taillights bleeding through our blindfolds.

Upon finally coming to a stop, we were led into short lines, hands on the shoulders of the participants in front of us; and slowly, awkwardly, we inched through our shared darkness, bending low at the waist when someone ahead hissed the word for "branch." When we got to what seemed to be a clearing, we felt lush, dewy grass underfoot. The coyotes steered us, still blindfolded, into a circle for the third time. Our leader's voice was familiar to us by now, and he spoke again. He made poetic allusions to the jugular vein, about how it is the connection be-

tween the heart and the mind. He spoke about the four elements: earth, air, water, and fire. Finally, at his direction, we raised our hands over our heads and, at the count of three, removed our blindfolds for the climax.

We were not in the United States. We were back in the canyon of Parque Eco-Alberto, standing on the shore of the Tula River. The vertical rock walls towered above us and were magically lit with hundreds of small torches. It was like the stars had fallen into the hills. The Mexican flag was brought back out for several more loud renditions of the national anthem, which echoed through the canyon walls. At the close, we were invited to make connections with our fellow travelers, to embrace, to shake hands, to wish each other well and give a word of welcome, and then we were invited up to the cabaña restaurant for hot, sweet coffee and thick slices of fresh bread topped with beans, cheese, and minced chilies. It was about 1:30 a.m.

So, we didn't wind up in *el Norte* but, nevertheless, found something deep, "authentic": a different kind of *sueño*. Tamara Underiner and Joaquín Israel Franco Sandoval pick up on this surprise, message-laden ending, calling EcoAlberto's offering an example of performance that "recreate[s] local history starting from a migratory experience . . . where visitors participate in a virtual border-crossing, only to find they've 'arrived' at a transformed community space."[36] In this regard, the simulated U.S.-Mexico border crossing may be more appropriately termed an "adaptation" of real life, in Linda Hutcheon's sense of the word, than a faithful copy. According to Hutcheon, the success of adaptations, being as they are "announced" creative transpositions of other things that feature an "intertextual engagement" with those things, ought to be measured by their creative interpretation of the adapted material (she avoids use of the term "original") rather than their fidelity in reproducing it.[37] The border-crossing simulation, as it is not the actual border but a creative/interpretive act of "appropriation" or "salvaging" of that environment, becomes, in Hutcheon's schema, a "heterocosm," literally, an "other world" or cosmos, complete, of course, with the stuff of the story—settings, characters, events, and situations.[38] To be more precise, it is the *res extensa*—to use Descartes's terminology—of the world, its material, physical dimension, which is transposed and experienced through multisensorial interactivity.[39]

Hutcheon utilizes the notion of the heterocosm to discuss adaptive video games that simulate already familiar environments (a world from the movies, the historical Dallas of JFK's assassination, etc.), but it makes sense here to apply it to an "interactive," "multisensorial" experience that is the *Caminata Nocturna*. While tourist performers' activity and decision making (such as it is) is driven by ludic, singular experiences encountered in the moment, the storyline or narrative

is imposed by strategic framing—by our leader's metaphors, for example—in the same manner that an adaptive video game frames the ludic play of the gamer with narrative scenes from the movie or from history, so that the gamer plays out the existing story even while making choices during the gaming interface. Like in a live video game experience, then, we contribute to the meaning-making (here, achieving the real *sueño*) through ludic engagement with the script.[40]

If we take Diana Taylor, Dwight Conquergood, and others at their word, my body and those of my fellow *Caminata* participants generated the above and other meanings through our performance, rather than passively receiving them. In explicit ways, our bodies collectively acted out the production's intended messages. By holding the flags, answering the leader's call-and-response sermonizing, grasping each other's hands, and so forth, we gave framing to the experience and co-produced its points. First, illegal border crossing is dangerous. The desert, spiders, dehydration, and treacherous terrain make it inadvisable. It is better to stay in Mexico, or at least pursue legal means for entering the United States. This message made it across, at least to some. One Mexican teenager admitted afterward that any hope she had of crossing to *el Norte* was squelched by the experience: "I learned that it's very difficult. It's awful. I can't survive this, I think."[41] Second, migration drains resources from the community. When young people leave to seek a living elsewhere, the community is decimated. This is brought home not only by the *Caminata* but by what we saw on the way here, crossing through Ixmiquilpan. Third, many people die chasing this dream. The border patrol, the antagonists in this drama, even reminded us of the dangers of the desert, encouraging us to turn back for our own safety. (The flags at the park flew half-staff in remembrance of a local community member who in recent weeks died in a car accident attempting to cross.) Fourth, regardless of cultural or political differences, humans are humans. To testify to this, my nationality, as well as that of Johnson (American) and Bonello (British), was called out by our guide in one of his speeches. A lot of the problems surrounding migration, he suggested, can be solved by talking, by opening up to genuine dialogue. And, caught up in the moment, in the magic of the torchlight, we found ourselves assenting, however remote these possibilities may have seemed in the light of day.

The taxing physical activity, the intense running, the cowering in small spaces, the tromping through water and muck, and the blindfolding were also ways our bodies made meaning, as was our tracing of the physical route through the landscape. We transgressively moved through spaces not easily policed—the rock ledge, the riverbed, the culverts, the hills—rather than following the normative rules and thoroughfares of intra- and international traffic. We were tactically maneuvering through a space that was not our own, a la Michel de Certeau's *Practice of*

Everyday Life, avoiding the strategies of those who were charged with regulating the space of the border.[42]

The environment and our engagement with it were risky, to say the least. At several junctures, we were put into situations with strenuous physical exertion, unpredictable terrain, and low visibility, where minor injuries could result (or worse, in the case of the high stone-ledge balancing act). Our safety was important to the park staff, but, unlike the Conner Prairie Underground Railroad experience, we were never forbidden from running, never given an "out" like tying on a strip of cloth, and certainly never asked to sign a liability waiver. Delfino Santiago, one of the park's managers and producers of the *Caminata* experience, with whom I spoke the next day, says the organizers change the route from time to time, taking the participants along different paths and terrains.[43] I asked Santiago about whether people had ever been injured in the evening program. Some of the participants have gotten hurt, he said rather casually. There have been twisted ankles and broken bones, but he's got crew along who are trained in setting broken or displaced joints if the need arises.

One meaning that clearly *wasn't* generated was that this experience would in any way prepare our bodies for an actual border crossing. As I indicated earlier, this program has fomented deep distrust among some populations in the United States. Many readers responded to the *Los Angeles Times* piece that described the evening I did the *Caminata,* and the discourse spread to other Web sites and blogs in the following days. The mild critiques echoed the anxiety about training programs and accused the *Times* and other media of celebrating illegal immigration. The more intolerant and hateful remarks included readers taking it upon themselves to counter these threats with fantasies of electric fences and personally rounding up migrants and sending them back to Mexico. I wasn't spared either, even though I remained anonymous in the *Los Angeles Times* article. As one Military.com self-appointed watchdog put it, referring to the "Ohio college professor" mentioned in the article, "I'll bet he will be coming back to class with some real bleeding heart claptrap for his young charges. I wonder if the university is paying for his training?"[44]

But it is clearly ridiculous to think of this as a training program. The *Caminata* is more like an extreme sports event, with a bit of proscenium theater thrown in. It was an intense, heart-pounding six hours, yes, but there was nothing to prepare us for something as grueling or perilous as the actual border several hundred miles to the north. It is "as watered down as an airport cocktail," Patrick O'Gilfoil Healy of the *New York Times* aptly sums up (and notes, for instance, that in the simulation "the guides don't desert their groups").[45] And Reed Johnson figures "the *Caminata* probably prepares one to cross the border about as much as play-

ing a game of paintball would prepare one to take part in a Marine sweep of Sadr City."[46] It is a spot-on assessment. We weren't coached in technique, the border patrol behavior didn't match up with the real thing (*la migra* rarely shoots or employs the use of sirens; these were apparently added for dramatic effect), and the script explicitly discouraged migration.[47]

Yet, did it really? There seemed to be a bit of toeing the party line on this point. Everyone I spoke to, and those interviewed for the *Los Angeles Times* and earlier newspaper and magazine articles, all said the same thing about the reasons for the *Caminata* and why they participate. They all concur that this is a program designed to encourage people not to migrate but rather to stay at home and invest in the community, that there are better things to do than to put oneself in harm's way, and that this program is a way to finally make something good out of migration. But, in the actual experience of the *Caminata,* the border patrol came off as buffoonish, the bravery of migrants was celebrated, the thrill of being on the run was exhilarating, and the car chase scenes were just plain entertaining— all of these elements seeming to operate as counter-narratives to the "don't try to cross the border" message. And there is an additional irony that, to a person, everyone I personally heard saying "don't go" is a migrant himself, working in Las Vegas, but home on a required one-year community service stint, and counting the days till he can go back. ("It's like being drafted," said one individual.) Another young man, an EcoAlberto staff member with whom I spoke earlier in the day on Saturday, also volunteers mornings as an aide in a local preschool. For the *Caminata,* he plays one of the border patrol police, the one who yells in English at the migrants over the bullhorn. In three months, he said that he'll be done and will go back to Vegas, where he's lived since he was ten. He recently got his U.S. citizenship.[48]

But there's more going on here than just paying lip service. These are sophisticated and layered statements in a complex set of discourses. This is a winking "don't go." Implicit in the utterance is an indictment of the sociopolitical system, lack of resources, and economy that keep many Mexicans in a hopeless state of poverty.[49] There is an equally implicit indictment of the lack of enabling channels to cross into the United States legally. It is also likely that the reasons enunciated for the program, voiced by each of its participants, are a set of scripted responses to the naïve, uninformed claim that this is a training camp for migrants. One must remember, this is a coproduction with the Mexican government, which has footed part of the bill for the development of the park and its feature program; and, as Roger Bartra argued in 1990, the dangers presented by the border with the United States are one of the foundational narratives that in part allow conservative Mexican nationalism to exist.

The idea of the boundary, the tear, or the border is an important ingredi-
ent in the constitution of Mexican national identity. . . . The border is a
constant source of contamination and threats to Mexican nationality. The
mere existence of the border is what permits nationalist passions to remain
tense. It permits, we may say, a permanent state of alert against outside
threats. Clearly this functions mostly on a symbolic level, since the demo-
cratic reality of the thousands of Mexicans who come and go across the
border (more coming than going) generates a sociocultural process of *mes-
tizaje* and symbiosis that no nationalist discourse could bring to an end.[50]

Even with Mexican nationalism put aside—as it increasingly will be if Bartra is
correct in identifying an emergent post-Mexican identity, following Jürgen Hab-
ermas's concept of postnationalism,[51] after NAFTA and the 2000 elections—it
would still be untoward of the Mexican national government to officially stamp
approval by financing a program that condones illegal crossing, despite the revenue
that migrant labor brings into the country's rural economies through remittances.

The wink lets us, the tourists, in on the irony. The American press and blog-
gers can waggishly poke fun at the *Caminata* and the Parque EcoAlberto, call
this an immigration theme park, and smile at the idea of snapping cell phone pic-
tures while running from *la migra,* but we tourists are savvy to the multiplicity of
narratives going on.[52] There are many opportunities in the evening's narrative for
self-aware commentary by the leaders and participants, for unmasking the simu-
lation as such, for breaking the fourth wall to editorialize or crack jokes. Never
in EcoAlberto's literature or in the script does the *Caminata* actually promise to
be an accurate experience. It is one part homage, one part smart business, one
part thrill ride, and it comfortably acknowledges all these things aloud. While
the simulation was meant to be somewhat realistic in parts, the leaders had no
problem with breaking character, weaving in poetry, and shifting the whole mise-
en-scène, along with our roles, into a staging of metaphorical narratives. There
were moments of staged community (holding hands in the circle) and more pro-
found moments of sincere, if fleeting, camaraderie: my adoption by the teenagers,
hugging and shaking hands afterward, lingering in the torches and moonlight
at the end with fellow travelers just a little bit longer to compare experiences and
muddy pant legs before parting.

Furthermore, as I said above, as participants, we tourists actively coproduced
the meaning of the experience rather than simply receiving the narratives pro-
duced for our benefit.[53] And the morals of the evening—discouraging border
crossing, reaffirming the commitment to the home community, affirming the law
(if not the status quo)—are not necessarily what our bodies will remember most

vividly from the event. Rather, we'll remember the transgression of the rules, the thrill of the chase, the profundity of the abjection and loss we at least witnessed to, if only nominally experienced. In other words, regardless of the explicit message in the end, that is, the injunction to *not* misbehave, it is the *mis*behavior that makes the experience memorable; and that, as such, exists in our memories as continual potentiality, like Bakhtin's carnivalesque.[54]

But it is also at these most intense moments of simulated transgression where the witness falls away and the thrill of the present dissolves any intended pedagogy about the politics and history of illegal border crossing. *This American Life*'s Alix Spiegel experienced something similar when she participated in Conner Prairie's "Follow the North Star." When she contributed a piece about playing slaves with a bunch of Indianapolis suburbanites to the radio program, she described the way all pretense of historical reenactment quickly evaporated as she and her fellow participants reveled in the kicking-in of primal fight-or-flight instincts.[55] I guess that's where I found myself when Johnson and Bonello interviewed me as we briefly rested about a third of the way through the *Caminata*. "What are your impressions so far?" asked Johnson. "This is *intense*. Much more so than I thought it would be," I answered, short of breath. "Are you learning about migration?" I pause. "I don't know," I answer truthfully. "I'm having a very thrilling experience of being chased by the bad guys, but I don't know if I'm learning about migration." Thankfully, perhaps, this didn't make it into the news story. At least so it wouldn't give fuel to the minutemen naysayers in their blog writings about college professors.

But there are other ways my fellow participants read and coproduced meaning in the performance, too. Marcelo Rojas, the biology PhD from Mexico City, was more critical of the experience. The narratives of the brutal U.S. border guards privileged by the *Caminata* don't acknowledge that the Mexican guards on the border with Guatemala and the rest of Central America can be just as draconian in their treatment of migrants coming north. As Rojas told the *Los Angeles Times*, "I agree that Mexicans suffer a lot when they cross. . . . But on the other side, we Mexicans aren't the best example of good hosts toward foreigners. [At] the southern border, which is the border we almost never look at, we Mexicans treat the Central Americans very badly."[56] Moreover, participants in the *Caminata*, especially those born and raised in Mexico, experience the event in the context of many, many other state-sponsored works of pageantry that tend to be framed in similar ways—the bookmarking of the program of events with loud and rousing iterations of the Mexican national anthem, for example—in order to inculcate traditional and conservative feelings of Mexican nationalism, a kind of propaganda Patricia Ybarra terms "state-sponsored affect." Through the rote rehearsal

of familiar markers intended to produce a visceral sense of patriotism, loyalty, and pride, argues Ybarra, such procedures entrench the *Caminata* squarely into a deep genealogy of the government's attempt at hegemonic conditioning of its people to have affective responses by making their bodies speak its state narratives—procedures that have been vigorously renewed since the economic crisis of 1982 to shore up solidarity in the increasingly "post-national moment."[57] The question for Ybarra, then, is what happens when we examine the *Caminata* and other state-sponsored pageants in terms of the mechanics of the event and, by extension, the manner in which the participants *actually* respond to those mechanics? The national anthem, she contends, is belted out at *every* state event and can be experienced on multiple levels. "Mexicans know how to read irony into things," she says.[58]

Herein also lies the complexity of the *Caminata Nocturna*'s relationship, as a popular cultural construction, to the cosponsoring nation state; and, as Ybarra points out, the *Caminata* can be linked to other cultural constructions on the local level that similarly bear the mark of state intervention. Mary Kay Vaughan's essay "The Construction of the Patriotic Festival in Tecamachalco, Puebla, 1900–1946," suggests that this is particularly the case with the local Mexican fiesta. Vaughan succinctly identifies two strains of thought on the power of the Mexican government to shape the character of its citizens through popular celebrations. She cites Judith Friedlander as correcting the long-held anthropological assumption that the Mexican village fiesta can be identified with "collective renewal and cohesion," arguing instead that the fiesta "often has links to the state, affirming both the local collectivity and a hierarchical, extra village order," and that the state uses the popular festival to mask its hegemonic agenda, just as the Catholic missionaries did with their construction of the religious fiesta, "making the Indian Villagers accomplices in their own oppression."[59] In contrast to this, Vaughan cites Alan Knight's argument that revisionist historians like Friedlander err in projecting the current power of the Mexican nation-state back onto early post-revolutionary Mexico, giving the government more credit than it deserves in the production of the village fiesta in the first decades after the revolution of 1910. Knight's contention, rather, is that the fiesta at this time was much more a result of "popular movements, demographic change, and socioeconomic change."[60] State narratives of patriotism and nationalism, he says, had popular appeal and were taken up at the grassroots level to give meaning to "real political experiences in the nineteenth century civil wars" and the revolution of the early twentieth century.[61] Framing her own analysis betwixt and between Friedlander's and Knight's takes, Vaughan offers an interpretation that allows for a give-and-take between the local and state entities in the production of the fiesta, which admit-

tedly varies from locale to locale. As "negotiated constructions," then, between popular movements, communities, and the state, fiestas can facilitate the "penetration" of the narratives of the nation-state while still helping to "confirm social cohesion" and "enhance collective identity."[62] "State penetration," she explains, "is not necessarily state imposition."[63] I find it helpful to draw on Vaughan's profile of the local celebrant in the fiesta (a "social subject") as a model for understanding the multiplicity of ways that a participant can access, produce, affirm, or reject meanings of the *Caminata:* "Social subjects," she writes, "[respond] to the vocabulary selectively by adopting, reinterpreting, discarding and internalizing parts of it."[64]

What becomes clear, then, is that, while touristic performance of abject, lived experience can be an act of witness that honors and pays tribute to those who may not be adequately remembered in the textbook and other written sources, the complexity of these performance practices, the subjective selection of the narratives, and the tourists' choice of which narratives to coproduce and actualize do not guarantee an unproblematic testimony across the board. On this point, we do well to remember that, though some of us may tend to privilege performative acts of knowledge production (Taylor's repertoire) over textual ones (Taylor's archive) as more authentic or more adequate in expressing voices and experiences, especially those of the disenfranchised, this does not mean that such performative acts of witness are uncontestable, free of political charges, or unfraught with contradictions. As Freddie Rokem cautions us in his work on performing the history of the Shoah/Holocaust, we are often tempted to assume testimony is true and/or unmediated—authentic. With Michael Bernstein, Rokem identifies this as one of "the most pervasive myths of our era."[65] Even so, it is not that we can say that traditional written histories are, in the end, any more unproblematic in their selectivity of accounts, their biases, erasures, and morals.

With all of its problems, tourist performance events like the *Caminata Nocturna* may still be, at the very least, a beneficial supplement to the archive. And, at their best, through their incorporation of bodily immersion, along with a winking metanarrative that recognizes and affirms the multiplicity of possible interpretations and the tourists' agency in negotiating and activating the "right" ones, they can be a transcendent mode of paying tribute to the past—especially to those pasts that are given short shrift in the written narrative.

Notes

Special thanks to the members of the Visual and Cultural Studies Cluster and the Latin American and Latino/a Studies Cluster at Bowling Green State University's Institute

for the Study of Culture and Society. Both groups gave me helpful feedback as I revised this essay for publication. Thanks also to Dr. John Nielsen and the History Department at Loyola University of New Orleans, for inviting me to share early drafts of the material that appears herein.

1. See Mary E. Forgione, "When in Rome, go gladiator at the Rome Cavalieri Hilton," *Los Angeles Times,* July 27, 2007, http://travel.latimes.com/articles/la-trw-rome29ju129 (accessed June 3, 2008); "Learn Gladiator Moves at the Rome Hilton Cavalieri," hotelchatter.com, http://www.hotelchatter.com/story/2007/6/21/124451/811/hotels/Learn_Gladiator_Moves_at_the_Rome_Hilton_Cavalieri (accessed June 3, 2008); Hilary Howard, "We Who Are on Vacation in Rome Salute You," *New York Times,* August 26, 2007, http://www.nytimes.com/2007/08/26/travel/26COMglad.html?ex=1345780800&en=0604648591b34ffc&ei=5088&partner=rssnyt&emc=rss (accessed June 3, 2008).

2. Diana Taylor, *The Archive and the Repertoire: Performing Cultural Memory in the Americas* (Durham: Duke University Press, 2003), 2–3.

3. Brian S. Osbourne and Jason F. Kovacs, "Cultural Tourism: Seeking Authenticity, Escaping into Fantasy, or Experiencing Reality," *Choice* 45, no. 6 (February 2008), Choice Reviews Online, www.cro2.org (accessed January 16, 2008). Osbourne and Kovacs cite Wally Owens as identifying tourism's growth rate at 9 percent a year (Owens, *On Bfland* [London: Thames and Hudson, 2005]), and Jim Butcher as estimating "that some 700 million international leisure trips are made annually and that, if these trends continue, the annual rate will be 1.6 billion international tourists by 2020 (Butcher, *The Moralisation of Tourism: Sun, Sand . . . and Saving the World?* [London: Routledge, 2003]). Tourism is becoming the world's fourth largest industry: According to the United Nations World Tourism Organization, as of February 2006, tourism accounted for 215 million tourism jobs, or 8.1 percent of the total workforce (Osbourne and Kovacs, ibid.).

4. Osbourne and Kovacs, "Cultural Tourism," n.p. See David Brett, *The Construction of Heritage* (Cork, Ireland: Cork University Press, 1996); Ernie Heath and Geoffrey Wall, *Marketing Tourism Destinations: A Strategic Planning Approach* (Hoboken: Wiley, 1992); Robert Hewison, *The Heritage Industry: Britain in a Climate of Decline* (London: Metheun, 1987); and Howard Hughes, *Arts, Entertainment and Tourism* (Oxford: Butterworth-Heinemann, 2000).

5. Osbourne and Kovacs, "Cultural Tourism," n.p.

6. Barbara Kirshenblatt-Gimblett, "Afterlives," *Performance Research* 2, no. 2 (Summer 1997): 4.

7. Ibid., *Destination Culture: Tourism, Museums, and Heritage* (Berkeley: University of California Press, 1998), 171.

8. Dean MacCannell, *The Tourist: A New Theory of the Leisure Class* (Berkeley: University of California Press, 1999), 91.

9. See Scott Magelssen, "Making History in the 'Second-Person': Post-Touristic Considerations for Living Historical Interpretation," *Theatre Journal* 58, no. 2 (May 2006).

Freeman Tilden advocated for visitor immersion in historic tasks and activities at historic sites and museums as early as 1957, "even if it was just a leisurely carriage ride at Williamsburg" (Jay Anderson, *Time Machines: The World of Living History* [Nashville: American Association for State and Local History, 1984], 36, citing Freeman Tilden, *Interpreting our Heritage* [Chapel Hill: University of North Carolina Press, 1957], 69).

10. Charles Isherwood, "When Audiences Get In on the Act," *New York Times,* Sunday, February 10, 2008, AR 7, 34.

11. See John Troyer and Scott Magelssen, "Living History with Dead Bodies: Civil War Reenactment Embalming Demonstrations and the Museum of Funeral Customs," paper delivered at the Conference on Holidays, Ritual, Festival, Celebration, and Public Display, 2008, Bowling Green State University, Bowling Green, OH.

12. "Boston Tea Party Annual Reenactment," Old South Meeting House, www .oldsouthmeetinghouse.org/osmh_123456789files/AnnualReenactment.aspx (accessed February 28, 2008). See also "Boston Tea Party Reenactment," *USA Today,* October 16, 2007, www.destinations.usatoday.com/boston/2007/10/boston-tea-part.html (accessed February 28, 2008). Special thanks to Stephen Harrick for providing this information.

13. The Bostonian Historical Society and Old State House Museum Calendar of Events, www.bostonhistory.org/?s=osh&p=calendar (accessed February 28, 2008).

14. This was founded by Zero Gravity Corporation, a privately held space entertainment and tourism company. These participants enjoy weightlessness in a way that is "safe, fun, convenient and affordable" on a ninety-minute flight in a specialized plane that matches the parabolic maneuvers used in NASA training. "Like nothing on Earth" is the attraction's advertising slogan ("The Sharper Image" catalog, *Skymall* [November 2007]: 43). Tourists (including Stephen Hawking) experience fifteen thirty-second periods of zero-gravity free-fall over the course of the ninety-minute flight (http://gozerog .com/ [accessed May 23, 2008]).

15. Thomas G. Bauer and Bob McKercher, *Sex and Tourism: Journeys of Romance, Love, and Lust* (London: Routledge, 2003).

16. See recent studies on tourists attracted to the "'shadow landscapes' of 'sites of death and disaster,'" for example, John L. Lennon and Malcolm Foley's *Dark Tourism: The Attraction of Death and Disaster* (London: Continuum, 2000) (cited in Osborne and Kovacs, "Cultural Tourism," n.p.).

17. See Fritz Gysin, *Model as Motif in* Tristram Shandy (Berne: Francke Verlag, 1983), esp. chapter 4, "Model and Reality: 'Battles' on the Bowling Green." Of course, remediative "rehearsing" of moments of trauma through performance are nothing new. Henry Bial, for example, reminds us that this is a foundational idea behind Jewish liturgy (Henry Bial, respondent, "Not Jewish Enough? Jewish Identity in Performance and Text—Questioning Authenticity, Intention, and Reception," panel at the Association for Theatre in Higher Education Twenty-second Conference, Denver, CO, August 1, 2008). Nor, as in the *Tristram Shandy* example, are these kinds of performances necessarily tied to the tourist in-

dustry. Harvey Young's recent work, for example, treats the commemorative Choktaw Trail of Tears Walk and the Commemorative Trail of Tears (Motorcycle) Ride as a way of exploring and bearing witness to acts of trauma perpetuated upon native peoples in the United States (Harvey Young, "Remembering Genocide within Our Borders: Trail of Tears Memorials," paper presented at the Association for Theatre in Higher Education Twenty-second Conference, Denver, CO, August 2, 2008).

18. See Scott Magelssen, "'This Is a Drama. You are Characters': The Tourist as Fugitive Slave in Conner Prairie's 'Follow the North Star,'" *Theatre Topics* 16, no. 1 (March 2006).

19. Stephen Harrick delivered a paper on this experience at the Association of Theatre in Higher Education Preconference, Denver, CO, August 2008.

20. Osborne and Kovacs, "Cultural Tourism," n.p. "The privileging of the power of the 'local,'" write Osborne and Kovacs, "is central to the concept of 'glocalization.' This clever neologism captures that relationship between the nurturing of the local at a time of the assertion of the global, both in culture and economy" (Osborne and Kovacs, "Cultural Tourism," n.p., drawing on John Eade's *Living in the Global City: Globalization as a Local Process* [London: Routledge, 1996], n.p.). "Glocalization's 'invention' of locality is reminiscent of the constructions flagged by [Eric] Hobsbawm and [Terence] Ranger's *The Invention of Tradition* and Anderson's *Imagined Communities,*" write Osborne and Kovacs (citing Roland Robertson, *Globalization: Social Theory and Global Culture* [London: Sage, 1995]). See Roland Robertson, "Glocalization: Time-Space and Homogeneity-Heterogeneity," in *Global Modernities,* ed. Mike Featherstone, Scott Lash, and Roland Robertson (London: Sage, 1995), 25–44. See also Erik Swyngedouw, "The Mammon Quest: 'Glocalisation,' Interspatial Competition and the Monetary Order: The Construction of New Scales," in *Cities in the New Europe: The Global-Local Interplay and Spatial Development Strategies,* ed. Mick Dunford and Gregores Kaukalas (London: Belhaven, 1992); and Pricilla Boniface and Peter J. Fowler, *Heritage and Tourism in the "Global Village"* (London: Routledge, 1993).

21. Sara Miller Llana, "Mexicans cross 'the border'—at a theme park: The attraction, criticized by some as a training ground for would-be illegal migrants, is meant to help the local economy," *Christian Science Monitor,* February 21, 2007, http://www.csmonitor.com/2007/0221/p01s04-woam.html (accessed May 22, 2008). See also Jessie Johnston and Emily King, "Borderline Loco," *National Geographic Traveler,* July 27, 2006, http://www.nationalgeographic.com/traveler/extras/blog/blog0607_4.html (accessed April 22, 2008); and Anna Burroughs, "Mock Illegal Border Crossing: Tourism with a Cultural Twist, *Associated Content Travel Trend,* February 15, 2007, http://www.associatedcontent.com/article/144158/travel_trend_mock_illegal_border_crossing.html (accessed May 15, 2008).

22. Patrick O'Gilfoil Healy, "Run! Hide! The Illegal Border Crossing Experience," *New*

York Times, February 4, 2007, http://travel.nytimes.com/2007/02/04/travel/04HeadsUp.html?ref=travel (accessed May 15, 2008).

23. Healy, "Run! Hide!" n.p.; Ian Gordon, "Flight Simulator: When crossing the Mexican border—or pretending to—is a walk in the park," *Slate,* December 29, 2006, http://www.slate.com/id/2156301/pagenum/all/ (accessed May 15, 2008).

24. Reed Johnson, with Deborah Bonello, "Mexican town offers illegal immigration simulation adventure," *Los Angeles Times,* May 28, 2008, http://www.latimes.com/news/nationworld/nation/la-et-border24-2008may24,0,4001298.story?track=rss (accessed May 25, 2008).

25. Healy, "Run! Hide!" n.p. Delfino Santiago, one of the organizers, told me that sometimes, especially around Easter, upwards of four hundred people participate in the *Caminata Nocturna* a night. When this happens, the large group is split into three or more smaller groups to better accommodate the numbers. Delfino Santiago, personal interview, Parque EcoAlberto, May 18, 2008.

26. "It's the Immigration Theme Park," *Metro,* March 25, 2007, http://www.metro.co.uk/weird/article.html?in_article_id=42576&in_page_id=2 (accessed May 15, 2008).

27. Healy, "Run! Hide!" n.p.

28. See, for instance, "Mexican Amusement Park Teaches Border Crossing Tricks," posted by the Watchdog in Border crossing, Mexico, http://www.immigrationwatchdog.com/?p=1910 (accessed May 15, 2008).

29. Johnson with Bonello, "Mexican town offers," n.p.

30. Gordon, "Flight Simulator," n.p.

31. Ibid., n.p.

32. Johnson with Bonello, "Mexican town offers," n.p. "'It's part of our culture, and it's important to know it,' said Sergio Mendieta, a secondary school teacher from the state of Mexico" (ibid.). Some individuals had personal connections among friends and family who had migrated or experienced tragedy along the way: "Marcelo Rojas, a Mexico City biologist, knows 'many, many Mexicans, some of them my relatives,' who have crossed back and forth between their country and the United States. 'What pushes them is to have the prospect of a better life,' he said. 'I know at least three people that went and didn't make it, that wanted to cross the desert. They died there'" (ibid.).

33. Because of my limited speaking proficiency in Spanish, especially over the phone, I am grateful to my colleague Amy Robinson, in romance and classical studies at Bowling Green State University, for assisting me in making travel arrangements and *Caminata* reservations as well as for her welcome counsel on getting around in Mexico.

34. Julia Preston, "270 Illegal Immigrants Sent to Prison in Federal Push," *New York Times,* May 24, 2008, http://www.nytimes.com/2008/05/24/us/24immig.html?_r=1&th&emc=th&oref=slogin (accessed May 29, 2008); and Susan Saulny, "Hundreds Are Arrested in U.S. Sweep of Meat Plant," *New York Times,* May 13, 2008, http://www.nytimes

.com/2008/05/13/us/13immig.html?scp=1&sq=iowa+arrest+&st=nyt (accessed May 29, 2008).

35. Johnson with Bonello, "Mexican town offers," n.p.

36. Tamara Underiner and Joaquín Israel Franco Sandoval, "Performances of Migration and Reterritorialization," 2008 call for papers for Working Sessions, www.astr.org (accessed May 29, 2008). See also Tamara Underiner, "Playing at Border Crossing in a Mexican Indigenous Community . . . Seriously," paper delivered at the American Society for Theatre Research (ASTR) Annual Meeting, Boston, 2008.

37. Linda Hutcheon, *A Theory of Adaptation* (New York: Routledge, 2006), 8.

38. Ibid.

39. Ibid., 14, citing Oliver Grau, *Visual Art: From Illusion to Immersion,* trans. Gloria Custance (Cambridge: MIT Press, 2003), 3.

40. See also Marie-Laurie Ryan, *Narrative as Virtual Reality: Immersion and Interactivity in Literature and Electronic Media* (Baltimore: Johns Hopkins University Press, 2001); and Marie-Laurie Ryan, *Narrative across Media: The Languages of Storytelling* (Lincoln: University of Nebraska Press, 2004). The way that the *Caminata adapts* a story of migration with which we are already familiar is what differentiates this kind of experience from "Follow the North Star" or other simulated living history environments, which cannot be experienced *as adaptations* of original material because that original material has not been experienced. Thus, their visitors are denied the "palimpsestic" pleasure (Hutcheon, *A Theory of Adaptation,* 173) of comparing the adaptation with the material they've experienced before. Living history museum scripts, while technically adapting the past (or, at least, a historical record), can only be experienced, then, as what Hutcheon terms "eidetic" images: the afterimages that exist when the original is gone (Hutcheon, *A Theory of Adaptation,* 172).

41. Tamara Vazquez Hernandez, a fifteen-year-old from Mexico City, cited by Johnson with Bonello, "Mexican town offers," n.p.

42. Michel de Certeau, *The Practice of Everyday Life,* trans. Steve Rendall (Berkeley: University of California Press, 1984).

43. Delfino Santiago, personal interview, Parque EcoAlberto, May 18, 2008.

44. Opfor6, on Military.com discussion board, http://forums.military.com/eve/forums/a/tpc/f/409192893/m/9080080581001 (accessed May 28, 2008).

45. Healy, "Run! Hide!" n.p.

46. Johnson with Bonello, "Mexican town offers," n.p.

47. Mexico Reporter, "Illegal border crossing—for tourists," May 22, 2008, http://mexicoreporter.com/2008/05/22/illegal-border-crossing-for-tourists/ (accessed May 28, 2008).

48. Personal interview, Parque EcoAlberto, May 17, 2008.

49. As Roger Bartra wrote in 1988, "in spite of revolutionary nationalism, today millions of Mexicans are living in the United States, not only peripheral to democracy but ac-

tually outside the law. Millions more inside Mexico find themselves in a similar situation: their vote is manipulated by the authoritarian system. Even worse, they live in an economy deep in a crisis that ballots can do little against: the answers to inflation or to external debt are to be found less and less on the terrain of national political decisions" (Roger Bartra, "The Crisis of Nationalism," reprinted in *Blood, Ink, and Culture: Miseries and Splendors of the Post-Mexican Condition,* trans. Mark Alan Healy [Durham: Duke University Press, 2002], 132). Bartra has since articulated some amount of hope for the situation in the defeat of the Institutional Revolutionary Party (PRI) in 2000 (ibid., 223ff.).

50. Bartra, "The Crisis of Nationalism," 11. See also Claudio Lomnitz, *Deep Mexico, Silent Mexico: An Anthropology of Nationalism* (Minneapolis: University of Minnesota Press, 2001).

51. Bartra, "The Crisis of Nationalism," 63, citing Jürgen Habermas's *The Postnational Constellation: Political Essays,* trans. Max Pensky (Cambridge: MIT Press, 2001).

52. It is worth noting that the *Caminata,* by calling attention to this multiplicity, seems to transcend or get around Linda Hutcheon's observation that "effective games, like theme parks and rituals, must eschew the metafictional or the self-reflexive" (Hutcheon, *A Theory of Adaptation,* 136, quoting Ryan, *Narrative as Virtual Reality,* 284). I should say, too, that Hutcheon prefers referring to savvy audiences as "knowing," rather than with terms like "learned" or "competent," which are charged with bias toward specific educational or cultural experiences (Hutcheon, *A Theory of Adaptation,* 120).

53. See Marvin Carlson, "Theatre Audiences and the Reading of Performance," in *Interpreting the Theatrical Past,* ed. Thomas Postlewait and Bruce A. McConachie (Iowa City: University of Iowa Press, 1989).

54. As Paula Rabinowitz reminds us, referring to the fact that the sexy, transgressive elements are always reined in at the end of film noir movies (the transgressive woman ends up dead or married and domesticated), we don't remember the endings—we remember Joan Crawford's shoulder pads, deviantly wide metonyms for this femme fatale's infringement of decorum and gender roles. Paula Rabinowitz, speaking at a special invited seminar as part of the Provost Lecture Series 2008, Institute for the Study of Culture and Society, Bowling Green State University, January 30, 2008, citing Molly Haskell, *From Reverence to Rape* [Chicago: University of Chicago Press, 1987]; and Marjorie Rosen, *Popcorn Venus: Women, Movies, and the American Dream* [New York: Avon, 1985]; and Paula Rabinowitz, personal correspondence, May 23, 2008.

55. Alix Spiegel, "What's so Funny about Peace, Love, and Understanding?" *This American Life,* originally broadcast in 1999, Chicago Public Radio and Public Radio International, 1999.

56. Marcelo Rojas, quoted in Johnson with Bonello, "Mexican town offers," n.p.

57. Patricia Ybarra, responding to the conference-length version of this essay at the Association for Theatre in Higher Education Twenty-second Conference, Denver, CO, August 2, 2008, and personal correspondence, August 8, 2008. See also Patricia Ybarra,

Performing Conquest: Five Centuries of Theater, History, and Identity in Tlaxcala, Mexico (Ann Arbor: University of Michigan Press, 2009).

58. Ybarra, at conference, August 2, 2008.

59. Mary Kay Vaughan, "The Construction of the Patriotic Festival in Tecamachalco, Puebla, 1900–1946," in *Rituals of Rite, Rituals of Resistance: Public Celebrations and Popular Culture in Mexico,* ed. William H. Beezley, Cheryl English Martin, and William E. French (Wilmington, DE: Scholarly Resources, 1944), 213–245, 214, citing Judith Friedlander, "The Secularization of the Cargo System: An Example of Post-Revolutionary Mexico," *LARR* 16 (1981): 132–144.

60. Vaughan, "The Construction of the Patriotic," 214, citing Alan Knight, *The Mexican Revolution,* 2 vols. (Cambridge: Cambridge University Press, 1986).

61. Ibid., 214–215.

62. Vaughan, "The Construction of the Patriotic," 215.

63. Ibid., 232.

64. Ibid., 233. With thanks to Patricia Ybarra for referring me to the work of Mary Kay Vaughan and Roger Bartra for this project.

65. Freddie Rokem, *Performing History: Theatrical Representations of the Past in Contemporary Theatre* (Iowa City: University of Iowa Press, 2000), 32, citing Michael Andre Bernstein, *Foregone Conclusions: Against Apocalyptic History* (Berkeley: University of California Press, 1994), 47.

Ping Chong & Company's
Undesirable Elements/Secret Histories
in Oxford, Mississippi

Rhona Justice-Malloy

The stage is bare with the exception of five chairs with five music stands placed before them. The performers enter and ceremoniously circle the stage three times. We hear, "*Ichi, ni, san*" ("One, two, three" in Japanese). Lights up.

YUKAKO: Sa hejeemeh yoh.
JOE: Empecemos.
BRITTANY: Let's get started.
ANNIE: Let's get this thing started. Please sit.
(All sit in chairs and open books.)[1]

Thus begins "Secret Histories: Oxford," an iteration of the *Undesirable Elements* series developed by Ping Chong & Company. This production was written and directed by company member Leyla Modirzadeh.

World-renowned theater director, choreographer, and video and installation artist Ping Chong began the ongoing series *Undesirable Elements/Secret Histories* in 1992 at New York City's Artists' Space. Since that time, Mr. Chong, with collaborators, has created over thirty productions. These performances are community-specific oral histories that explore "the effects of history, culture and ethnicity on the lives of individuals in a community."[2] Over the years Chong has cultivated a very effective process of developing his pieces. Each production is specific to its host community, be it Atlanta, Berlin, Cleveland, Seattle, Rotterdam, or Tokyo. In 1995 Modirzadeh became involved in collaborating and performing in *Undesirable Elements* in Seattle.

Modirzadeh is a Persian American actress, writer, and director who was working at the Group Theatre in Seattle when the call came for multicultural actors. She interviewed with Ping Chong and was cast and, subsequently, became a company member. Since that time she has collaborated on many *Secret Histories,* including two productions she wrote and directed for the Lincoln Center

Institute, New York City. In 2008, Modirzadeh came to Oxford, Mississippi. Not long after arriving, Modirzadeh sent out the call for "Secret Histories: Oxford." In this essay I document her process of creating this production, how it differed from a typical Ping Chong production, and how the production affected those involved.

As Modirzadeh explained, *Secret Histories* tells stories from marginalized identities or, as Ping Chong has said, gives voice to those who share the common experience of being born into one culture but living as part of another; this form and content have developed over the years:

> The first "Undesirable Elements" production, ten years ago, had nothing to do with history, nothing to do with immigrants. It began simply because I was interested in seeing if I could do a show using multiple languages. I've always been interested in other people's cultures. It was never a project specifically about immigrants or refugees.
>
> Originally, "Undesirable Elements" was also a response to the post-Reagan nation that we live in; about intolerance coming back in women's issues, gay issues, class issues. It was not about immigrants and refugees alone. Since then, immigrant and refugee issues have very much risen to the surface.[3]

The purpose, or the hope, for reflection is to encourage audience members to consider questions such as these:

- How can a work of art provoke or move an audience that has not felt excluded to better understand those who have? How can it help those who feel excluded feel less so?
- Can an artist's work make a difference in healing a cultural divide?
- In what ways do you feel excluded/included in the society?
- How do political situations prompt theatrical choices in Ping Chong's [and Modirzadeh's] work?
- Can you respect a culture without having an affinity with it?
- What does it mean to feel at home?[4]

These are all issues that the performers will address as they tell their stories.

First: The Call!

Dear Prospective Secret History Participant,[5]
Participants in the *Secret Histories* project vary in many ways but share

the common experience of people who are born in one culture but are now living as part of another, either by choice or circumstance. The aim is to gather a group that is geographically and culturally diverse that includes men and women of different ages, professions, experiences and identities.[6]

Participants in *Undesirable Elements* must:

Speak and read English, as well as the language of their native culture, if English is not their first language (with some exceptions).
Be willing to talk openly about their lives, family, culture and customs, and share their thoughts in a public forum.
Be willing to talk openly about cultural differences and identity issues, and make critical observations about the culture in which they currently live.
Be willing to recite poetry and sing in their native or adopted language. (Do not panic about this requirement! You do not have to be a trained singer!)
Be willing to allow others to talk about what is desirable and undesirable in their culture of origin and what they have found to be desirable or undesirable in their new cultural setting.
Be available for an initial interview lasting approximately 2 hours.[7]

"*Secret Histories,*" Modirzadeh explained, "are the stories from marginalized identities that we don't hear, tell, or concentrate on. History is told by the people who win, those who have the power to decide whose history is told. These are the histories we don't hear about, unless you make a play about them. Also, we don't want to hear these stories: racism, homophobia, being albino."[8]

Modirzadeh began the process by sending out the call. This began in September 2008. She started interviews in September, cast in October, extended interviews in November, wrote in December and January, tuned up in February, rehearsed in March, and held the performance in April. Next Modirzadeh distributed a questionnaire that has also been developed over the years by Ping Chong & Company:[9]

What is your full name? Do you have a separate traditional/cultural name? . . .
Where and when were you born (date, year, city, country)?
What time of day were you born and what season/time of year was it in your country/culture (rainy season, winter, harvest time)? . . .

Did anyone ever tell you any special stories of the day you were born (you were born during a blizzard, in a taxi, on your mother's birthday, you came out green, etc.)?

Does your name have any special meaning, and were you named for anyone? . . .

What is your earliest memory?

What language did you speak growing up? What language(s) do you speak now? . . .

Have you struggled with issues of cultural identity? How do you currently identify yourself?

Do you have memories of feeling like an outsider/other in your culture of origin and/or current community?

Have you experienced direct or indirect racism or discrimination?

Have you witnessed racism or discrimination within your community towards others?

WHAT DO YOU THINK OF?

In the space below, please write what you think of when you think of your country/place of birth. These impressions can be anything that comes to mind: smells, sights, people, traditions.[10]

Please fill out the below form with major events that have happened in your lifetime. These should include the date of your birth, births and deaths of close family members, and moves between cities or countries.

Also include relevant historical events that impacted you, such as war or natural disaster. . . .[11]

Please list six male and six female names that are common names in your culture (e.g., John or Mary). Please also note if the name has any special meaning (e.g., Rosa means Rosem, Hakin means wise, Aiko means beloved), or if it is the name of an independent religions, cultural, or political figure.[12]

The Process

The questionnaires are supplemented with a two-hour interview. Chong does not tape the interviews but simply takes notes. His goal is to unify the voices into a sort of chorale in the melody of his own voice. The voices blend in a poem that is highly ritualized, unified, and even generic. He "essentializes the mate-

rial that is, in a way, very artistic, removed, formalized, and elegant."[13] Chong's shows depend heavily on ritualized movement and distillated gestures more than text, much of which is spoken in languages other than English. The stylized gestures are formal and repetitive, fundamentalizing the nature of each moment. He avoids a documentary or prosaic style and leans heavily on the poetic. There is extensive use of light and shadow in his performances, and performers systematically exchange looks to signal movement in and out of pools of light, shifting positions on the stage. Modirzadeh explained that this circling and changing of positions literally and metaphorically symbolizes migration of territory and patterns of flight. Rock salt is spread on the floor, which adds auditory and visual complexity as light reflects off the crystals and they make a crunching sound as actors step on them during their processionals around the stage.[14]

Modirzadeh's production differed from the typical format in a variety of ways. The performance space for "Secret Histories: Oxford" was a renovated warehouse with a modest stage platform, temporary seating in the house, and insufficient lighting; however, these limitations did not in any way diminish the power of the performance, which attests to the effectiveness of the *Secret Histories* format. Modirzadeh adapted the form to suit her own style and aesthetic preferences. She cast two actors, Joe Turner Cantú and Brittany Ray, two non-performers, Yukako Yamada and Annie Hollowell, and a narrator, Annette Hollowell, Annie's daughter. We discussed the challenges of working with each group. "Non-actors can be dull and flat," she told me. "You can't hear them; they don't color the words; they don't have technique. On the other hand, non-performers are guileless. For them, the act of telling their stories requires an amount of bravery and courage. This fear keeps them in check and keeps it formal. Their telling remains simple and truthful." Performers who have experience and technique tend to "turn it into a show," playing for a desired effect on the audience.[15]

Having assembled her cast, Modirzadeh conducted the two-hour interviews that, unlike Chong, she recorded and spent over a month transcribing word-for-word to retain the colloquialisms of expression. From the transcribed tapes, Modirzadeh found phrases that would be repeated to serve as auditory anchors for the performance. Using the turn of a phrase, word choice, rhythm, and accents, Modirzadeh achieved a complex auditory design. While Chong's style unifies the language into one formal voice, Modirzadeh strove for a more familiar, individualized set of voices.[16]

Many other elements remained consistent with the *Secret Histories* format. Stories are not told one by one in chronological order, although there is a very loose historical chronology. This historical narrative runs from Hernando DeSoto's arrival in Mississippi through the Indian Removal Act, the Civil War, the legal-

ization of segregation, World War II, prohibition, the civil rights movement, the assassination of Martin Luther King Jr., the war in Vietnam, the Saudi Arabia bombing, and, finally, September 11, 2001. These historical references contextualize the narratives and lend a sense of universality in the minds of the audience. This integration of public events with personal responses creates a feeling of empathy between audience and performers.

The performance begins with the name/nickname game, which was part of the information provided at the very beginning of the process.

ALL CLAP.
ALL: Name
JOE: Preston
ALL: Nickname
YUKAKO: Popcorn
ALL: Name
BRITTANY: Uncle Willie
ALL: Nickname
JOE: Uncle Meat
ALL: Name
YUKAKO: Coreen
ALL: Nickname
BRITTANY: Stripe
ALL: Name
ANNIE: David
ALL: Nickname
BRITTANY: Bunky
ALL CLAP.
JOE: In Brittany's family, young mothers create new names for their children:
BRITTANY: Juckevious One Yay
JOE: Kinarius Keeshon
BRITTANY: (His aunt calls him "Pontussy")
JOE: And Kwonzarian
BRITTANY: He can't spell his name yet; he's only 6.
ALL CLAP.[17]

Other elements that remained unchanged were the use of repetition and clapping. The clapping (as many as ten claps in a row) emphasizes shifts or, as Modirzadeh explained, "They clear the space for the next entry the way Chinese firecrackers at New Year's clear the way for the coming year." The dialogue con-

sists of rapid exchanges, quick give-and-take, and is free of long monologues. Modirzadeh also incorporated poems and songs, in Spanish, Japanese, and English, without translation. She told me, "Poems and songs in native tongues are important because not everything is translatable. Some things are better left in their original form, they are personal, mysterious. We recognize another language and culture but don't know it. This is somehow a respectful, unique experience for the audience. It is as if the speaker is saying 'I will say my story but you will never really know it.'" These stories are at once universal and personal, public and private.[18]

During the rehearsal process Modirzadeh consulted with Ping Chong and members of the company on her script. Honing, refining, cutting, and rearranging pieces of the stories is a "reductive" process, she told me. Chong was briefly in residence in Oxford, attending rehearsals and offering Modirzadeh and the cast notes, suggestions, and encouragement.[19]

Modirzadeh incorporated the "What do you think of" question for each of the performers. These were very moving and came at the end of the performance.

ANNETTE: What do you think of when I say the word "Mexican"?
ALL: Illegal immigrants.
JOE: Building the condos and working the restaurants of Oxford.
ALL: Migrant workers.
JOE: The backbone of American agriculture.
ALL: Yo quiero Taco Bell!
JOE: I think of ignorance about my people.
ANNETTE: What do you think of when you hear the word "gay"?
BRITTANY: AIDS, musicals, feather boas.
YUKAKO: It's Adam and Eve not Adam and Steve!
ANNIE: You're going straight to Hell!
ANNETTE: Joe?
JOE: Yes, Annette?
ANNETTE: What do you think of when I say the word "gay"?
JOE: I think of what the world would be without gay people: Without Virginia
 Woolf, Alexander the Great, Tchaikovsky. Without James Baldwin. Without
 Tennessee Williams.
ALL CLAP TEN TIMES.[20]

As the rehearsal process progressed, it became clear that Joe was serving as an anchor for the other performers. Joe was the only professional actor in the cast, and he was instrumental in setting and resetting the tempo, breathing rhythms,

and tones. While Joe told me he didn't particularly enjoy the attention and deference given to him by Modirzadeh and the other performers, he also realized his acting experience and technique served as effective models for the other performers. Joe explained the process:

> She treated it always with respect. Above all it was work, work, work. We were striving for a chorale harmony, not like a vocal or song way of balancing the voices. The timing of everything—it was so important. It got to where we were more worried about the timing and vocal balancing and getting it to work, and we were really not paying that much attention to the fact that we were sharing all of this. We were doing it over and over again. We were kind of numb to it. When we got the audience, that was shocking. We were all shocked. Oh my God, they (the audience) are hearing all this for the first time. It was a shock. In rehearsal we were dealing with form more than content.[21]

"Secret Histories: Oxford" opened on April 17, 2009, and played four performances to packed houses and standing ovations. It was, quite simply, one of the most *moving* pieces of theater I have ever witnessed. As simple as it was, the dramatic narrative, auditory, visual, and even kinetic design were complex, and interesting. These stories were told with a simplicity, truthfulness, and sincerity that created the feeling between performers and audience that confirmed the production's theme: "We are all from the same place."[22]

As Joe put it, "We are all not just similar but the same. I could truly empathize with a black woman my age."[23] Or, as Annie told me, "People's stories are the same, told differently. Don't get so fed up on race, get fed up on people and listen to them and their stories. You will find that you a have a lot more in common than you know. We just have to learn how to discuss things."[24]

The Performers

The four performers in "Secret Histories: Oxford" teach, work, or study at the University of Mississippi, also known as Ole Miss. The university is in Oxford, Mississippi, in Lafayette County. Nobel prize–winner William Faulkner, who lived in Oxford, wrote about Lafayette County.

ANNETTE: When William Faulkner wrote about Lafayette County, he called it:
BRITTANY AND YUKAKO: Yokna.
JOE AND ANNIE: Ptawpha.
BRITTANY AND YUKAKO: Yokna.

JOE AND ANNIE: Ptawpha.
ANNETTE: Translated from the *Dictionary of the Choctaw Language* as:
BRITTANY: "Yakni."
YUKAKO: Meaning "The earth,
BRITTANY: "the nation, the land."
JOE: "Patafa."
YUKAKO: Meaning
JOE: "to split, to divide, to rip apart,
BRITTANY: "to cut open for disemboweling."
ALL: "Yoknaptawpha."
ANNIE: The land divided.
BRITTANY: The nation ripped apart.
JOE: The earth cut open for disemboweling[25]

Brittany Ray is a twenty-three-year-old Bachelor of Fine Arts acting student at the University of Mississippi. She was born in the majority-black community of Indianola, Mississippi. She is African American, she is legally blind, and she is albino. Brittany tells her story, as do all of the participants, with humor and candor, but she does not mitigate the difficulties of being black and literally white:

BRITTANY: When Mom gives birth to me, people think she lost the baby and went crazy. They think she's carrying around a white baby doll. When I start moving they say:
YUKAKO: Oh it is a baby! It's your baby! And she's albino! Oh ok.[26]

In first grade, a fight with a bully on the school bus causes Brittany to be kicked off the bus. For the next six years she walks to school. By the fourth grade she has found one way to avoid the teasing.

BRITTANY: I like reading because if you're reading they won't pick on you. I can't see well so I need to read right up close to the books. The school gives me huge books: two feet tall—a foot and a half wide. I threaten to hit people with my big books. Still not allowed on the bus. I have to walk home carrying them. I look like Moses carrying the Ten Commandments.[27]

Brittany laments the frustrations of being a student in the Mississippi Delta. The public library closed due to an infestation of snakes, and access to computers was extremely limited. It finally reopened seven years later. "That's progress in the Delta." After seven years, "the local kids feel discouraged, frustrated and forgotten."[28]
Brittany talks about the time the white Teach for America teachers came to

the Delta. The students quickly realize they can have some real fun with the in-experienced college graduates. "The old teachers might have been old but they didn't hesitate to whup you." The Teach for America teachers are much gentler in their methods and the students take full advantage of this to pull pranks and test the classroom rules. Brittany talks about the day George W. Bush comes to town and no one shows up. After all, she says, "It's George Bush. Just some random white guy." Only half of her high school class graduates. The rest are "dead or in jail."[29]

In an interview, Brittany told me that the one part of her story she was most eager to share was the influence her parents have had on her. "I don't think I would have turned out to be such a strong, ambitious person had it not been for my mom and dad."[30] In the performance she says, "To this day my mom still threatens to whup me. I believe she would do it too and I would just sit there and take it cuz that's my momma."[31]

During the "What do you think" section, toward the end of the play, Annette asks Brittany, "What do you think of when I say the word 'albino'?"

BRITTANY: I think of how I feel all alone everywhere I go: out in the world, going to class, everywhere. It makes me sad but loneliness is a big part of who I am [fig. 9].[32]

Joe Turner Cantú introduces himself in Spanish: "Yo me llamo Jose Luis Turner Cantú. Nací en Weslaco, Tejas, a las 7:45 de la mañana en el 28 de agosto, 1954. Mi madre me denominó Augustin por 24 horas hasta que ella se diera cuenta de que ella había orado al Santo Jose todo el tiempo ella estuvo embarazada."[33] Part of this introduction is shaped by the format Chong developed early on, integrating the blend of different languages. But also it is a necessary revelation of part of Joe's "secret" history: his Mexican American heritage. While Brittany Ray's "secret" is obvious, at first sight Joe's is not. His fair skin and facial features do not reveal his Mexican identity. Neither is the second part of his secret obvious; he is gay. He talks about a childhood spent in Weslaco, Texas, in the heart of the Rio Grande Valley, speaking mostly Spanish until the day his mother lays down the law:

BRITTANY: This little ignorant Mexican boy is going to learn English before he goes to the first grade. So from now on—only English in this house![34]

He is five years old.

Joe tries to be a daddy's boy, but he tells us, "No matter how hard I try, I can't

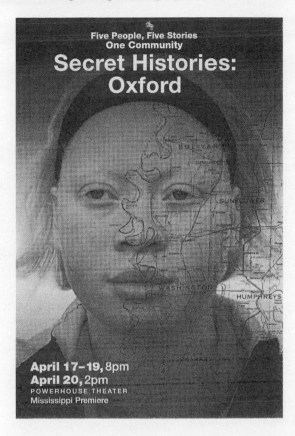

9. "Secret Histories: Oxford" poster (Brittany Ray). Image courtesy of Ping Chong & Company and Leyla Modirzadeh.

hit a ball with a bat." When he is six, his mother asks what he wants to be when he grows up. "A Negro," he responds, because "in Shirley Temple movies the Negroes are always dancing and singing and having fun." At thirteen Joe wants to be the pope. He knows he is gay but has no label for it. He asks to be sent to seminary to become a priest, but there is another reason: boys. At the seminary, he is caught with another boy and is dismissed. The prefect father tells him, "It would break you mother's heart if she knew the truth, so I am going to tell your parents that you just got too involved in Drama."[35]

In 1971 Joe's mother is diagnosed with cancer. Due to Joe's father having been briefly married and divorced (rather than having the marriage annulled), his parents are "living in sin" and the church considers Joe and his siblings bastards. Joe's mother has not been able to take communion. As she is on her deathbed, Joe explains, "in order for her to finally receive Holy Communion, she has to sign a paper saying that if she gets well, she and my father would live as brother and sister. For her, it is a joy that she can have Holy Communion before she dies.

For me, I break all ties to the Catholic Church." Joe allows his father to use the inheritance his mother left him to pay bills with the condition that "I don't want anybody in this room to question me about my life or my lifestyle—ever. Is that clear?"[36]

The next year, 1972, Joe attends Ouachita Baptist University. He declares, "It's my first year in college. I'm an actor. I have long hair, wear overalls—no underwear, just overalls—clogs and a tweed jacket. When I have to look decent I put a T shirt on under the overalls. And it's the year I come out. I'm a homo."[37]

Proclaiming "I am a homo" is somehow shocking in our politically correct culture. I asked Joe if he had any reluctance to so publicly announce his orientation. He told me that at first he did experience an unexpected fear of sharing his personal story but ultimately was pleased that he overcame that fear.[38]

The rest of Joe's story deals with reconciling with his father and stepmother, finding his life partner, and moving to Oxford (where he heads the BFA acting program at Ole Miss). Joe and I talked about how the process of making and performing "Secret Histories: Oxford" affected his sense of identity personally and in the community. "I thought the gay thing was going to be the big deal," he told me. "As it turned out, the bigger deal for me was growing up Mexican American."[39] Joe talked about his childhood and feeling as if he never fit in with the Mexican community in Texas. He didn't look Hispanic and he was gay. He talked about the move to Oxford, where he and his partner were easily accepted as a gay couple, yet is dismayed by the prejudice toward African and Mexican Americans when a friendly neighbor tells him:

BRITTANY: And if you hire anybody—get yourself some Mexicans and they'll get the job done. These dark folks aren't interested in getting the work done. But those Mexicans—they'll do it for you.[40]

Finally, I asked Joe how the experience of making "Secret Histories: Oxford" affected him (fig. 10). "It has affected how I think about things, the whole immigration issue. When I was growing up, immigrants were celebrated. When my grandmother came across with her seven children, she was sewing and making cigars. She came for a better life. It's a cliché, but it's true. The whole goal which they had was to become American citizens, which they did. I don't understand why today they don't want to become citizens . . . and why there is so much negativity towards America."[41]

The story that perhaps best exemplifies the idea of being born in one culture and living in another is that of Yukako Yamada, born in Hekinan, Japan, in 1981. While all of the participants expressed feeling solitude, Yukako told me, "I was

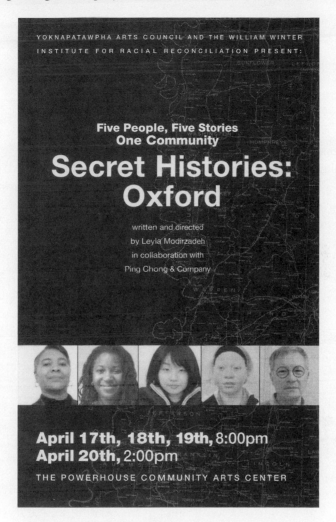

10. "Secret Histories: Oxford" program. Image courtesy of Ping Chong & Company and Leyla Modirzadeh.

scared about talking about myself in public because I didn't know what reaction I would get. In the show I am always saying 'in Japan' because I am the only one from another culture. I feel that I am much more different from the others. That's what makes me more scared."[42] Yukako spoke about Japanese culture and the fact that as the first-born girl child, her parents could make all of their mistakes on her in anticipation of the birth of a son. When little brother finally arrives, her grandmother calls him "yookun" to show that she likes him the best. She tells him,

BRITTANY: You are most important to the family because when you marry, you will grow the Yamada name by adding a wife and children.

When Yukako first plans to travel to the United States, her parents tell her,

JOE: The U.S. is full of guns! And you'll get fat—everyone is fat in the U.S.![43]

What is perhaps most interesting about Yukako's story is her attention to propriety. Yukako worried about how her message would be received. She told me: "I was so scared, the interview was so much fun with Leyla, but I was wondering what part of my interview would be in the show. I just hoped what I'm telling her won't be exaggerated or offending people. Since I'm not a native speaker, I'm not sure I can tell them correctly what I want to say. Scary . . . that's the key word for me."[44]

Yukako was residing in Washington, D.C., on September 11, 2001. It is hard for any of us to make sense of that day, but for her it was particularly difficult:

YUKAKO: September 11, 2001.
JOE/BRITTANY: SEPTEMBER 11, 2001.
ALL: September 11, 2001.
JOE: Washington, D.C.
YUKAKO: I am going to see my friend who works near the Pentagon. I see a lot of people pouring out of the buildings. Someone runs by me saying—
BRITTANY: "Someone is attacking us—Go back to your houses NOW!"
YUKAKO: That night on TV President Bush is talking but I can't understand what he is saying. I can only feel that something very bad is happening. When my housemother comes home I ask her: "What happened?"
BRITTANY: "Well, Middle Eastern people are jealous of the U.S. so they attacked us."
YUKAKO: I think: It's more complicated than that. There are a lot of causes for this. But she thinks:
BRITTANY: We are good—they are bad.
YUKAKO: September 12, 2001.
BRITTANY: September 12th, 2001.
JOE: Washington, D.C.
YUKAKO: I am more scared of the American people's reaction than of the next attack. I am getting scared of everyone waving the American flag and if you don't wave the American flag—you are the enemy![45]

When she arrives at Ole Miss as the coordinator of Japanese Outreach Initiatives, she is dismayed by the ROTC students in their uniforms. She sees them as military people and questions their appropriate place in an educational setting. She is also surprised by the public displays of affection and southern hospitality. "A man holds the door for me when I walk in a building. In Japan, there is no 'ladies first.'"[46]

She is amazed by the proximity of shows of affection: "In Japan we don't hug. We don't even shake hands. Distance is very important, particularly when you meet someone for the first time. Here it's: close close close hug hug hug *(hugging gesture)*."[47]

Yukako relates what might be the most distinct example of growing up in one culture and living in another. Yukako, who grew up in a Buddhist family, attends a Pentecostal church service with an African American friend:

YUKAKO: I am very curious about Christianity. My African American roommate invites me to her Pentecostal church. Before the service starts, people are communicating with God out loud:

ALL MIXED: "Oh god!—Holy lord!—Hallelujah! Praise God! Jesus, oh my savior!"

YUKAKO: When the service starts, a lot of people are coming up saying what God has done for them. They are very, very emotional, always emphasizing with

ALL: AMEN! AMEN! AMEN BROTHER!

ANNIE: AMEN SISTER!

YUKAKO: I do not understand. In Japan, religion is very private and never emotional.

ANNETTE: A girl goes up the aisle to the pastor.

The pastor says something to her.

She falls down shaking.

Then people from the church come close,

Cover her,

And take her away—

YUKAKO: I am very scared. I can't imagine what she believes to make her do that. After the service I ask: "Why did she fall down?"

ANNETTE: "She communicated with God and that's why she fell down! She's very happy now."

YUKAKO: "Have you done this before?"

ANNETTE: "Hmhm hmhm, and I hope you will have this experience one day."

YUKAKO: I say: "No thanks—I'm fine."

I'm curious: If you fall down on the floor that means you are close to God. If

you do not fall down does that mean you are not close to God? Everyone cries at church after they communicate with God. People walk around with tissues—even men are crying. In Japan we never cry in public. Even if you communicate with God.[48]

Perhaps the most striking presence in "Secret Histories: Oxford" is that of Annie Hollowell. Annie was born in Holly Springs, Mississippi, in 1953. She is one of fourteen children; her parents are sharecroppers. She tells us:

ANNIE: 1959.
JOE AND YUKAKO: 1959.
ANNETTE: Holly Springs, Mississippi.
ANNIE: My parents are sharecroppers. We have
YUKAKO: No windows.
BRITTANY: No lights.
YUKAKO: No electricity.
JOE: No toilets.
BRITTANY: Four beds, two rooms,
YUKAKO: and 14 children.
ANNIE: I start working in the cotton fields. I am 6 years old.[49]

By the time she is sixteen, she can pick 460 pounds of cotton a day and must miss four months of school each year to work. She leaves home and an abusive father, marries her next-door neighbor, who is also her childhood sweetheart, and follows him around the world throughout his military career. She talks about the devastation of the assassination of Martin Luther King Jr. and of marching during the civil rights movement. Her description of April 4, 1968, is terrifically moving:

ANNETTE: Holly Springs, Mississippi.
YUKAKO: April 4th, 1968.
ANNIE: I'm working in the cotton field, singing under a beautiful sky. We always
 sing when we pick or chop cotton—that's our way of getting through the day:
(Lights to half.)
ALL: Tell the angels, tell the angels
I'm on my way
Tell the angels, tell the angels
I'll be home someday
Tell the angels, tell the angels
I'm on my way to glory

Up there—
(All stop singing abruptly.)
(Lights bump up to full.)
ANNIE: All of a sudden we hear a single bell. When tragedy happens, my grand-
mother only rings once. We see her running toward us.
ANNETTE: "Dr. Martin Luther King Jr. is shot—He's dead!"
JOE: One.
YUKAKO: Two.
BRITTANY: Three eternities pass.
ANNIE: Momma starts to cry.
I feel something hit me in the pit of my stomach,
Warm tears run down my face.
We lay the hoes down and go into the house. Momma says:
ANNETTE: "That's a great man. But he has fallen."[50]

Annie talks about being refused seating at a local restaurant that posts a sign
"No Coloreds Allowed." She and a friend must go around to the back door to
pick up their food. It is 1973.

In Mississippi, 1974:

ANNIE: My husband and I find a house we want to buy.
ANNETTE: Annie and her husband would be the only black people in an all-
white neighborhood. When they go for a loan, the bank says:
JOE: "That's too much house for you."
ANNETTE: Eventually they manage to get the loan and move in.
ANNIE: I start preparing my front garden.
ANNETTE: A cop drives through looking and staring. He says:
JOE: "There's a black lady pulling some hedges on Swaney Drive."
ANNETTE: Annie's husband, who is now a policeman, gets on the police radio:
JOE: "Her name is Annie Hollowell. That is my wife, and that is my house."
ALL CLAP.[51]

Her husband returns to the military and barely escapes the 1996 truck bomb-
ing in Dharan, Saudi Arabia.
In 2003, working as a receptionist at Ole Miss, Annie receives disturbing news:

ANNIE: I am diagnosed with breast cancer. It has spread into the ducts of
my left breast. I must have my breast removed. At first, I am scared. I feel
ashamed. My daughter says:

ANNETTE: "You need support right now. Go to a support group."

ANNIE: "This is mine. I have to deal with it my own way." I begin to pray and read the Bible a lot.

(Annette reads quietly from the Bible ["The Lord is my Shepherd . . ."])

ANNIE: This gives me a peace of mind and the will to go back to church. Finally, I feel content with myself.

(Annette stops reading.)

ANNIE: I am no longer ashamed.

ALL CLAP.

ANNIE: 2003.

ALL: 2003.

ANNIE: I am in the bathtub taking a bath.

JOE: Annie's husband walks in and immediately jumps back into the other room.

ANNIE: I call him back and say: "You know what? I have to live with this. You have to see it. So you have to be a part of it. Don't ever run from this because in the end you make me think that you are not happy with what you see." For years and years I've been "Yessir" "nossir"—doing whatever my husband wants. But now I'm my own woman living my own life.

ALL CLAP TEN TIMES.

(Blackout.)[52]

Today Annie is a cancer survivor. She has been married to Bill for thirty-six years and has two grown daughters and lives on a farm in Holly Springs. When asked what she thinks of when she hears the word "Mississippi," she replies:

ANNIE: I think of making my own corn liquor:

Take 800 husks of corn; put them in a thirty-gallon drum—then add raisins, grapefruit, apples, sugar and dry yeast, water.[53]

Conclusion

At the end of each interview I asked the performers what they had learned about themselves through the "Secret Histories: Oxford" experience. Yukako told me, "It became more clear to me what it meant to be Japanese in Oxford, Mississippi. It gave me confidence and made it easier to understand who I am and what I am doing here."[54] For Joe it was the recognition that his parents were good people who brought him up well. "I didn't know that in the process of doing this I was going to be able to validate who my parents were. It reinforces what good par-

ents they were. I didn't know it at the time, but I do now."[55] Brittany answered, "The process hasn't really changed how I live. But it did give me a better sense of who I am as Brittany Ray, the whole person, not the Ole Miss student, or the girl from the Delta with the thick accent, or an albino woman."[56] For Annie, it was not so much a discovery as it was an affirmation. "There was a time I didn't like being a black woman, but I am a black woman . . . a beautiful black woman, and I'm very proud of it. When you know yourself and you're proud of what you do, racism can't bother you."[57]

These answers reflect the issues Scott Magelssen pointed out in the introduction to this collection. Issues of authenticity, race, ethnicity, and gender are addressed in nearly every essay. Immigration, cultural pride, and personal and national identity are also considered. All, he said, "bear witness to a moment or a set of moments of the past, whether actual or largely imagined."[58] And, in the case of "Secret Histories: Oxford," moments remembered: private, personal moments of individual histories.

The stories of "Secret Histories: Oxford" are not secret because they are indiscreet or shameful. They are secret because we often chose not to look. These stories direct our attention. We look, and when we attend to something we are changed by it. When we tell our stories and hear them and attend to them we are connecting with one of the most human of attributes: storytelling. But what Ping Chong & Company have given us is, in Modirzadeh's words, the sense that "we are all from the same place."

ALL CLAP TWICE.

JOE: 2008.

ALL: 2008.

JOE: When I think of my identity, I could say "gay" or "Mexican American" or "Tejano," but what I really want to say is just "human being." I live in America and identify as an American, but I'd prefer a world identity where I can let go of all borders, past and present, and stop asking where anyone is from, because it will be obvious that we are all from the same place.

YUKAKO: We are all from the same place.

BRITTANY: We are all from the same place.

ANNIE: We are all from the same place.

ANNETTE: We are all from the same place.

ALL CLAP TEN TIMES.

(Lights out.)[59]

Ping Chong & Company
Undesirable Elements/Secret History
Participant Information Form- BACKGROUND

Please answer these questions to the best of your knowledge. Do not worry if you do not know an answer, just write that you do not know. Please use the back of this form or another page if you need more room to write. Use as much space as necessary.

What is your full name? Do you have a separate traditional/cultural name?
山田悠花子　Yukako Yamada

What is your current profession?
Japan Outreach Initiative Coordinator

Where and when were you born (Date, year, city, country)?
May 13TH, 1981, Hekinan, Japan

What time of day were you born and what season/time of year was it in your country/culture (rainy season, winter, harvest time)?
Late spring; not hot, not cold, plants are blooming, beautiful and comfortable season.

How much did you weigh at birth?
About 2800g.

Did anyone ever tell you any special stories of the day you were born (you were born during a blizzard, in a taxi, on your mother's birthday, you came out green, etc)
Not really. It was very hard for my mother because I was a first born child. It took for a long time to give birth.

Does your name have any special meaning, and were you named for anyone?
Someone who is famous and professional to give names gave my parents various names and they chose my name. Yu; an image of calm, peaceful, wildness... etc, Ka; being pretty like a flowers, Ko; is added at the end for girls

How many brothers and sisters do you have? What is your place in the birth order?
I have three; me, brother, sister.

What is your earliest memory?
I make a frond of mine cry at a kindergarten.

What language did you speak growing up? What language(s) do you speak at home now?
Japanese.

What are/were your parents names? What is/was their profession?
Father: Kazuo who is a teacher at elementary school
Mother: Akiko who is a house wife working at library at school as a part-time worker.

Do you know your grandparents' names and professions? If so, please write below. Also note if you knew your grandparents while growing up.

11. Yukako Yamada's Participant Information Form.

Participant Information Form- BACKGROUND

Father's side
Grandfather: ?? who was a teacher.(passed away)
Grandmother: Tomie who worked at a company.

Mother's side
Grandfather: Shojiro who was a teacher.
Grandmother: Sumiko who was a housewife. (passed away)

How did your parents meet? Are there any stories about their courtship or wedding?
I heard that they met a class on campus. My father was in 4-year university, my mother was in 2-year collage but they shared with campus. One day he attended a collage class which was recreation class or something because he didn't study well and he needed a grade to graduate. They met there and started going out but after her graduation, somehow they stopped seeing each other. However, they thought that they liked each other so that a few years later, they started dating again to get married.

How did your grandparents meet? Are there any stories about their courtship or wedding?
They met at marriage meeting. She grew up in wealthy family. Yet when she was a teenager, her father or uncle failed their business and lost a lot of properties. So that it was difficulty for her to find one to get married. Finally she found him and got married.

Please share any unique or unusual stories about your family's history

If not born in the US, what year did you arrive in the US and how old were you?
20 years old.

If not born in the US, what was the first "American" meal that you ate?
Macdonald stuff.

What are some traditional foods from your culture? Do you eat these now?
Miso is one of traditional foods from Japanese culture. When I in Japan, I have Miso soup twice every day so I thought that I will miss one after coming to US.

What are some holiday, festival, or ceremonial traditions from your culture? Describe in as much detail as possible (wedding ceremony, naming ceremony, harvest festival, etc). Do you currently observe/celebrate them?
At the wedding, a bride goes out from her own house wearing white wedding kimono and neighbors celebrate her. Her family gives neighbors small souvenirs like a box of chocolate. I saw that when I was elementary student but not anymore.

At 15th in August, we celebrate for our ancestors. We make a horse with a concombre and cow with a eggplant. A horse means ancestors come here from another world as soon as possible. A cow means ancestors stay here as long as possible and go back to another world late. We make a fire to welcome ancestors and after we send them, we burn everything. I heard that many people don't do this event anymore. They don't have even an alter at their home anymore.

We have a lot of foods in New Year's day. Seven days after a new years day, we have "nanakusa-gayu" which means rice gruel with seven herbs. It wishes your health the year and take a rest your stomach because your stomach would be tired of a lots of foods in New Years Day.

Ping Chong & Company
Undesirable Elements/Secret History
Participant Information Form- BACKGROUND

If not born in [city of current residence] how long have you lived here, and what brought you here?
I live in Oxford and will be here for 2 years. My organization Global Partnership and Laurasian Institute decided to send coordinator to Mississippi so that I am here.

How is your cultural identity reflected in your daily life (foods, traditions, activities, etc)
I think that cultural Identity reflects in your daily life every time. Yet I also have gotten used to it. If you say "I prepare for lunch for you tomorrow" to an American, she would imagine peanut butter and jerry sandwiches but I would cook rice balls. Your culture identity reflects at even such a little things.

Foods are fine here, however, the way to take nutritions are different. Particularly, irons and minerals are difficult to take in daily life with only American foods.

Religion is a one of big parts of reflecting my cultural identity. It is amazing for me to see so many people are belonging to the religious. I haven't thought about my religious in Japan but that have asked me what you believe in.

In a relationship, I often say "I am sorry" but Americans hardly say it.

Was there a person in your life who had a profound influence on shaping the person you are today? If so, please give an example of how he/she influenced you.
I think everyone that I met has had profound influence on me.

Have you struggled with issues of cultural identity? How do you currently identify yourself?
I haven't had that yet.

Do you have memories of feeling like an outsider/other in your culture of origin and/or current community?
Yes. There was not special incidents at all but sometimes I feel that way. Sometimes can be anytime. For example, when I am going shopping at Walmart, when I am driving somewhere, when I am working at my office, etc.

Have you experienced direct or indirect racism or discrimination?
Not to me yet.

Have you witnessed racism or discrimination within your community towards others?
Sometimes they discuss that on Daily Mississippian which is a campus newspaper. As for personal experiences, I haven't had that yet.

What are some assumptions that people make about people from your culture?
I do not understand the question. I am sorry.

What are some of the major issues that you see as currently pressing within your community?
I would say that religious thing because people recommend me to believe their god.

Ping Chong & Company
Undesirable Elements/Secret History

Participant Information Form- BACKGROUND

What do you like about living in [city of current residence]

Oxford is calm and quiet. There are a lot of nature. It is a kind of cosmopolitan because it is a campus city. That makes me live in easier.

What do you dislike about living in [city of current residence]

Driving manner is not good here. Public transportation is not common in Oxford. There is particularly nothing to do in this city.

If not currently living in your culture/country of birth, what do you miss?

I miss my family, friends and my mother's taste.

Where is "home" for you?

Okazaki city.

How did you hear about this project, and why do you want to participate?

I thought it was interesting project because this project focuses on individual history, not the history on a textbook. We often forget that we are a part of history. And naturally people are interested in someone's life even if they don't ask.

Are there any other details about yourself that you wish to share?

Notes

1. Leyla Modirzadeh, "Secret Histories: Oxford," 2. Unpublished script, in collaboration with Ping Chong & Company, performed at the Powerhouse Arts Center, Oxford, MS, 2008. I have included long passages to give the reader a sense of the form and content of these unique performances. More information can be found at http://www.pingchong.org and http://www.Undesirableelements.org/.

2. See http://www.artsand . . . org/artists/pingchong.php.

3. Ping Chong and Leyla Modirzadeh, *Secret History: Journeys Abroad, Journeys Within* (New York: Lincoln Center Institute, 2006), 10. *Secret History* is a guidebook for an LSI program and was conceived by Ping Chong and written by Ping Chong and Leyla Modirzadeh in collaboration with Sara Zatz.

4. Chong and Modirzadeh, *Secret History: Journeys Abroad, Journeys Within,* 7.

5. All of the information in this section remains the intellectual property of Ping Chong & Company and may not be copied, quoted, or used without permission.

6. Ping Chong & Company, letter from Ping Chong and Leyla Modirzadeh, "Dear Prospective Secret Histories Participant." This, as well as materials in notes 7, 10, 11, and 12, are original, unpublished materials I received from Ping Chong and Leyla Modirzadeh that they use in auditioning performers and putting together *Secret Histories* performances and scripts.

7. Ping Chong & Company, "Undesirable Elements/Secret History Participant Information Form."

8. Author's interviews with Leyla Modirzadeh, Oxford, MS, January 12, 2009, and May 12, 2009.

9. Ibid.

10. Ping Chong & Company, "Undesirable Elements/Secret History Participant Information Form—BACKGROUND."

11. Ping Chong & Company, "Undesirable Elements/Secret History Participant Information Form—CHRONOLOGY."

12. Ping Chong & Company, "Secret History/Undesirable Elements Participant Information Forms—NAMES."

13. Interviews with Modirzadeh.

14. Ibid.

15. Ibid.

16. Ibid.

17. Leyla Modirzadeh, "Secret Histories: Oxford," 5–6.

18. Interviews with Modirzadeh.

19. Ibid.

20. Modirzadeh, "Secret Histories: Oxford," 67–68.

21. Author interview with Joe Turner Cantú, Oxford, MS, June 22, 2009.

22. Modirzadeh, "Secret Histories: Oxford," 70.

23. Interview with Cantú.

24. Author interview with Annie Hollowell, Oxford, MS, May 15, 2009.

25. Modirzadeh, "Secret Histories: Oxford," 5–6. Established in 1836, Lafayette County was one of ten counties into which the Chikasaw Cession was divided. Private land was purchased from the Native Americans and people flooded into the area. The white settlers needed slaves, and by 1860 slaves outnumbered whites in Mississippi. Oxford was incorporated in 1837, and the state's first university, Ole Miss, opened to eighty students in 1848. During the Civil War, Oxford and much of the university were burned to the ground. Ole Miss and Oxford recovered and rebuilt. In 1962, James Meredith became the first African American student at the University of Mississippi. This event was a defining moment in the American civil rights movement. Ole Miss is the home of the William Winter Institute for Racial Reconciliation, and the university hosted the first 2008 presidential debate between John McCain and Barack Obama.

26. Modirzadeh, "Secret Histories: Oxford," 40–41.

27. Ibid., 49.

28. Ibid., 53.

29. Ibid., 60.

30. Author e-mail interview with Brittany Ray, Oxford, MS, June 25, 2009.

31. Modirzadeh, "Secret Histories: Oxford," 63.

32. Ibid., 66–67.

33. Ibid., 3.

34. Ibid.

35. Ibid., 22, 19, 30.

36. Ibid., 33–34, 35.

37. Ibid., 35.

38. Interview with Joe Turner Cantú.

39. Ibid.

40. Modirzadeh, "Secret Histories: Oxford," 54.

41. Interview with Cantú.

42. Author interview with Yukako Yamada, Oxford, MS, June 17, 2009.

43. Modirzadeh, "Secret Histories: Oxford," 41, 49.

44. Interview with Yamada.

45. Modirzadeh, "Secret Histories: Oxford," 51–52.

46. Ibid., 62.

47. Ibid.

48. Ibid., 63–65.

49. Ibid., 17. This is a good example of the *Secret History* style: the division of lines and the dynamic, *stychomythic* format and the repetition for cadence and emphasis.

50. Ibid., 26.

51. Ibid., 36–37.
52. Ibid., 55–56.
53. Ibid., 66.
54. Interview with Yamada.
55. Interview with Cantú.
56. Interview with Ray.
57. Interview with Hollowell.
58. Magelssen, introduction to this volume, 3.
59. Modirzadeh, "Secret Histories: Oxford," 70.

Contributors

Leigh Clemons is an associate professor of Theatre/Women's and Gender Studies at Louisiana State University. She is the author of *Branding Texas: Performing Culture in the Lone Star State.*

Catherine Hughes, PhD, is a teacher, theater artist, researcher, and writer. She is the project director of Meet the Past at the Atlanta History Center. She has written about and spoken widely on the practice of museum theater. Her dissertation was an empirical study of spectators' aesthetic reception of performances in museum sites. She wrote *Museum Theatre: Communicating with Visitors through Drama* and founded the International Museum Theatre Alliance (*http://www .imtal.org*).

Rhona Justice-Malloy, PhD, is a professor in the Department of Theatre Arts at the University of Mississippi and the editor of *Theatre History Studies.* She is a member of the National Theatre Conference.

Kimberly Tony Korol-Evans received her PhD from Northwestern University and has been visiting assistant professor of theatre history at the University of Arizona and visiting assistant professor of performance studies at Missouri State University. Her areas of study include early modern drama and performance, contemporary popular performance, and performance theory and ethnography. She is the author of *Renaissance Festivals! Merrying the Past and Present.* Other publications include work on Tudor court culture and on the theatricality of the National Hockey League.

Lindsay Adamson Livingston is a doctoral candidate in the theater program at the Graduate Center, the City University of New York, and teaches in the Journalism, Communications, and Theatre Department at Lehman College. Her primary research interests include the social construction of space, memory, and history; contemporary theater and performance in the United States; and tourist performance. She has published work in *a/b: Auto/Biography, The Journal of the Wooden O Symposium,* and *The Children's Book and Play Review.*

Scott Magelssen is an associate professor of theater at Bowling Green State

University and the editor of the *Journal of Dramatic Theory and Criticism*. He is the author of *Living History Museums: Undoing History through Performance*.

Aili McGill is currently the assistant general manager for guest experience and was formerly the manager of the Museum Theater Initiative and of Prairietown, an 1830s living history village, at Conner Prairie in Fishers, Indiana. She has worked at Conner Prairie for seven years, during which time she received a bachelor's degree in Museums and Museum Management from Earlham College and a master's degree in Museum Studies from Indiana University–Purdue University at Indianapolis. She also appears weekly at Comedysportz Indianapolis, an improv comedy show with a sporting twist.

Richard L. Poole is a professor in the Department of Theatre and Speech Communication at Briar Cliff University in Sioux City, Iowa. A Fulbright scholar, he has given numerous professional papers on Midwestern rural and small town theater. His essays have appeared in *Theatre History Studies, The Guide to United States Popular Culture, The Tamkang Review* (Taiwan), and the *Cambridge Guide to American Theatre* (2nd edition). He is the co-author (with George Glenn) of *The Opera Houses of Iowa*.

Amy M. Tyson worked seven summers as a living history interpreter at Historic Fort Snelling in St. Paul, Minnesota. She received her PhD from the University of Minnesota in 2006 and is currently an assistant professor in the History Department at DePaul University.

Patricia Ybarra is an associate professor in Brown University's Department of Theatre Arts and Performance Studies. Her publications include *Performing Conquest: Five Centuries of Theater, History, and Identity in Tlaxcala, Mexico* and articles and reviews in *TDR: The Drama Review, Aztlán, Theatre Journal,* and *Modern Language Quarterly*. Her area of specialization is theater historiography of the Americas, with emphasis on the relationship between theater, nationalism, and American identities in North America. She is also a director and dramaturge.